Norwegian Folk Art

Norwegian Folk Art

The Migration of a Tradition

Abbeville Press Publishers
New York · London · Paris
in association with
the Museum of American Folk Art · New York
and
the Norwegian Folk Museum · Oslo

SCANDINAVIAN AIRLINES

Frontispiece: *Hjelle in Valdres* (detail). Johan Christian Dahl (1788–1857). 1851. Bergens Billegalleri. Photo: O. Væring.

Front endpaper: Coverlet in square interlock technique (*rutevev*). NORW. IN AM. Folkedal family, Hardanger. Found in Iowa. 19th century. Wool, cotton or linen. H. 62¼" W. 54¾" Adeline Haltmeyer Collection. John Haltmeyer.

Back endpaper: Back of a plank construction bench (*brugdebenk*) with carved figures. NORW. Setesdal. 18th century. Pine. H. 28" W. 63" Norsk Folkemuseum (NF 1928–521).

Copyright © 1995 Abbeville Press. All rights reserved under international copyright conventions. No part of this book may be reproduced or utilized in any form or by any means, electronic or mechanical, including photocopying, recording, or by any information storage and retrieval system, without permission in writing from the publisher. Inquiries should be addressed to Abbeville Publishing Group, 488 Madison Avenue, New York, N.Y. 10022. The text of this book was set in ITC Galliard. Printed and bound in Canada.

ISBN 0-7892-0194-1 (hardcover)
ISBN 0-7892-0196-8 (paperback)

First edition
10 9 8 7 6 5 4 3 2

Catalogue photo credits: Appendix I, page 265.
Originals of Norwegian Inscriptions: Appendix II, page 266.

PRODUCED BY
Stanton Publication Services, Saint Paul.

DESIGNED BY
Will Powers, Stanton Publication Services, and Ann Artz, Studio Artz, Minneapolis.

Contents

Acknowledgments	6
Lenders to the Exhibition	7
Directors' Prefaces	8
Introduction MARION NELSON	13
Illustrations 1–30. Continuity and Change; Remnants of the Middle Ages	17
Folk Art of Norway MARION NELSON	37
Illustrations 31–45. Reflections of the Renaissance	49
Illustrations 46–71. The Baroque Revolution in Wood; Aberrations of the Acanthus	73
Norwegian Folk Art in America MARION NELSON	89
Illustrations 72–100. Figure Carving from Acanthus Times and After	101
The Social and Economic Background of Folk Art in Norway HALVARD BJØRKVIK	119
Emigration and Settlement Patterns as They Relate to the Migration of Norwegian Folk Art ODD S. LOVOLL	125
Illustrations 101–121. Geometric Textiles of the 18th and 19th Centuries; Folk Dress	133
Rural Norwegian Dress and its Symbolic Functions AAGOT NOSS	149
Norwegian Folk Dress in America CAROL HUSET COLBURN	157
Illustrations 122–145. Forms Dictated by Function and Technique; Open, Incised, and Burnt Decoration	171
The Immigrant's Luggage: Observations Based on Written Sources JON GJERDE	185
Rosemaling: A Folk Art in Migration NILS ELLINGSGARD	189
Illustrations 146–205. Paint and the Flowering of Norwegian Folk Art	195
Collecting, Researching, and Presenting Folk Art in Norway TONTE HEGARD	239
Tradition and Revival: The Past in Norway's National Consciousness ALBERT STEEN	249
Illustrations 206–210. The Outer Edges of Tradition	259
Appendices	265
Bibliography	269
Index	271

Acknowledgments

THIS CATALOGUE and the exhibition to which it relates were made possible by a major grant from the Royal Norwegian Ministry of Foreign Affairs to the Museum of American Folk Art in New York and the Norwegian Folk Museum in Oslo, Norway. SAS, Scandinavian Airlines System, is generously contributing the international transportation. Support for programs relating to the New York showing has been given by the American Scandinavian Foundation.

The assistance of Vesterheim, Norwegian-American Museum, Decorah, Iowa, in assembling, crating, and photographing most of the 140 items from American collections has been invaluable in bringing the exhibition to reality. These responsibilities for the seventy objects from Norway were assumed by the Norwegian Folk Museum, which also contributed to the planning of the exhibition and remained its major advocate in Norway.

Many strains met in the making of this exhibition, one of which went back to the 1980s when the idea was discussed by the late Robert Bishop, former Director of the Museum of American Folk Art, with Marion Nelson, former Director of Vesterheim. The receptiveness of Gerard Wertkin, present Director of the Museum of American Folk Art, to the idea when revived by representatives of the Royal Norwegian Ministry of Foreign Affairs in the early 1990s led to its realization. The retirement of Nelson from Vesterheim and from his professorship in the Department of Art History, University of Minnesota, at this time allowed him to assume major responsibility for the exhibition as its guest curator.

Much credit for the exhibition goes to the dedication and expertise of staff members at the supporting, sponsoring, and assisting institutions. Key figures in the Royal Norwegian Ministry of Foreign Affairs were Jan Flatla, Eva Bugge, Ellen Høiness in Oslo and Janis Bjørn Kanavin and John Petter Opdahl of the Norwegian Information Service in New York. Of central importance at the museums were the directors, Gerard Wertkin of the Museum of American Folk Art, Erik Rudeng of the Norwegian Folk Museum, and Darrell Henning of Vesterheim. Special mention must also be made of Stacy Hollander, Curator, and Ann Marie Reilly, Registrar, at the Museum of American Folk Art; Janike Sverdrup Ugelstad, Curator, and Liv Hilde Boe, Associate Director, at the Norwegian Folk Museum; and Carol Hasvold, Registrar/Librarian, and Robert Hervey, Preparator and Conservation Assistant, at Vesterheim. The success of the New York showing owes much to the promotion of Susan Flamm, the programming of Lee Kogan, and the exhibition design of Howard Lanser.

The positive responses to the concept of the exhibition made by Peter Anker, former Director of the West Norwegian Museum of Applied Art, Bergen, Norway, and Stephan Tschudi Madsen, Norway's former Director for Cultural Heritage, gave encouragement in carrying the effort to completion. Important to this as well were the observations and direct assistance of Aagot Noss, former Chief Curator of Costumes and Textiles at the Norwegian Folk Museum, and Nils Ellingsgard, Norwegian painter and scholar of rosemaling. The copy editing of Mary Hove, copy editor for the Norwegian-American Historical Association, and the personal attention given the project by Don Leeper of Stanton Publication Services, Inc., contributed much to the quality of the catalogue, as did suggestions from Clarence Sheffield.

Credit for bringing the exhibition to a broad national audience must go to the hosting institutions. These are, in addition to the Museum of American Folk Art and the Norwegian Folk Museum, the North Dakota Heritage Center, Bismarck; the Minnesota Museum of American Art, St. Paul; and the Nordic Heritage Museum, Seattle.

The exhibition could not have taken place without the generous cooperation of the ten Norwegian and sixty-six American lenders. Major among these are the Norwegian Folk Museum and Vesterheim, who together are lending ninety-seven of the two hundred and ten items.

Lenders to the Exhibition

NORWEGIAN

Kathrine Holmegaard Bringsdal, Kristiansand
Drammens Museum, Drammen
Fylkesmuseum for Telemark og Grenland, Skien
Kunstindustrimuseum i Oslo
Sandvigske Samlinger (Maihaugen), Lillehammer
Norsk Folkemuseum, Oslo
Ryfylkemuseet, Sand
Samuel Thengs, Egersund
Vest-Agder Fylkesmuseum, Kristiansand
Vestfold Fylkesmuseum, Tønsberg

AMERICAN

Eldrid Skjold Arntzen, Windsor, Connecticut
Liv Bugge, Neenah, Wisconsin
Karine Clark, Ames, Iowa
Sallie Haugen DeReus, Leighton, Iowa
Gladys Fjelland, Huxley, Iowa
Eugene E. Gangstad, Madison, Wisconsin
Norma Getting, Northfield, Minnesota
Jean Giese, DeSoto, Wisconsin
Don and Nancy Gilbertson, Osseo, Wisconsin
Grant County Historical Society, Elbow Lake, Minnesota
Enid Jerde Grindland, Alexandria, Minnesota
Kay Hurst Haaland, Minneapolis, Minnesota
John Haltmeyer, Prairie du Chien, Wisconsin
James L. Hanson, Rapid City, South Dakota
Carol and Tim Harmon, Tomah, Wisconsin
Martha Langslet Hoghaug, Grand Forks, North Dakota
Erik Rist Holt, Arlington, Washington
Nancy Jackson, Vallejo, California
Jo Sonja Jansen, Eureka, California
Karen E. Jenson, Milan, Minnesota
Betty Bumbaugh Johannesen, South Bend, Indiana
Roger and Shirley Johnson, Houston, Minnesota
Gene and Linda Kangas, Concord, Ohio
Allan Katz, Woodbridge, Connecticut
Helen Kelley, Minneapolis, Minnesota
Estelle Hagen Knudsen, Eden Prairie, Minnesota
Irene M. Lamont, Eau Claire, Wisconsin
David Landsverk, Mar Vista, California
Roger and Kathe Lashua, Akeley, Minnesota
Family of K. O. Lee
Little Norway, Blue Mounds, Wisconsin
Miles Lund, Boise, Idaho
Jack McGowan, Forest Lake, Minnesota
Alex and Suzanne Medlicott, Haverhill, New Hampshire
Minneapolis Institute of Arts, Minneapolis, Minnesota
Minnesota Historical Society, St. Paul, Minnesota
Nancy Morgan, West Des Moines, Iowa
Mike and Jan Mostrom, Chanhassen, Minnesota
Betty Rikansrud Nelson, Decorah, Iowa
Lila Nelson, Minneapolis, Minnesota
Warren and Kirsten Landsverk Netz,
 San Francisco, California
Dr. and Mrs. E. J. Nordby, Madison, Wisconsin
Nordic Heritage Museum, Seattle, Washington
Nordland Rosemalers Association,
 North Dakota and Minnesota
Norskedalen, Coon Valley, Wisconsin
Phillip Odden, Barronett, Wisconsin
Orman Overland, Ames, Iowa
Otter Tail County Historical Society,
 Fergus Falls, Minnesota
Mary and Arnold Pleuss, Altoona, Wisconsin
Jim and Mary Richards, Callaway, Minnesota
Grace Nelson Rikansrud, Decorah, Iowa
Judy Ritger, River Falls, Wisconsin
Roseau County Historical Museum and
 Interpretive Center, Roseau, Minnesota
St. Louis County Historical Society, Duluth, Minnesota
Scandinavian Cultural Center, Pacific Lutheran University,
 Tacoma, Washington
Norman Seamonson, Stoughton, Wisconsin
Smith-Zimmermann State Museum,
 Madison, South Dakota
Barbara S. Solberg, Port Chester, New York
State Historical Society of North Dakota,
 Bismarck, North Dakota
Aaron Swenson, Flom, Minnesota
Mary Temple, St. Paul, Minnesota
Gene and Lucy Tokheim, Dawson, Minnesota
Bruce and Linda Tomlinson, Alexandria, Minnesota
Vesterheim, Norwegian-American Museum,
 Decorah, Iowa
Willis and Norma Wangsness, Decorah, Iowa
Wisconsin Folk Museum, Mt. Horeb, Wisconsin

Director's Preface

GERARD C. WERTKIN
Director, Museum of American Folk Art

Norwegian Folk Art: The Migration of a Tradition is a celebration both of a richly expressive and vigorous heritage in the arts and an enduring relationship between two nations. Allies in wartime and in peace, Norway and the United States have shared much in common ever since the arrival in 1825 at New York harbor of fifty-two pioneer immigrants aboard the sloop *Restauration* after a fourteen-week voyage from Stavanger.

To be sure, Norwegian contacts with North America can be traced back much earlier, but by the mid-19th century Norwegians in large numbers were taking the long, often perilous journey to stake out their claims to America. They brought with them not only memories of time-honored traditions but also the tangible expression of their heritage that would enrich American life.

Ole Edvart Rolvaag (1876–1931), the great Norwegian-American scholar and novelist, anticipating today's debate about multiculturalism, suggested that continued devotion to the Norwegian heritage was an ethical duty of the immigrants and their families to America because the strength of America was in its diversity. As the exhibition that is documented by this handsome volume eloquently demonstrates, Rolvaag's hopes have been realized. Norwegian folk traditions remain a lively force on both sides of the Atlantic.

The Museum of American Folk Art was founded in 1961 to foster knowledge and appreciation of American folk art. In its programming, the Museum embraces the folk arts of all Americans, regardless of national background. It also seeks to indicate parallels and precedents in the folk arts of those parts of the world to which Americans trace their roots. I am therefore especially pleased that the Museum of American Folk Art and the Norwegian Folk Museum, with the cooperation of Vesterheim, Norwegian-American Museum, have brought the varied textures and rich hues of Norwegian folk art to new audiences here in the United States and in Norway.

July 19, 1995

Director's Preface

ERIK RUDENG
Director, Norwegian Folk Museum

The Norwegian Folk Museum is deeply pleased to have a part in the realization of this book and the exhibition to which it relates.

Folk art and folk craft lie at the core of Norwegian tradition. It is natural that the immigrants from Norway not only saw the practical side of the objects they took with them but eventually saw also the symbolic value in them as mementoes of their ancestral and national culture.

Norway's rich and luxuriant folk art is in the last analysis one of the most powerful expressions of a decisive characteristic in Norwegian culture, the relative weakness of a domestic aristocratic class and the presence of an unusually high percentage of landed farmers, at least when seen in a European context. The historical foundation of Norwegian folk art is not the great estates with their villages of tenants found farther south in Europe but small farms scattered along the least populated stretch of land on the continent.

If Jefferson's ideal of the independent primary producer has anywhere been realized as a dominant principle, it would be in 19th century Norway. Europe's oldest written constitution, the ruling document of Norway since 1814, reflects this egalitarian situation, one which continues to make itself felt in Norwegian politics today.

The range of activities involved in Norway's rural economy (agriculture, fishing, hunting, lumbering, crafts, and the like), made the local production of tools and everyday equipment a matter of necessity. Economic independence, on the other hand, also made it possible for many farmers on occasion to commission refined products of urban inspiration from either local or itinerant specialists, often accomplished artists.

The continuation and partial transformation of these traditions under other circumstances in the United States was not only the result of a natural historic process. It also involved the contributions of many personally motivated individuals. It is perhaps precisely these we should be recognizing today, both from an American and a Norwegian point of view.

The Norwegian Folk Museum in Oslo opens its arms to an American public that wants to see more of the material culture the immigrants brought with them.

July 14, 1995

Editor's Note

Norwegian Folk Art: The Migration of a Tradition is organized into eight photoessays and ten text sections. To distinguish between the illustrations in the photoessays and those in the text, two different numbering systems are used: The illustrations in the photoessays are numbered (1, 2, etc.) while those in the text sections are called Fig. (figure) and numbered (Fig. 1, Fig. 2, etc.). Both types of illustrations are referred to in the text.

The eight photoessays beginning on pages 17, 49, 73, 101, 133, 171, 195, and 259 may be read consecutively and present an illustrated story of Norwegian folk art. The illustrated text sections, which are placed among the photoessays, may also be read as a separate narrative. The photoessays replicate the exhibition while the text expands on the story of how Norwegian folk art developed and found its way to America.

Norwegian Folk Art

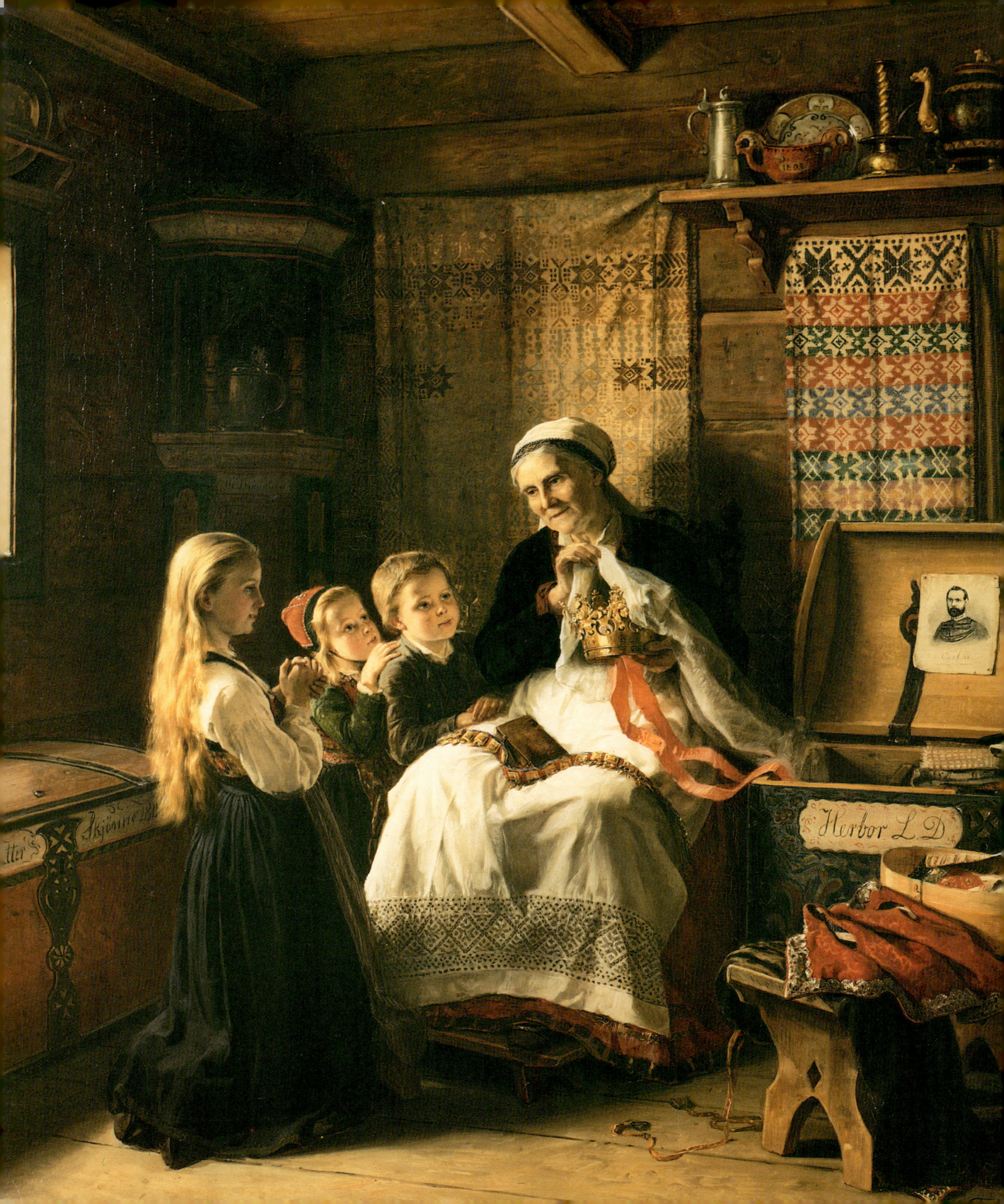

Introduction

Norwegian Folk Art: The Migration of a Tradition has two aims: first, to give a comprehensive presentation of Norwegian folk art from its beginnings in the late Middle Ages, through its development under the influence of mainstream European art, to its decline with the coming of the Industrial Revolution; and, second, to follow that art across the Atlantic with the 19th and 20th century emigrants who settled in the United States. The major question that it asks is: What happens to a folk tradition when the people to whom it belongs move to an environment with few of the conditions that brought it into being? From an American standpoint, the book is an intensive investigation into the background of a specific strain in the art of the people in this country.

The amount of American material included here that the purist would consider folk art is limited. Much was created during the past twenty years by people in a wide range of social circumstances. The fact that it is part of a group phenomenon based on a genuine folk tradition, however, gives it a place in the total history of that tradition whether or not the circumstances of its production are those characteristic of folk art. The study is not so much of folk art *per se* as of an artistic tradition that has continued to have creative and symbolic significance for its national group. The segment of that group which is followed in particular is the approximately 900,000 Norwegians who emigrated to America and their descendants.

Even much of the early Norwegian folk art which meets all the circumstantial conditions of that term does not have the naive character associated with it by Americans. What collectors and even museums in this country generally seek in folk art is individual expression which lacks as much as possible the marks of tradition. This continues in spite of

Grandmother's Bridal Crown. Adolph Tidemand (1814–1876). 1869. Norwegian Royal Palace. Photo: O. Væring.

the emphasis folklorists have for the past twenty-five years put on tradition as a necessary element in folk art.

That the naive should be looked on by Americans as a distinctive characteristic of folk art is natural when one considers that their own folk art is the product of a young, mixed, and mobile society with limited possibility for the development of tradition. In Norway, where the rural population was homogeneous and stable and where many communities had unbroken histories going back to prehistoric times, tradition could not be avoided. One finds a commonality in the art of every district based in a deeply rooted traditional culture. Even innovation, and it can be great, is generally within a tradition and cuts across the culture broadly rather than taking the form of scattered isolated phenomena. Almost all pure decoration in Norwegian folk art bears the strong mark of tradition in both concept and execution. Figures can be another matter. Except for a local strain in figurative powderhorn decoration and another in picture weaving, the use of figures was comparatively rare. No strongly unified tradition in their presentation came into being. Figures in Norwegian folk art, therefore, can have the naive charm and individual expressiveness so cherished by Americans (42, 72–74, 77, 81-83, 166, 171–173, 190).

Norwegian folk art from the decline of the Middle Ages to the Industrial Revolution constitutes by far the greatest amount of art produced in the country at the time, a circumstance resulting from Norway's largely rural population and the limited economy as well as limited size of the urban upper class. Folk art grew out of what had been mainstream art in the proud and independent Medieval kingdom of Norway which came to an end in the 14th century. It represents a cultural link between that old kingdom and the new that came into being in 1905. Not only in quantity but in vitality and artistic quality, Norwegian folk art overshadows the rather modest artistic efforts made by

the approximately ten percent of the population that constituted the urban society and had its cultural affinities with the country's administrative center in Denmark.

The prominence of tradition in Norwegian folk art gives much of it a sophistication and refinement that is associated with mainstream decorative arts. These were, indeed, the models, primarily from the 18th century on. Like mainstream artists, the folk artists too became professionals within the framework of their rural society. As Nils Ellingsgard points out, farming was more a supplementary source of income to their art activities than the reverse. They had no guilds, but their art was passed down from generation to generation through an informal apprentice system that had the strengths of guild education without its stifling rigidities.

The almost academic emphasis on mastery in Norwegian folk art, especially in acanthus carving and stylized floral painting, has made it easy to build on in modern times. Doing so involves considerable training and practice but it does not call for the artificial regression to a primitive state necessary to produce folk art of a genuinely naive kind. Little Norwegian folk art is naive.

Even stylistically, Norwegian folk art absorbed much from urban mainstream culture. It went through its major phases from Renaissance to Baroque, Regency, and Rococo, incorporating elements of these into its creative vocabulary (1). This may be another reason for the naturalness with which it can be built on and with which it finds a place in Norwegian mainstream culture today and that of Norwegian immigrants long settled on another part of the globe. It is distinctive enough to satisfy needs of identity, but it is familiar enough to anyone in the western world to have direct appeal purely as decoration apart from national associations.

Whatever the explanation, Norwegian folk art is an art of exceptional potency that can still generate aesthetic response. Except for a geometric strain represented by chip carving, much burnt decoration, thread-count embroidery, and square interlock weaving, it is in blatant defiance of the machine age. The extraordinary organic vigor in much of Norway's folk carving and almost all of its folk painting is a welcome antidote to modern life.

The majority of this presentation is devoted to illustrations of over 200 objects which with their captions tell the story of Norwegian folk art. About one-third are from Norwegian museums; another third have crossed the Atlantic, largely with early immigrants, and are now in private and public collections throughout America. This latter group represents the first and most concrete step in the migration of Norwegian folk art. The remaining objects have been produced in America by immigrants who continued the tradition or by their descendants and others under their influence who are building on the vestiges of it. These objects are shown alongside those in the historical presentation so that one can readily compare the tradition in its original form with that which it took when continued far from its place of origin and increasingly far from the time when it began. This final category of material represents the human migration of the tradition and the generative power of it on people who for the most part have never known it as an integral part of life.

The organization and interpretation of the objects in the pictorial history of Norwegian folk art are based largely on their visual character, their style, rather than on their functional significance in the culture of which they were a part. What migrated and survived was an art tradition increasingly cut off from its original cultural context. The objects, by virtue of their fixed material state, remained essentially unaffected by the Atlantic crossing, while other elements in the culture, such as language, music, and social customs, underwent almost immediate change. Even the new objects, both early and late, made on the basis of that tradition by the immigrants reflect greater concern with retaining the visual character of the models, although these were not always accurately remembered or understood, than with adapting them to functional needs in the new culture.

The deviations from early models that did occur were more the product of imagination than of accommodation. Examples of this are the rosemaling of August Werner (206) and the carving of Hermund Melheim (67–69). The tradition's stubborn resistance to entering the shifting stream of the time was what eventually gave it new meaning for its group. It no longer had an integral place in the culture of that group but it became a welcome symbol of something stable and distinctive that had once belonged to it in an all but forgotten past. It could also satisfy long dormant aesthetic needs unrelated to other elements in the culture. This is something which Norwegian folk art appears increasingly to have done even when still in the environment of its origin.

The pictorial presentation is supplemented with two essays by the editor on the general subject of folk art in Norway and among the immigrants, both of which are also written from a largely art historical point of view, and with eight essays by other authors that put the material more in its social and cultural context. The milieu in which Norwegian folk art was created is given an extraordinarily factual presentation by Halvard Bjørkvik, Former Director of the Norwegian Folk Museum in Oslo, while Odd Lovoll, King

Introduction

Olav V Professor of Scandinavian Immigrant Studies, St. Olaf College, Northfield, Minnesota, gives an equally graphic presentation of Norwegian emigration to America and settlement here. Jon Gjerde, Professor of History, University of California Berkeley, focuses his essay on what the immigrants brought with them and how their choices were made.

Two essays throw light on the early cultural scene in rural Norway. Nils Ellingsgard, a Norwegian painter and scholar of folk art, describes the migrant nature of *rosemaling,* Norwegian folk painting, even before it made the Atlantic crossing; and Aagot Noss, Chief Curator Emeritus of Costume and Textiles at the Norwegian Folk Museum, defines the messages conveyed in traditional dress. Carol Colburn, who teaches Costume History and Design at the University of Northern Iowa, Cedar Falls, follows up on Noss's subject with an essay on the wearing of traditional Norwegian dress in America and the changes which occurred in its character, use, and symbolic connotations.

Tonte Hegard, Senior Advisor, Directorate for Cultural Heritage, Norway, traces the long history of collecting and researching folk materials in Norway that accounts for the rather complete picture we have today of Norwegian folk art. Albert Steen, former Curator at the Museum of Applied Art, Oslo, discusses the role of Norway's Medieval and folk culture in establishing its national consciousness in modern times.

MARION NELSON

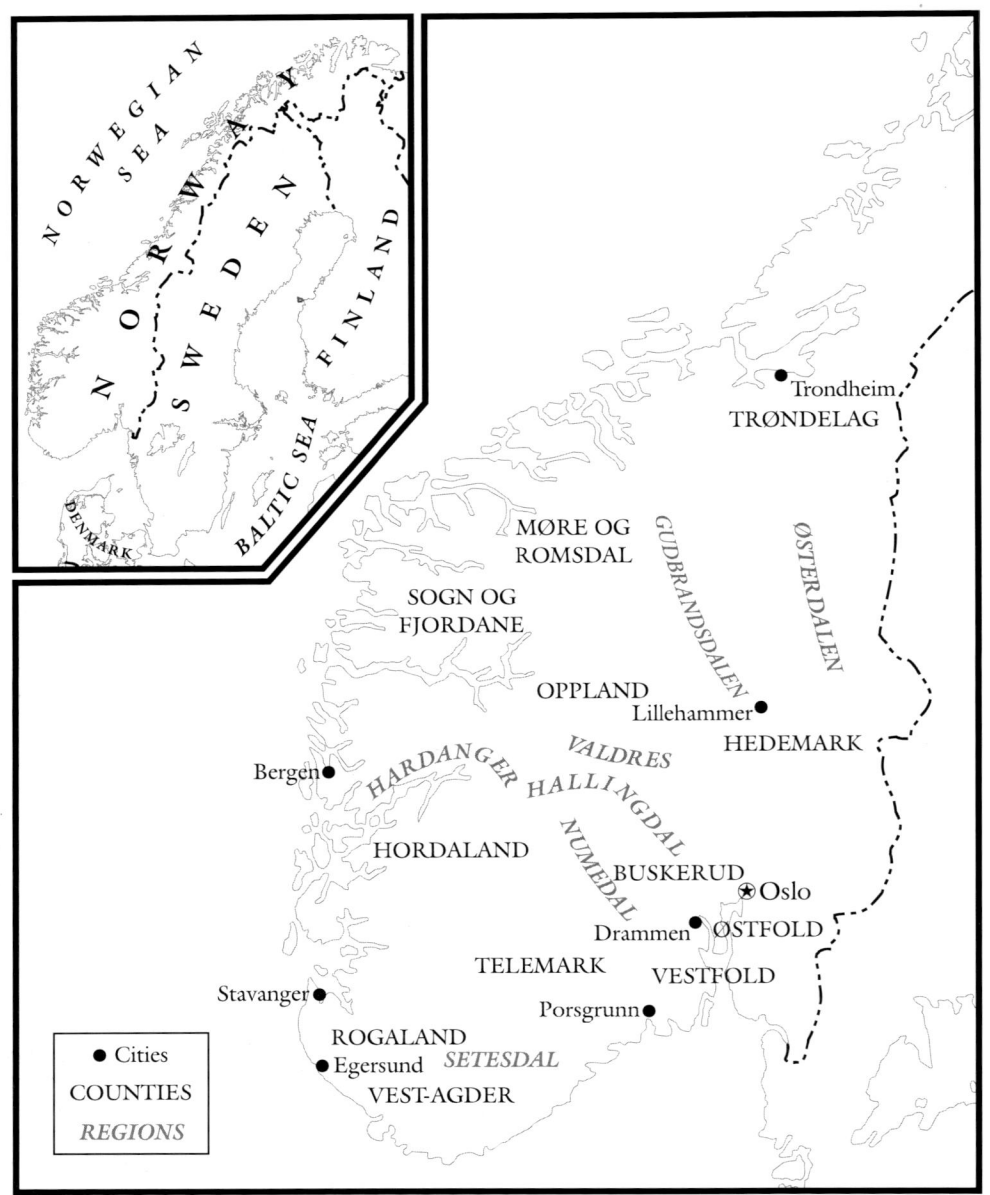

KEY TO ABBREVIATIONS IN CAPTIONS

Catalogue items are indicated by isolated numbers.

Fig.	Illustrations in articles.
Norw.	Objects made in Norway that remained there.
Norw. in Am.	Objects made in Norway that migrated to America.
Norw.-Am.	Objects that reflect Norwegian tradition made in America by Norwegian immigrants or by others under their influence.

Continuity and Change

1.

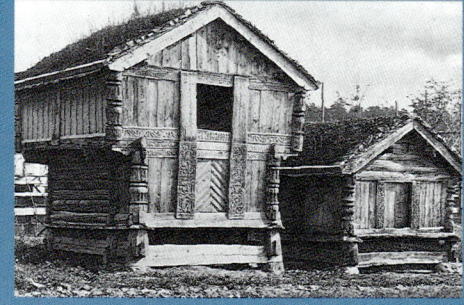

1a.

1. Pair of storehouse portal posts with flat relief carving (*flatskurd*). NORW. Telemark. 18th century. Pine. H. 88½″ W. 20½″ D. 7⅞″ Norsk Folkemuseum (NM 3167).

Carving in the Medieval stave churches was concentrated on the portals. The tradition continued, primarily on the rural storehouses of Telemark, but what had been dynamic high-relief plant and animal interlace was tempered by the lightness, symmetry, and flatness of the Renaissance. To this style too belong the rosettes on intertwining Baroque tendrils from which chip-carved Romanesque leaves and 18th century *rocaille* also project.

1a. Rofshus storehouses from Telemark at the Norwegian Folk Museum. Buildings of the type on which the posts are found.

Remnants of the Middle Ages
Beasts and Interlace

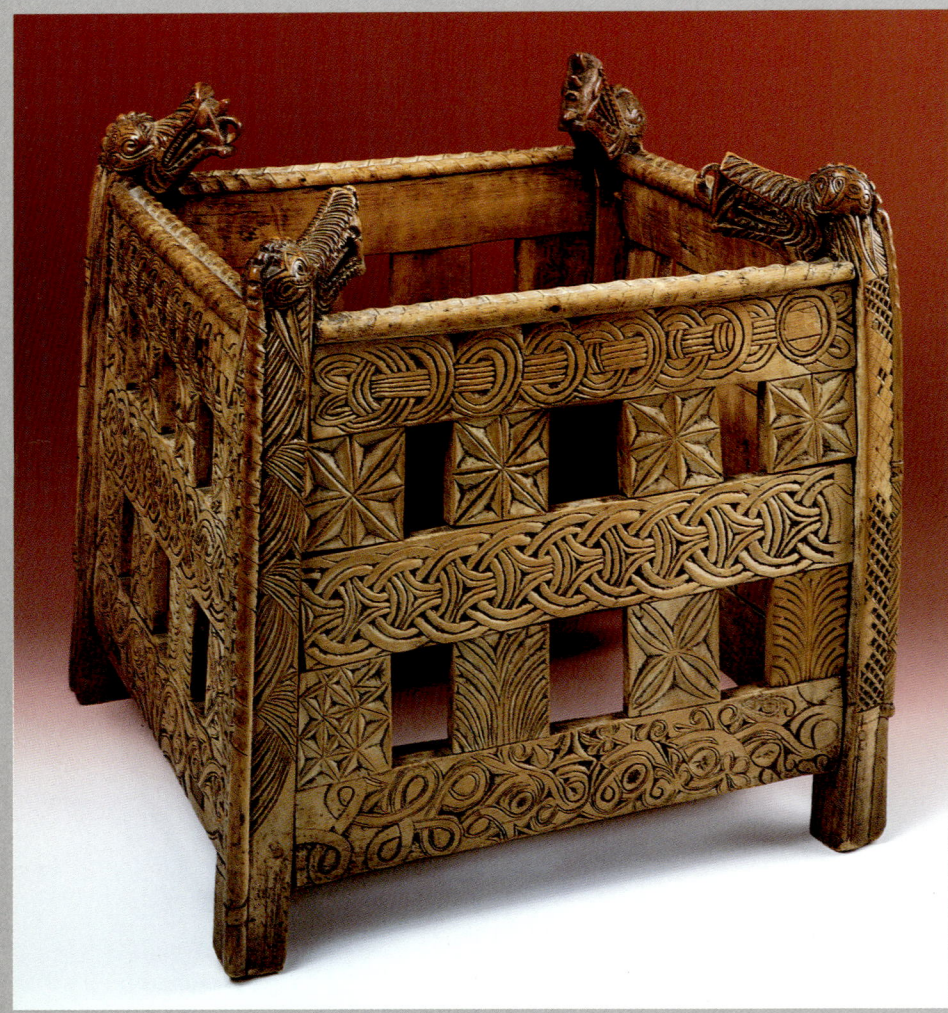

2.

2. Wool basket (*ullkorg*) with carving of Medieval type. Norw. Fjagesund, Kviteseid, Telemark. 15th–17th century. Wood. H. 17⅞″ W. 17⅜″ D. 17″ Fylkesmuseum for Telemark og Grenland (BM 1954–22).

The decoration here is like a sampler of geometric chip-carved and organic relief designs from pre-history and the Middle Ages. These continued in various guises as a dialogue between the geometric and the organic in Norwegian folk art. They could have come down through an earlier folk tradition or have been consciously revived in a last attempt to retain the old as impulses from the south increased around 1500.

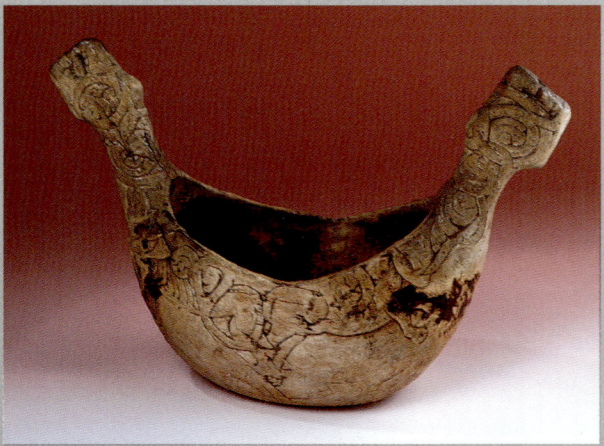

3.

3. Two-handled ale bowl (*kane*) with carving of Medieval type. Norw. Telemark. 14th century? Wood. H. Ca. 8½″ W. 14⅜″ Fylkesmuseum for Telemark og Grenland.

The decoration on this boat-shaped vessel of the type that replaced the horn for drinking is dominated by beasts of pagan character. From their mouths project tendrils that ensnarl them, a common motif when Christian art comes in. Meandering tendrils and two-handled beer bowls retained prominence in Norwegian folk art.

4. Drinking horn of Nordic revival type. NORW. IN AM. Lars Kinsarvik (1846–1925), Hardanger. Signed and dated 1890. Birch. H. 13½″ W. 19″ D. 6″ Dr. and Mrs. E. J. Nordby.

Animal interlace as seen in this late folk interpretation of a Viking object was revived in the National Romanticism that preceded Norway's break with Sweden in 1905. Created by the most imaginative and skilled artist of the style, this *tour de force* in Nordic art was exhibited at Chicago's Columbian Exposition of 1893 and has been in Norwegian-American possession since, an example of migration.

5. Bishop's chair of Nordic revival type. NORW.-AM. Reverend Erik Kristian Johnsen (1863–1923), St. Paul, MN. Ca. 1905. Painted wood. H. 44″ W. 33″ D. 29″ Vesterheim, Luther College Collection (756).

While a student in Oslo around 1890, the Stavanger-born Johnsen attended the evening classes in early Nordic carving offered to promote retention of the national arts. After emigrating in 1892 to become a professor of theology in St. Paul, MN, he carved the furniture for his house. The row of dancers and other details here are based on a late Medieval chair from Gåra, Bø, Telemark, a drawing of which was published by J. C. Dahl in 1837, but an artistic naiveté gives these genuine folk character.

4.

5.

Two-handled Ale Bowls

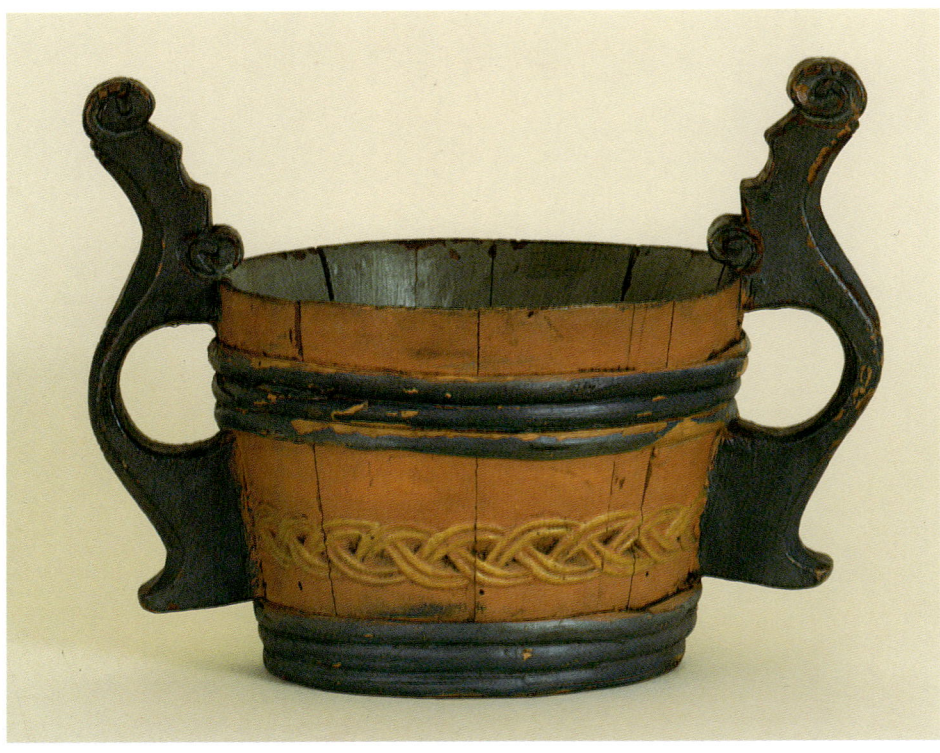

6.

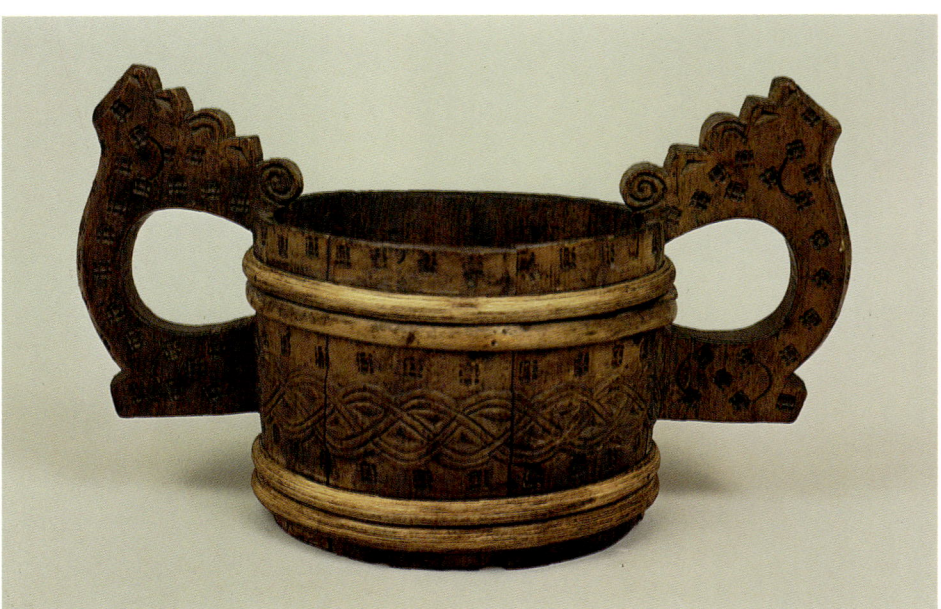

7.

6. Two-handled ale bowl in stave construction (*staup*) with carved braid. Norw. Hordaland. Early 19th century. Painted wood. H. 7⅞″ W. 9″ D. 6½″ Norsk Folkemuseum (NF 1992–695).

These stave vessels relate to the carved type (3) in that the handles suggest the heads of dragons or horses. The braid, a common motif in Viking art, is also found on early *carved* examples, indicating a connection.

7. Two-handled ale bowl in stave construction (*staup*) with carved braid. Norw. in Am. West Norway. Ca. 1800. Pine. H. 7″ W. 11¾″ D. 6″ Inscription: "HR". Several bands replaced. Vesterheim, Luther College Collection (810).

This vessel of Medieval type (See 6) came apparently as a functional object with immigrants to the American Midwest and has now long been on public display as an example of their heritage.

8. Carved ale bowl with horsehead handles (*kjenge*). Norw. Voss type. Late 18th century. Wood. H. 11¾″ W. 19½″ D. 12½″ Norsk Folkemuseum (NF 1921–400).

Carved drinking vessels of more vertical orientation with horse rather than dragon heads developed in western Norway and far outlasted the Telemark type (2). Their organic shapes are often complemented by incised geometric decoration. Associations with fertility may originally have led to the horse appearing on these vessels which played a prominent role at weddings.

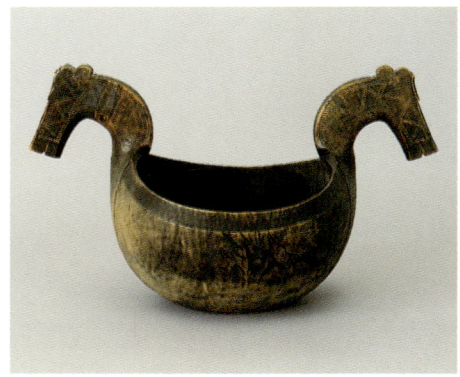

8.

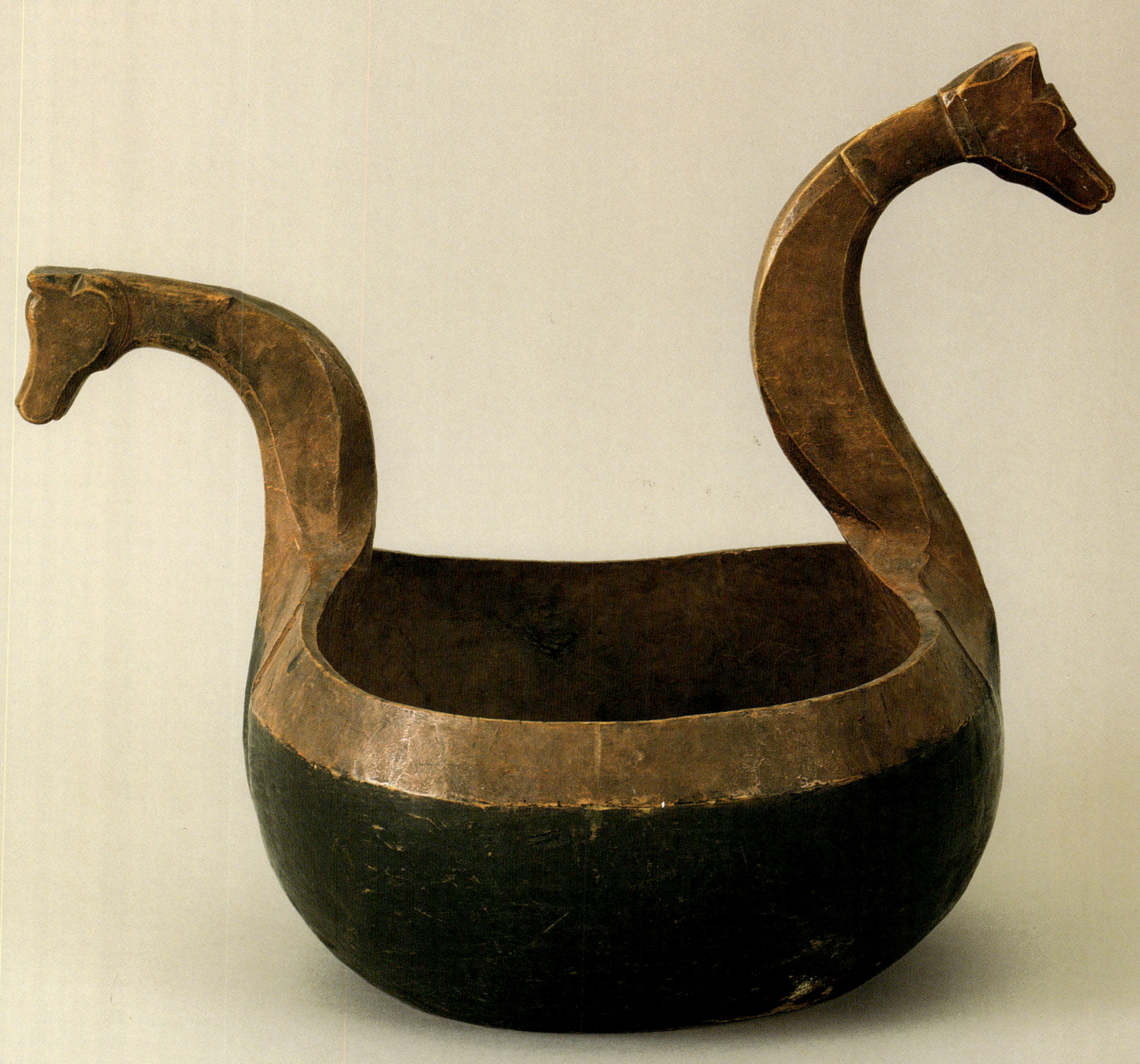

9. Ale bowl with asymmetrical horsehead handles (*kjenge*). Norw. Variant of standard type (8). 18th–19th century. Painted wood. H. 17½″ W. 19¾″ D. 16½″ Norsk Folkemuseum (NF 1906–951).

Asymmetry was characteristic of early Nordic art, but its use here on a generally symmetrical vessel is probably an example of individualism overriding tradition, a frequent occurrence in Norwegian folk art.

11.

10.

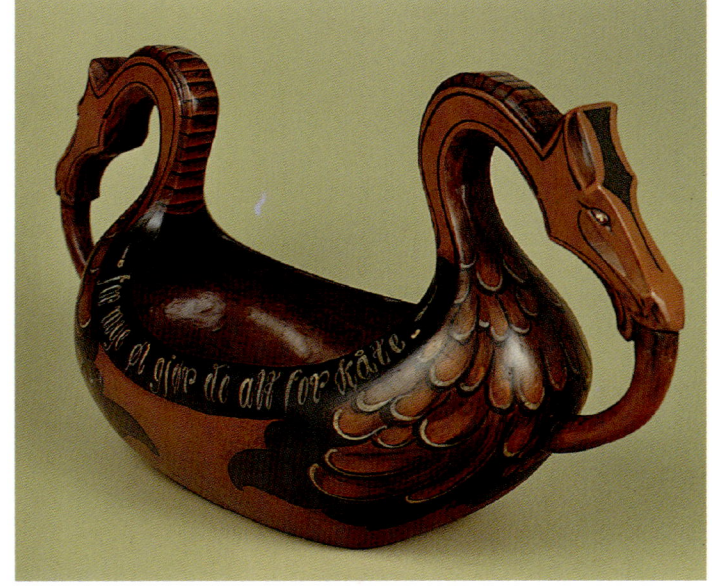

10. Ale bowl with horsehead handles (*kjenge*). Norw.-Am. Carver: Aaron Swenson, Flom, MN. Painter: Karen Jenson. Milan, MN. Signed. 1993. Painted basswood. H. 8½″ W. 16″ D. 6″ Translated inscription: "Drink of the bowl but drink with moderation. Too much beer makes you far too wild." Aaron Swenson.

The models on which this recent immigrant example is based (See 10a, Bergens Museum) generally lack its strong organic shape. In spite of their removal from the tradition, immigrant artists often grasp the essence of early forms rather than directly copy them.

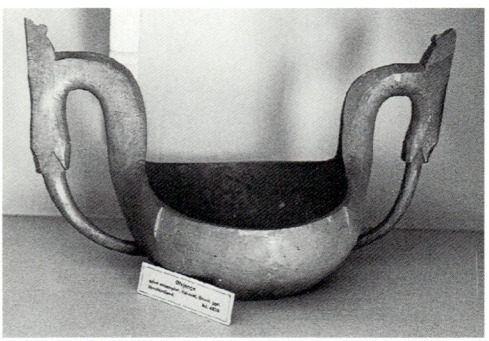

10a.

11. Ale bowl with horsehead and human figure handles (*kjenge*). Norw. in Am. Jon Endresen Folkedal, Hardanger. Signed and dated 1816. Painted birch burl. H. 9¼″ W. 19¼″ D. 10½″ Translated inscription: "Take a round of drinks. Be pious. Empty the bowl." Vesterheim, gift of John Haltmeyer in memory of Adeline Johnson Haltmeyer (93.2.1).

What had been the horses' tongues in the preceding bowl (10, 10a) have become little men holding the horses by the mouth in the work of this exceptional folk carver with a taste for 19th century realism. The piece and a coverlet (104) came to America with a member of the maker's family around 1850.

12. Ale bowl with crowned lion and serpent head handles (*kjenge*). Norw. in Am. Hardanger type. Painted by Thomas Luraas, Tinn, Telemark. 1845. Painted birch (partly burl). H. 10¾″ W. 16¾″ D. 11¾″ Translated inscription: "God give us peace and good harvest. Then we take many good drinks from me. D:G.D.M. 1845." Little Norway.

Only about 10 bowls of this Hardanger type are known. The Telemark decorator of this one was in Hardanger in 1845. An inscription on a bowl from the same area indicates that the lion may represent courage and joy while the serpent holds the food of temptation.

12a. Detail from a cupboard made in Benson, MN, by the immigrant Lars Christenson (70) from Sogn north of Hardanger. The artist interpreted the serpent with the apple as a reminder of the temptor's presence.

12a.

12.

13.

13. Ale bowl with double serpentine handles (*kjenge*). NORW. IN AM. Sogn type. Painted 1800. Painted birch burl. H. 8″ W. 13½″ D. 8⅜″ Inscription: "Anders Christensen Qvatem 1800." Vesterheim, gift of Rochester Friends of Vesterheim (88.83.1).

The bowl belongs to a small group in Sogn all having been painted at about the same time but possibly dating earlier. These serpents may not relate to temptation but to folk beliefs that serpents were prone to drink.

14. Ale bowl with double perforated handles (*kjenge*). NORW. IN AM. Carver: Christen Oleson Kjørnes, Sogndal, Sogn. Attributed painter: Sevat Bjørnson Uppheim, Hallingdal. 1830. Painted birch burl. H. 7⅜″ W. 12½″ D. 7″ Inscription: "C:O:S:K 1830." Vesterheim, gift of Rudolph L. Dalager (68.27.1).

14.

Related to the previous bowl (13) from the rim down, this piece brings together the geometric and organic strains in native Norwegian art. The carver is the father of the immigrant artist Lars Christenson (70 and Fig. 10).

Chip Carving

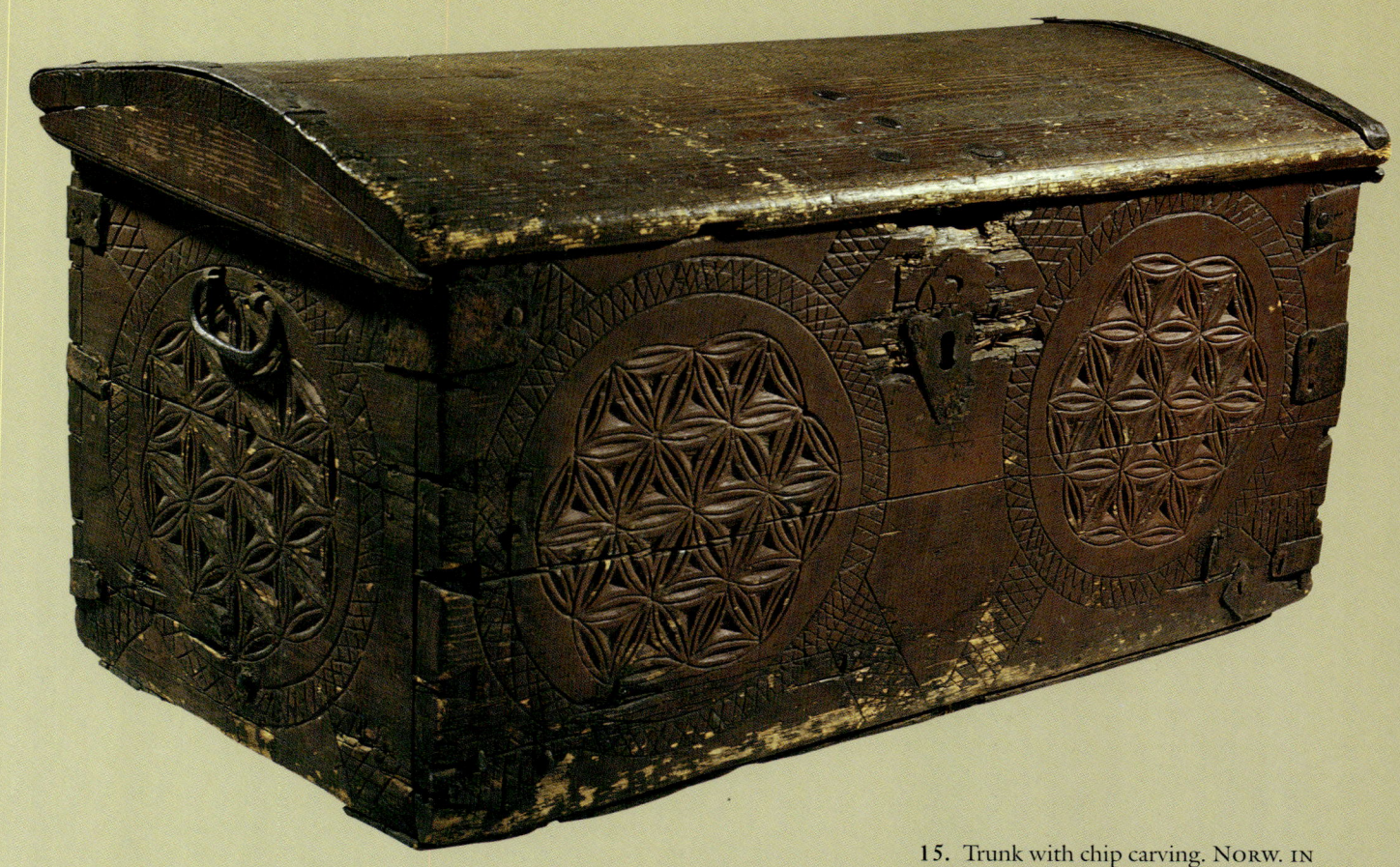

15. Trunk with chip carving. Norw. in Am. Probably Hedemark. Found in midwest America. 1623. Painted pine. H. 18" W. 34" D. 18½" Inscription: "1623" "Ole H Huslegaarden til Kilbere City Wiskonsin North Amereka Skib Pontoervo." James L. Hanson.

Chip-carved designs are generally based on straight or curved intersecting lines. Early Norwegian examples often have bold isolated rosettes, generally considered of Gothic inspiration. The complexity of this one in relation to the date and the trunk's east Norwegian origin make it unusual.

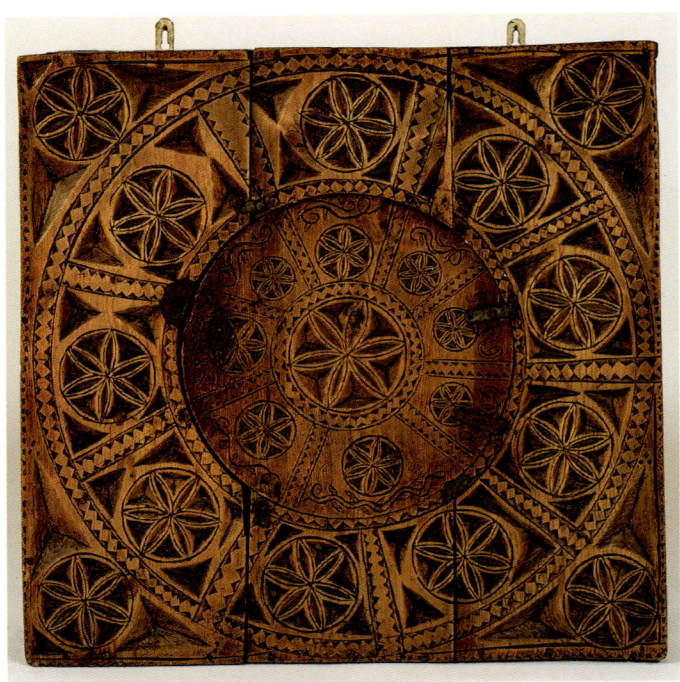

17.

16. Trunk with chip-carved rosettes and axe motifs. Norw. Setesdal. 18th century. Wood. H. 20½" W. 38¼" D. 21¼" Norsk Folkemuseum (NF 1927–1259).

The trunk is a classic example of south Norwegian chip carving. The spear and axe motifs, actually stylized Romanesque plant forms, are often combined with the rosette in Setesdal and Telemark.

17. Hanging wall cupboard with chip carving. Norw. Valdres. 18th century? Wood. H. 33¼" W. 33" D. 10⅞" Norsk Folkemuseum (NF 1925–590).

Other than on trunks and beds in Setesdal and parts of Telemark, chip carving is rare on furniture. The square hanging cupboards of Valdres, a central valley with little chip carving, are dramatic exceptions. They confirm the early widespread presence of the geometric even where the organic would assume dominance.

18. Woman's side saddle with incised and chip-carved decoration. Norw. in Am. Hegg farm, Voss. 1797. Birch. H. 26" W. 19½" D. 24" Inscription: "SGSH AR 1797." Nordic Heritage Museum. Gift of James and Marilyn Bergstrom.

The heraldic clarity of the six-pointed stars cut through a black-stained surface suggests symbolic significance. Coming from Voss, where the bride rode side-saddle in an elaborate wedding procession, this object and its motifs may relate to that.

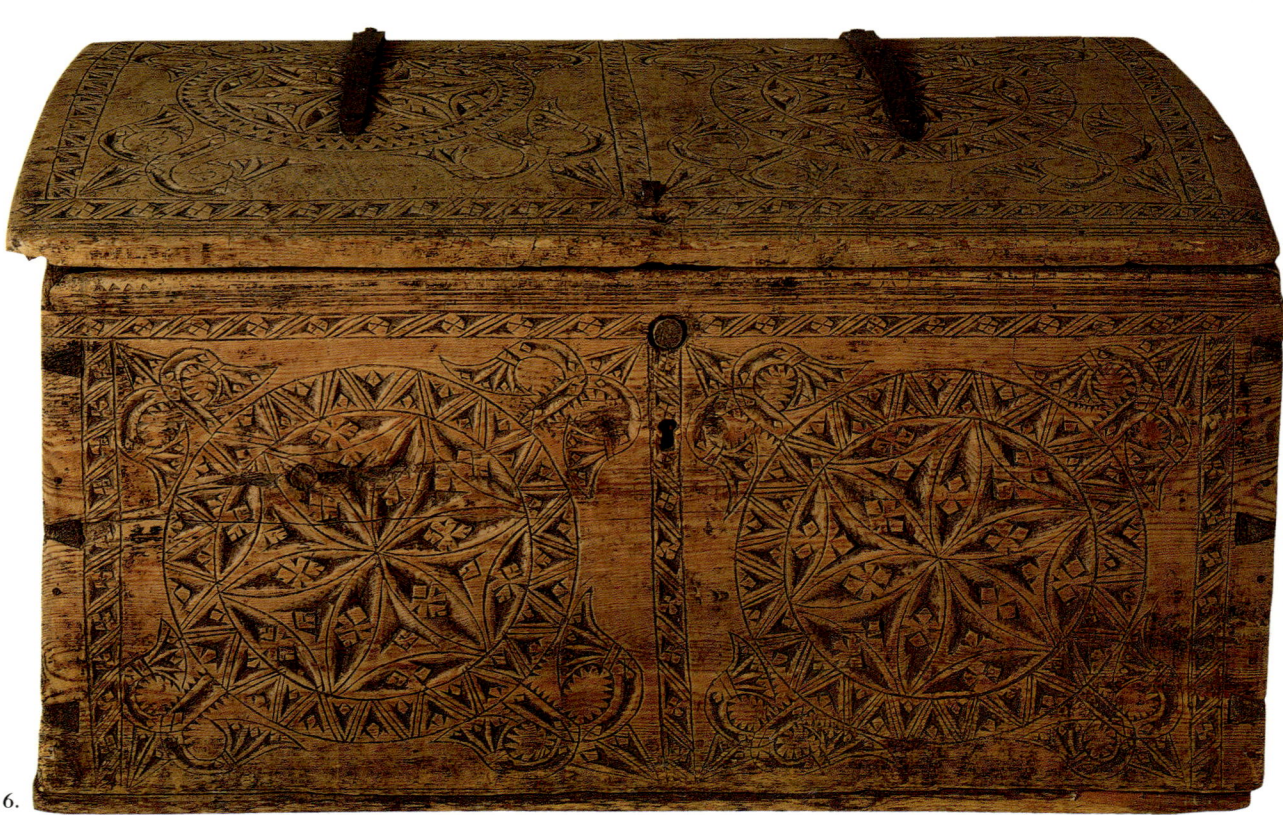

16.

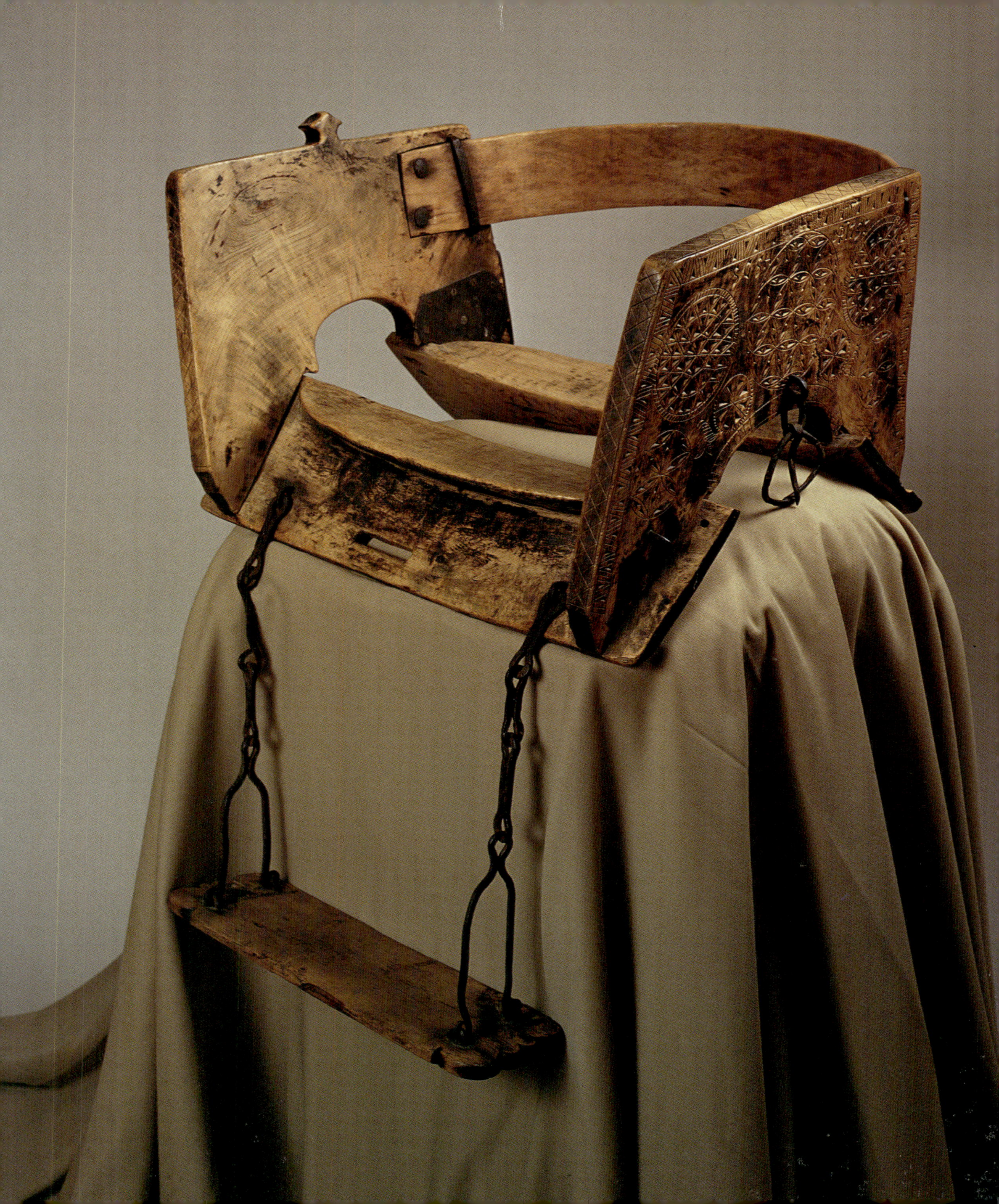

19. Oval bentwood box and clamp-on cover (*tine*) with chip carving. Norw. in Am. Setesdal? Found near Sunburg, MN. Ca. 1800. Birch, pine. H. 3½" W. 4½" D. 3¼" Roger and Kathe Lashua.

Tight repeated chip-carved patterns based on straight intersecting lines belong more to Setesdal than to the west coast. They represent an element of classic restraint in native Norwegian art that has received little attention.

20. Bowl with chip carving inspired by an Acoma Indian pot. Norw.-Am. Miles V. Lund, Boise, ID. Signed and dated 1991. Basswood. H. 6⅛" Diam. 7½" Vesterheim (91.79.1).

It was chip carving based on straight intersecting lines (19) that made it possible for the half Norwegian, Wisconsin-born Lund of Idaho to create an effect in wood like that which had impressed him in the painted decoration on an Acoma Indian pottery bowl.

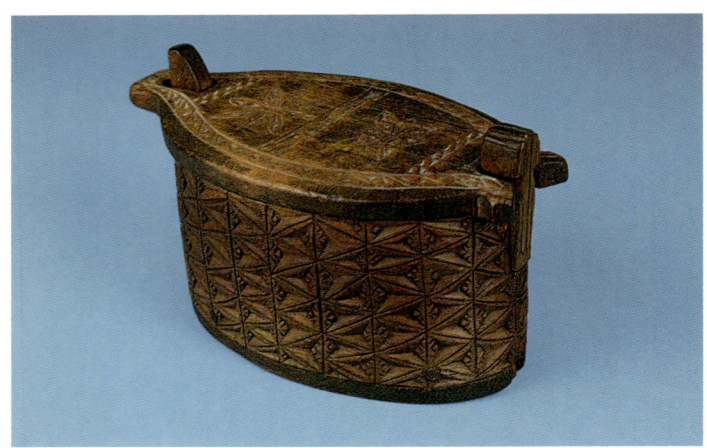

19.

20.

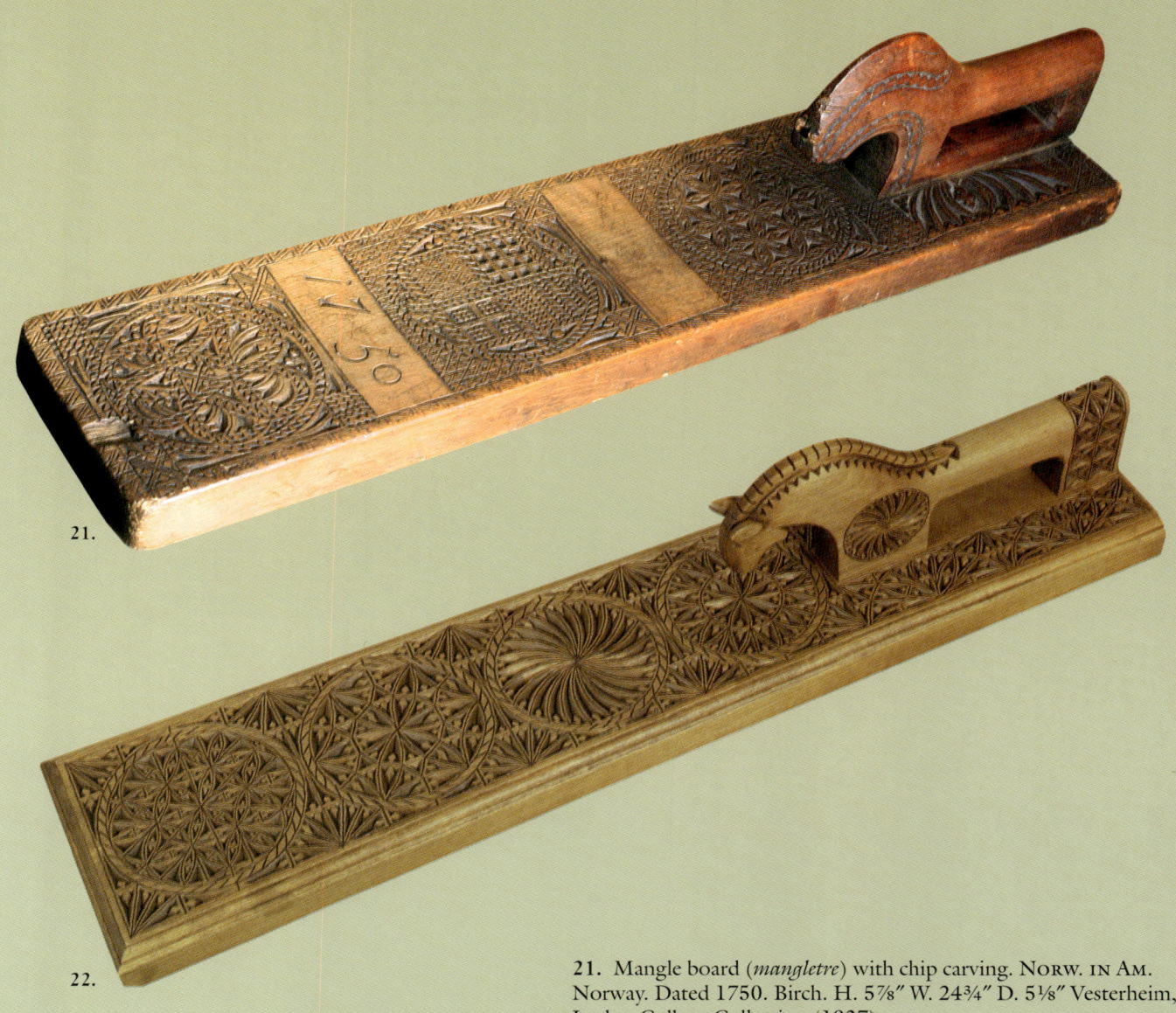

21.

22.

21. Mangle board (*mangletre*) with chip carving. NORW. IN AM. Norway. Dated 1750. Birch. H. 5⅞" W. 24¾" D. 5⅛" Vesterheim, Luther College Collection (1837).

A fine detailed chip carving began entering Norway through imports from southern Denmark and north Germany in the 1600s. It came primarily on mangle boards with horse-shaped handles for working wrinkles out of cloth. The weight of this one suggests Norwegian origin but the carving reveals foreign influence. Used as betrothal gifts, mangle boards are numerous and varied in design.

22. Mangle board (*mangletre*) with chip carving. NORW.-AM. Norman Seamonson, Stoughton, WI. 1994. Basswood. H. 5½" W. 21½" D. 6¾" Norman Seamonson.

After years of woodworking, this second generation immigrant first learned chip carving through observing examples in his heavily Norwegian community. His point of departure is traditional, but he never directly copies or repeats designs.

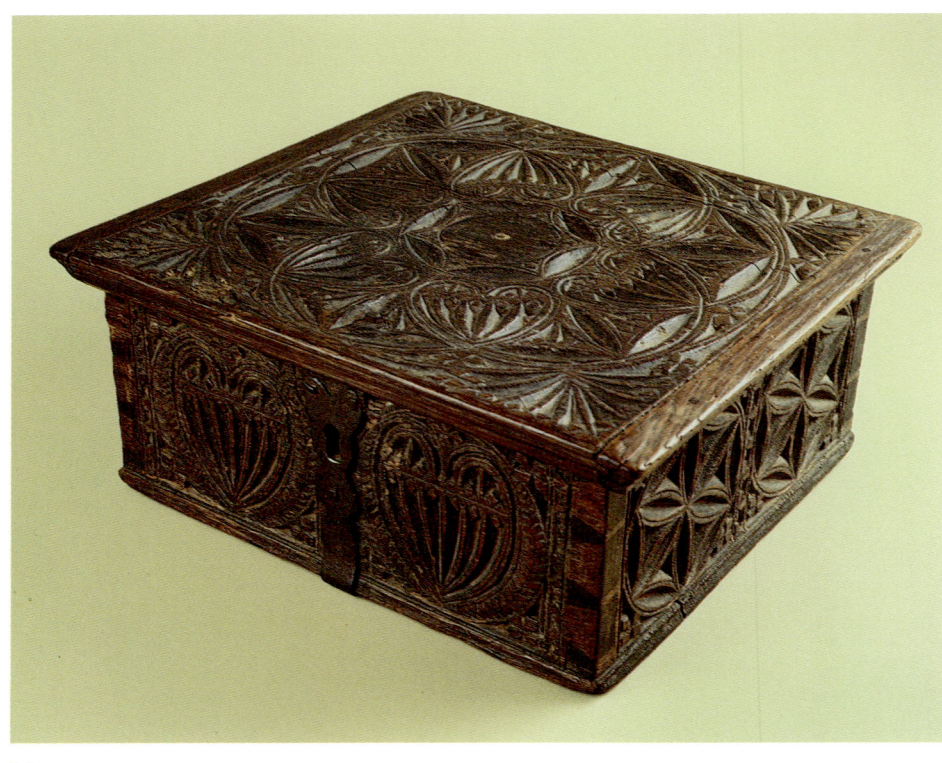

24.

23.

23. Box with chip carving. Norw. in Am. West Norway? Found in midwestern America. 1757. Fir? H. 7¾″ W. 12½″ D. 7¼″ Inscription: "LiS 1757." Adeline Haltmeyer Collection. John Haltmeyer.

Chip carving appears often on boxes. The rosettes on the front panel here interlink vertically but not horizontally to fill the rectangular space. This type of logic and the pronounced borders give classic order to a complex design. (Back panel shown)

24. Box with chip carving. Norw. in Am. Norway or Denmark. Found near Faribault, MN. 1734. Oak. H. 5½″ W. 12″ Diam. 10¾″ Inscription: "Ano 1734 CIHB." Bruce and Linda Tomlinson.

A category of chip carving distinct from that seen has free curves revealing little use of the compass or ruler. A Gothic connection is quite apparent. The oak material and highly professional character of this Norwegian immigrant example suggest that its ultimate origin may have been Denmark.

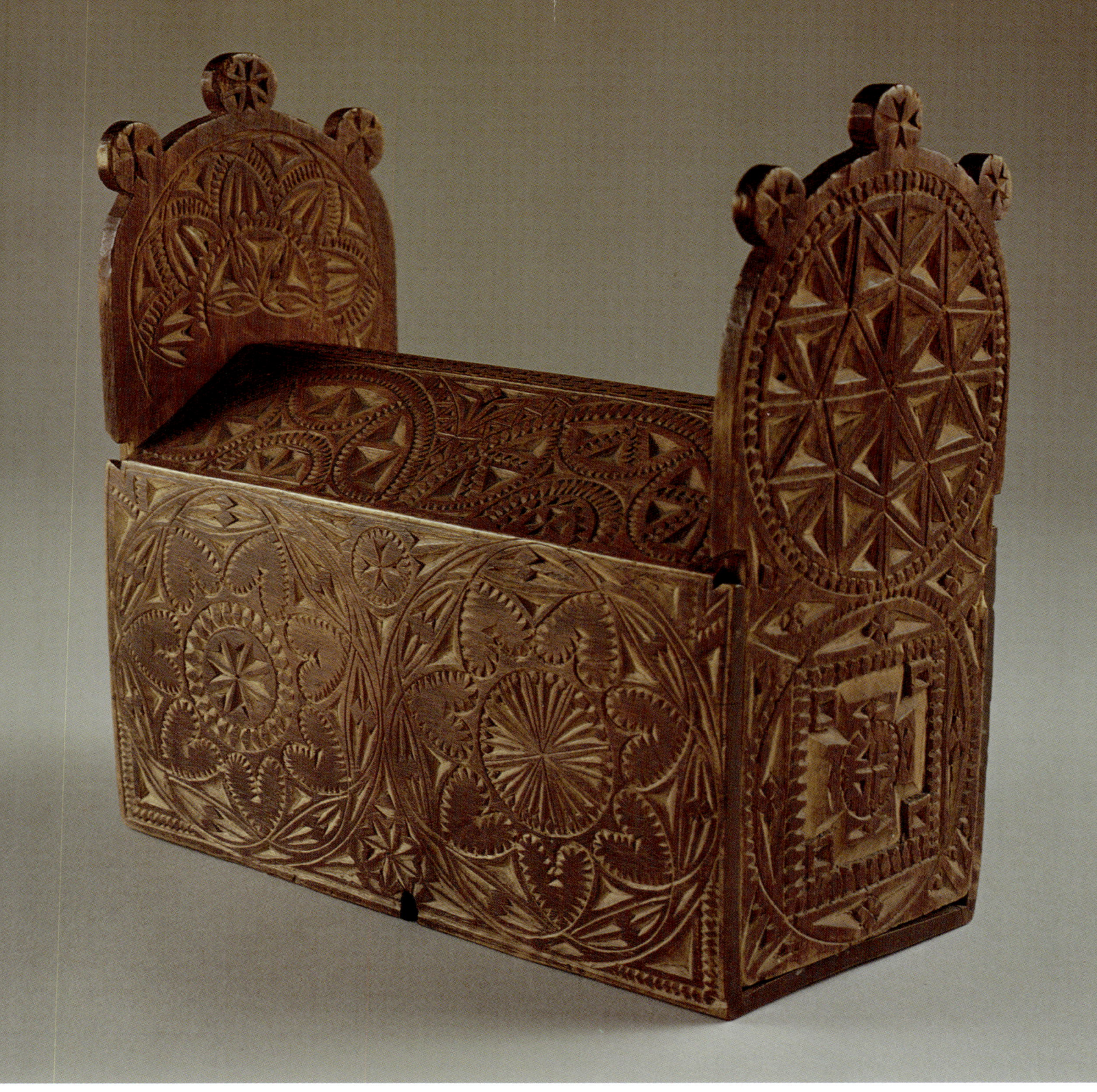

25.

25. Box with pull-up end and chip carving. Norw. in Am. West coast type. 1793. Fir. H. 7¾" W. 8" D. 3¾" Inscription: "MDCCLXXXXIII Ano 1793. PH SWEH MDD7(?)" Scandinavian Cultural Center, Pacific Lutheran University.

The design of this American-found piece relates to that in 24, but it is clearly Norwegian. The type of box, the rondels with Mickey Mouse ears (known from the end of early Gothic pews), and the stained surface all belong to Norwegian folk tradition.

26. Plate with chip carving. Norw.-Am. Tim Montzka, Forest Lake, MN. Signed and dated 1988. Basswood. H. 1″ W. 14½″ D. 14½″ Vesterheim (91.64.1).

The Gothic also dominates this piece carved at age 23 by the son in a largely German woodworking family closely associated with the Norwegian immigrant community. The aureole nature of the design may reflect the artist's religious faith, an element present in much art from the immigrant milieu (149, 181–183).

27. Chip-carved panel: *Fyrverkeri* (Fireworks). Norw.-Am. Miles Lund, Boise, ID (See also 20). Signed and dated 1993. Basswood. H. 25″ W. 36″ D. 1¾″ Miles Lund.

After thinking 3 or 4 years about the relationship of chip carving designs to fireworks, this grocer without training in art merged a traditional geometric style of decoration with a representational subject in an astonishingly imaginative way.

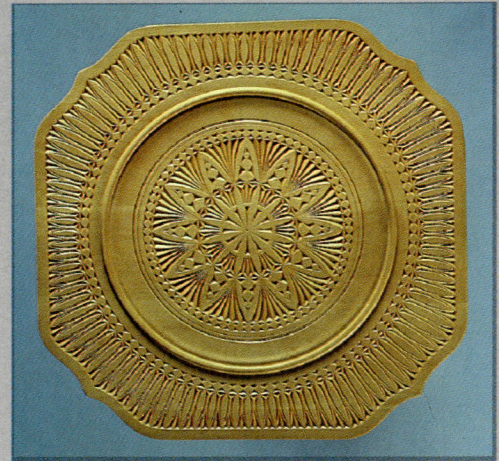

26.

27.

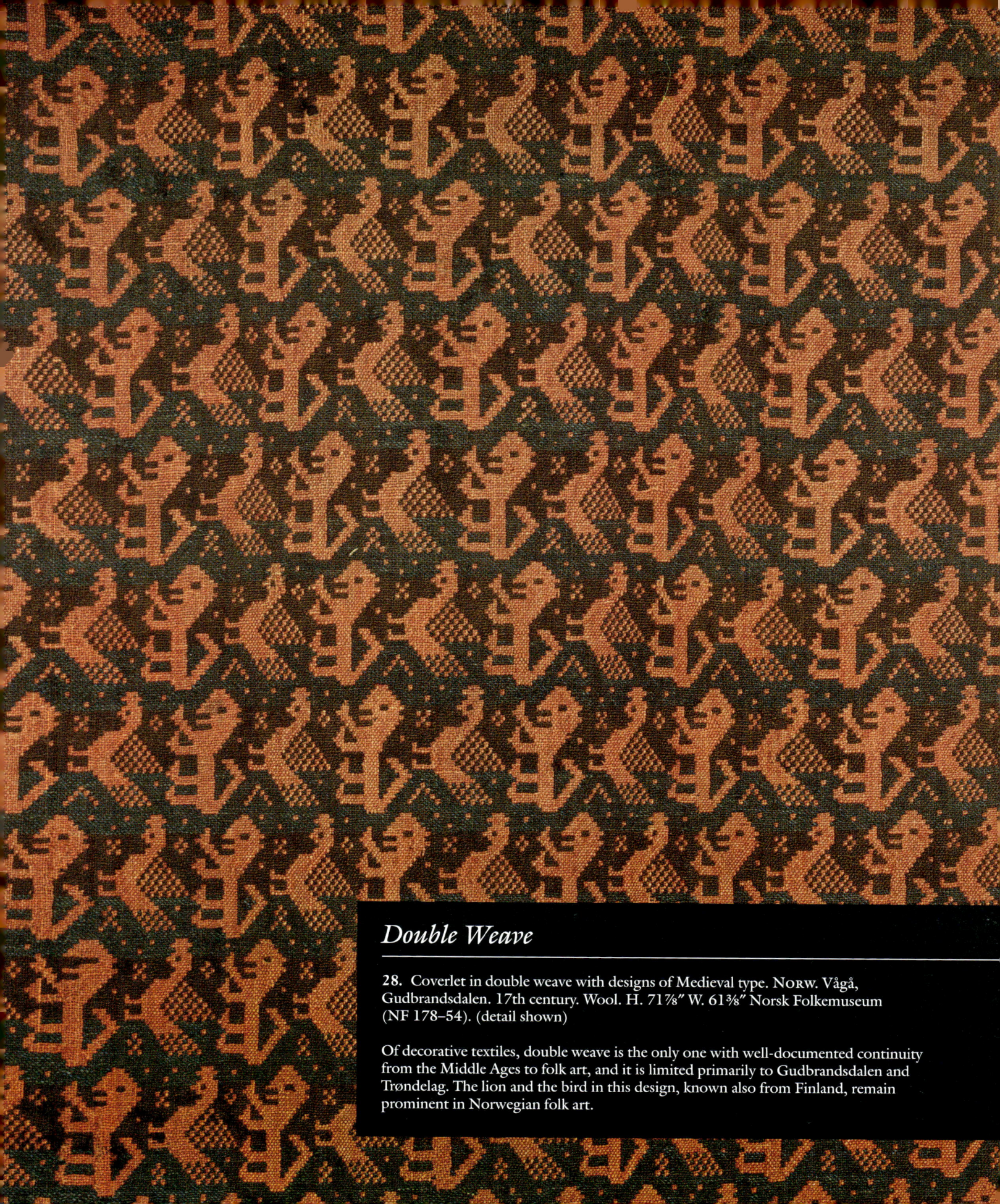

Double Weave

28. Coverlet in double weave with designs of Medieval type. Norw. Vågå, Gudbrandsdalen. 17th century. Wool. H. 71⅞″ W. 61⅜″ Norsk Folkemuseum (NF 178–54). (detail shown)

Of decorative textiles, double weave is the only one with well-documented continuity from the Middle Ages to folk art, and it is limited primarily to Gudbrandsdalen and Trøndelag. The lion and the bird in this design, known also from Finland, remain prominent in Norwegian folk art.

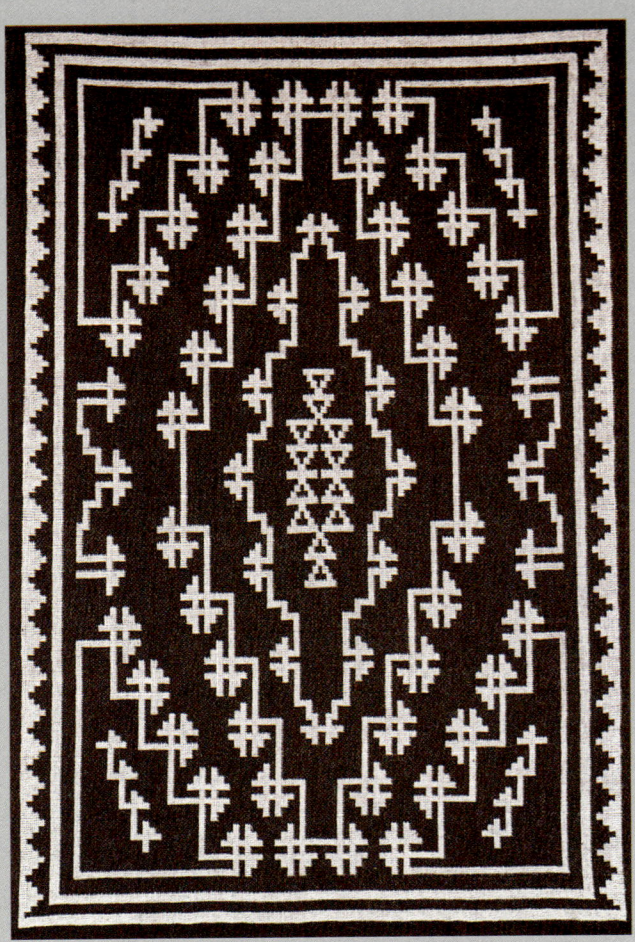

29.

29. Wall hanging in double weave inspired by Two Grey Hills Navaho rugs. Norw.-Am. Betty Nelson, Decorah, IA. 1994. Wool. H. 46″ W. 29″ Betty Rikansrud Nelson.

The artist descends from an immigrant family of crafts people, her mother being a traditional needleworker (121). Having also an interest in Native American arts, Nelson has adapted a double weave technique learned from a Norwegian teacher to designs inspired by Navaho rugs.

30. Coverlet in *Meråker* double weave technique. Norw. in Am. Ane Bitnes (Kirkeby) (1868–1951). Guda, Trøndelag. Came with weaver to South Dakota about 1890. Dated 1886. Wool. H. 71″ W. 50″ Smith-Zimmermann State Museum. (detail shown)

Having learned double weave from her mother, Ane wove this coverlet in the complicated *mothjart* (opposing hearts) pattern just before emigrating. The red and green color is unusual and must have been her personal choice. In America she wove rugs and, according to her grandson, always used red and green warp.

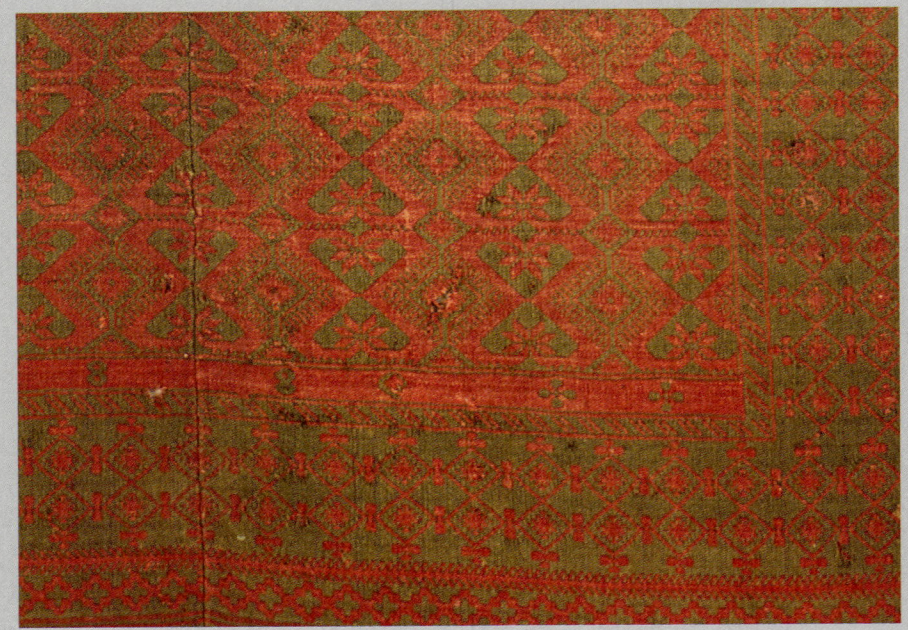

30.

Folk Art of Norway

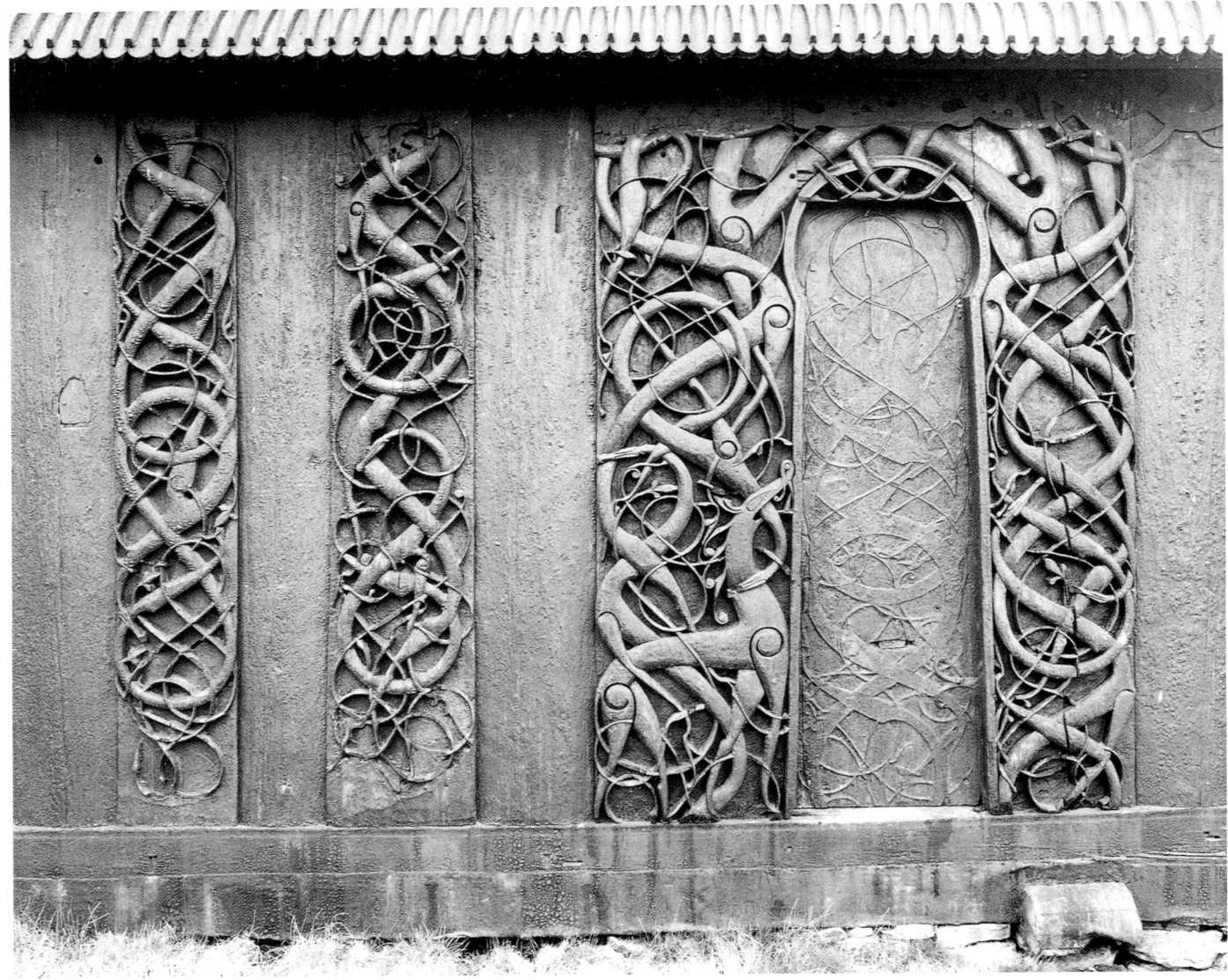

Fig. 1. Stave church portal. Urnes, Sogn. Ca. 1060. Photo: University Collection of Antiquities, Oslo.

Folk Art of Norway

MARION NELSON

About ninety percent of Norway's approximately 880,000 inhabitants around 1800 can be called folk, people who lived from the land with some supplementary income from lumbering and fishing and who were socially and culturally distinct from an urban elite group. The latter included government officials and clergy who were responsible to the king of Denmark across the sea to the south and who, together with merchants, land and ship owners, and some developing industrialists, had their own society centered in a small number of scattered cities with populations well under 20,000 each. Even this society, geographically fragmented and in a country far north, had only indirect contact with the mainstream of European culture. The rural population was one step further removed.

In spite of isolation and limited economy, the rural population in most areas of Norway retained considerable cultural vitality during the period between the country's loss of political autonomy in the 14th century and the restoration of it at the beginning of the 20th. Land ownership among farmers was not only a tradition but had been legally protected since the Middle Ages. Especially where this could be maintained, as shown by Halvard Bjørkvik elsewhere in this volume, a culture with roots in both pagan and Medieval times remained strong. This is well exemplified by the dress of women, which underwent little change except in additions and ornamentation through the period of our concern (117–119). A similar continuity is shown in domestic architecture, the folk song, and folk stories. An ongoing body of customs and beliefs lies at the base of this continuity. They were more embellished than substantially altered by the introduction of Catholicism in the early 11th century and of Lutheranism in the early 16th. The Danish critic and cultural historian Georg Brandes (1842–1927) is credited with saying that Norway was first Christianized in the early 19th century by the pietist Hans Nielsen Hauge (1771–1824). The exaggeration has an element of truth.

A FUNDAMENTAL DICHOTOMY: THE GEOMETRIC AND THE ORGANIC

Before considering further the reflection in art of the firm and ancient cultural base on which Norwegian folk society stood, we will look at Norwegian folk art in general from the standpoint of form. This is the one that will dominate the presentation throughout the volume, as stated in the Introduction, because it is the forms, the material entities themselves, that are what ultimately migrate and prove to possess the power to survive and acquire new meaning long after they are severed from the culture that brought them into being.

It is not uniformity that first strikes one in making a rapid visual survey of Norwegian folk art but a dichotomy between the geometric and the organic. The Norwegian scholar Marit Monsen has argued convincingly for the use of the terms static and dynamic, but they are being avoided here because of negative connotations in the word static as it relates to art. The two types now appear to be partly regional because in more recent centuries the geometric has been most prevalent on the west coast and the organic in the valleys to the east. Such a geographic division, however, is less evident if one follows Norwegian folk art back to its sources in the Middle Ages. At that time the west coast was the center of production for the highly organic stave church portals (Fig. 1). An object of Medieval type that retained a place in west coast folk tradition was a very organic carved ale bowl with two handles in the form of animal heads (8–13).

Geometric chip carving was also early on the west coast (18–19, 21, 23–25), but it was just as early and prevalent in Setesdal (16) and Telemark to the southeast. Throughout the entire eastern region from the late 17th century a type of geometric burnt decoration on wood (141–143), also usually associated with the west coast, continued during

Fig. 2. Head Post. Oseberg ship find. Ca. 850. Viking Ship Museum, Oslo. Photo: University Collection of Antiquities, Oslo.

periods when organic styles became increasingly prominent in woodcarving and dominated in the new folk art of painting. The geometric retained its appeal inland but was far more often supplemented by the organic, at least in surface decoration, than on the west coast. Rather than being strictly regional, the two strains must be looked on as representing two types of formal expression that both had a place in Norwegian folk culture.

Historically the two strains, the geometric and the organic, might be explained as the meeting of a dynamic northern animal style going back to prehistoric times with the formalizing tendencies found in the classic art of Greece and Rome. The two had been in contact and had co-existed or merged in various ways on Norwegian soil since the Migration period in the 6th and 7th centuries A.D. A post of unknown function from the Oseberg Viking ship of about 800, with a fierce animal head at its top and a simple grid design of horizontal and vertical bands at its base, is a striking example of this meeting at a time when Carolingian Classicism was making itself felt in the north (Fig. 2). It already embodies the dichotomy that continues in what one is tempted to call a native Norwegian aesthetic from late prehistoric times to the end of the folk tradition.

A wool basket from Telemark (2), representing the transition from Medieval to folk art at some time between the 15th and 17th centuries, like the Oseberg head post still shows geometric and organic elements in one object. About one-third of the decoration consists of strictly geometric chip carving; another third of highly organic interlacing tendrils or serpentine forms; and the last, except for one animal of wolf-like character, is made up of highly stylized curvilinear motifs that combine the organic and the geometric. Of these motifs, the most prevalent is various versions of the ring chain: interlinking circles which sometimes have a band running through them. The artist was clearly no amateur; his complete command of motifs drawn from the preceding one thousand years of Norwegian art combines the geometric and organic with boldness and confidence. It is but one example of many in which this occurs (14, 132, 204). The two strains can also appear on separate pieces but from the same time and area (143, 188).

The history of the geometric strain in Norwegian folk carving from possible origins in Romanesque and ultimately late Gothic art has been well traced by the Norwegian scholars Haakon Schetelig (also Shetelig) (1877–1955), Svein Molaug, and Ellen Marie Magerøy. The gradual transition of the organic strain from the stave church portals of Sogn in the west (Fig. 1) to the portals of storehouses in Telemark (1) and the gradual transition in that strain from animal to plant subjects (3) has been systematically considered by Peter Anker. This Norwegian scholar has also presented the supposition that the Medieval elements prevalent in Norwegian folk art well into the 18th century could represent revival, or renaissance, rather than retardation. The almost encyclopedic eclecticism of the decoration on the wool box would tend to support this, but another possible explanation for it will be mentioned later. Our concern now is the fact that the dichotomy of the geometric and the organic in Norwegian folk art is already part of its inheritance from the Middle Ages.

The dichotomy with which we are dealing need not be of purely historical origin. The coexistence of the geometric and the organic is found in the art of many cultures as if both relate to basic formal inclinations in the human psyche. Heinrich Woelfflin based his "principles of art history" on a duality somewhat analogous to that which we

Folk Art of Norway

find in Norwegian folk art but drawn from the art of the Renaissance and Baroque periods in mainstream culture.

THE MEDIEVAL LEGACY
Was There an Earlier Folk Art?

What is the line of development in Norwegian folk art? Of the arts presented in this volume, woodcarving best reveals the legacy of the Middle Ages. This appears to have come from the art of the dominant culture at the time. It has not been possible clearly to identify a separate art of the common people before the 16th century. There are indications, however, that such could have existed. What is found in the apparently earliest examples of adorned objects on farms in Norway, as we have seen in the case of the wool basket, has motifs and styles that on the basis of archaeological evidence had been making their appearance sequentially in mainstream arts over a period of close to one thousand years.

In the archaeological material, each stylistic direction with its accompanying motifs belongs to a rather limited period and then gives way to or becomes absorbed in later styles and motifs. In the early folk material, however, they can reappear after centuries of absence in the archaeological or early historical material. One such object is a pad terret, a wood neckpiece belonging to traditional Scandinavian harness equipment, that was found on a farm in Lom, Gudbrandsdalen, in the late 19th century and made part of the collection at the Nordic Museum in Stockholm (Fig. 3). It is carved with small animals which grip each other and the frame around them in a manner common in Viking art from around 800 A.D. (Fig. 4) but having no prominence in later known art of the Viking and Medieval periods. It has been dated by carbon 14 testing to the mid 14th century but was found in a folk context and would even with this early date represent extreme stylistic retardation. A log chair from Sauland, Telemark, too, which also reached the Nordic Museum at an early date, has gripping beasts very similar to the Viking but has the date 1571, which tree-ring dating indicates may be correct (Høeg). Our wool basket, in addition to its Viking dragon heads and 10th century ring chain, both of which could have been passed on to folk art through the Romanesque, also has a snake knotted in a

Fig. 3. Pad Terret (part of horse harness). Lom, Gudbrandsdalen. Late 12th century. Nordic Museum, Stockholm. Photo: Nordic Museum.

Fig. 4. Interior plate of prow. Oseberg ship. 825–850. Viking Ship Museum, Oslo. Photo: University Collection of Antiquities, Oslo.

chaotic way strikingly near a style from the Migration period in the 6th and 7th centuries. Peter Anker has wisely cautioned against assuming a direct connection, but considering the other anachronisms that appear in this material, the possibility of a connection should perhaps not be totally dismissed.

These accumulations in the early folk material of archaic elements that had long disappeared from mainstream art lead one to ask if there may not in the Viking period and Middle Ages themselves have been a folk tradition that was far more conservative than that of the dominant culture. The early folk art collected on Norwegian farms a century ago would then be a continuation of this tradition rather than a direct inheritance at a later time from existing high art. This refutes Peter Burke's assumption that popular culture is a post-Renaissance development, but the material begs the question. It also weakens Anker's hypothesis of a possible Nordic revival or renaissance in the folk culture of the period. The Norwegian scholar Robert Kloster (1905–1979) also speculated on the possibility of an earlier folk art but as an explanation for later regional differences between east and west Norway. The question will not be answered until more extensive research on the periods involved has been carried out.

Chip Carving

The obviously Medieval motifs in early examples of folk art, such as dragons, intertwining serpents, and ring chains are three-dimensional or in relief. A type of folk decoration on wood with precedent both in prehistoric and Medieval times is chip carving. It usually consists of V-shaped gouges in patterns created by intersecting horizontal, vertical, and diagonal lines or circles and arcs. Evidence of this approach to carving can be found in Scandinavia as early as the 5th century, when the ubiquitous star motifs characteristic of it already appear. Rectangular work of the type is found in Romanesque stone carving and appears in wood on a 12th century stave church portal in Vågå, Gudbrandsdalen. The early examples nearest the type most common in Norwegian folk carving are on the ends of pews from a church on the Faroe Islands, thought possibly to be Norwegian work. Here the source is quite obviously Gothic tracery. Both the Romanesque and the Gothic types appear to have left their mark on the Norwegian folk tradition.

Much has been made by Haakon Schetelig and Robert Kloster of chip carving's special prevalence on the west coast, where weaving and embroidery also reveal a predilection for the geometric; but, as mentioned in another connection, it is in actuality also very prevalent in the south-central valley of Setesdal and adjoining Telemark where it, unlike on the west coast, appears frequently on beds, trunks (16), and doors as well as on smaller objects. The use of chip carving on furniture is found as well in the more northern valley of Valdres, where it totally covers the front of a specific type of hanging square cupboard (17). A chip-carved trunk dated 1623 that came to America with immigrants from Hedemark indicates that a tradition in the technique must originally also have existed in this eastern area (15). Its association with the west coast results more from its being left there without competition from the organic style in relief acanthus carving that entered the east than from any exceptional prevalence of it in the area.

The Norwegian scholar Svein Molaug in the 1950s followed up on an idea of Haakon Schetelig and demonstrated that much early chip carving found in Norway may have been imported. This involves primarily mangle boards produced in southern Jutland under Dutch and north German influence. The craftsmanship is more precise and detailed and the designs more intricate (21, 24) than in most Norwegian examples (15–18). They appear to have grown even more directly out of late Gothic tracery than those in the native work. The two traditions appear to merge (25), and it is extremely difficult to determine what in Norwegian chip carving is indigenous and what is the product of influence from northern continental countries. Importation began at least as early as the 1600s.

The burnt decoration referred to earlier is probably an outgrowth of chip carving because of similarities in the basic character of the designs. It too has been associated with the west coast because of fewer other decorative treatments of wood there. It appears extensively throughout Norway from the 17th century on but has been given little attention by scholars because of the routine nature of most designs and the method of their production. It generally relates well to the formal elements of the piece on which it appears and can lead to total design effects of exceptional beauty (141–143). While originally representing the geometric strain in Norwegian folk art, the technique was adapted to organic designs in Telemark and Hallingdal in the 19th century (144–145). In the latter region particularly, a shift from impressing the designs to scratching them in with the hot, ultimately electric, iron occurred.

Methods of Construction

It is not in decoration, however, that the greatest legacy of the Middle Ages in folk objects of wood is found but in the form of these objects and in the techniques with which they were made. These lie outside the major concern of

this presentation except where they relate to the expressive or decorative character of the works, but they still deserve comment as evidence of the underlying Medieval base in Norwegian folk culture.

The four techniques used in the construction of most Norwegian folk objects of wood—1) carving or turning, 2) binding staves around a base or a base and top (*lagging*), 3) bending a thin sheet of wood around a base and lacing the joint (*sveiping*), and 4) corner joining—were all inherited from Medieval times and have even longer histories in the north.

TURNING OR CARVING FROM ONE PIECE OF WOOD

Bowls are the most common objects produced by turning, and turned examples were found in the Oseberg Viking ship from the early 9th century A.D. The technique, however, does not have great prominence in Norway until post-Renaissance times when it appears to have been introduced, or re-introduced, to the folk culture by professional craftsmen representing a north European urban tradition. Turned ale bowls from the time of their introduction to the folk culture were painted and occasionally given additional carving (152). The Norwegian scholar Albert Steen has said, "Nothing can be much more Norwegian than an ale bowl with rosemaling." (180)

Bowls carved from one block go far back in prehistoric times, but as drinking vessels they have an unbroken tradition in Norway from at least the late Middle Ages when they were replacing horns for this purpose. Dippers are related objects of equally long tradition (91, 93, 99, 132). Carved vessels often get their artistic character through shape rather than surface decoration. A common feature of these early drinking vessels is two handles with animal heads that project out from the body in opposite directions (8–11). In the earliest examples, the vessel itself is elongated and the heads—which are dragon-like, probably to ward off evil—project directly out and up from it (3). The type is found primarily in Telemark and surrounding areas where it is called "*kane*," a word related to one meaning "boat."

In the 18th century, the *kane* underwent what looks like domestication when the dragon heads gave way to heads of horses with necks that gracefully arch up and turn back down to form better grips than found on the earlier type (8). The shift may have seemed quite natural at the time because the horse too had been associated with protection. An additional association was with fertility, which has led to speculation that the horses' presence on the bowls may relate to their prominence at weddings. Other than in dress, however, specific symbolism in Norwegian folk arts is hard to document.

The later type of vessel, which has more vertical orientation than the *kane*, belongs largely to the west coast, where it goes by the name "*kjenge*," a local word related to *kane*. Variants in the handles include horse heads with tongues curling in and touching the vessel (10, 10a) or combinations like horse heads over ram heads or horse heads being held in the mouth by miniature human beings (11). Types which do not include horse heads are also many, but none occurs in great numbers. Among them are examples with rams heads only, twisting snakes (13), or large rosettes in open work (14). The variety suggests that no specific symbolic association remained with this type of vessel.

The carved drinking vessels that have symmetrical handles like the *kane* and the *kjenge* relate to a type with a head for one handle and a tail or some other projection for the other (87, 89–91, 93, 99–100). The great majority of these asymmetrical vessels represent birds, generally hens, roosters, geese, or ducks, ranging in treatment from naturalistic to fanciful to almost totally abstract. Among several exceptions to bird forms is a lion with dragon characteristics whose tail is a snake's head (12). The concept of vessels in the form of animals or birds is found in most cultures and has both prehistoric and Medieval prototypes in Europe. In Norwegian folk tradition the type appears to be later, at least in gaining prominence, than the vessels with two heads or variations on them.

The early ale bowls in the shape of a bird or animal occasionally have a short spout in or near the head (87, 89). The type is then related to a common turned bowl with a short spout or lip carved at one end and often a projection vaguely reminiscent of a bird's tail at the other (156, 162–163). Both carved and turned bowls in this category are called "*trøys*."

Most bowls of the kind discussed were for ale, a drink used on special occasions such as Christmas, weddings, and funerals. Although not necessarily drunk with moderation, it was drunk with ritual. This accounts for the attention given the form and decoration of the vessel.

But ale bowls are not the only type of wood objects shaped from one piece. Retaining as much as possible the integrity of wood as found in nature appears to have been a principle with early Norwegian craftsmen. Log construction—using the full trunk of the tree for building—is an example of this (Fig. 45a-b). In pre-Renaissance Norway joining was kept at a minimum. Even the most common Norwegian folk chair, the *kubbestol*, is carved from a solid log, taking advantage of its round shape in making it fit the

body (52–55). The center is hollowed out to prevent cracking on the outer edge when contraction from age or drying occurs, and the seat, which is the only added element, was traditionally set in loose, also to prevent putting stress on the log when it contracts. The Norwegian-American John Barikmo applied this principle even to a table by using a hollowed-out tree trunk for the base (45). The same attempt to keep joining at a minimum is found in the heavy plank furniture characteristic of the folk tradition before it came under Renaissance influence (38).

STAVE CONSTRUCTION

As mentioned concerning the log chair, a problem with wood objects made from one piece is that cracks can develop unless precisely the right relationship exists between the shape of the object and the behavior of wood in aging and being exposed to changes in humidity. A technique with built-in cracks, so to speak, that are tightened by moisture was used in England well before the time of Christ and found in Norway from prehistoric times. It is being referred to here as "stave construction" though it is not to be confused with that term as used in architecture. By the 9th century when the Oseberg Viking ship was buried, stave construction was being used for a wide range of vessels. Barrels are the most common stave-constructed objects familiar to most people today. For open vessels (7), such as pails, this construction consists of comparatively narrow, slightly arched slabs of wood (staves) cut from around the center of a log and given a groove perpendicular to their length on one side near one end. The outer edges are beveled to make a close fit when they are bound with split willow branches or thin bands of wood around a circular base that fits into the grooves. When filled with liquids or anything moist, the staves expand and the joints tighten.

Stave construction was the most common technique for the making of household vessels in rural Norway, ranging from undecorated buckets, pans, kegs, and barrels to decorated porridge (58–59, 65, 143, 204) and butter (141) containers, ale bowls (usually with two handles on the sides (6–7), and tankards (73, 153, 155). All these types of vessels, with the possible exception of spouted tankards, go back at least to the Middle Ages although their specific uses may have changed.

The shapes of stave-constructed objects are largely determined by their construction, limiting their decorative or expressive possibilities primarily to the treatment of the surface. Exceptions are the two-handled ale bowls called "staup" (6–7). These vessels relate in form to the *kjenge* because the loop-handles on both sides, consisting of narrow staves set perpendicular to the body, are often topped by forms that resemble horse heads or other motifs found in the carved vessels. A difference, however, is that the *staup*, like many stave-constructed vessels, generally has burnt decoration while the *kjenge*, like most other objects made from one piece, either has a plain surface or simple carved decoration. Among several early exceptions to this rule are the *staup* with a braid in relief surrounding the body (6–7), a motif going back to pre-Viking times and which also appears on two early Telemark *kaner* (Gjærder) but is not known on a *kjenge*. These distinctions between the *staup* and the *kjenge* could mean that they have separate histories, the *staup* possibly being the older. The similarities would then have developed through long coexistence in west Norwegian folk culture.

Although stave construction involves joining many pieces of wood, the tankards of this type with spouts also reflect the early tendency to use wood in its natural form. The staves from which the spouts project are chosen from trunks that have limbs which can serve this purpose simply by being hollowed out. No joining is necessary.

BENTWOOD CONSTRUCTION

Bentwood, like stave construction, leaves a surface for applied decoration and has limited possibilities for artistic expression in itself. The technique as found in rural Norway involves three major steps: 1) binding a thin sheet of wood around a base that is usually circular or oval, 2) lacing the joint where the ends meet with fine birch roots, and 3) securing the base to the sides with pegs. Containers made in this way are sometimes left open as baskets with or without handles (187) but are more commonly given covers made in one of two ways. The simplest are constructed like the piece itself but large enough to fit over the top (134). They belong to a general category of boxes called "sponesker" but also have other names depending on locality and use. The most common cover on oblong boxes is a slab of wood slightly larger than the opening that is clamped between two posts pegged into the ends opposite each other (19). "Tine" is the name of this type.

Bentwood construction may be the oldest wood technique involving joining that remained in use in the Norwegian folk tradition. Archaeological finds indicate that thin boards were laced together to form the hulls of Norwegian boats already in the Stone Age about 2000 B.C. Continuity in technique between these boats and the folk boxes can, of course, not be proven, but fragments of an oval bentwood box with holes for lacing the joint exca-

vated from a grave dating about the middle of the first millennium B.C. in Hallstatt, Austria, indicate that the technique was widespread and could have had an unbroken history. Types of decoration with Medieval character on bentwood boxes include chip carving (19), carved twisted bands, and Romanesque tendrils (133). Burnt decoration is also common (145), as painting ultimately became (174–175, 185, 189, 191, 196, 198).

A type of bentwood container that has interest as form apart from surface decoration consists of multiple or stacked units (135). They belong primarily to Trøndelag, a province to the north of those already discussed. Playfulness or a tendency toward the eccentric characterizes the folk art of the area. The type is probably of post-Renaissance origin as the decoration is generally stylized floral motifs incised through a stained surface. This decorative device was characteristic of the area and is found on standard bentwood boxes as well. A type with exceptionally fine floral motifs of almost realistic character has been identified through signed and dated examples as the work of John H. Budalsplads, Budalen, Trøndelag, who worked during the early decades of the 19th century (134).

Corner Joining

The Medieval approach to corner joining generally consisted of 1) butting the end of one board perpendicular to the edge of another and pegging them, 2) using a mortise and tenon, or 3) setting boards into grooves on two adjacent sides of a square or rectangular post (2, 60). These continued to the 18th century but were then being replaced by dovetailing and other more sophisticated joining systems. The major revolution in the joiner's art at this time was the shift from solid plank construction (38) to frame and panel construction (44). It occurred slowly after the appearance of the new approach had for some time been simulated on the surface of plank-constructed pieces. This is a striking indication of how long the fundamental material culture held its own through periods of dramatic change on the surface of things. Corner joining of all kinds in the folk culture, apart from that used in architecture, remained limited primarily to furniture (including trunks), while the ancient stave and bentwood techniques continued to be preferred for smaller containers.

Textiles

We have seen that the greatest continuity from the Middle Ages relating to the folk arts was in the basic material culture upon which the arts were an embellishment. It changed gradually and comparatively little while the surface treatments from the 18th century on underwent rapid and extreme development. This will be returned to. The observations have been made from objects of wood. Something comparable was true of textiles as well. The basic twills and plain weaves in wool used for clothing underwent little change while few examples of carry-over in decorative weaving can be documented. There are two exceptions. One is double weave, in which even some motifs were continued from the late Middle Ages into folk weaving, at least in Gudbrandsdalen (28) and Trøndelag (30). The other is card weaving, a technique for weaving belts with decorative patterns known in Norway from pre-Viking times and used to this day for the making of a belt which has a central place in the traditional costume of east Telemark. Continuity here, however, is not as well documented as for double weave.

REFLECTIONS OF THE RENAISSANCE
Coverlets
PICTURE WEAVING

It is in textiles, on the other hand, that the first dramatic impact of the Renaissance on Norwegian folk art was felt. Already in the late 16th century two references are made in Bergen documents to female tapestry weavers, both, incidentally, relating to witch trials. Since the women were urban and of some social standing, they undoubtedly had learned the art from professional weavers. Itinerant professionals from Flanders and surrounding areas, where both court and provincial traditions in Renaissance tapestry weaving had developed, are known to have been active in southern Scandinavia during the 16th century. The word "Flemish" is used in both records to describe the weaving with which the women were involved. One, Johanne Jonsdatter, had come to Bergen from Skien in Telemark, an area where three fine examples of provincial upper-class weaving of the Flemish type have come to light.

During the course of the late 17th century, picture weaving of Renaissance inspiration found its way into the folk culture; precisely when has been much debated. Here it became the basis for prestigious coverlets, generally with Biblical subjects relating to festivity. Major among these were the Feast of Herod, episodes in the life of King Solomon, the Wise and Foolish Virgins (a wedding subject)(32, 36), and the Adoration of the Magi (33–34, 36). The choice may have resulted from the coverlets being used largely for festive occasions such as Christmas and weddings.

A great majority of the approximately 200 extant

picture-woven coverlets and many of the far more numerous related cushion covers have come from Gudbrandsdalen in north-central Norway. It is assumed that most were also woven there between the late 17th and mid 18th centuries. The tradition continued in areas to the south and west until the 19th century but with the motifs increasingly stylized.

These late stylizations were the final manifestation of a process that began as soon as tapestry weaving found its way from the sheds of the court weavers in Paris and Brussels to Holland, North Germany, and Scandinavia. Perspective gave way to two-dimensional pattern, and the pictorial elements moved more and more toward abstract design. The borders, which in many of the upper-class Renaissance models had been festoons of fruits and flowers (32), became in Norway either stepped triangles alternately facing each other or a more complex zigzagging tendril with an eight-petalled rose in the alternating triangular spaces (31, 33, 34, 36). The Wise and Foolish Virgins became two rows of five increasingly similar women. Along the way they lost the bridegroom (Christ) at the end of the row with the wise virgins and an innkeeper or candle vendor at the end of the row with the foolish (still evident in 36). The suggestion of a city or of windows behind them gave way to more eight-petalled roses (36).

THE RELATIONSHIP OF PICTURE TO SQUARE WEAVING

The schematicizing tendencies in folk picture weaving put it, like most of the decoration on wood discussed so far, in the category of the geometric in Norwegian folk art. This has led to speculation that a tradition in geometric coverlet weaving in a tapestry technique may have existed in the folk culture of Norway prior to the introduction of Renaissance picture weaving. If this were the case, the direction taken by picture weaving would have been a gradual reversion to a more deeply rooted local tradition, a common phenomenon when new elements enter the folk arts.

Thousands of purely geometric tapestry-woven coverlets were in use throughout Norway during the 18th and 19th centuries, most of them known to have been woven on the west coast. These have indeed the stepped triangles, the lozenges, the eight-petalled roses (also referred to as eight-pointed stars), that gradually replaced the representational elements in the picture weaving (101–105, 107, cf. 36). No absolute evidence exists, however, of such coverlets having been produced in Norway prior to the 17th century. But neither is the likelihood very great of the firmly established tradition in geometric coverlets having resulted exclusively from the stylization of earlier picture-woven examples. Inheritance records reveal a long history of woven coverlets in Norway.

The techniques in the two types differ. The weft threads in the totally geometric coverlets are interlocked at the point where two colors meet along a warp thread while in picture weaving they turn back each in its own direction on separate warp threads. This technique relates to that of the Oriental kilim and French and Flemish tapestries except that in the Norwegian examples slits in the fabric are avoided by four means: 1) keeping the line where colors meet diagonal, 2) alternating the warp threads at which they meet (dovetailing), 3) having one color cut into the other in little blocks (toothing), or 4) having them cut into each other in long narrow lines (hatching). These provincial solutions to a technical problem in the weaving method that came with tapestry weaving from the south create the effect of geometric pattern even in coverlets that otherwise remain comparatively true to the pictorial models. This geometric pattern, however, has a totally different character from that found in the square-woven coverlets. The division between colors in the latter occurs exclusively along horizontal and vertical lines.

The looms used for the two types of Norwegian tapestry-woven coverlets were also different, the geometric examples being generally woven on the ancient vertical warp-weighted loom while the picture-woven were done on a vertical frame loom of later introduction to Scandinavia. The relationship of picture weaving to square weaving is one of several mysteries remaining in the history of Norwegian folk art. A hypothetic solution will be ventured.

If the geometricizing tendencies in Norwegian picture weaving were not a reversion to a more indigenous tradition, they could be explained in terms of the Renaissance itself. The tapestry weaving of the time was an imitation of painting. Renaissance design outside painting and sculpture had a strong element of the geometric. This is particularly evident in Renaissance pattern books for textiles. They include the step motifs, the stylized eight-petalled rose motifs, and the lozenges to which the realistic borders and other details in the high art tapestries gave way in Norwegian folk weaving. These are also the motifs that dominate the more everyday square-woven coverlets. They appear as well in Norway's white-on-white cut-out Hardanger embroidery (119–121), colored cross-stitch, black "Holbein," and other related embroideries, thought generally to have grown out of international traditions in Renaissance stitchery.

The geometric strain in Norwegian textiles as we know it could be as much a product of the Renaissance as pictor-

ial weaving but would have come from a different source in the Renaissance itself, one which made its strongest impact in southwestern Norway. The impact of Renaissance pictorial art was greater in the south-central and north-central areas. The two, as seen, required different techniques. The one needed for picture weaving was picked up from the continent with the designs themselves and the frame loom on which they were executed. The one best suited to square weaving could have been developed locally for use on the warp-weighted loom that had been the basic one in Norway since at least Viking times. But the technique for these may also have come in from abroad where the pattern-book designs could already have been adapted to native looms. A closely related technique, and even some of the same designs, appears to have been passed on by the Spanish to the Navaho.

With the increased communication between east and west Norway that got underway in the 18th century, the two strains in tapestry woven coverlets met and began to merge. That the geometric won out is not surprising. It was based on the grid of horizontal and vertical threads that constitute weaving of this type, and it also satisfied the tendency for schematization that is characteristic in the folk arts. The amazing thing is that Renaissance-inspired picture weaving could have occurred in Norwegian folk textiles at all.

A NEW LOOM AND ITS IMPACT ON FOLK WEAVING

A major consequence of Renaissance developments for Norwegian folk textiles was the introduction of the spinning wheel and the horizontal loom with multiple foot-controlled harnesses that allowed complex patterns to be woven without manipulating the threads individually with the fingers. Just when this occurred is not certain, but areas where the transition from the one loom to the other was still in progress are known from the 18th through the early 20th century. Pattern weaving in techniques that involved carrying the weft across the entire width of the fabric had already been done on old upright warp-weighted looms, but such weaving was considerably simplified and became much more prevalent with the introduction of the horizontal floor loom with pedal-controlled sheds. Coverlets in these techniques with continuous weft threads are generally woven in two strips that are stitched together down the middle (109, 111, 113, 115). On the warp-weighted loom this would have simplified production for the weaver working alone. Ultimately it was made necessary by the limited width of many horizontal looms.

The most common across-the-loom weave for coverlets is *krokbragd*, a three-harness point twill (108) related to the American bound weave. With proper coordination between the treadling and the insertion of colors, stripes having systematically jagged contours were produced. Much of the yarn floated on the back giving added warmth to the coverlet. A comparatively rare variant of this called "*danskbrogd*" introduces a pattern of dots on the surface between which the yarns on the back must also float (109).

Most other coverlet weaves were overshots in which the pattern was made by colored wool yarns that floated over and under a linen or cotton ground like embroidery threads (113). In addition to being used as coverlets, weavings of this type could also serve as a backing on sheepskin bed covers, as a wrap for the child at christenings, a cushion on the bridal bench at weddings, or a cover for the coffin at funerals.

Norway also has two major types of coverlets in which supplementary wool yarns are added to a plain or twill-woven ground in which the weft too is of wool. The Scandinavian center for these weaves is Finland and Sweden. One type has the yarns laid in while weaving to form lacy patterns over the surface (111). It had a short heyday in Vestfold, from which it gets the name Vestfold weaving, in the late 18th century. The family of weaves to which it belongs extends through much of eastern Europe, the Near East, and north Africa. The other type, called "*rya*" in Norway and Sweden, is a pile weave in which short lengths of yarn or rags are knotted into the warp while the ground fabric is being woven. The final effect is of coarse fur. Colored yarns can be used to create designs in the ground, the pile, or both (115). The type is widespread but found largely on the west coast where a common use has been on fishing boats. The technique relates to that of Oriental pile rugs, but the type found in Scandinavia appears to be quite indigenous to the area, where it is referred to in records going back to the Middle Ages.

Carving the Figure
SETESDAL BENCH BACKS

The Renaissance brought the figure to prominence not only in folk weaving but in folk carving as well. In the early 18th century the plank backs of benches in Setesdal began to be elaborately decorated with reliefs of subjects generally drawn from folklore or the Bible (38). The specific sources of almost all, according to the Norwegian scholar Halvor Landsverk, were the illustrations in the Bibles published by Christian III and Frederik II or in two folk books *Karl Magnus Kronike* and *Olger Danskes Kronike*. All ap-

peared first in the 16th century but continued to come out in later editions.

The figures on the bench backs are in high Renaissance dress and occasionally stand under arches or in rondels characteristic of Renaissance design. The overall compositions are formal, but the activity within them is agitated and chaotic. Fragments from the sources are put together with total disregard for narrative. Occasional carryover from Medieval decoration, such as intertwining bands and Romanesque tendrils, indicate that the Renaissance was merely feeling its way ahead on essentially Medieval ground.

POWDER HORNS

The bench backs have a counterpart in pictorial carvings on powder horns from the same period and possibly from the same area or just to the south in Lista. They represent an extremely high aesthetic and expressive tradition with the stylization resulting in part from the hardness of the material and the small format in which the work was done (39). The subject matter is generally drawn from the same sources as that on the bench backs, and there is similar formality in the overall design. An indication of a link between the two traditions is a wood bowl from Setesdal with reliefs related to those on bench backs but signed by the horn carver Ola Olason. (Landsverk)

Forty-eight carvers of pictorial horns have been identified from signed and often dated examples. The period of production is from the mid 17th through the late 18th centuries. In spite of the documentation on the pieces themselves, the circumstances that led to this comparatively isolated phenomenon in figurative carving near the southern tip of Norway are no better understood than those behind the sudden flowering of pictorial weaving in Gudbrandsdalen well to the north at approximately the same time. Just as that gave way to geometric weaving, the figurative powder horn gave way to plant-decorated examples in the stylistic traditions characteristic for the area and period in which they were made (64, 140).

Flat Relief Carving

The Renaissance made its contribution to plant decoration in the form of the so-called "flat carving," a type of relief consisting of two planes with the ground cut back only slightly from the surface (44). The latter is left essentially without modeling. The approach is found in Medieval architectural decoration as early as the 11th century when it appears on the original door of the Urnes stave church in Sogn on the west coast (Fig. 1). It appears again with a more deeply cut ground in 13th century church portal carvings in Telemark, the area where it also becomes most prevalent in the folk arts. However, since one of its early uses in the folk arts is on the panels of furniture simulating Renaissance style and since it was a common type of decoration on Renaissance architecture and furniture, its appearance in the folk arts of Norway is generally credited to this source. The tendril, which is the major motif, acquires in its folk manifestation a meandering character and often sprouts a trefoil motif related to one on Romanesque tendrils. This suggests a meeting of the Renaissance and the Medieval.

Flat carving has its major home on cupboards in Tele-

Fig. 5a. Open hearth room of 17th and early 18th century type. Amli, Valle, Setesdal. Now in Norwegian Folk Museum, Oslo. Photo: Norwegian Folk Museum.

Folk Art of Norway

mark but is also common on the posts of porches there (1). It is occasionally seen on furniture in surrounding valleys and to the north. A secondary center of it is Gudbrandsdalen, where it appears primarily on small tankards and on low square traveling trunks.

Cabinet Making. The Chimney. A Reorganized Interior

The furniture on which flat carving appears has totally different styling from that found earlier in the rural Norwegian home and represents one aspect of the most significant change that occurred in the basic material culture of rural Norwegian society during the high period of folk art. It was the transition from carpentry to cabinetry, as Peter Anker puts it. Joining, which had been kept at a minimum and remained simple up to the 18th century, now became a specialty apart from building, with which it had been closely associated. It now linked itself to urban culture and to cabinet making as practiced in the guilds. The major consequence was that the rural interior acquired a lighter appearance. The heavy planks gave way to frames filled with comparatively thin panels. The transition, as mentioned in another connection, was slow, beginning with simulation before assimilation. It led to the development of the great cupboards (154) and secretaries (148) that in the late 18th century became the symbols of substance in the interior of the house as the storehouses had been in the farmyard (Fig. 14).

The rise of rural cabinetmaking went hand in hand with giving the interior a new organization through the introduction of a chimney that channeled smoke from the hearth directly out rather than allowing it to escape through a hole in the ceiling. The location of the new hearth with chimney came generally to be a corner. In western Norway the open hearth had long been there so the change was nominal. The chimney was also late in coming to this area. In the eastern valleys, however, where the hearth had always been in the center of the room (Fig. 5a), a complete reorganization became necessary. The usual solution was to place the dining table in the corner opposite the hearth. The high seat, which had been behind the table in the middle of the back wall, was now moved to the end of the table in the corner. A third corner was occupied by the built-in master bed, and the fourth had the door to the entry area, the location where this had generally been (Fig. 5b).

Closing the smoke hole in the ceiling eliminated the major source of light and led to the need for windows. Getting a more confined hearth made possible the introduction of wood floors to replace the packed earth on which most domestic activities had been carried out since prehistoric times. For both of these innovations, as for the development of fine cabinetmaking, industrial developments helped prepare the way. The water-powered saw, which had been used in places on the west coast since the 16th century, in the 18th became widespread, even in the east. It made possible the rapid production of lumber that had previously been prepared with the axe. In the 18th century, too, Denmark transferred most of its glass production to Norway because of the greater supply of wood for fuel there. This increased the availability of window glass.

(Continued on page 61)

Fig. 5b. Traditional interior with corner fireplace of late 18th century type. Federåd house. Bjørnstad, Vågå, Gudbrandsdalen. Now at Maihaugen, Lillehammer. Photo: Sandvig Collections.

Reflections of the Renaissance
The Tapestry Technique and Picture Weaving

31.

31. Coverlet with cloud motif (*skybragd*) in tapestry technique. Norw. Vågå, Gudbrandsdalen. 18th century. Linen, wool. H. 63″ W. 74¾″. Norsk Folkemuseum (NF 772–06).

The diagonal orientation of repeated motifs here echoes the design of the double weave coverlet of Medieval type (28) that was also woven in Vågå. Here the pattern is built up with patches of color that go through the fabric, a technique which first gained prominence in Norway with the Renaissance-based picture weaving (32–34, 36). The borders reveal a direct connection. The simplicity and yet vitality of the color and the balance in geometric, organic, horizontal, vertical, and diagonal elements give *skybragd* a unique position in Norwegian weaving.
In spite of the name, the design grows out of a pomegranate motif found in Spanish and Near Eastern brocades.

32.

32. Coverlet in pictorial tapestry technique (*billedvev*): *Wise and Foolish Virgins*. Norw. in Am. Gudbrandsdalen? Brought by an immigrant to Menomonie, WI. After 1660. Wool, linen? H. 82¼″ W. 61¼″ Somewhat garbled inscription referring to the wise and foolish virgins. Minneapolis Institute of Arts.

Norwegian pictorial folk coverlets descend in direct line from professional tapestry weaving in the lowlands. Even the technique is fundamentally the same, but the provincial weavers developed schematic ways of dealing with the joins where colors meet that both eliminated slits and replaced the illusion of space in the Renaissance models with two-dimensional pattern. The parallel figures in the Wise and Foolish Virgins made it ideal for this decorative stylization. The Biblical source and the relation to a festive event are typical. While the subject conveys a moral, the occasion is a wedding; and it was primarily at weddings, funerals, and holidays that these coverlets were used.

33. Coverlet in pictorial tapestry technique (*billedvev*) with scenes from the Adoration of the Magi. Norw. in Am. Probably Gudbrandsdalen. After 1625. Wool, linen. H. 75½″ W. 55½″ Inscription: "SAO 1625" plus garbled phrase relating to the subject. Vesterheim, gift of Sylvea Bull Curtis. Once owned by violinist Ole Bull (84.123.1).

The arrival of the Magi was the second most popular subject on coverlets. A version of supposedly Renaissance origin appears here (only the lower left hand corner is shown). The piece migrated through the descendants of Ole Bull, whose American wife is said to have purchased it.

33.

34.

34. Coverlet in pictorial tapestry technique (*billedvev*) depicting the Adoration of the Magi. Norw. Gudbrandsdalen, after 1661. Wool. H. 76¾″ W. 56⅝″ Kunstindustrimuseet i Oslo.

A version of the arrival of the Magi that is considered of Baroque origin combines the figures of the supposedly earlier version (33) in one space surrounded by a ring of animals.

35. Quilt: *Renaissance*. Norw.-Am. Helen Kelley, Minneapolis, MN. Signed and dated 1983. Cotton, poly-batt. H. 70″ W. 50″ Helen Kelley.

The impact of the preceding work (34) led to the migration of its image. The quilter, among the most recognized in America, is of English and German descent but made the quilt in honor of her husband's Norwegian grandmother. Cultural migrations can take many forms.

35.

36. Coverlet in pictorial tapestry technique (*billed-vev*) depicting the Wise and Foolish Virgins and the Adoration of the Magi. NORW. Kvamme farm, Lom, Gudbrandsdalen. 1760. Linen, wool, metallic threads. H. 71½″ W. 47¼″ Norsk Folkemuseum (NF 1906–841).

This is one of three preserved coverlets belonging to three sisters from Glomsdal, Bøverdalen, and could possibly have been woven by them. It represents the tradition after it had become clearly rooted in the folk culture. The combining of subjects and increased schematization together with the well-preserved color make it exceptional.

37. Tapestry: *Battle of the Horse and Bull.* Norw.-Am. Nancy Jackson, Vallejo, CA. Signed. 1991. Wool, cotton. H. 40¾″ W. 58″ Nancy Jackson.

Building on the techniques and stylization in the Norwegian pictorial coverlets, this contemporary Norwegian-American weaver created a fanciful version of the struggle between good and evil.

37.

Figurative Relief Carving

38.

38. Back of a plank construction bench (*brugdebenk*) with carved figures. Norw. Setesdal. 18th century. Pine. H. 28″ W. 63″ Norsk Folkemuseum (NF 1928–521). (See detail on back endpaper.)

Between 1650 and 1800 a tradition in figure carving based on illustrations in two Bibles and in folk books on Holger the Dane and Charlemagne existed in Setesdal and surrounding areas. Stylized but expressive interpretations of the images were put together with little concern for narrative on bench backs, powder horns, and bowls. The central figure here is the horned Moses. The stylization and Biblical subject matter bring Gudbrandsdal picture weaving to mind, but the sources and specific characteristics are different. In carving, presumably a male art, emphasis is on combat. In weaving, it is on festivity.

39. Powder horn with figurative relief carving. Norw. Tallag Pederson, Setesdal or Lista. 1716. Horn, wood. L. 7⅞″ D. 2½″ Translated inscription: "Olaf Strangeson. Adam man Eve woman. Samson. K. Tidrick and Lavrin Rolland went traveling (unclear). Tallag Pederson. In his own hand. Anno 1716." Norsk Folkemuseum (NF 340–99).

Geometric framing and twisted bands reveal Renaissance connections; but the style is primitively expressionistic. Many signed and dated examples indicate professional production within folk society.

40.

40. Ale bowl with painted carving. Norw. Setesdal. 1799. Painted wood. H. 3⅜″ Diam. 14¼″ Translated inscription: "At Moses' stroke, the rock gave water. Pour ale in me and I can quench your thirst. Anno 1799 TTSB." Other inscriptions refer to Burmann and Holger the Dane. Kunstindustrimuseet i Oslo.

The tendrils with chip-carved leaves (palmette variants) are of Romanesque origin, but the simple clarity of the bowl's form suggests Renaissance influence. The arcade border could be either Renaissance or Romanesque.

41. Ale bowl with short spout (*trøys*) and painted carving. Norw. Telemark. 1789. Painted wood. H. 10⅝″ W. 20⅞″ D. 12½″ Inscription: "1789" "GVDK 1797." Norsk Folkemuseum (NF 1906–299).

The multi-plane flat relief and the architecture and ship decoration on this bowl make it highly unusual, a dramatic example of the artist's ability to defy tradition and make a personal statement.

41.

42.

42. Oval bentwood box and complex locking cover (*tine*) with carved figures. Norw. in Am. Setesdal? 1782. Birch. H. 5″ W. 6¾″ D. 4″ Inscription: "JOD Ano Dominn MDCCL 1782 7C C7." Little Norway.

Like the preceding, this work is without specific artistic context. Two heads with halos, an anchor, and crosses suggest Christian content, but Bible illustrations are not apparent sources. A mystic world is created where figures and symbols run together. Royal Norwegian lions with halberds on the cover establish the Norwegian origin of this immigrant piece.

43. Pad terret for horse harness with carved human figures and royal lions. Norw. in Am. Trøndelag? 19th century. Painted wood. H. 11⅝″ W. 18½″ D. 6½″ Vesterheim, gift of Lorin and Lorraine Warg (74.3.3).

This piece was purchased in Oslo by an American collector about 20 years ago. The type of object and the motifs are common, but the style is unusual. The shape of the arch (also found in Sweden) suggests Trøndelag as a place of origin. Pad terrets, through which the reins of the harness passed, rested on the horse's neck.

43.

Flat Relief Carving

44.

44. Hanging wall cupboard with flat relief carving (*flatskurd*). Norw. Telemark. 1798. Wood. H. 28⅛" W. 27⅛" D. 11 ⅝" Inscription: "STSV 1798 SLD." Norsk Folkemuseum (NF 1896–710).

Among early reflections of the Renaissance in Norwegian folk art were cornices, moldings, and simulated or real paneling on furniture. In Telemark these were often accompanied by stylized meandering tendrils in two-plane low relief which also had Renaissance prototypes.

45. Log table with flat relief carving. Norw.-Am. John Barikmo (1872–1965), Iola, WI. Signed and dated 1938. Maple, conifer. H. 30″ Diam. 28″ Vesterheim, gift of Ida and Hannah Swensrud (83.57.2).

Depending on the mass of the material for structure is Medieval, but the decoration here is of the Renaissance flat relief type found in Telemark (44), from where Barikmo emigrated. Differences are the stained surface and a modern Aesthetic Movement stylization.

45.

Folk Art of Norway *(Continued from page 47)*

THE BAROQUE REVOLUTION IN WOOD
Acanthus Carving

The simple meandering tendrils of flat carving heralded the stylistic revolution in Norwegian folk art which came with the Baroque acanthus. This was nothing but a bolder and more dramatic version of a motif that had been known in Norway since Christian art began appearing around 1000 A.D., but it did not significantly spark the creative imagination of the folk artists until it took its Baroque form. This was more full bodied, with greater variation in its spiraling and interlacing elements. Flowers of a rosette or tulip type now also gained more prominence in it.

Since revolutions are not characteristic of folk art, which is by definition conservative and tradition-bound, consideration must be given to how and why one was brought about by the Baroque acanthus in Norwegian folk art during the 18th century. The geometric up to this time had been gaining ground in native Norwegian arts. The dynamically interlaced serpentine and plant motifs on the portals of the stave churches, for example, had become highly schematicized and generally symmetrical arrangements of bands and fragmented palmettes on the portals of storehouses in Setesdal and Telemark. Chip carving, with its systematic intersecting of circles and straight lines, and the geometric burnt decoration that followed in its wake had become the major ornamentation on small objects of wood. Figures had given way in tapestry-woven coverlets to abstract patterns with a small square as the module, and most embroidery was of the thread-count variety based on the horizontal and vertical grid of warps and wefts in the ground fabric.

To what extent the Baroque acanthus released a latent affinity for the complex and dynamic curvilinearity that had dominated Norwegian art from the Migration period in the 5th century A.D. through the Middle Ages is difficult to determine. It had not completely disappeared from the visual environment although it had lost its creative energy. It was present to various degrees in the approximately 100 stave churches still scattered throughout the country in the 18th century. More of it may also have existed on farms than is now apparent. We recall that the folk material brought from Norwegian farms to the Nordic Museum in Stockholm during the late decades of the 19th century included a pad terret from Gudbrandsdalen with gripping beasts of early Viking type and also a log chair from Telemark with related decoration, both dramatic examples of the organic in Norway's early art tradition.

In spite of these pieces that were purchased and preserved in the late decades of the 19th century, it would appear that material reflecting great antiquity was not necessarily of highest priority to collectors of the time. The Swedish scholar Sune Ambrosiani discovered fairly recently a box with exceptional medieval characteristics in an assemblage of uncatalogued material retained for possible exchange in the Nordic Museum. It proved to have been sent with other things to the director Artur Hazelius (1833–1901) from his "picker" in Telemark in the late 19th century. This person had not even put it on his list, an indication that it might simply have been used for packing (Svensson). When one considers this, together with the fact that approximately sixty stave churches were razed during the 19th century, it appears that the time was one of ridding the environment of Medieval vestiges in preparation for the new era that almost everyone must have seen on the horizon. The group that showed protective interest in Norway's ancient past during much of the 19th century must have been exceedingly small. The extent of Medieval presence in 18th century Norway is now impossible to perceive.

If the lingering of a Nordic Medieval aesthetic contributed to the immediate and enthusiastic reception of the Baroque acanthus in rural eastern Norway and the miraculously rapid technical and stylistic mastery of it, what happened here in the 18th century should be called a renaissance, as Anker has suggested the slightly earlier upsurge in more specifically Nordic material might be, rather than a revolution. That, however, would be confusing because the term Renaissance must also be used for the reflections in the north of the southern style bearing that name. It would also suggest a closer relationship between what happened in the centuries surrounding 1800 and the local past than can actually be documented.

There are historical reasons less speculative than the one mentioned for the sudden impact of the Baroque acanthus in Norway's inland valleys. It was introduced just when the interiors of the rural houses in these areas were being made receptive to adornment through the introduction of the chimney that removed soot, of paneling that gave ready-framed surfaces for decoration, and of windows that gave light.

The Baroque style was also ideal for the general social

Fig. 6. Lesja altar. Jakob Klukstad (1714?–1773). Lesja, Gudbrandsdalen. 1749. Photo: Teigen, Oslo.

and economic climate of the time. The economy in rural Norway had shown marked improvement during the 18th century because of a rapidly growing lumber industry in the east and fishing industry in the west. By the latter part of the century a national awareness was also developing that would lead in 1814 to Norway getting its own constitution and an alliance with Sweden that was less restrictive than the one it previously had with Denmark. The peasant in this new wave of nationalism was looked on as the bearer of true Norwegian culture as opposed to the old official class with its Danish and international connections. He became increasingly cognizant of his new economic and cultural position, making prestige a strong element in Norwegian folk art after the mid-18th century.

Contradictory as it may seem, although not without precedent, the peasant drew the symbols of his new status precisely from the urban international culture of the people who had been his social, economic, and political oppressors. Chip carving, burnt decoration, and serpentine bands with fragmented palmettes belonged to the rural art establishment. They were associated with the darkness that came in the wake of the Black Death. The Baroque acanthus came clearly from outside and had its associations with the Church and the homes of the wealthy through which it entered peasant culture. The Baroque was also by its very nature symbolic of new life and strength, having arisen in the Counter-Reformation atmosphere of Rome and been picked up by Louis XIV of France in establishing his absolute monarchy. It came ready-made to satisfy the desires for power and prestige that were awakening in the Norwegian people.

The acanthus in its Baroque manifestation had appeared in Bergen in the late 17th century but did not make an impact on the still economically deprived rural population of the west coast. It was first after 1699, when the Baroque acanthus was used by an immigrant artist known only as "The Hollander" for the altar and pulpit of Our Saviour's church in present-day Oslo, that it began its sweep through the eastern Norwegian countryside. The disseminators were urban professional craftsmen, such as Thomas Blix, who brought it to churches west of Oslo in the second and third decades of the 18th century, and Lars Borg (46), who as early as 1703 took it north to Gudbrandsdalen. It was there picked up by local carvers and within two generations took on an exuberance and technical perfection which surpassed that of much professional urban work. A key figure in this was Jakob Bersveinsson Klukstad (1714?–1773) whose masterpiece is his first major work, the altar of 1749 in the Lesja church (Fig. 6) (See also 50).

While Klukstad and his guild-trained predecessors in

Fig. 7. Trunk. Ola O. Bjella (1821–1863). Ål, Hallingdal. Now in Iowa. 1859. Photo: Courtesy Clarence Breen. Photographer: Darrell Henning.

the Oslo area worked largely in churches, Lars Pinnerud (1700–1767), who may have contributed to Klukstad's knowledge of the acanthus, and Jens Strammerud (1674–1737), both from Hedemark between Oslo and Gudbrandsdalen, were decorating such secular objects as trunks already in the 1730s (48).

The major figures in bringing acanthus carving from the church into the home were Sylfest Nilssen Skrinde (1731–?) (49) and Ola Rasmussen Teigeroen (1744–1802), called Skjåk-Ola after the area in Gudbrandsdal where he lived. Regency and Rococo elements entered their acanthus, as they did that of other folk carvers whose work grew out of the Baroque, giving it greater playfulness and individuality than is usually associated with this style. The free Norwegian folk acanthus found its way to cupboards (49), chairs (52), clocks, mangle boards (56), porridge containers (58), beer bowls (89), and most other objects of the household (60) as well as to sleds, hames, pad terrets, and other equipment associated with the farmstead.

Although Gudbrandsdalen remained the unchallenged center of acanthus carving, the art was also developed in Trøndelag, where it acquired an exceptionally distinctive

style; in Valdres, where it appears as bands on the exterior of beer bowls (152); and in Telemark, where it is found largely on architectural posts and as framing elements on objects decorated with floral painting (177, 179). By the mid 19th century folk acanthus carving acquired the status of a national style and was produced everywhere, even in cities, where it was the first folk craft sold in considerable quantities to tourists and collectors of *objets d'art*. (Sveen in I.L. Christie, *Med egin hand*)

Acanthus carving related closely to figure carving. The ability to produce fully modeled masses with subtle curves, which was fundamental to carving Baroque acanthus, was also important for figure carving. The creators of the early acanthus altars in Norway carved not only the frame but also the Biblical scenes and figures appropriate to an altar of the time (Fig. 6). These were generally drawn from the Passion, with either the Crucifixion or the Last Supper given the central position. The ascending Christ often appeared in three dimensions at the top.

Figure Carving of the Acanthus Period and Later

Although the folk carvers rapidly mastered the decorative elements in the acanthus, they had difficulty giving their figures the appearance of professional work. This was clearly not a problem of technique but of understanding the subject. In this they were reflecting a characteristic that goes far back in native Scandinavian art. When representations of figures in the Classic style reached Scandinavia on coins and medallions during late Roman times in the 4th century, they were over the next two centuries reduced to almost totally abstract patterns on the locally made gold pendants called "bracteates." The Vikings and their immediate descendants down to the 12th century almost completely ignored the European figurative art to which they were exposed on their raids and explorations. They did, on the other hand, develop extremely complex and aesthetically sophisticated *decorative* styles incorporating elements from outside sources. These included the image of the lion, but it was distorted almost beyond recognition in being brought into conformity with artistic tradition (Fig. 1). These early examples of the decorative taking precedence over the figurative in Norwegian art parallel what has already been seen in the folk adaptation of Renaissance tapestry art. The figures over a period of several generations gave way to purely decorative patterns.

It would be easy to assume that what happened to the figure in Norway is simply in the nature of folk or primitive art. The decorative, as mentioned in connection with weaving, can be built on repeated elements and does not therefore involve the technical or intellectual demands of figurative art. The type of decoration one has in the old Nordic animal interlace or in the Baroque acanthus, however, does not have these advantages. It appears therefore that the matter is one of tradition and group aesthetics apart from ease or convenience. An indication of this is the prominence of competently executed though quaint figures in the folk paintings on paper or linen in neighboring Sweden. Complex and technically demanding pure decoration, such as the acanthus in Norwegian carving and painting, on the other hand, never gained prominence there.

The comparative ineptness of the acanthus carvers when they attempt figures gives this category of their work a charm that can have more personal appeal than their highly accomplished decorative work. The figures often have a doll-like character, with heads that are large in relation to the body and features that are large in relation to the heads. Those in Klukstad's Lesja altar are typical in this respect, but they also have exaggerated gestures and agitated drapery that give them special expressiveness (Fig. 6). Their movement often reflects that in the acanthus around them, bringing remarkable unity even to a work of this size and complexity.

Giving figures the agitated quality of acanthus carving also characterizes the work of Kristen Erlandsen Listad (1726–1802), a Gudbrandsdal carver better known for his figures than for his decoration (56, 74). Rather than being chubby like Klukstad's, Listad's figures are attenuated and of jagged contour. This is true of his horses as well as his people. When he gives them acanthus tails, one is not aware of any contradiction.

The acanthus carver whose figures are the most primitive of all is also the one now most highly regarded for them, Iver Gunderson Øvstrud (1711–1775) of Numedal, just north of Telemark in south-central Norway (73). Unlike Klukstad and Listad, who make their figures conform to the style of their acanthus, Øvstrud allows them to have their own expressive character apart from aesthetic concerns. He was a contemporary of Klukstad, but his exposure to acanthus and figure carving would have been different.

While Klukstad's relief is high to the point of the figures being almost three-dimensional (Fig. 6), Øvstrud's is low, giving them an almost calligraphic character. They are shown frontally, from the side, or in a combination of both views. Heads and features are large and limbs are flattened against the grounds to make gestures unmistakable. Although the realism of the Bible illustrations on which most of his figurative scenes are modeled is lost, the narrative and human content of those illustrations is actually in-

tensified in his translation. Fluid and elegant acanthus borders become soft background music to Øvstrud's powerful figurative presentations. In Klukstad the opposite is true, the acanthus serving as a great fanfare that draws attention to an intimate drama.

Although Øvstrud's figures are primitive, they are not without style. He had developed his approach, which he utilized with complete assurance. Ole Sletten of Ål in Hallingdal is more genuinely naive, probably having produced little figurative work, and is therefore also more directly expressive. Even the concept in his best known work, the cupboard with carved reliefs at the Norwegian Folk Museum (72), is childlike: miscellaneously placed animals, drawn in part from a popular 16th century pictorial reader, counterbalance a monumental Whore of Babylon riding the beast with seven heads and ten horns. The bold asymmetry and expressive exaggeration in the figurative panels stands in high contrast to the symmetrical and rhythmic decorative crown of the piece with its two heraldic lions.

Many of the small three-dimensional Norwegian wood carvings done during the late 18th and the 19th centuries, such as wedding processions, other genre scenes, individual animals (of which horses and lions are the most common), and the like, reveal connections with acanthus carving. The manes on the well-known candlestick lions from Setesdal (86), for example, are acanthus scrolls. The bodies of these lions, as of early carved horses, flow with the rhythms of the acanthus (74, 77, 81).

The full-bodied character of figures in what I am considering the acanthus approach to figure carving gave way sometime in the early 20th century to a more literally chiselled character in what has come to be called "flat-plane" carving (82). In it the rough cuts of the knife are left on the surface as part of the carving's expressive vocabulary. The style has been associated with Cubism because it breaks up rounded surfaces into facets, but it might more appropriately be related to Impressionism. The facets are not the result of viewing the object from several angles to analyze its formal structure as in early Cubism. They are rather analogous to the broad brush strokes of Impressionist painting that represent only the patches of light to which objects are reduced when given a quick glance. The aim of the flat-plane carver is to create the illusion of a figure with very specific characteristics by making a minimum of small flat cuts. The all-time master of the approach was the Swede Axel Petersson, known as *"Döderhultarn,"* (1868–1925), who from folk beginnings was elevated to the status of fine artist. Contemporaneous with him were Norwegian carvers working in the same style (82). Since World War II it has become the basis of a Norwegian industry in woodcarved souvenirs. The major practitioners of it as a creative art at present appear to be among Norwegian Americans (83–85).

Paint and the flowering of Norwegian folk art
The North Central Valleys and Eastern Lowlands

Woodcarving as a technique had a long tradition in Norwegian folk culture when the Baroque acanthus brought about a revolution in it. Painting had essentially none and therefore developed in the wake of carving. Thomas Blix (1676–1729), a mysterious character whose status was somewhere between a folk and an urban professional artist, disseminated the Baroque acanthus in painting as well as in carving from Oslo west as far as Telemark in the second decade of the 18th century. During 1713–1714, while painting acanthus scrolls in the church at Kviteseid, he decorated bowls left on local farms with painted acanthus tendrils and sometimes portraits of distinguished personages. Imported bowls of somewhat similar character had been finding their way into rural areas at the time, but those by Blix appear to be among the first painted on location. Blix also applied bright colored paints to his acanthus carving, which is far more flamboyant and interesting than his painting. Gold leaf was the more common early finish for acanthus carving, at least when used in the church (Fig. 6).

The first distinctive local styles of painting in Gudbrandsdalen too were developed by, or at least in close association with, carvers. Some scholars consider Jakob Klukstad, carver of the Lesja altarpiece, also the founder of the Lesja style of painting. There is general agreement that it came into being in the circle of artists dominated by him and his sons. In one strain of Lesja painting even the three-dimensionality of the carved acanthus leaves is simulated through shading (146). More common are flat S and C-tendrils terminating in stylized tulips and rosettes. While shades of blue dominated in the former style, deep greens as well as blues with accents of bright red are found in the latter. This type continued in north Gudbrandsdalen far into the 19th century and also moved northwest into the area of Møre and Romsdal.

In the southern part of Gudbrandsdalen a generation after Klukstad, the carver Peder Kastrup (1732–1799) and his sons established a Rococo tradition in painting closely related to urban work. They were also the folk artists most successful in bringing a Rococo element into acanthus carving without completely abandoning its Baroque base.

In spite of the role played by Blix, Klukstad, and Kastrup in early rosemaling, this art did not grow as much out

of carving as out of a parallel tradition in professional Renaissance and Baroque acanthus painting that was more widespread than carving in the decoration of both churches and upper-class homes. Many anonymous folk artists in almost all parts of the country attempted to imitate it as early as the first half of the 18th century, but neither a folk movement in painting nor the development of regional styles got underway until the latter part of the century, when Rococo had become a strong element in mainstream decorative arts.

An early bridge in the transfer of urban decorative painting to the country was Peder Aadnes (1739–1792) of east-central Norway (148), who had worked with the country's first major Rococo fine artist Eggert Munch (1685?–1764) and had also studied art for a short time in Oslo. He was, however, of rural origin and traveled widely in eastern Norway as a painter for all classes of society after about 1760. His blue Rococo landscapes painted wet on wet with delicate trees, stumps, and quaint buildings, together with his clusters of brightly colored realistic flowers, left their mark on folk painting throughout eastern Norway from the Oslo area in the south and up the valleys north to lower Gudbrandsdalen. His greatest impact was made in Valdres (151–152) to the west where his painting in the Bagn church became a major point of departure for the highly gifted and prolific local painter Ola Hermundson Berge (1768–1825).

Hallingdal Rosemaling and Related Styles

The two areas in Norway that developed the most distinctive and influential styles of rosemaling were Telemark and Hallingdal in the south-central part of the country. The high period for both was the century from 1775 to 1875. One cannot be said to precede the other, but since Hallingdal produced the earliest rosemaler known by name, Truge Gunhildgard (1699?–1760?) from Ål, we will begin there.

It was indeed Ål that became the center of a distinctive development in Hallingdal rosemaling, but Gunhildgard did not contribute significantly to it. The key figures were Herbrand Sata (1753–1830) and his two sons Nils (1785–1873) and Embrik (1788–1876), both of whom took the name Bæra from farms on which they settled (155–157). Herbrand came early under the influence of Rococo and made much initially of its asymmetry and the flame-like tongues that on Germanic ground had developed from the French *rocaille*. His obviously Rococo-based style soon gave way to one that in general character was nearer the earlier Baroque. It was from this that the motif which dominates Hallingdal painting developed in his hands and those of his followers (Fig. 7). The center became a heavy flower, generally viewed from the side, with petals that often resembled acanthus leaves. Such flowers could build, one on the other. They also sprouted fine branches with additional flowers viewed from both the side and the top (157). Between these main elements were often delicate black stems ending in jagged leaves. Below the central flowers might be the suggestion of a vase, basket, or roots. All that remained of the Rococo were the flame-like tongues that now had become one with acanthus leaves, petals, or other elements in the design.

The above symmetrical motif was occasionally put on its side, so to speak, to fill the center of a round bowl (160). Since this created a rather strange though dynamic asymmetry, an alternative to bowl decoration was presenting the central flower *en face* with the other elements projecting out from it or forming a border around it (156,162). Flowers viewed from above could also be made the center of a design placed on an upright surface as seen on a tankard by Herbjørn Sata from 1804 (155). A characteristic of many Hallingdal flowers is that the petals twist in a spiraling fashion (14,159). When this is carried to an extreme, they come close to the swirl found in chip carving (24) without there necessarily having been a connection.

Except for wall and ceiling decoration, where scrolling tendrils, occasionally incorporating figures, might still be found (Fig. 8), Hallingdal painting was dominated by the motifs just described. The Bæra brothers were the most versatile in their use (156–157), but other painters developed their own versions of them. Major among these in Ål were Ola Feten (1808–1884)(72,159) and Ola O. Bjella (1821–1863)(Fig. 7). A less influential contemporary of Feten, Sevat Bjørnson Uppheim (1809–1889), developed the most individual interpretations of all (14). For him the flowers of spiraling character become a hallmark. These, together with agitated foliage, give Uppheim's painting an expressionistic quality not adequately evident in the illustrated example. This can also be found in the work of Embrik Bæra (157) and to a lesser degree in that of other Hallingdal artists. The predominance of red as a ground color and of strong yellows and blues in the decoration gives Hallingdal painting in general greater emotional intensity than is found in most rosemaling.

Hol, a community neighboring Ål on the west, was the second center of Hallingdal painting and had its own counterpart to Herbrand Sata in the even earlier Ketil Rygg (1728–1809). Its later significant painters, such as Torstein Sand (1808–1887)(162) and Syver H. Grøt (1816–1885)(160), developed under strong influence from the Bæra brothers and bring Hol essentially into the stylis-

Fig. 8. Medhus house. Herbrand Sata (1753–1830). Ål, Hallingdal. 1794. Photo: Teigen, Oslo.

tic sphere of Ål. A door with a depiction of Samson and the lion by Torstein Sand (166) reveals his ability to transfer the vitality of his decorative painting to figures, a talent that he shared with the Bæra brothers.

Hallingdal was one of the areas from which the organic strain in Norwegian art, which had gradually been gaining ground in eastern Norway since the acanthus revolution in woodcarving, found its way back to the west coast where it had essentially died in native work with the decline of stave church portal carving in the 13th century. Sogn, where this carving appears to have had its first great flowering and where a great number of examples survive, was precisely the area where the immigrant rosemalers from Hallingdal found the most fertile ground for their floral decoration. This may be purely coincidental, because the soil was not fertile enough for a strong local tradition to strike root. The rosemaling of Sogn is primarily an immigrant art produced by painters from Hallingdal (14), Valdres, and ultimately Telemark, or by local painters who remained rather directly under their influence.

The situation was different in Rogaland far to the south of Sogn, another area on the west coast where painters from Hallingdal made a formative impact. Lars Aslakson Trageton (1770–1839) of Hol began spending long periods in Ryfylke, a district in Rogaland, about 1800. Ten years later he made it his home. He adjusted his style to local tastes and, together with other Halling painters, founded a distinctive tradition grafted on local roots that was carried on by painters of the area. It is more delicate and linear than painting in Hallingdal, not only because Renaissance elements had remained strong in the art of the area but because Trageton left Hallingdal before the more Baroque character of its style was fully developed. Much of the

Folk Art of Norway

painting by local artists remained primitive but reveals taste and charm (192).

Telemark Rosemaling and Related Styles

A parallel figure in Telemark to Herbrand Sata in Hallingdal was his slightly younger contemporary Ola Hansson (1760–1843) from Hovin in the eastern part of the district. He was an even more spontaneous and all-encompassing artist than Sata but perhaps therefore also more apart from the chronological development of rosemaling in his area. Being in a locality where urban painters from Oslo had been active and not far from the mining town of Kongsberg, where a major Rococo church was being built and decorated in the mid 18th century, he was exposed early to all the post-Renaissance styles and quickly developed a creative understanding of them (173–174). When only twenty-two, he decorated the walls and ceilings of Ryjestova, a farmhouse in Heddal, with bold scrolls, flowers, and figures that reflect Baroque, Regency, and Rococo sources. In his hands, however, they acquire a unity of their own and become part of a well-conceived total decorative scheme. Whatever the style or nature of the motif, Hansson's work bears the mark of health and vitality.

Like Sata, Hansson after a period of vacillation around 1800 moved away from the looseness of Rococo (174) toward the tighter and more contiguous forms of the Baroque (173). Unlike Sata, however, he did not have significant immediate followers. One who shares his love of the unbroken tendril and of quaint figures is his contemporary Sondre Busterud (1763–1842), but what in Hansson was healthy vigor in Busterud becomes nervous energy (172). Every inch of his surfaces is invigorated with twisting lines or detail, leaving nothing at rest. His expressive imagination in the treatment of figures goes beyond that of any other Norwegian folk painter.

The nervous energy and exceptional originality found in Busterud is characteristic of a small group of Telemark painters, several of whom have connections with Busterud's native area of Kviteseid and Brinkeberg. One is a painter of unknown name and specific location in Telemark, apparently a generation earlier than Busterud, who has as an identifying characteristic the use of ships in his designs (171 center motif). The other two are major representatives of the high period in rosemaling during the second quarter of the 19th century, Knut Mevasstaul (1785–1862)(Fig. 9) and Bjørn Bjaalid (1791–1859). While working basically with the motifs and within the styles of their time, they gave them a slightly distorted and agitated character that creates an air of uneasiness. The group reveals, as do several painters in Hallingdal, that rosemaling is not only the routine type of decoration expected in folk art but a channel for individual expression.

The motif that was to become the hallmark of Telemark painting in all parts of the district had its major development farther west in the district around 1800. It is referred to as the Telemark rose (177) and has as its major element a C-shaped stem, often with different colors on each side that are blended along the middle. Leaves of an acanthus type curl out from it, and fine stems with flowers or more leaves spring out from between them. At the base are usually shell or *rocaille* forms that can be interpreted as roots. These elements are combined with fine linework that does primarily three things: 1) defines the contours of the main design (sometimes with a double line to give vitality); 2) embellishes the major elements with designs that generally parallel their contours; and 3) fills the areas between these elements with fine secondary details, usually stems, leaves, flowers, or spirals. The painters most responsible for giving it its form and early prominence were Olav Torjusson (1754–1828) and Aslak Nestestog (1758–1830). The son of the latter came to America where he continued some woodcarving (63) but apparently no painting.

There are purists who do not recognize painting that lacks the Telemark rose as rosemaling. This has an historic

Fig. 9. Trunk. Knut Mevasstaul (1785–1862). Telemark. Now Minnesota. 1835. Photo: Courtesy Roger and Shirley Johnson. Photographer: Marion Nelson.

explanation. Telemark rosemaling, like Gudbrandsdal acanthus carving (50) and the festive dress of Hardanger (119), acquired the status of national symbols in turn-of-the-century national Romanticism. This meant that other carving (with the exception of the Medieval), other decorative painting, or the festive dress of other regions came to be looked on as not properly Norwegian.

The position given Telemark rosemaling was not totally unjustified. The high degree of development in it will soon be seen. The style itself, based on a motif as flexible as the C-curve, was easily adapted to filling spaces of any shape. It inherited those characteristics of Rococo that account for this style's ongoing significance in upper-class decoration. The proliferation of rosemalers in Telemark and their search for new markets also brought the style to almost all parts of Norway, a subject discussed elsewhere by Nils Ellingsgard. Telemark painting was also the best suited to being a symbol because its C-scroll gave it clear identity. The central motif of Hallingdal painting, for example, was not quite as consistently used or as easily recognizable.

Once the major elements of the Telemark style were established around 1800, rosemaling of a comparatively unified character began appearing throughout the district. The major scholar of it, Øystein Vesaas, was able to identify about 130 painters by name who were active in the region during the high period of the art. There were in addition many painters known only from the style of their work. The geographic distribution within the district was also broader than elsewhere, including Hallingdal. There Ål was the undisputed center and Sata the father, literally as well as figuratively since his sons dominated the art through the next generation. In Telemark, rosemaling arose in several areas and merged into a regional style. Even the Telemark rose is thought to have been arrived at in several places independent of the one in west Telemark mentioned earlier. Ola Hansson (173-174), to be sure, has a special place in the early period but more because of his exceptional talent and versatility than his formative significance.

Among the earliest of what might be called the second generation of Telemark painters is Nikuls Buine (1789–1852), who used the Telemark rose as an isolated element in fanciful compositions rather than as a central unifying motif (175). To link the scattered elements he introduced flowers and leaves of original design in apparently chaotic and yet essentially rhythmic ways. His career was broken off by emigration in 1852 and death from cholera in America the same year.

Of Telemark painters from whom a fair body of work is known, Hans Glittenberg (1788–1873) (176–177) and Thomas Luraas (1799–1886)(12, 179–180) are the classic examples. The compositions of both are built on strong and simple C-scrolls with fine line work enlivening both the main elements and the areas between them. If one dares use gender terminology, it is tempting to consider Luraas the representative of the masculine and Glittenberg the feminine in Telemark rosemaling. Luraas's colors are strong and clear, in his early work seldom going beyond the primaries, red, blue, and yellow. These are articulated with black and white detailing. Those of Glittenberg can also be limited but are more subdued and with a greater amount of blending and mixing. Even pinks appear counterbalanced by soft blues. The forms in Luraas are bold and simple, initially with rather little detail. Those in Glittenberg are finer and include delicate embellishment. Luraas's floral painting is quite abstract, while at least the roses of Glittenberg appear almost real. The differences are not in quality or in the fundamentals of design but in personal style.

The Luraas family was something of a dynasty in Telemark rosemaling but without the dominant position of the Sata family in Hallingdal. Two of Thomas's brothers, Knut and Øystein, were painters, and all three got their introduction to the art from an uncle, Knut Luraas-Rui. Thomas's son Olav (1840–1920) acquired much of his father's facility but belonged to a generation which tended to overload the painted surfaces and to somewhat indiscriminately add new colors (184). He tried to carry further an art that his father and uncles had already brought to its limits and so ended up contributing to its demise. The work, however, has appeal like the eye-dazzler rugs of the Navaho.

The development of decorative painting in Numedal, Sigdal, and Eggedal immediately to the north of Telemark was so close to that of its neighbor that it is difficult completely to distinguish between what is indigenous and what was under Telemark influence (185–186). The C-curve dominated but the symmetrical Hallingdal flower also found its way here. Both were given a crispness, lightness, and almost whimsical quality that must be considered a part of local tradition. The early painting of the Kravik family in Numedal is more directly under Rococo influence from the city of Kongsberg and can include flaming red *rocaille* against a black ground. The designation "Oriental" has been used for much painting in the area, and it often fits.

Telemark elements even penetrated areas farther north, such as Valdres and Hallingdal, where distinctive local traditions were established early. An interesting example is a bentwood basket with a running design around the body

that is completely Telemark in character (187 cf. 176) but is painted in colors and in a manner that reveals Hallingdal production.

Aust-Agder, which borders Telemark on the west, has a relationship to it not unlike the areas to the north. Here too the difference might loosely be referred to as Orientalizing. Much of the Telemark vocabulary was abstracted and loaded with crisply executed detail. Filling dark grounds with leaves, flowers of all types, *rocaille,* etc., in orange-red, some greens, and with yellow and white outlining and detailing characterizes much of the painting in the area. The work of Jørund Tallaksen Tjørehom is typical of how Telemark motifs were translated into an Aust-Agder dialect (188).

Rosemaling in West Norway

Having received early impulses from Dutch Renaissance and Baroque decoration, painting in Vest-Agder relates more to that of its neighbors along the west coast than to Telemark. Symmetry dominates and it tends toward the light and delicate. Characteristic small objects of the area are turned ale bowls with bridal processions around the interior (190) and oblong bentwood boxes with slip-on covers and delicately executed symmetrical designs (191), probably modeled on the so-called bride's boxes of Holland and Germany.

The impact of the painters from Telemark on Hordaland farther north and up the coast to the city of Bergen was greater than in neighboring Vest-Agder because no strong tradition in painting existed there before the impulses from Telemark came during the first decades of the 19th century. The most distinctive earlier style was a simple one in Hardanger with quaint figures and flowers of Baroque origin painted in broad strokes of white, blue, black, and yellow on a red ground (11). Quaint figures were prominent at least on the small boxes in the style. They are said to have been produced for sale by Per A. Århus (1758–?) and others to supplement income from the farm.

Remaining in one location and painting objects for sale rather than moving, like the eastern painters, from job to job and accepting food and shelter as partial payment continued to be the practice of artists on the west coast. A more advanced money economy due to the fishing industry there and the lack of a tradition in decorated interiors because of the late introduction of the chimney undoubtedly contributed to the difference in practice.

The Telemark influence was especially strong on a group of painters in Hardanger who, in the tradition of Århus, produced trunks for sale. A key figure was Trond Larson Hus (1806–1878), the father of the woodcarver Lars Kinsarvik (4). He is thought to have learned painting from Bjørn Bjaalid when this Telemark artist was working in Hardanger, but it is the virtuoso style of Thomas Luraas (12), who came here often, that left the strongest mark on the so-called "sale trunks."

Two areas on the west coast are best known for carrying rosemaling into the era of mass production, Os in Hordaland and Viksdalen in Sunnfjord farther up the coast. The activity at Os is closely associated with the family of the painter Johannes Tveiterås, Sr. (1763–1842) of Samnander, whose two sons were also painters. Nils settled in Os just south of Bergen in 1820. Here he took the name Midthus after the farm that he acquired through marriage. He continued to paint and to develop his own style, which often included the Telemark rose but also had flowers that resembled ornate rosettes (197–198, 200). The leaves were patches of green, sometimes shading to yellow on one side, with a black vein down the center from which lesser veins projected outward. The ground color was generally white or bright red, which, together with the highly decorative character of the designs, created a festive and lively effect. Buildings, flowering trees, or pots of flowers often appeared together with the C–scroll.

Nils Midthus had two pupils, Lien Midtbø (1831–1925) and his own son Annanias (1847–1924), who later took the name Tveit. Annanias developed the style to the fullest but did not let it become routine in spite of the fact that his production moved more and more toward the commercial (202). For a period around 1890 he hired out to a merchant in Bergen and painted small items for sale. A little later he set up a sales shop at home in Os and took in students who assisted in production. When the *Vestlandske Husflidslag* (The West Coast Arts and Crafts Society) was founded in 1896, Annanias Tveit and his studio became major suppliers to its sales shop.

While decadence had fallen on east coast painting a generation earlier, the Os school remained fresh and creative within the restraints of a distinct style. Being of late origin and located in an area where an early money economy had led to modern merchandising being taken for granted, the Os painters could make the transition from painting for their own group to painting for a general market without losing either their restraint or their freshness and vitality. The older folk art traditions in the east that had developed both culturally and economically as an integral part of their immediate communities had greater difficulty weathering the transition.

The making of small painted objects for sale at Viksdalen in Sunnfjorden, according to the mid-19th-century reporter on social conditions Eilert Sundt (1817–1875), was begun by G. Kjellstad near the beginning of the century. By the time of Sundt's visit around 1860, this had come to involve the entire community. Close to 5,000 items of various traditional types were now being produced and decorated there annually. These were sold largely in Bergen through a well organized marketing system.

Viksdal rosemaling, if it can be called that, was schematic, consisting largely of yellow, blue, black, and white S and C-scrolls with partial palmettes in the open spaces (196). The grounds were almost always deep orange, a color produced with red lead. Its simple and quite abstract character was not necessarily a compromise made for ease of production. The early local tradition in design as known through chip-carved and burnt decoration, weaving, and embroidery was also schematic and abstract. The Viksdal painting reduced the plant motifs of traditional rosemaling to their basic formal elements, bringing them as near as possible to geometric decoration without abandoning that organic quality which made them suited to free application with a brush. The artists appear to have painted without patterns. They revealed infinite imagination in the way they filled the various spaces presented them by the great variety of boxes and bowls produced.

From folk art to commodity

What happened at Os and Viksdalen was not a break with but a further development of practices that had long existed in Norwegian folk art. The material that has been dealt with in this essay was for the most part produced by specialists for people outside their own households. One would expect textiles to be an exception because spinning and weaving were basic skills for women, but square woven coverlets (101–102, 104–105) are known to have been produced for sale in rural Hardanger already in the 18th century (Kloster), and the complex picture weaving of Gudbrandsdalen (32–34, 36) from slightly earlier could scarcely have been every woman's art. The work at Viksdalen and the trunk production of Hus showed the least break with earlier tradition because the customers represented the same socioeconomic group as the producers. The difference was in the extended geographic area reached by the product through wider marketing. The direct personal connection between the producer and the user, of course, was lost.

Os presented a greater departure because its consumers came increasingly from outside. Tourists and city-dwellers were major constituents of the new clientele. The development at Os, together with even earlier ventures in producing traditional wood carving for sale in Oslo and Trondheim, heralded a fundamental shift in the role played by the folk arts in Norway (Sveen. In I. L. Christie, *Med egin hand*). They became increasingly segregated from the lives of the people in the society that produced them and became looked on as art for its own sake or symbols of what that society represented, that is, souvenirs or mementoes. The significance of what happened at Os is that the artists recognized the passing of the old culture, and rather than letting its art die as well, they adjusted it to fill needs in the new. This accounts for its ongoing vitality.

The shift in meaning of folk art that came with its new customers had, like the methods of its production and distribution, also been prepared for while it was still a part of the old culture. It may always have had some symbolic connotations, but while these were originally of things within the culture, it had come increasingly to be of things outside, primarily of the good life lived by the upper classes. Their milieu was known through occasional glimpses into their homes or from what was seen in the decoration of the churches for which the minister, a representative of those classes, was responsible. The finest folk art was generally not in the everyday living area of the house but in the party room on the second floor made possible by the introduction of the chimney or in a comparable room built as an extension on the end of the house near the entry. This room was reserved for festive occasions with guests when the art work together with the ritualistic ale could, if only for awhile, transport the farmer and his neighborhood friends into that good life of the upper classes known only through viewing from the outside.

But the experience in this special room need not have been only one of association with a better life. Based on the aesthetic traditions of mainstream culture as well as on a long-developed local sense for beauty, the forms and colors themselves in these rooms made an impact. The increasing intricacies and refinement in Norwegian folk art indicate that a search for beauty apart from the symbolic had long been a major motivation in its development.

When objects in the Norwegian folk tradition began being purchased and even produced by people outside its own culture, it was ready for an expanded public. Being adequately near mainstream art to have direct aesthetic appeal to anyone within western culture, it was also distinctive enough to have for Norwegians associations with a passing local culture toward which they now felt romantic longing and with which they were now proud to link themselves. The symbolic element was still present, and

prestige and escape were still a part of it, but the roles of the consumer and the life of which the work was symbolic had been reversed.

Who made folk art and how did that relate to its future?

Most rural men in Norway possessed the woodworking skills necessary for making implements and household objects. These would generally have included the complicated bentwood and stave construction techniques. The production of many implements also involved considerable skill in carving apart from any decoration on them. But decorative carving skills too must have been quite widespread because the mangleboards (21, 56), which were common betrothal gifts, appear to be the product of many hands. Most women must have known the fabric arts necessary for producing clothing and basic household textiles. The latter, to be sure, also involved knowledge of traditional designs and complicated techniques. Embroidery also required special skills and some creativity although much in the west and south was geometric and highly tradition-bound. Little is known about who did the extensive amount of burnt decoration, but it also appears to have had a broad base in the rural population and could have been done by women as well as men. Almost every member of Norwegian rural society must have had a fair range of rather high skills in the crafts, but most of the folk art presented here was the work of specialists.

Extensive studies of acanthus carvers and rosemalers indicate that at least the founders of the local traditions were often in contact with urban artists. The distinction between the folk and the urban artist was not always even clear, primarily during the late 18th century. Artists primarily associated with the urban tradition, like the painter Peder Aadnes, often worked in rural areas for wealthy farmers; while artists of completely rural origin and little known urban training, like Jakob Klukstad, were given official commissions in churches, commissions for which the urban bishops were ultimately responsible. Craftsmen's guilds were being established in Norway from the late 16th century, and laws attempting to restrict the practice of specialized crafts outside the areas where guilds determined policy were introduced in the 17th century. These were never effectively enforced in Norway, however, and by the latter half of the 18th century all attempts at restrictions were abandoned.

After the period of close connection between professional urban and rural craftsmen in the 18th century, the two again went their own way. Painters from the high period of rosemaling, such as Thomas Luraas and Hans Glittenberg, got no church commissions, nor did urban artists working in the Classic mode of the time make much impact in the country outside the flatlands to the north and east of Oslo, which had always retained close connections with urban culture. But by this time the concept of the professional craftsman within the rural society was already well established.

Most folk artists were from the lower social and economic classes: small farmers, regular tenants or tenants with official obligations in labor or kind to a resident owner (*husmenn*), or workers without land. This did not mean that any social stigma went with being an artist. Artists were respected for their abilities (Ellingsgard). Rural representatives to Parliament or wealthy landowners were among them, but they were exceptions to the rule.

The people who specialized in an art or craft were often those who stood apart from the average in other ways as well. Many were fiddlers, storytellers, teachers, sextons in the church, political agitators, or leaders of one kind or another in the community. Sometimes their distinctiveness was purely physical, a handicap or ill health. Halvard Bjørkvik gives a dramatic example of this at the end of his article. Even an element of rebellion could not have been uncommon in them because, as Nils Ellingsgard shows elsewhere, a number ran into trouble with the law.

Restlessness also appears to have been a trait. The nature of their occupation, of course, often required them to live somewhat itinerant lives, but even their home addresses often changed. It is difficult to know if the painters from Telemark, Valdres, and Hallingdal who worked on the west coast were there purely for economic reasons or if they were driven in part by wanderlust. Half the painters in Hallingdal at some time painted in the areas to the west and about one-fourth of the known painters in Hallingdal and Telemark emigrated to America, a figure well above that of the national average. Whatever the specific motivation, artists from the mid 18th century and on were people open to change. Their capacity for absorbing new impulses, such as the Baroque in carving and the Rococo in painting, make them more the innovators in their culture than the bearers of tradition, the role generally associated with folk artists. Their role within the group was not unlike that of the fine artists in upper-class society. As Ellingsgard has said, they would probably have been fine artists had they belonged to a different social class.

This look at the artists poses the question of how tradition relates to innovation in Norwegian folk art. Tradition dominated until the middle of the 18th century and was so deeply rooted that remnants of a millennium of Norwegian

art could still be found in it. Fundamentally this conservatism continued in the folk culture even after the revolution which we have seen occurred in art. The material culture, the form and structure of material things did not substantially change, nor did their use. The revolution we have seen was primarily in the appearance of things, a revolution in art that brought it in a sense ahead of the socio-economic level of the society.

The major cultural break did not come until a century later when intense industrialization in Norway finally got underway. The early innovations in the folk arts and their linking into the international strains that would ultimately overtake the old culture made it possible for these arts to flourish right up to the time when that culture met its demise in the late 19th century. These circumstances, together with others already mentioned, also prepared Norwegian folk art for retaining a position even in the culture that replaced the one which had brought that art into being.

Back to the geometric and the organic

One would have expected the Baroque revolution with its emphasis on the organic to have totally wiped out the geometric strain which was earlier presented as the other half of a dichotomy in Norwegian folk art. That was not the case. The geometric went on in thread-count embroidery, square- and other pattern-woven coverlets, chip carving, burnt decoration, and the like, through the high period of acanthus carving and rosemaling even in areas like Telemark, Hallingdal, and Valdres where these were strong. There continued to be greater balance between the two strains in Norwegian folk art than is ordinarily assumed to be the case. The sensational nature of the organic strain and its association with international styles has led to its receiving disproportionate attention. No thorough studies have been made of burnt decoration, thread-count embroidery, or decorative treadle loom weaves. These have far exceeded the other arts in quantity since the latter half of the 18th century. The only comprehensive study of chip carving was made by Schetelig in 1913, and it covered only the west coast. Rosemaling, acanthus carving, and picture weaving, in contrast, have been subjects of intense investigation by Norwegian scholars for the past two generations.

When one enters an authentically reconstructed early 19th century interior from the central valleys of Norway in a Norwegian open-air museum and sees the acanthus-carved and rose-painted furniture on the one hand and the pattern-woven coverlets and the shelves of unpainted wood vessels with geometric burnt or perhaps chip-carved decoration on the other, one realizes that the two approaches to design, the organic and the geometric, continued a duality in Norwegian folk art through much of its history. What we experience in such rooms is not far from the aesthetic found in the 9th century Viking post with intertwining animal decoration on one end and horizontal and vertical bands on the other (Fig. 2). The question remains: is this the result of a formal southern tradition meeting a more dynamic northern one, of a primitive tendency toward the schematicized meeting a sophisticated tendency toward the free, or simply of two coexisting inclinations in the human psyche? The answer is undoubtedly that all three have been present to varying degrees in shaping the stylistic character of native Norwegian art.

Sources

The specific information utilized in this essay is drawn almost exclusively from the invaluable secondary sources included in the general bibliography for this volume. The ideas have resulted from about forty years of contemplating them and making observations from Norwegian folk material in the museums of Norway and of areas where Norwegians have settled in the United States. The collection of material from Norway at Vesterheim, Norwegian-American Museum, Decorah, Iowa, has been especially valuable in giving me an intimate understanding of the physical, intellectual, expressive, and aesthetic constituency of Norwegian folk art.

The Baroque Revolution in Wood

46. Acanthus carved altar panel from Old Bragenes church, Drammen. Norw. Attributed to Lars Jenssen Borg (?–1710), Christiania (now Oslo). 1708? Wood. H. 86½″ W. 26¼″ Drammens Museum.

A revolution in Norwegian folk carving resulted from the introduction of the Baroque acanthus in Norway during the decades preceding 1700. Borg, a professional urban carver, was the most important early propagator of the motif.

47. Acanthus carved altar panel from Old Coon Valley Church. Norw.-Am. Knud Lie (also Knut Lee) (1831–1900), Coon Valley, WI. From Øyer, Gudbrandsdalen. 1866. Wood. H. 51″ W. 13⅓″ D. 1⅛″ Family of K. O. Lee.

Borg (46) carved furnishings for many churches in Gudbrandsdalen shortly after 1700. They became models for local carvers, of whom Bjørn Olsrud, who supposedly carved the altar at Øyer in 1724 (47a), is one. The acanthus panels on this are the direct models for those by Lie, who immigrated to Coon Valley in 1866.

47a.

46.

47.

48. Trunk with painted acanthus carving. Norw. Jens Strammerud (1674–1737), Hedemark. Trunk from Flisaker, Veldre, Ringsaker. Before 1737 (painted date 1754 added later). Painted pine, iron. H. 32¼″ W. 50⅜″ D. 28⅛″ Inscription: "KLD 1754." Sandvigske Samlinger, Maihaugen (2853).

Being older than Olsrud (47a), Strammerud like Borg is thought to have been an influence on him. Strammerud and his son-in-law Lars Pinnerud, Hedemark, are among the first carvers to bring the acanthus from the church into the home.

49. Hanging cupboard with acanthus carving. Norw. Attributed to Sylfest Nilssen Skrinde (1731–?), Skjaak, Gudbrandsdalen. Cupboard from Morken, Lesjaskog, Gudbrandsdalen. Dated 1749. Pine. H. 46½″ W. 30¾″ Sandvigske Samlinger, Maihaugen (01171).

The early date on this small hanging version of a floor cupboard type soon to gain great popularity is puzzling. Its attenuated foliage is characteristic of the artist credited with it, but he was only 18 in 1749. He may already have been training at Lesja with Jakob Klukstad (50, Fig. 6) who soon made him an assistant.

49.

48.

50. Hanging wall cupboard with acanthus crown. Norw. In the style of Jakob Klukstad (1714–1773), Lesja, Gudbrandsdalen. Cupboard of Sør-Trøndelag type. Mid 18th century. Painted wood. H. 41⅜" W. 31¾" D. 12½" Norsk Folkemuseum (NF 1897–1128).

The acanthus carving has the fullness and flamboyance of the seminal Klukstad, but the cupboard is of a type found well north of Klukstad's area. Whoever the carver, it represents Norwegian folk acanthus at its best.

51. Box with acanthus carving. Norw.-Am. Erik Rist Holt, Arlington, WA. 1993. Nordic birch. H. 4¼" W. 11½" D. 7" Erik Rist Holt.

The acanthus never died in Norway. It was still alive when given new impetus in the 1870s by classes designed for its preservation. A consequence of these classes was a school at Dovre, Gudbrandsdalen, where Holt, an American with a Norwegian immigrant mother, took the full course in carving. Klukstad (50, Fig. 6) is a major model.

53.

52.

52. Log chair (*kubbestol*) with carved acanthus band. Norw. Area unknown. 19th century. Painted wood. H. 35½" W. 27" Norsk Folkemuseum (NF 1898–546).

The first major union between acanthus carving and the log chair occurred with turn-of-the-century nationalism. This early example is exceptional. Among Norwegian-Americans the two became almost synonymous (53–55), both being national symbols.

53. Log chair (*kubbestol*) with acanthus carving. Norw.-Am. Tarkjel Landsverk (1859–1945), Whalan, MN. Ca. 1915. Elm? H. 33½" W. 22¼" D. 18½" Norskedalen.

Landsverk did acanthus carving before emigrating from Seljord, Telemark, to Minnesota in 1883. He never quit. His early connection could have been the budding revival rather than direct tradition. The linear elegance relates both to the revival style and the Telemark interpretation of the motif.

54. Log chair (*kubbestol*) with acanthus and pictorial carving. Norw.-Am. Halvor Landsverk, Whalan, MN. Signed and dated 1975. Basswood. H. 34¼″ W. 23¾″ D. 18″ Vesterheim, gift of Halvor and Pernella Landsverk (75.63.1).

Tarkjel's son Halvor continues in the tradition of his father. The relief is deeper, a development facilitated by the use of a router for roughing out the design. The romantic element is strengthened by the addition of other national symbols such as the stave church (bottom) and the storehouse (top).

55. Log chair (*kubbestol*) with acanthus carving. Norw.-Am. Hans Sandom, Minnetonka, MN. Signed and dated 1994. Basswood. H. 37″ W. 18″ D. 17″ Vesterheim, gift of Ruth Johnson.

Emigrating from Atnadal, Gudbrandsdalen, Sandom grew up with the acanthus. He observed the carving methods of an uncle but did not begin carving until much later in America. Here he remained close to the much older master carver from Gudbrandsdalen, Leif Melgaard (57, 59).

54.

55.

56.

57. (56 in background)

56. Mangle board (*mangletre*) with free ac
(1726–1802), Sør-Fron, Gudbrandsdalen
Birch. H. 6⅜″ W. 31″ D. 3½″ Inscription:
Josefa Andersen (85.120.1).

Tradition gave Norwegian folk artists a bas
whose later acanthus is tight and agitated a
his figures, is a good example. The function

57. Mangle board (*mangletre*) with acanth
(1899–1991), Minneapolis, MN (See also
W. 32½″ D. 4″ Vesterheim, gift of Leif Me

Born to a family of wood carvers that had i
first twenty-one years in Sør-Fron where th

59.

58. Stave-constructed porridge container (*ambar*) with acanthus carving. Norw. Gudbrandsdalen. 18th century. Wood. H. 11 ⅞″ W. 11 ⅞″ D. 11″ Norsk Folkemuseum (NF 1943–599).

Acanthus carving gradually found its way to smaller household objects. Next to mangle boards in popularity came containers for the sour cream porridge (*rømmegrøt*) carried as a contribution to festive occasions or as a gift to a mother after childbirth.

59. Stave-constructed porridge container (*ambar*) with acanthus carving. Norw.-Am. Leif Melgaard (See also 57). Signed and dated 1978. Fir, soft maple; basswood bands. H. 12½″ Diam. 11¾″ Minnesota Historical Society.

The porridge container, like the log chair and acanthus carving itself, around 1900 became a national symbol and therefore continued to be made as such or purely as an object of art.

58.

61.

62.

61. Spoon rack and eight spoons with acanthus and line-incised carving (*kolrosing*). Norw.-Am. Tarkjel Landsverk (See also 53 and 62). Early 20th century. Basswood. H. 13″ W. 10″ D. 3″ David Landsverk.

The immigrant Landsverk transferred the concept of a spoon box to a rack, possibly inspired by spoon racks on silver sugar bowls. The 1) continuity between the line-incised designs on the spoons and the acanthus carving at the top and the 2) contrast between their dynamic curvilinearity and the simplicity of the fluted base reveal an aesthetic that only long tradition in art could have brought to a small farm in southern Minnesota.

62. Round box with acanthus carving. Norw.-Am. Tarkjel Landsverk (See also 53, 61). Ca. 1913. Maple? H. 8½″ Diam. 11″ Warren and Kirsten Landsverk Netz.

Landsverk here as in the spoon rack (61) has applied traditional decoration and aesthetics to a non-traditional object. The lack of obvious national symbols suggests aesthetic rather than nostalgic motivation behind these works.

60. Table or wall spoon holder (*skjekopp*) with acanthus panels. Norw. Tynset, Hedemark. Dated 1845. Painted wood. H. 8″ W. 8⅝″ D. 7½″ Norsk Folkemuseum (NF 1934–409).

The tradition in tasteful acanthus decoration on household objects in Hedemark seen as early as the 1730s (48) is still evident over a century later in this traditional spoon container designed either to hang or stand on the table.

63. Hanging letter box with acanthus carving. Norw.-Am. Aasmund Aslakson Nestestu (1797–1885), Cottage Grove, WI. Signed and dated May 2, 1876. Birch, pine. H. 17″ W. 12½″ D. 7″ Eugene E. Gangstad.

The son of a major painter in the development of rosemaling in Telemark, Nestestu was a recognized craftsman before leaving Vinje in 1843. Little creative work continued. Here, as in Landsverk's spoon rack (61), a decorative tradition has migrated apart from association with a traditional object.

64. Powder horn with acanthus carving. Norw. in Am. Gudbrandsdalen? l9th century? Found in Viroqua, WI. Bovine horn, wood. H. 3½″ W. 7½″ D. 1⅞″ Inscription: "IES". John Haltmeyer.

This horn is representative of many small functional objects with acanthus decoration that came to America in fair numbers because of their portability. Even more prevalent than horns are knife handles and snuff boxes.

63.

64.

Aberrations of the Acanthus

65.

65. Stave-constructed porridge container (*amba*r) with abstract plant decoration. Norw. in Am. Sigdal? 1772. Pine or fir. H. 12½″ Diam. 10″ Inscription: "Anno 1772 ISD." Carol and Tim Harmon.

Spiraling acanthus tendrils lend themselves well to stylization. In this immigrant object brought from an unknown location in Norway only the rhythms of the acanthus remain without any of its detail. A mangle board from Sigdal, Norway, at Vesterheim comes closest to it in style.

66. Shelf with abstract plant and geometric decoration. Norw.-Am. King Olson, Lake Park, MN. Ca. 1885. Pine. H. 45″ W. 30″ D. 8″ Bruce and Linda Tomlinson.

Decoration similar to that on the previous piece (65) is found on this Norwegian-American shelf by a carver whose name is known through oral tradition but not his place of origin. Distortion and simplification is expected in early immigrant work where the models often existed only in memory.

66.

67.

67. Mantle clock with free acanthus carving. Norw.-Am. Hermund Melheim (1891–1990), Ray, MN. From Marifjøra, Sogn. Dated 1955. Elm? H. 31½″ W. 38″ D. 6¾″ St. Louis County Historical Society.

The rhythms of the acanthus but little of its detail are also found in this creation by a man who emigrated at age 20 from an area where there was no tradition in acanthus carving. He did not consider his work Norwegian, but awareness of the acanthus is obvious.

68. Grandmother's clock with free palmette and acanthus carving. Norw.-Am. Hermund Melheim (See also 67). Ca. 1940. Pine. H. 78¼″ W. 18″ D. 15½″ St. Louis County Historical Society.

That the acanthus when stylized comes close to the palmette is seen throughout its thousand-year history. The technique and design advantages of the palmette with its repeated elements are clear. Melheim uses it with great drama here, defying the aesthetic for expressive impact.

69. Log chair (*kubbestol*) with palmette and incised carving. Norw.-Am. Hermund Melheim (See also 67–68). Ca. 1940. Pine. H. 34¾″ W. 17″ D. 15″ St. Louis County Historical Society.

Considering the amount of linear activity in this log chair carved to simulate one with feet, it is remarkably unified. The focal point lies clearly in the rather traditional acanthus motif on the inner back.

68.–69.

70. Corner cupboard with bow front and free acanthus and other carving. Norw.-Am. Lars Christenson (1839–1910), Benson, MN. Ca. 1890. Pine, elm. Finish and lower drawer pulls not original. H. 87″ W. 36½″ D. 26″ Vesterheim (75.22.2).

Less eccentric than Melheim and drawing more on Rococo, Christenson, too, also from Sogn, reveals exceptional individuality in his acanthus-based designs. The plants in pots build more on painting than traditional carving. The cupboard was probably a study for the artist's altar (Fig. 10).

71. Secretary with relief carving and mother-of-pearl inlay. Norw.-Am. Engebret Sletten (1815–1898), Wanamingo, MN. From Hallingdal. Ca. 1880. Butternut, shell. H. 84″ W. 42″ D. 20″ Vesterheim (92.89.1).

Sprigs of acanthus given palmette character, as in Olson, Melheim, and Christenson (66–70), pervade this immigrant creation. Specific prototypes are not known for the tree with three-part leaves and clusters of three berries, but the lions that eat from it appear on several Norwegian works by an unrelated Sletten, also from Ål, Hallingdal (72).

70.

71. detail of door panel

71.

Dog se, hans Haand som mig forraader er over Bordet med mig

Norwegian Folk Art in America

MARION NELSON

MATERIAL IN AMERICA TODAY that can in one way or another be considered Norwegian folk art falls roughly into three categories: folk art from Norway which has come primarily as the result of immigration; material made in America largely by first-generation immigrants, which to varying degrees is a direct continuation of Norwegian folk tradition; and material made in America as a revival of Norwegian folk tradition largely by later generations of immigrants and others in their cultural sphere.

Folk art from Norway

The phrase "has come *primarily* as the result of immigration" was very consciously used because Norwegian folk art has also reached America in other ways. Wealthy Americans in the East who in the 19th century went to Europe in search of art that would give cultural distinction to their homes did not ignore Scandinavia. The three early pictorial coverlets of Gudbrandsdal type now at the Norwegian immigration museum Vesterheim in Decorah, Iowa, were purchased abroad by eastern Americans. Two were typical collectors without Scandinavian connections. The third was Sara Thorp, whose eastern family was living in Madison, Wisconsin, when the Norwegian violinist of international fame Ole Bull (1810–1880) visited there in the 1860s. He married her and took her back to Bergen where they built an exotic little castle of wood on the island of Lysøen. According to her family, it was she who had the special interest in folk art and bought fine examples, among which was the pictorial coverlet now at Vesterheim (33). It came to America with her family that returned to the Boston area after the death of the violinist in 1880.

Fig. 10. Altar. Lars Christenson (Kjørnes) (1839–1910). Benson, Minnesota. Now Luther College Collection, Vesterheim, Decorah, Iowa. Ca. 1900. (See also 70). Photo: Vesterheim. Photographer: Darrell Henning.

The purchasing of folk art in Norway continued among both immigrant and non-immigrant Americans, but on a nominal scale until World War II. The most significant importers of the time were the immigrant collector P. D. Peterson, Eau Claire, Wisconsin, whose material was purchased by Vesterheim in 1930, and Isak Dahle of Mount Horeb, Wisconsin, who during the ten-year period prior to his death in 1937 created the private museum Little Norway which is still intact and open to the public (12, 42, 113, 128, 202). Since both also collected material that had come with immigrants and neither kept detailed records of purchases, the precise provenance of much in their collections is not known.

The major importers of Norwegian folk art since World War II have been dealers (43), primarily in Minnesota; their clients are largely midwestern collectors, of whom many are without Norwegian background. The immigrant collectors have tended to concentrate more on material that came with their ancestors and which they purchase "off the land," to use their own term (15, 123).

It is immigration-related material that makes up the overwhelming majority of early Norwegian folk art found in America today, material that came either with the immigrants as a part of their household goods or as inheritance or mementoes at a later time (177, 204). The amount is not surprising when one considers the circumstances: emigration occurred largely among the folk; many folk art traditions were still alive or at least very present at the time of mass emigration; emigration was heavy from Telemark, Hallingdal, Valdres, and Gudbrandsdalen, where the folk arts were strong; and most immigrants knew they would be pioneers who would need the basic everyday materials necessary for getting established. Much of the simple folk art appeared precisely on such everyday materials.

Containers, from small boxes to trunks, had traditionally been favorite objects for artistic decoration, and they

were the most important types of objects for a move. Trunks, which became the crates and luggage for the move, had long been used for dowries and had therefore been given special decorative attention. The number and artistic significance of these trunks that migrated is revealed in Nils Ellingsgard's *Norwegian Rose Painting in America*.

Most of the material relegated to serving purely practical purposes for the move appears to have lost whatever broader significance it might previously have had in the culture. The new address was not uncommonly carved into, or painted or stapled over fine decoration on old dowry chests. In America these served as tables or benches until proper furniture became available, and then they were often relegated to outbuildings, where they held tools, feed, or the like. This was not necessarily out of disrespect for them but was simply the continuation of the peasants' practical attitude even toward objects of special character. Fine early decorated trunks had long been repainted with new initials and dates when passed from one generation to another regardless of the quality in the earlier work. Trunks had also by the time of emigration begun to lose their fixed place in the culture as chests of drawers took over for the storage of textiles and as the concept of a dowry waned. Only isolated instances are known of the trunk or other everyday immigrant objects having had emotional or aesthetic significance to the immigrant during the early years of settlement. That came later when nostalgia and concern with identity arose.

One must then ask why so much Norwegian folk material is still found in America today. One reason is conservatism that prevented disposing of things even after they were no longer thought of as serving a function. This was especially true on farms where space was not a major concern. Another is an early awareness in immigrant academia of immigrant objects as historic documents. This was the motivation behind the systematic collecting of Norwegian-American artifacts that got underway about 1895 at Luther College, the founding institution of what came to be Vesterheim. The fact that such collecting was taking place at an institution of high visibility in the immigrant community must also have contributed to a general awareness among its members of possible value in material things from the past. This may have been of more importance in the preservation of immigrant materials than what was actually collected by the institutions.

A third explanation for the preservation of a substantial body of Norwegian folk material in America is that when a national awareness developed among the Norwegian-American people in the 1890s it grew with absolute consistency until it reached a high point in the 1920s. It has not substantially declined since. For many immigrants any object of Norwegian origin acquired symbolic significance relating to nostalgia, roots, identity, and ethnic pride. Much material still functions this way in Norwegian-American families (157, 177, 198, 204).

Continued folk art production

No Norwegian folk art tradition survived the Atlantic crossing and remained alive as an integral part of an immigrant community. There are also historical reasons for this. Folk art was coming to an end even in Norway by the late 19th century when mass emigration occurred. Industrialization, which was largely responsible, had advanced much further in America than in the old country. What there is of direct continuation took place for the most part among individuals who worked in varying degrees of isolation. A limited amount of folk craft that related to the community, such as the making of furniture, wooden shoes, wooden spoons, and even spinning wheels continued for the first several decades in early settlements. Some line incising on spoons (136) is generally the only art accompanying this, again except for the work of a few unusual individuals. Much of this traditional craft activity appears to have been centered in southwestern Wisconsin, northeastern Iowa, and southeastern Minnesota, farther from large industrial and commercial centers than the earlier settlements in southeastern Wisconsin.

Decorative woodcarving was the art most commonly continued in America by immigrant artists, all working in isolation. Three of the earliest created major altars. The first to arrive was Aasmund Aslakson Nestestu (1797–1885), Cottage Grove, Wisconsin, the son of a key figure in the development of Telemark rosemaling and himself the recipient of royal recognition for his craft activities before emigrating in 1843. Perhaps about 1860 he carved an acanthus altar frame for the Norwegian Grove Lutheran Church, DeForest, Wisconsin, now known only through photographs. A letter box (63) carved in 1876 when he was seventy-nine years old reveals that he retained the exceptional creativity for which he was known before emigrating at age forty-six. Its more linear than sculptural character may reflect his background in rosemaling, an art which he does not appear to have continued. He stands alone in his generation of immigrant artists.

The next carver in the early trio, Knut Lee (1831–1900), came from the center of acanthus carving, Gudbrandsdalen, and during his first summer in America, 1866, carved the altar for the Old Coon Valley Church, Coon

Valley, Wisconsin. All that remains are the acanthus side panels (47) which indicate that he modeled his work directly on the 18th century altar in his home church at Øyer (47a). Descriptions of the Coon Valley piece indicate that it was not only a frame but included a crucifixion that probably filled the central panel. In about 1883–1884 he carved an altar frame for the Aal Church near Hillsboro, North Dakota, with similar side panels and also an elaborate upper section that may be without a specific model (Fig. 11). He, like Nestestu, was also a gunsmith who practiced that art as well in America.

Lars Christenson (1839–1910), Benson, Minnesota, the third of the altar carvers, came in 1864 from Sogndal, Sogn, where there was no acanthus carving tradition. This and the fact that the Benson altar dates from over thirty years after his arrival give it greater individuality than the previous works (Fig. 10). The acanthus, as on a cupboard which just precedes the altar in date (70), is highly stylized. The strength of the altar lies in the figurative reliefs on the central panels. The figures themselves have the doll-like quality of those by Norwegian acanthus carvers but they lack their Baroque agitation (Fig. 6). The models here are illustrations in the 1890 Norwegian version of the Holman Bible, which had a strong element of German Neo-Classicism.

Quite different stylizations of the acanthus, if the acanthus is indeed the source, appear on the doors of the secretary by Engebret Sletten (1815–1898) carved in Wanamingo, Minnesota, about 1880 (71). Coming from Hallingdal, he, like Christenson, would have seen little true acanthus in his home area. He has, however, continued a tradition of heraldic lions eating from a central tree found in several works by Ole Sletten from the same community of Ål (72). Stylization goes even farther in the work of an apparent contemporary, King Olson of Lake Park, Minnesota (66), known by name through oral tradition and said to be the maker of two similar shelves, one dated 1886. The chip-carved stars at the top suggest west coast origin, but other characteristics point to Sigdal. It is not likely to be Gudbrandsdalen because two carvers of the same generation from there working in Wisconsin, Erik Teigen (1842–1902) and Jon Jackson (1836–1910), remained much nearer traditional acanthus style.

Several immigrant carvers before the immigrant craft revival of the 1960s built on the carving revival in Norway that from weak beginnings in the 1850s was in its heyday between the 1870s and 1900. This was true for both Erik Kristian Johnsen (1863–1923), who learned the Medieval style at night classes in Oslo around 1890, and Tarkjel Landsverk (1859–1948), who appears to have learned the linear Telemark type of revival acanthus when he was in

Fig. 11. Altar. Knut Lee (1831–1900). Aal church, Hillsboro, North Dakota. 1883–1884. Photo: Courtesy Aal church. Photographer: Darrell Henning.

teachers' training at Kviteseid in the early 1880s. Both continued to create and carve designs freely on the basis of what they had learned, Johnsen bringing an element of the genuinely naive to his pseudo-Medieval creations (5) that save them from the detailed academic character of much Norwegian revival work, and Landsverk, at least through his entire early period, retaining a sure sense of rhythm and taste (53) that he could apply even to non-conventional pieces (61–62). His introduction of romantic pictorial motifs, such as Vikings, in later work marks a shift from continuing an aesthetic tradition to nostalgic involvement with the past. His attraction to log chairs, practically national symbols, of which he carved about twelve, suggest an element of nostalgia in his work from the beginning.

Tarkjel's son Halvor carried the romanticism of his fa-

ther into another generation, carving over 300 log chairs and still working at age eighty-six (54). Viking motifs or scenes from Norway assume a more prominent place on them than in those by his father, but acanthus also continues, now having a bolder, more agitated character.

Halvor Landsverk was one of a trio of immigrant carvers born around the turn of the century who were all still active in 1990 and served as a link between the carvers working out of direct tradition and those of the revival, which in wood carving did not get underway until the 1970s. The other two represent opposite poles, both of which had several representatives in Norwegian immigrant folk art at the time, the free and the academic. Hermund Melheim (1891–1990), Ray, Minnesota, like Christenson spent his early years in west coast Sogn where there was no acanthus tradition. He developed his own style on the basis of slight familiarity with the acanthus and the palmette (67–69) and a sure sense of rhythm in both mass and line. His is an American approach to folk art, finding one's own way, but the presence of an underlying tradition is still strongly felt in the assurance, daring, and stylistic consistency of his work.

Leif Melgaard (1899–1991), Minneapolis, Minnesota, is the creative academician (57, 59), steeped in tradition from his native Sør-Fron in Gudbrandsdalen where Lars Borg (46) had carved the pulpit in the church and where Kristen Listad (56, 74) had a place in his family tree. He could create his own designs, but retaining as much of tradition as possible was clearly his goal.

Except for Melheim, the carvers mentioned are a core group based rather firmly in what may be called mainline Norwegian folk carving. Among the most consistently traditional of those on the periphery of this were the violin makers. The old practice of carving a head rather than a scroll at the end of the fingering board was continued by the master maker of standard violins, Knute Reindahl (1868-1936) from Telemark, who worked in Madison, Wisconsin, and by all the makers of the traditional eight-stringed folk instrument, the Hardanger fiddle. Major among these was Gunnar Helland (1885–1976), who with his brother Knut continued making Hardanger fiddles (125) much in the tradition of their violin-making family (124) through the first half of the 20th century in Wisconsin and North Dakota.

There were some immigrant carvers who retained the love of working in wood but brought little of specific tradition with them. Theodore Rovelstad (1866–1950) knew the concept of the log chair but he either did not know or ignored the tradition of hollowing out the log (208). This left him with a piece of tremendous weight to which he added rockers, unheard of on early log chairs in Norway but also done by Melheim in America. This at least gave the sitter some mobility. The decoration is of the naive American folk type done unashamedly with a power router, the marks of which are rough rather than disguised through surface carving. Halvor Landsverk too uses the router but only to rough out the design (54), which is then completely hand carved.

Refinement was the direction in wood working taken by Chris Moe (1862–1940), Portland, Oregon, who immigrated at twenty-five in 1887. Between about 1920 and 1931, after a career as seaman and carpenter, he produced a set of furniture and related pieces, numbering twenty-four in all, covered totally with ornate wood inlay surfaces. He considered the floor lamp his masterpiece (209), consisting, according to him, of about 8,000 pieces of wood. Although he belongs in the category of the obsessive folk artist, like the best of these he also had a message. In the lamp this relates to his dual ethnicity, indicated by the presence of a Norwegian cathedral among American national monuments, and to the love of God and country. The inlay panels below the sculpted pieces reveal that he had great potential in a type of expression generally associated with the fine arts. This unfortunately remained little developed because of his obsessive passion with the technical intricacies of wood inlay. His folk art is on the outer edges of tradition but therefore all the more art as individual communication.

Early Norwegian-American figure carving reveals the elegance of line found in the Norwegian (78. Cf. 77, 81, 86) but moves rapidly toward the more realistic (79) and/or naive (88). Alfred Anderson's outstretched pheasants (92) of about 1940 bring together in a very special way traditional expressive elegance (91), a striving for realism, and a naive imagination. Norwegian-American decoy carvers do much the same but with less of the naive. Harold Thengs (1893–1974) even adds to his birds from around 1930 a touch of Art Deco streamlining, at least in the painting (94–95).

Animals and birds dominate most early figure carving among the Norwegian immigrants (75, 78–79, 88). When the carving of three-dimensional human figures became common among them in the 1930s (83), the rougher and more angular flat-plane approach with its base in realism rather than elegant expressive line had taken over in America. It may have come with carvers from Sweden, the Scandinavian center of the style, but may also have grown in part out of amateur whittling. The work of the little

known Olav Bakken in Telemark (82) documents its presence in Norway as well by the mid 1920s before its known use among Norwegian immigrants.

The line of continuity from the past found in Norwegian-American woodcarving is all but absent in painting and weaving. The most dramatic exception in painting is the work of a rosemaler proficient in a Valdres style who is known from the painting on two cupboards done for the Engeseth family from Sogn in DeForest, Wisconsin, in 1868 and 1870. It was also in DeForest that Nestestu from Cottage Grove, not far to the southeast, carved his altar, an indication that some communication between two major immigrant artists may have occurred here. Recent research by John Holzhueter of Wisconsin and Reidar Bakken of Norway indicates that the Ingeseth cupboards (154) are made by Aslak Lie (1798–1885) from Valdres and that the painting could also well be his. Two fragments of painted furniture from this area, one in the style of the Engeseth master and one in Telemark style, both now at Vesterheim in Decorah, Iowa, suggest that there may also have been additional folk art activity in the community. This specialized work of unusual individuals is found near urban centers, in this case Madison, while the production of traditional everyday objects was greater in more remote areas.

It is near Decorah that one finds the only documented instance of an established early rosemaler from Norway continuing work in this country. He was Erik Veggesrudlia, son of a major painter, Gunnar Veggesrudlia in Eggedal (186). Unfortunately Erik's finest known American work, a small trunk, was recently lost in a house fire (Fig. 12). The high-level artists active in the DeForest and Decorah areas around 1870 appear to have had no immediate followers.

Another Norwegian painter who continued his art in America, Per Lysne from Lærdal, Sogn, came in 1907, too late to be classified with the Engeseth painter and Veggesrudlia. Lysne, like Veggesrudlia, was also the son of a painter, Anders Olsen, who had a place in the revival of national art in Norway. This early connection with revival sets Lysne too apart from the previous two painters (201). He, however, had also become intimately familiar with the one style of rosemaling that was still a living art in Norway, that of Os in Hordaland, well south of Sogn. His best work in this country is in that style. Unlike the other artists, he did develop a following in America but not until the 1940s. Then he became a mentor to Ethel Kvalheim (153, 178) and other key figures in a revival of rosemaling that was budding in the 40s but did not reach full bloom until the late 1960s and the 70s.

Fig. 12. Traveling trunk. Erik Gunnarsen (Veggesrudlia). Decorah, Iowa. 1873. (See also 186). Photo: Courtesy Gordon Fulsaas. Photographer: Darrell Henning. Destroyed in fire Ca. 1990.

An interest in rosemaling separate from that centered around Per Lysne in the midwest also developed on the coasts in the 1940s. In the east it centered around the Norwegian Art and Craft Club of Brooklyn, and in the west largely around two figures living in Seattle, Agnes Rykken (1901–1991) and August Werner (1893–1980). Their approaches are so different that they probably had little or no contact with each other. Rykken felt close to tradition, having been introduced to rosemaling through a miniature family trunk with late Hallingdal painting and further inspired by a family porridge container from her husband's family with painting in the Os style. This piece from 1885, which even includes her new family name, was given the couple when they were in Norway after World War II (204). She also studied prints made from water color copies by Knut Hovden, Sand, Ryfylke, of old painting in the area and even made contact with this central figure in the revival of rosemaling in Norway. He at one point produced designs for her and a friend who had also become involved. In spite of this concern with authentic sources, she worked very freely within tradition and created designs of exceptional originality and charm (205).

Werner used what he happened to know of rosemaling as a point of departure for free expression (206). The results are not unlike that of late 18th century folk painters who went off on their own after nominal exposure to Rococo painting. Flame-like red flowers or rocaille also appear in their work, primarily in Numedal and surrounding areas. The detailed expressive curliques around the large images, however, are unique to Werner. Painting figures from folklore as in his troll chair is also without early tradi-

tion (207). Neither Rykken nor Werner founded local traditions, although Seattle and other areas in the Pacific Northwest also became involved in the later revival.

Of early painting among the immigrants, primitive religious figure painting has a place apart from rosemaling. Martin Olsen (1829–1881) of Telemark painted thirty-two Biblical figures modeled on those in an English Bible on four doors in the Elkhorn area of Wisconsin as early as 1860, preceding any known Norwegian-American rosemaling (170). Although he came from the area in Norway with the richest rosemaling tradition and left there when it was at its height, the only possible carryover from that art is a decorative rhythmic quality in the individual figures. His general approach, like that of many American folk artists, was to duplicate his models as best he could, giving them the characteristic strong outlines and applying to them areas of pure color. The hues were apparently of his own choosing because the original illustrations, which have not been located, were undoubtedly in black and white.

The immigrant John Rein (1858–1916) in the northernmost part of Minnesota also depended on Bible illustrations for the facial characteristics of the disciples in his Last Supper of 1895, painted for Rose church near Roseau (169), but the concept of using the Last Supper as the main subject for an altar, practically unknown in American Lutheran churches, and of placing them around a table under a candelabrum is completely Norwegian (168). Many examples are known, some of which he must have seen in the areas around Trondheim where he lived for twenty years before emigrating. While the faces are drawn from Leonardo's as presented in the form of separate portraits in one of the many editions of the Holman Bible, the expressive exaggeration of their features is very characteristic of Norwegian folk interpretations of Baroque models (Fig. 6).

Of known folk figure painters among Norwegian Americans, Rein's slightly younger contemporary Peter Oliver Foss (1865–1932), of the Boston, Massachusetts, area, reveals the least inheritance from Norwegian folk painting. An attraction to sensational Biblical subject matter, as seen in his *Samson and Delilah*, is one exception (167). But when this Samson is compared to Torstein Sand's of Hallingdal (166), it is evident that none of the stylistic tradition transferred. Probably also working from a Bible illustration, Foss aspired to academic realism, struggling to reproduce the sensuous softness of human flesh, the textural richness of billowing drapery, and the contrast between interior and exterior space. The work still has the exaggeration and awkwardness of naive painting, but it does not have the rhythmic linear character of Sand's

quaint and decorative "guardian of the door." The fact that it is on canvas, unrelated to architecture or any functional object, is another indication of departure from Norwegian folk tradition. In spite of their Norwegian backgrounds, Olson, Rein, and Foss are all Americans attempting to be academic realists rather than translating their motifs into an existing decorative language as Sand had done.

Weaving fared even worse than painting in the Atlantic crossing. Only one traditional coverlet, now at Vesterheim, is known to be of pre-revival Norwegian-American production. It is woven in a simple striped twill as the backing for sheepskin. The few additional examples of early immigrant weaving are simple and reveal little of specifically Norwegian tradition. Since the home production of household textiles was still the rule in most areas from which the immigrants originated, looms and other equipment for textile production were brought or made here during the early immigrant period. Their limited use was probably due to the availability of reasonably-priced mass-produced materials from America's highly developed textile industry. The looms, when used at all, were relegated to weaving rag rugs.

Spinning wheels did remain in use but to make yarns for knitting socks, mittens, and occasionally sweaters. The art of knitting, not originally as important in Norway as it became in the 20th century, did continue among the immigrants, probably because it could be easily done in leisure moments in any place where the activities of the farm might take the woman. Embroidery has a similar advantage over weaving, and it too continued. Most popular was the white, thread-count, cut-out embroidery known as Hardanger, traditionally used on the apron and blouse of what during the late 19th century came to be the national Norwegian costume (119–120) both in Norway and among the immigrants. While this transition in the costume from being regional for Hardanger to being national was taking place, Hardanger embroidery spread from it to sheets, pillow cases, tablecloths, runners, and a great range of objects, partly the result of promotion by producers of embroidery materials. Something similar went on in the yarn industry with Norwegian knitting, resulting in the migration of these arts to all areas of the western world.

The greatest known achievement in Norwegian-American folk textiles before the revival, or even after, has little to do with tradition. Nettie Halvorson, in a remote area of southeast Minnesota, developed what appears to be completely her own technique in off-the-loom weaving, producing essentially a knotted net into which she threaded inch-square pieces of colored cloth in little bunches. By this means she produced her 7′ × 11½′ car-

pet, wall hanging, or whatever it may be, now at Vesterheim (210). It is the only known piece in its technique. Having been a dressmaker, Halvorson knew the art of creating with ready-made materials and brought this to a new dimension. She relates to Chris Moe in being an obsessive folk artist of the American type. And as with Moe, her art was the vehicle for a message. Hers is a declaration that faith is greater than the law, revealed through a text in Norwegian that may also be her own creation. After two years of almost constant work, she put the piece in a closet where it remained until an auction on the farm long after her death. She is the classic example of the isolated immigrant folk artist working apart from a community and, in this case, even in a technique and style unfamiliar to it. The language of her text too was losing familiarity. This isolation made the circumstances of the pre-revival immigrant folk artists totally different from those of their predecessors in Norway. Parallels are to be found rather among American folk artists. Even the nature of the works brings theirs to mind.

Widespread revival

The revival of creativity in Norwegian folk art traditions among Norwegian Americans and others in their communities during the latter half of the 20th century will be dealt with only in a general way. A precise historic account with reference to all the important individuals in it will not be attempted. Most of the especially accomplished participants are named in Appendix III as Gold Medal winners in the annual traditional craft exhibitions sponsored by Vesterheim since 1967. The traditional artists/craftsmen that have been brought from Norway by Vesterheim as teachers since 1967 and who have contributed much to giving the products of the revival their character are listed in Appendix IV.

The revival cannot be completely distinguished from the crafts activity discussed so far, much of which had direct links back to Norway through the individuals involved. In much of that there were already, if not precisely revival characteristics, at least elements of conscious clinging to something that no longer had an integral place in the culture but was looked on as psychologically, historically, and aesthetically important. The early retention, however, occurred among isolated individuals who had little or no awareness of each other. It was not a significant cultural element in the immigrant community as a whole.

What characterizes the revival is, first, that people who have been totally cut off from the arts and crafts traditions try again to link into them and, second, that this begins to happen among large numbers of people, which gives the phenomenon a community base. The surviving individuals from the earlier period, however, were naturally embraced by the new group. A third and major distinction of the revival period is that formal instruction in the techniques and styles of the old traditions, often given by artist/craftsmen from Norway, gets underway, and competitive competitions allow cross influences to occur and encourage high quality.

It is first in the revival that the production of material based on old folk tradition acquires a place in immigrant culture that has some relation to that which it had in the peasant culture. Now as then it serves aesthetic needs as well as symbolic, the latter relating to identity and prestige. It no longer conveys subtle messages to the group as details in traditional dress, according to Aagot Noss, originally had done, nor does it relate to magic powers. Scholars, however, generally agree that little of the latter remained in the folk arts of Norway during its high period, although certain motifs and practices in it developed when associations with magic were still present. The objects on which the art is now placed also seldom serve practical purposes as many of the originals had done. But, as mentioned previously, there had also originally been a large category that existed more for prestige and identification with a society outside the makers than for serving everyday needs. The revival material is in its function a continuation of this.

Much revival material is made for people of the group that produce it, as was true in the folk culture. Even the old custom of commissioning work so that the consumer has a say in the product is not uncommon. But a fair amount of the revival work also goes outside to people whose attraction to it is purely aesthetic. In this, it is a continuation of what happened in Norway during the last half of the 19th century. Much Norwegian folk art, as has also been mentioned, falls adequately within the framework of western art to have general appeal, not so much for its quaintness as for its sophistication.

The revival folk arts since the 1960s are especially marked by the academic. The desire among most of the people involved with them has been to get back to original sources. There was an awareness that much of the work by isolated individuals continuing what were essentially forgotten traditions had strayed far from the original folk art. Reestablishing contact with roots was an important motivation behind the revival. The response was overwhelming when Vesterheim announced classes by artists/craftsmen from Norway brought up in the old traditions, first rosemaling in 1967 and later woodcarving, weaving, and other crafts. Study in Norway, either in groups organized by

Vesterheim and other organizations or as individuals, has been extensive. The discovery of new sources appears to have been almost as important as production itself for the present generation of Norwegian-American artist/craftsmen working in the folk tradition. The Vesterheim competitive exhibitions, always with one of three judges being from Norway, has also contributed to this academicism. In spite of it, however, there is very little direct copying of old models. The more accomplished artist/craftsmen in the revival are creative within the tradition, much as the early folk artists had been.

The wood carving revival has the strongest links with the past because Halvor Landsverk (54), Leif Melgaard (57, 59), and Hermund Melheim (67–69) remained active into their eighties and nineties, overlapping at least thirty years of the broader revival. In wood carving, as mentioned, this did not get underway until the early 1970s. The three men represented highly different approaches to acanthus carving. Melgaard, who always had a strain of the academic, is the one who related best to the new movement. Hans Sandom can be considered a direct disciple (55). The romanticism and distinctive traditional style of Landsverk still stands somewhat apart, as does the free and daring manipulation of traditional elements found in Melheim's work. Two of the American-born acanthus carvers, Phillip Odden (76, 90) and Erik Rist Holt (51), have taken the full three-year course in traditional wood carving at the major school for this art in Dovre, Gudbrandsdalen, Norway, on which Melgaard too kept a close eye. Most of the wood-carving teachers from Norway (See Appendix IV) have also been products of this school. Holt represents the acanthus style in its pristine purity (51) while Odden has during the past few years moved toward a rougher style and introduced some of the playfulness and fantasy found in some early folk material (90. Cf. 74). It represents a direction that the revival may possibly take now that the original sources have been quite well explored and many of the techniques mastered.

Miles Lund has recently shown a departure from the academic in chip carving (20, 27) comparable to that of Odden in acanthus carving. The academic approach here too, however, is still being superbly represented by the creative Tim Montzka (26) and the self-taught but highly traditional Norman Seamonson (22).

In freestanding figure carving the earlier representative who relates most closely to the revival is "Ole the Hermit" (83). His flat-plane approach has come to dominate the modern period. Through the study of Swedish as well as Norwegian sources, Harley Refsal of Decorah, Iowa (85) has reached a level of accomplishment that has made him a mentor to many working in the style. It had since the 1930s been acquiring status as an American as well as a Scandinavian national style through the widespread influence of Swedish immigrant carvers. Some of the most powerful work is still being done by artists who have remained on the periphery of the academic, retaining a more primitive approach. Aaron Swenson is a classic example, recreating in his *Breaking Sod* (84) an image of specific pioneer ancestors. The roughness of the style is in complete harmony with the subject.

Textiles are the latest category of Norwegian folk art to experience a major revival in the Norwegian-American community, getting underway in the mid 1970s. Originally the weaves that had acquired national status in Norway, picture and interlocking square weaves, dominated. The latter has retained a place in the work of Jan Mostrom (103) among others. An amazing recent example of picture weaving is Nancy Jackson's *Battle of the Horse and Bull* (37) in which echoes of the famous 13th century Norwegian Baldishol tapestry, of banquet scenes in 17th century Norwegian pictorial coverlets, and of Picasso all come together in a strong statement about good and evil.

An interest in the complicated twills, overshots (114) inlays (112), and pile weaves (116) of the 18th and 19th centuries has characterized the last ten years of the revival. Turning to the original examples of Vestfold inlay weaves, most of which are in Tønsberg, Norway (111), led several immigrant weavers (112) to quite different uses of it than those in a 1930s Norwegian revival that has furnished the models for much later work. Lila Nelson (112) has based her work more directly on an 18th century example than have most American weavers. Americans have led in the creative use of the little-known coverlet technique called *"danskbrogd"* in Vest-Agder (109–110).

Since an interest in Norwegian knitting and Hardanger embroidery has existed well outside the immigrant groups in America through much of the 20th century, it is difficult to detect what in it belongs to a specific recent revival. One does, however, seem to exist. The center of Hardanger embroidery for the last several decades has been Fargo, North Dakota, although a major Norwegian-American embroiderer working in all traditional thread-count techniques is Grace Rikansrud of Decorah, Iowa. While generally academic in her approach, in 1974 she designed and made a dress of traditional cut for herself in which Hardanger embroidery is used in a non-traditional way (121).

Rosemaling is the art that most typifies the Norwegian-American ethnic crafts revival of the past thirty years, acquiring dimensions that far exceed those of the other arts. One must ask if this might not be specifically because it

was the one most immediately abandoned by the early immigrants and was also the one given the least attention in the late 19th century revival of traditional crafts in Norway. It was actually then looked on as too recent to be adequately rooted in Norwegian tradition (Sveen. In I. L. Christie, *Med egin hand*). An element of discovery may have contributed to the burst of interest in it that occurred in mid-20th-century America.

The ground was well laid for the academic revival of rosemaling beginning in the 1960s. Many fine examples were still present as models in immigrant communities because rosemaling was still a flourishing art in Norway during the early waves of emigration. People in Wisconsin, Minnesota, and Iowa had begun painting earlier under the influence of Per Lysne. University extension programs and vocational schools, primarily in Wisconsin, offered classes in rosemaling during the 40s and 50s. The instructors themselves, however, in these early experiments in ethnic craft education felt insecure about techniques and styles, knowing little more than what could be gleaned from a few books and from study of immigrant examples. Lysne did not teach nor did he share his techniques, which had already departed far from tradition, with many people. It is natural that anticipation was great when the first class by Sigmund Aarseth was announced at Vesterheim for July, 1967.

Although born on the west coast of Norway and living in Valdres, Aarseth had learned rosemaling in Telemark and brought that style with him. It laid the base for the revival of the art in America and is still strongly present today (181–183). Fortunately Aarseth was a man with confidence and energy who got his students to think big and work freely. This helped dispel a tendency toward the tight and detailed that was characteristic of the earlier immigrant work (201). It also taught the painters to bring personal character into their creations even when staying within a traditional style, something that Norma Getting (182) and Karen Jenson (183) have gained especially from.

Classes ranging from two days to two weeks in length have continued at Vesterheim, usually with two or even three teachers from Norway a year (See Appendix IV). Groups in other areas too have brought in Norwegian painters. The classes by them are also supplemented by those of American teachers, many of whom have received Gold Medal status through repeated awards in the annual national rosemaling exhibitions at Vesterheim (See Appendix III). The fact that these competitions have one judge from Norway may also add to the generally academic character of the movement.

The Norwegian teachers who have made the greatest impact other than Aarseth include Nils Ellingsgard, a painter with deep personal roots in the painting of Hallingdal. A number of his students have become masters of the style (158, 161, 163). As Norway's major scholar of rosemaling, Ellingsgard has in more recent years introduced styles from other areas of Norway. Best received of these is that of Peter Aadnes from the low country north of Oslo and his Valdres followers (148–153).

Bergljot Lunde of Sand, Ryfylke, around 1970 introduced her version of the Rogaland style that for a period had more widespread appeal among American painters than any other regional style. Out of it grew the most distinctively American rosemaling of the revival (193–195). Vi Thode of Stoughton, Wisconsin, was instrumental in its development (193), and it has been internationally propagated from there by Gary Albrecht. It became formalized to the point of being easily taught and has therefore served as an introduction to rosemaling for many painters who have later gone on to freer styles. Trudy Peach of Monticello, Minnesota, has further developed American Rogaland and introduced design elements from other traditional Norwegian art to it that have led to works of great imagination and beauty (195. Cf. 132).

The style with which Lysne was most intimately familiar, that of Os (197–198, 200, 202, 204), has never been taught by a Norwegian in America. The style is also too late and, in a sense, too simple to have been given much attention in Norway, but Ethel Kvalheim painted superbly in it before Aarseth brought her into Telemark, and Norma Wangsness of Decorah has long painted in the style with some of the whimsical lightness characteristic of original work (203). Her inspiration has been largely early examples that found their way to America. Jo Sonja Jansen was the first to include it in an instruction book on rosemaling, but her forte is creating designs with total disregard for regional consistency that get their unity through what she brings to them. Her wedding bowl (164), based on her personal mythology of marriage, masterfully brings Medieval dragons, Hallingdal flowers, acanthus carving, and products of her own imagination into a remarkably consistent artistic statement. It is an example of totally digested heritage.

CONCLUSION

How and why the physical manifestations of a folk culture would and could be so fully reabsorbed by fourth, fifth, and sixth generation descendants of the people who had brought it into being under totally different cultural circumstances is a question with no simple answer. An ethnic

group's need for identity appears to enter in, because the waves in Norwegian-American arts and crafts activity have followed those of ethnic awareness in other immigrant groups as well. It was building in the 30s, was cut off by World War II, and broke through with full force in the 1960s and 1970s. There has been no substantial decline in the movement since. The melting pot concept all over the world has proven to be built on a shaky psychological and sociological foundation. A recognition of the country's cultural diversity is slowly gaining ground in America.

But why is it precisely the folk arts that are given such prominence by the Norwegian Americans in expressing and establishing their identity in the New World? The visual and tactile, that is, the material, has traditionally had a prominent place in the folk culture of Norway. Music and storytelling were also highly developed, but they were not as integral a part of the culture here as, for example, in Ireland, where the *material* culture of the rural people went little beyond the purely functional. Halvard Bjørkvik relates the folk arts of Norway closely to peasant pride in land ownership. Where the tiller owned his land, the folk arts thrived best. Pride and prestige relating to ownership had a formative place in Norwegian folk culture, and that can best be expressed through the material, the visual. The medium, so to speak, becomes the message.

Norwegian farmers had a special reason for wanting to make visual display of who they were and what they possessed. They had long lived as second-class citizens in a country dominated by a foreign power represented locally through a small and largely urban elite. Folk art was an almost subversive expression of self-esteem on the part of the farmer. Behind the flourishing of it during the late 18th and early 19th centuries may also have been an underlying awareness among rural Norwegians of gradually winning out, of being on the threshold of recognition as the cultural essence of the subjected nation that was by steps moving toward independence.

Pride, prestige, identity, and the dream of acquiring a place in that better world outside theirs were all part of what gave Norwegian folk art its character. They are also the concerns of immigrant ethnic groups in America who find themselves outside the culture of old-stock Americans. The immigrants from Norway inherited in the folk art of their ancestors a symbolic language ready made for their needs. The tendency toward the large and the imposing in early Norwegian material (1, 50, 148, 130, 180), partly an inheritance from Baroque Europe, was continued by the immigrants. The monumental Engeseth cupboard (154) with the names and dates of the owner in a very prominent position is the perfect document of this, as is the more recent Karen Jenson bed (183). It may be significant that though Swedish in background, Jenson turned to Norway for the symbols through which she has made her strongest ethnic statement.

The tasteful geometric burnt decoration that was the most widespread type of ornament on early wood objects (141–143) was never continued nor revived by the immigrants. Its visual message is not strong enough to serve the needs of pride and identity. Even chip carving (15–27) was slow in finding a place in the revival and has remained an art of a few exceptional individuals. The limited attention given these by the immigrants or by 20th century Norwegians is one of several reasons for the unbalanced picture that now exists of the relationship between the geometric and the organic in Norwegian folk art.

But the effectiveness of the organic strain in Norwegian folk art as a symbol of pride and identity does not completely explain the extent of the revival and what there was of retention. In our age of mass culture the individual longs for a means of personal expression. This is exceptionally true of women, whose lives often do not allow for the degree of communication available to men through their work and such play as sports and hunting. The hobby craze is a consequence, and the ethnic craft revival definitely links into this. Its broad base is essentially there. Two needs are satisfied with one activity. But such crafts as acanthus carving, rosemaling, and traditional Norwegian weaving, when practiced creatively rather than imitatively, offer such technical and aesthetic challenges and such unlimited possibilities for development that the individuals with ability and exceptional need, either for ethnic identity or personal expression, tend to rise out of the hobby level. They approach that of professionals in proficiency and visual communication.

The ethnic artist/craftsmen who do excel find customers and get commissions because feelings of ethnic pride, or the need for identity can be satisfied by owning as well as creating the proper symbols. In Norway, in fact, it was not so much the cultural needs of the producers, who were generally from the lower levels of society, that found expression in the folk arts as of the commissioners, members of the rural establishment. The icons, which in a sense represent a meeting of the producer and the consumer, however, contribute both to further unity in the group and to distinguishing it from whatever is outside. This was as true in Norway as it is among immigrants today.

The above explains the revival primarily in ethnic terms, but there must be more to it. A survey of the partic-

ipants in an exhibition of recent American work in the Norwegian folk tradition held in 1989 showed that only one-half of the blood in the artists' veins flowed from Norway. Some of the artists were completely non-Norwegian in background, some completely Norwegian, and many part Norwegian and part something else. The strongest outside element was German. The Swedish and Danish element, strangely enough, was minor. Among purchasers of the material, the outside element would undoubtedly be even greater. It is very high among collectors of early Norwegian folk art.

We get back to the cosmopolitan nature of much Norwegian folk art with its close relation to international Baroque and Rococo. No great leap has to be taken for anyone in the western world to appreciate or even produce it. This must contribute to the extent of the revival and the level of quality attained in it. Norwegian folk art is an art of tradition with distinctive characteristics that make it serve group needs, but that tradition is adequately near mainstream western art for it to survive and have a public greater than its own people even when transported to a place with circumstances quite different from the specific ones to which it owes its origin.

SOURCES

This essay is based almost exclusively on primary research. The specific sources of much information are given in the footnotes of Marion Nelson, *Norway in America* (Decorah: Vesterheim, 1989). The most significant secondary source material has been the work of Kristin Anderson on Per Lynse and immigrant altars listed in the bibliography at the back of this volume.

MARION NELSON is Professor Emeritus, Art History, University of Minnesota, Minneapolis, Minnesota, and Director Emeritus, Vesterheim, Norwegian-American Museum, Decorah, Iowa.

Figure Carving from Acanthus Times and After

72. Hanging wall cupboard with painted inscription and carved scene of the Whore on the Beast from Revelation and miscellaneous animals. Norw. Ole Olsen Sletten (1799–?). Painted by Ola Feten (1808–1894), Ål, Hallingdal. 1835. Painted wood. H. 53⅛″ W. 44″ D. 18⅞″. Translated inscription: "Stag Raven Lion Griffin Wolf Bear Crocodile Dragon In Revelation The Animal with 7 Heads and 10 Horns." Norsk Folkemuseum (NF 1910–841).

Engebret (71) was twenty and still in Norway when this exotic creation came into being on a farm in his neighborhood. The heraldic lions eating on a tree must have migrated in his memory and reappeared in central Minnesota. Those on a slightly smaller cupboard (H. 50½″ W. 41¾″) at the Norwegian Folk Museum (NF 1892–312) made by Ole Sletten the following year (72a) are in treatment even nearer the lions of Engebret carved in America (Cf. detail of 71). Some animals on 72 are drawn from Comenius' *Orbis sensualium pictus*, Danish edition, 1672. (Landsverk)

73.

73. Spouted ale tankard (*tutekanne*) in stave construction with carved and painted figures. Norw. Iver Gundersøn Øvstrud (1711–1775), Rollag, Numedal. Ca. 1750. Painted wood. H. 13″ W. 12½″ Norsk Folkemuseum (NF 1915–0.1102).

With the acanthus came a more intimate and less decorative approach to the figure than is found on the benches and horns (38–39). Inept attempts at realism now gave figures quaintness rather than heroic distance. Øvstrud is an extreme example of the new direction.

74. Carved toy horse and rider on wheels. NORW. Kristen Listad (1726–1802). Sør-Fron, Gudbrandsdalen (See also 56). Late 18th century. Painted spruce. Some restoration. H. 15″ W. 17½″ D. 6½″ Sandvigske Samlinger, Maihaugen (9773).

The childlike gaiety and expressiveness in Listad's figures made them excellent toys, and he produced many.

74.

75. Hobbyhorse. Norw.-Am. Wemark family, Calmar, IA. Ca. 1860. Pine, hardwood. H. 20″ W. 30″ D. 7½″ Adeline Haltmeyer Collection. John Haltmeyer.

Carved horses for children have a long tradition in Norwegian folk art. Familiarity rather than symbolic significance undoubtedly accounts for this. The immigrant example here made for riding could have been inspired by commercial hobbyhorses since the concept came late to Norway.

76. Hobbyhorse with acanthus carving. Norw.-Am. Phillip Odden, Barronett, WI. 1994. White pine. H. 23½″ W. 53″ D. 20″ Translated inscription: "Ride on, ride on. The horse's name is Blanke." Phillip Odden.

Odden, who is half Norwegian, here carries Listad's combination of the horse and the acanthus (56, 74) to its ultimate. Attraction to Norway's folk tradition led Odden to the school at Dovre, Norway, as it did Holt (51), from which he too graduated in carving.

75.

76.

77. Carved figure of soldier on horseback with dog. NORW. Møre og Romsdal. Ca. 1850. Painted wood. H. 18¾″ W. 14¾″ D. 10½″ Norsk Folkemuseum (NF 1927–398).

Fascination for the military comes out in much Norwegian folk art. A military figure painted on or near the entrance often served as a guardian for the house. The one shown here with his barking dog may have only amused a child.

78. Carved figure on horseback. NORW.-AM. Anonymous Norwegian immigrant, southern MN. Ca. 1900. Birch. H. 6¾″ W. 5½″ D. 1¾″ Adeline Haltmeyer Collection. John Haltmeyer.

Wearing even the same style of hat as his Norwegian predecessor (77), this cavalry officer carved by a Norwegian American in Minnesota, is probably the immigrant Civil War hero Colonel Heg of the Fifteenth Wisconsin Regiment. The high arch of the horse's neck suggests stylistic carryover as well from Norwegian tradition.

78.

77.

79. Carved horse. Norw.-Am. Hans Engan (1833–1917), Spring Grove, MN. Ca. 1890. Painted wood. H. 6¾″ W. 7¾″ D. 2⅜″ Roger and Shirley Johnson.

Of several Norwegian-American horse carvers in southern Minnesota, Engan is the earliest known by name. His models are clearly American draft horses which he realistically interprets, but a unifying elegance of line speaks of lingering tradition.

80. Carving of Norwegian horse with elves: *Little Rascals*. Norw.-Am. Becky Lusk, Coon Valley, WI. Signed and dated 1993. Partly stained basswood. H. 8½″ W. 9″ D. 4¾″ Vesterheim (93.75.1).

Norwegian-American horse carving long continued as a pastime. Younger people are now taking it up more professionally along with other carving. Lusk is a thirty-year-old farm wife who began carving at fourteen under the tutelage of her immigrant grandfather. The Norwegian horse and the elves reveal romantic motivation.

81.

82.

83.

82. Two male figures in flat-plane carving. NORW. Olav Bakken, Gransherad, Telemark. Early 20th century. H. 8″ and 8 ⅝″ Painted wood. Fylkesmuseum for Telemark og Grenland.

Much Scandinavian figure carving after 1900 underwent a change from smooth to faceted surfaces. This may have been a response, felt early in Sweden, to the broken surfaces in the modern fine arts. The new direction is seen in these Telemark farmers in the dress of two economic classes.

83. Immigrant man and woman in flat-plane carving. NORW.-AM. Ole "The Hermit" Olson (1882–1966), Valley City, North Dakota. Signed. Ca. 1945. Pine. Man: H. 7¼″ W. 1⅞″ D. 1½″ Woman: H. 5¼″ W. 2¼″ D. 1½″ Vesterheim (88.58.1 and 88.58.6).

The so-called "flat-plane" carving gained popularity in America through immigrant Swedes. Perhaps because of its relationship to amateur whittling, it has become the dominant technique in American figure carving. This unpretentious folk artist of Norwegian origin created touchingly human figures with it.

84. Carving: *Ola and Nils Breaking Sod at Washington Prairie, 1854*. Norw.-Am. Aaron Swenson, Flom, MN. Signed and dated 1988. Partly stained pine and oak. H. 9" W. 25⅛" D. 5½" Vesterheim, gift of Aaron Swenson (88.59.1).

Carving out of deep personal feeling for his immigrant past, Swenson achieves the simple power of his forerunner "Ole the Hermit" (83). As a resident of rural Minnesota, he knows the anatomy of both the immigrant farmer and his animals. This is conveyed through a minimum of cuts.

85. Carving: *Man and Woman Hauling Wood*. Norw.-Am. Harley Refsal, Decorah, IA. Signed. 1987. Partly stained oak and pine. H. 8⅝" W. 22" D. 5½" Vesterheim, gift of Franz Richter (88.94.1).

Refsal is the Norwegian-American master and major promoter of flat-plane carving, having brought it to students all over the country and having taught it in Norway. Mechanization there for souvenir production has led to some of the best work now being done in America.

84.

85.

86. Candlestick in the form of a lion. Norw. Possibly Olav Skolaas. Hyllestad, Setesdal. 1830–1840. Painted wood. H. 12¼″ W. 11¼″ D. 4¼″ Norsk Folkemuseum (NF 1897–38).

Functional folk objects often take animal shapes. Thought to stem from aquamanilia (water containers used in the church), candlesticks in the form of lions are largely a Setesdal phenomenon of about 1830. The whiplash tail has long Norwegian tradition.

87. Ale bowl in the form of a standing rooster (*ølhane*). Norw. Telemark. Painted wood. H. 13¾″ W. 15⅜″ Norsk Folkemuseum (NF 1906–1951).

This object relates to aquamanilia (See 86) even in its function as a vessel for liquids. The neck is a spout with its opening on top of the head. The type is rare, and this is one of the most rhythmically stylized examples.

88. Carved hen. Norw.-Am. Immigrant artist, Fertile, MN. Ca. 1930. Painted pine. H. 8¾″ W. 8″ D. 5¼″ Don and Nancy Gilbertson.

Although non-functional, this figure is included here to compare immigrant with Norwegian folk art (87). The high stylization is gone, as is the relation to use. The treatment of the comb has Norwegian prototypes, but the piece is primarily a naive rendition of the bird observed in nature.

88.

87.

89.

90.

89. Ale hen (ølhøne) with acanthus carving. Norw. Lesja, Gudbrandsdalen. Ca. 1800. Painted birch. H. 9¾″ W. 13⅞″ D. Ca. 8″ Sandvigske Samlinger, Maihaugen (SS.DS.1895:7).

Since ale bowls in the shape of hens belong largely to Telemark and Setesdal, examples with Gudbrandsdal acanthus carving are rare. The body here acquires the voluptuous grace of an acanthus scroll, making the actual acanthus tail seem quite appropriate.

90. Ale hen (ølhøne) with acanthus carving. Norw.-Am. Phillip Odden, Barronett, WI (See also 76). Signed and dated 1994. Stained linden. H. 7¼″ W. 17¼″ D. 6″ Phillip Odden.

Combining various elements in Norwegian folk art—the acanthus, the bird-shaped vessel, and a tendency toward primitive exaggeration—the young Gudbrandsdal-trained Norwegian-American Odden arrived at this fanciful creation. He advocates retaining the freedom within tradition that characterizes early work.

91. Ale goose (*ølgås*) with outstretched neck. Norw. Telemark. 1800. Painted wood. H. 5″ W. 15¾″ D. 4″ Norsk Folkemuseum (NF 1895–1151).

Of the many treatments given birds in Norwegian drinking vessels, attenuation is one of the less common. The result is a shallow dipper rather than a bowl.

92. Match and cigarette holder with pheasants. Norw.-Am. Alfred Anderson (1875–1956), Fosston, MN. 1940s. Painted wood. H. 6¾″ W. 24½″ D. 6¾″ Minnesota Historical Society.

Remarkably similar attenuation to that found in the dipper (91) recurs in the pheasants added as decorative elements here by an immigrant folk artist in northern Minnesota. Direct connection is not likely, but a common approach to form is evident.

91.

92.

93.

93. Ale goose (*ølgås*). Norw. Telemark. Early 19th century. Wood. H. 6⅛″ W. 7¼″ D. 4″ Norsk Folkemuseum (NF 1992–504).

The characteristics of geese, hens, ducks, and swans tend to merge as composite birds with their own aesthetic unity in many Norwegian drinking vessels.

94.–95.

94. Red-breasted merganser hen decoy. Norw.-Am. Harald Thengs (1893–1974), Long Island, NY. 1930s. Painted wood. H. 7″ L. 18″ D. 5¾″ Gene and Linda Kangas.

95. Old squaw drake decoy in winter plumage. Norw.-Am. Harald Thengs. 1930s. Painted wood. H. 7″ W. 18″ D. 5¾″ Gene and Linda Kangas.

Although decoys must be adequately realistic to convince their real counterparts to join them, those of Thengs, a Norwegian from near Egersund who spent thirty-two years on Long Island from 1929, have some of the generalized elegance of the Norwegian ale birds. The tendency toward graceful attenuation found in 91 is especially evident. Thengs would probably not have known decoys from Norway because they arrived late there, perhaps from America.

96. White-winged scoter drake silhouette decoy. Norw.-Am Harold Thengs (1893–1974), Long Island, NY. 1930s. Painted plywood. H. 13¾″ W. 26⅜″ D. ⅜″ Samuel Thengs.

96.

Perhaps the size of this sea duck found north of Long Island led to the two-dimensional execution of the decoy. The type, easy to make and transport, existed before Thengs' time. When in use, the base (not shown in this photograph) fits into a wood block. The decorative stylization again relates to Norwegian tradition.

97.

98.

97. Ale duck (*øland*). Norw. Fjotland, Vest-Agder. 18th century. Wood. H. 7⅞″ W. 14⅝″ D. 6¼″ Norsk Folkemuseum (NF 1923–2017).

While graceful rhythm characterizes Telemark's ale birds, an emphasis on mass and geometrically stylized detail is more typical of those from Vest-Agder.

98. Ale hen of Setesdal type. Norw.-Am. Gene and Lucy Tokheim, Dawson, MN. Marked and dated 1994. Stoneware. H. 8¾″ W. 14¼″ D. 6″ Gene and Lucy Tokheim.

Vessels for liquids in western cultures are often ceramic. This young Norwegian-American couple has transferred the characteristics of Norwegian wood vessels to turned and modeled stoneware.

99.

99. Ale goose (*ølgås*) with rosemaling. Norw. Telemark. Early 19th century. Painted wood. H. 5¾" W. 7¼" D. 3½" Norsk Folkemuseum (NF 1992–661).

The fluid lines of the ale birds, sometimes used for dipping drinks from a large communal bowl, made them excellent vessels for rosemaling. The painter took his point of departure from the bird's shape, giving token recognition of such realistic details as the wings.

100. Ale bird with rosemaling in Telemark style. Norw.-Am. Carver: Becky Lusk, Coon Valley, WI. Painter: Jean Giese, DeSoto, WI. Signed and dated 1994. Basswood. H. 8" W. 12½" D. 6⅛" Translated inscription: "With a bowl in my hand and a friend at my side the days of life pass happily. 1994." Jean Giese.

Norwegian Americans emulate well the organic strain in Norwegian folk art (See also 10). This ale bird, like many Norwegian examples, gets its unity through form rather than reference to an actual bird. The painting, done by the carver's mother, ignores realism but still relates comfortably to the object.

100.

The Social and Economic Background of Folk Art in Norway

Halvard Bjørkvik

This essay concerns Norway as geographically defined today but covers the period from about 1500 to 1870. Until the middle of the 1600s Norway also included three Swedish counties—Båhuslän, Jämtland and Härjedalen—which are not going to be dealt with.

At the beginning of the period, about 1520, the population of Norway was around 170,000, approximately that of an average Norwegian city today, larger than Trondheim but smaller than Bergen. There were only five or six areas of dense population that had the status of towns. Altogether their population totaled just under 13,000. The great majority of the 170,000 people were scattered throughout the countryside. Earlier, just before 1350, the population had been considerably larger, possibly 430,000, but it was greatly reduced by the plague of 1349 and other epidemics that followed.

If we could step back in time to 1520, we would find a few settlements in which the farms are clustered fairly close together with large uninhabited areas between. The total number of farms at the time was probably not over 23,000. Most of them were in outlying regions where fishing was easily possible or in the center of the best agricultural districts. The distance between the populated areas was greater inland than on the coast, but in both we would have found remains of deserted farms which probably would have been used for grazing or cutting hay after they were abandoned in the late Middle Ages. After 1520 people began returning to these farms, a sign that the population was increasing. Two or three generations later, about 1600, the population had reached 260,000, and after another two generations, about 1660, it had grown to 440,000, just exceeding the pre-epidemic level of the late Middle Ages. This did not happen until toward the end of the 1600s. The increases continued: 510,000 in 1701, and 883,000 in 1801. The first million mark was reached in 1822, and the second in 1890. By that time, however, the relationship between rural and urban areas had completely changed.

During the 1500s and 1600s rural and urban areas experienced about the same rate of growth, while in the 1700s the cities showed a greater increase, somewhat over 100 percent as compared to 74–75 percent in rural areas. As late as 1800 only something under 10 percent of the people lived in cities, but from then on urban and rural areas experienced quite different rates of growth. While the population in the rural areas during the first part of the 1800s increased by 50 percent, the increase from 1850 to 1900 was only half that and occurred primarily in the 1850s and the 1890s. During the middle decades, 1860–1890, there was almost a standstill, with the years from 1865 to 1875 showing an actual decline, largely due to the great waves of emigration at the time.

A completely different development, on the other hand, took place in the cities, where an increase of 150 percent was experienced before 1850 and as much as 250 percent during the last half of the century. In 1875, the end of the period with which we are concerned, the population of cities had reached 23 percent of the total for the country. With 77 percent in rural areas, however, Norway was still basically an agrarian society. But circumstances in both the towns and the country were now totally different from what they had been 350 years earlier.

What strikes one first is that the social structure was much more complex in 1875 than in 1520. Agrarian society had not been completely homogeneous then either; there were divisions of both an economic and a social nature. One was between the people who owned their land and those who rented it. Only about 30 percent of the land was owned by farmers in 1520; the rest was owned by the king,

Fig. 13. *Setesdal Storehouse*. Olaf Isaachsen (1835–1893). Painted on the Ose farm (See Fig. 14), Valle, Setesdal. 1878. National Gallery, Oslo. Photo: O. Væring.

the church, the nobility, or the bourgeoisie. Before about 1660, the peasantry was unable to gain title to more land; an actual decline can be detected in some districts. This indicates that the situation for farmers was not good; taxes were higher, and the growing population was putting greater pressure on the agricultural resources.

The major change for farmers came after 1660 when the state began selling land and property to pay off the large national debt accumulated during the wars with Sweden. Most of the land that the state sold was to creditors, well-to-do citizens of both Norway and foreign countries. Initially, therefore, nothing happened other than a change in ownership, which was not necessarily to the advantage of the farmer. The bourgeois proprietors looked on the farms as commercial investments from which they wanted to get the greatest possible return. The tenants were therefore pressed to the limit. Since the prices of farm products were high from the 1650s on, it was profitable to maintain ownership of the land as long as the revenue from the tenants was paid in kind. Toward the end of the century, however, this changed, and it became more lucrative to invest in other business enterprises, for example, mining. In addition, the authorities began passing legislation to hinder gross exploitation of tenant farmers.

The result was that proprietors began to sell farms, and the tenant farmers were able to buy their way to freedom. This process continued until close to the end of the 19th century. By 1835 nearly 70 percent of all farmers owned their land. Only in northern Norway, where fishing was the major enterprise, and in the domain of the Count of Larvik (today the county of Vestfold), which was patterned on the Danish structure, were there more tenant farmers than freeholders. By 1870 the tenant farmer system had come almost completely to an end, but for many people the result was no better then than it had been before, and often worse. Interest on the mortgages they had taken out was often as hard to pay as the previous rents. But the transition to ownership had significance beyond the economic.

There were great differences among geographic areas as to who owned the land, and changes in these differences also occurred but followed a clear pattern. Historically, there was a well-defined area of privately owned farms in the inner districts of the southern counties called Agder (including Setesdal), the upper districts of Telemark, and the adjoining valleys of eastern Norway. Here the amount of operator-owned farmland in 1520 and 1660 reached 70 percent and more, and it was also in these areas that one finds the highest proportion of land-owning farmers in 1835, over 90 percent. By this time farmers in the rich agricultural and lumbering districts of eastern Norway and in Trøndelag had also been able to buy land, bringing the percentage of farm ownership in these areas fairly close to that in the areas mentioned above.

What did it mean to be a tenant farmer? Personal freedom was not the issue. A tenant farmer was, in fact, guaranteed by law the same individual rights as one who owned his land. The tenant farmer also had full jurisdiction over the farm as long as he paid the stipulated rental fee and kept it from going to ruin. The restrictions which did exist related to the forests and did not come in until lumbering became a profitable industry in the early 1600s. Lifetime rental contracts were common and, with certain exceptions, the occupant could count on his son being able to carry on after him. Eventually also daughters and sons-in-law acquired the right of such inheritance.

But the renter lacked one thing that the freeholder had, the joy of knowing that the farm to which he was bound and the earth with which he struggled was really his. Neither could he share with the freeholder the pride of being able to pass on actual property nor the absolute assurance that what he put into the farm would be of benefit to his descendants. It cannot be coincidental that most of the log buildings that have survived from the Middle Ages, about 170 of the total 230, are located in the areas mentioned above where most farmers owned their land. When a domestic log building from the Middle Ages has withstood the centuries and still stands today, it cannot be only because of good timber, skilled craftsmanship, and favorable climate. We must also consider the owners who have taken the trouble to keep the buildings in good repair. It is no surprise that the stately Ose storehouse from about 1700 at the Norwegian Folk Museum (Fig. 13, interior, and Fig. 14), an example of wood craftsmanship at its very best, was erected on a farm in Setesdal which had been owned by the same family for many generations. What we see here is an illustration of how deeper values relating to a total socioeconomic milieu lie behind significant aspects of Norwegian folk art.

There was also great variety in the economic structure and farming methods in the agrarian society, those in the rolling landscape of Hedemark being different from those in the mountainous areas, and those in the fjord country of western Norway being different from those in the farming/fishing regions of northern Norway. Even within a single community, social and economic divisions could exist between large and small freeholders. The big farmers, both those who owned their land and those who rented, were the natural leaders in the community. To a great extent, a community was an independent entity with a bailiff (*bondelensmann*), a number of jurors (*lagrettes-*

Fig. 14. Setesdal farmstead with storehouse from Ose on the left (See Fig. 13). 18th century. Norwegian Folk Museum. Photo: Norwegian Folk Museum.

menn), and one or two sextons (*kirkeverger*) playing the major roles. These were generally large independent farmers. The juror presided over the local judicial assembly. From the end of the 1500s this was done together with the chief magistrate (*sorenskriver*) of the district, and the officers also had to carry other responsibilities. The sexton was responsible for the maintenance of the church building and other church properties. Later the pastor also got his own personal assistants who were chosen among the farmers and who acted as a link between the common people and the clergy. The judicial assembly had regular sessions which became natural gatherings for the entire community. At these, common people could meet with a representative of the king, the tax collector, who came with his royal demands and proclamations. It was here that the people heard the latest news of the community and the world outside.

During the 1500s, 1600s, and most of the 1700s, only small changes occurred in farming operations. Farmers from the plains of Hedemark in the east and also from the fjords of inner Sogn to the west sowed the same patches of land year after year. The Hedemark farmer, who had larger areas of open land, could allow certain fields to stand fallow every third year so the ground would replenish itself. The farmer in western Norway did not have enough land to farm in this way. He cleared small patches wherever it was possible between boulders, projections of groundrock, and rock slides in the mountainous terrain, and these fields were cultivated year after year, generation after generation. The expansive mountain and highland areas provided pasture. Food for the cattle during the long winters had to be brought in from remote spots. This had to be supplemented with leaves and bark stripped from trees. The pattern of activity throughout the year also included hunting and fishing with the goal of everything being to maintain the highest degree of self-sufficiency.

For most people leisure time was an unknown concept. They had to produce a large part of their necessary tools and utensils themselves: a sled had to be constructed, a mangleboard carved (21, 56), trawling nets made and mended, bird snares and animal traps repaired. If a house was to be built, the farmer got assistance from a local carpenter. Plowshares and other large equipment could generally be put into shape at the forge of the local smith. For large projects like roofing, the farmer could usually depend on assistance from his neighbors. Working together was accepted as a natural part of daily life. Occasionally in the evening the men would sit around the hearth and carve

things, more out of impulse than from necessity, while the spinning wheel whirled and a shuttle went back and forth in another part of the room. The woman's day, however, was generally completely taken up with housekeeping, caring for children, or working with the animals. The cattle, sheep, and goats were her responsibility, and during the summer she also helped with haying and growing potatoes. In western Norway women could be in full charge of the farm as well as the house when the men went north for long periods to fish. Married women became the family members with the most strictly limited time, but they thereby also gained a position of central control in everyday life.

Many a rural craftsman showed great artistry with his knife or at the forge, resulting in richly decorated mangleboards, chests (48) and cupboards (49–50), beautiful metal for furniture, keys, and the like. In the same way, deft young women could dye yarn with colors boiled from leaves and heather and later weave them into coverlets with pictorial (32–34, 36) or abstract designs (101–102, 104–105, 107–109, 111, 113, 115). Wealthy farmers were able to employ others in the community to do this kind of work for them. Craftsmen also sold their own products.

The situation was slightly different for the farmer/fisherman in the north. Their economy was based on trade and they were to a greater degree dependent on imports, even for such things as grain. But neither could the more southern farmers who aspired to self-sufficiency live totally unto themselves, cut off from the outside world. They could not produce everything they needed. Inland settlements had to get salt, and in several places along the coast there was insufficient arable land to produce the grain needed for flour. In the mountain settlements farmers could not count on the grain maturing every year. Well-traveled early roads indicate the lines of contact between the east and the west as well as between the inland valleys and coastal areas. People from different regions met at markets which were regularly organized at various places in Norway. In addition to exchanging wares farmers sold surplus products as well as things produced apart from their regular occupation. In western Norway they commonly made wooden barrels for salted herring; in Selbu, Trøndelag, they ground millstones; some places they burnt tar. Objects that we now consider folk art could also be sold at the market.

The roads that connected rural communities with towns were many and much used. The representatives of the king—the county governor, the judges, and the superintendent or bishop—all lived in the towns. People from near and far would not infrequently seek out the county governor to register grievances. The farmers who were appointed to the position of jurors had to be first sworn in by the presiding judge. This took them to a chartered town, the administrative center of the diocese, where the civil courts, which tried marital cases among other things, met. For centuries until the car and the train took over, both civil servants and large farmers sent traveling representatives on buying and selling trips to commercial centers. This is how people from the countryside became acquainted with other environments and other cultures and how they got impulses from the art of churches, from ironworkers, from silversmiths, and from the interiors of wealthy homes. The impulses that the farmers received could lead to new forms of creative activity when they returned to their rural districts.

The contacts could also go beyond the nearest city. For centuries Norway was in a political union with one of its neighbors, until 1814 with Denmark and after that to 1905 with Sweden. The Dano-Norwegian union, which went back to the late 1300s, was a real working union under the Danish crown. The king lived in Copenhagen, the location of the central administration, and the official language in Norway was Danish. However, the daily life and the conditions in society in the rural districts were only slightly affected by the Danish connection. The traditional forms of Norwegian culture continued, and Danish, which was the written language, never gained a complete foothold. One consequence of this political arrangement, however, was that Norwegian rural districts also gained access to the larger outside world. If the Norwegian farmers decided that something was unreasonable, such as a tax collector's proclamation of new taxes, they could send a delegation to Copenhagen for an audience with the king himself, referred to by them as "the father." Many Norwegian soldiers were sent to Copenhagen and to Holstein on the Danish border with Germany, where they learned a lot both good and bad.

The independent position of the Norwegian farmers became evident in 1814 when Norway was separated from Denmark as a consequence of the Napoleonic Wars. Norway was then joined with the Swedish crown but was, aside from that, an independent country with its own constitution and its own parliament, called "*storting*." In this the farmers were given the largest representation. Norway became completely independent in 1905 when the union with Sweden was dissolved and the country got its own king.

The sea was the connecting link between the coastal districts and the rest of Europe. From the early 1500s traffic between southern and southwestern Norway and Jutland

in Denmark was lively, and up to 1662, when Stavanger received new privileges, Scottish merchants came to the districts of southwestern Norway and bought timber directly from the farmers. Connections between southern Norway and the Netherlands were even closer, especially from the middle of the 1600s. The result of these connections is evident in the tax records from the beginning of the 1500s, when English clothes and textiles from Leyden and Deventer in the Netherlands were used as payment in kind along with grain, butter, and other goods that the farmers produced themselves. Young Norwegian men worked on Dutch ships and young women from settlements in Agder might hire out for several years as servants in the homes of merchants in Amsterdam. When they returned to Norway, they brought back new ideas and they shared their impressions from abroad. Dutch furniture found its way into both rural and urban environments in Norway, and foreign influences are evident in Norwegian rosemaling (191), woodcarving, and wrought iron.

Not all the Norwegians who left returned to Norway. Many died at sea, others settled down and became permanent residents abroad. Church records in Amsterdam show that between 1600 and 1800 close to 20,000 Norwegian women and men—mainly from Agder—got married there and were registered in the city's parishes. This migration was a significant prelude to the emigration to America that began in the 1820s.

By the end of the 1800s, most farmers were independent, but the difference in circumstances between the large landowner and the small one was greater than ever. Until the middle of the 1800s the expansion in population had to be absorbed within the agrarian economic sphere. From the second half of the 1600s, when most of the deserted farms from the late Middle Ages had been reinhabited, the struggle over resources was fierce. This led to a restructuring of the agrarian economy with a partitioning of the farms into several units and to the formation of a cotter (*husmann*) class. The new divisions resulted in smaller units of production, but this was to some extent compensated for by agricultural advances that occurred near the beginning of the 1800s: improved methods of cultivation; the introduction of new plants, such as potatoes, and of a greater variety of seeds; and better equipment. The final restructuring of Norwegian agriculture began in the second half of the century with a movement away from the earlier self-sufficiency toward an agriculture based completely on the production of commodities.

The cotter system, which had roots going back beyond 1660, gained prominence in the following century. A cotter was a person who did not own a farm but was given a plot of land by another farmer where he could have some animals and plant some grain and potatoes, which were introduced around 1800. Both independent farmers and tenant farmers were allowed to set up cotters. The rent for the plot of land was often paid in work, occasionally with money or a combination of the two. The largest number of cotters were found in eastern Norway and in Trøndelag, where the largest farms were located and where help was most needed. In these areas the cotters were more dependent on the farmer than in other places, and since contracts were seldom written, the cotter was often dismissed on short notice. Church records document the frequent migrations from farm to farm of cotters and their families. In 1723 there were a total of not quite 12,000 cotters' plots, compared to 67,000 farms. By 1801 the numbers had increased to 40,000 compared to 78,000 farms, and in 1855 there were 65,000 cotters' plots and about 110,000 farms. The growth of cotters as a class culminated in the 1860s and quickly decreased in the years that followed due to emigration to America and migration to industrial jobs in the cities.

The increase in numbers of cotters reflects the growing distance between the extremes in the social layering of Norway's rural inhabitants. The transition was subtle, however, with no clearly marked lines between the different groups—large farm owners, small farm owners, and cotters. Other groups within agrarian society had an even more tenuous position than the cotter. First came the sizable group of day laborers and servants, more than 170,000 in 1801, recruited to a great extent from the large cotter families. Second came individuals who fell in a sense completely outside the society, the sick and the old who could not take care of themselves and who had no family to accept responsibility for them. These developments led to conflicts and tensions in the rural society that far exceeded those at the beginning of the period of our concern, and they were also of a more serious nature.

The gains in agriculture resulting from what is commonly referred to as the Industrial Revolution also led to some significant losses. The solidarity that had developed in the working community and its social relations were destroyed. The old spirit of helping each other disappeared. Cheap, easily accessible industrial products replaced home-crafted tools, implements, and utensils. These were either thrown on the scrap heap or collected by museum curators.

There are large numbers of hand-crafted objects in the storage and display areas of Norwegian museums today: thousands of mangleboards, ale bowls, other drinking vessels, chests, cupboards, decorated sleds, among other things. How could so much be produced? The objects had

been made over a long period of time, most of them between the end of the 1600s and about 1870, in a country with sparse and scattered settlements having in 1801 an agrarian population of 800,000 divided among 78,000 farms and 40,000 cotter plots. The objects have come from all parts of the country, but the highest concentration of them has been in the areas where the farmers owned their own land and where we also found the greatest number of log houses surviving from the Middle Ages. Much has been lost, and much of what was for everyday use and which suffered the consequences of this does not fall into the category of folk art. The reason for the great concentration of folk material that can be categorized as art in the areas where land ownership among the farmers was high must be that people here had a special relationship to the farm, its buildings, and the land.

Not everything, of course, that comes to the museums today is of the same quality, but everything has significance as a document of culture. Much of the work can be characterized as commonplace; the more creative items were crafted by people with special artistic talents, often on commission. Many of the folk artists are known by name, and we get acquainted with them through the work they have left behind. Because of the importance of passed-on traditions and talents in the folk arts, certain families acquired the position of leaders in the handicrafts of their community (155–157, 179–180, 184). These were not infrequently cotters, small farmers, or people without land who by this means were able to leave their mark on the community. Regardless of their dependency, they could have more time than many farmers, at least in the areas where the demands on the cotters were not especially great. And, one must also remember that artistic talent and the joy of working with one's hands are not limited to any particular class of society.

In small rural settlements, not everyone was able or had the opportunity to develop his natural talent. Erik Olsen Hellelykkjun was a man able to realize his artistic gifts in spite of living in the worst possible circumstances (Fig. 15). He was born to a family of cotters in Vågå in northern Gudbrandsdalen around 1830 and sat for long periods bound with iron chains because of mental illness that went back to childhood. While still very young he had learned woodcarving from his uncle, the famous Hans Olson Hellelykkjun. Erik would probably have been equally good if he could have reclaimed his health or received the help he needed. For a time his restlessness was so extreme that he was not given knives or proper tools. He had to manage with simple implements that he made himself from nails, scraps of iron, and the like. With these he made small items of wood, knife handles and little boxes with covers so well carved that they fit the opening as if molded in it. The carved decoration had an exceptional consistency and refinement. What he was able to produce with his miserable equipment is beyond belief. He had a confused mind but he possessed a spark within him that was able to carry him beyond the circumstances of his everyday existence. It is precisely that kind of spark that lies behind much of the best in Norwegian folk art.

HALVARD BJØRKVIK is Professor Emeritus, History, University of Oslo, and Director Emeritus, Norwegian Folk Museum, Oslo, Norway. Article translated from Norwegian by Judith Torvik, Skien, Norway.

Fig. 15. Box, knife, and sheath. Erik Olson Hellelykkjun. Vågå, Gudbrandsdalen. Late 19th century. Maihaugen. Photo: Sandvig Collections.

Emigration and Settlement Patterns as They Relate to the Migration of Norwegian Folk Art

Odd S. Lovoll

The central highland districts—Telemark, Numedal, Hallingdal, Setesdal, Valdres, and Gudbrandsdalen—were early affected by overseas emigration to the United States. These same mountain valleys and upland communities produced the most distinctive Norwegian folk arts and peasant crafts. It was emigrants from these regions in particular who first shaped a Norwegian immi-

Fig. 16. *The Emigrants*. Gustav Wentzel (1859–1927). 1900. Private possession. Photo: O. Væring.

grant community and gave it its content and direction. They transferred to American soil the religious and secular values of their Norwegian home districts or *bygder*, a "*bygd*" being defined as a Norwegian rural community, neighborhood, or district. Their cultural baggage included folkways and ancient lore; local design in wood, fibers, and paint; folk music and dance; and venerable conventions and traditions that guided them in their festive as well as daily affairs. From the beginning in the early 19th century and well into the 20th goods from the peasant community,

objects of artistic and cultural worth, as well as the skills to produce them, crossed the ocean with the emigrants. On the other hand, not many immigrants had an opportunity to ply familiar rural craft and art traditions in America; during the early years of settlement the demands of getting established and the availability of inexpensive mass-produced goods severely reduced the amount of hand craftsmanship in the New World. Continuity with traditions from the past, however, was never completely broken and ultimately contributed to an arts and crafts revival of exceptional vitality and magnitude.

Emigration Begins

Norwegian emigration had a dramatic opening on July 4, 1825, with the sailing of the sloop *Restauration* from Stavanger on the southwestern coast of Norway. By Nordic standards this was a very early start. The "Sloopers," as these pioneer emigrants are called, numbered only fifty-two at the time of departure. Their numbers were increased by the birth of a baby girl before they landed in the port of New York on October 9 after a voyage of fourteen weeks. They were Quakers, Quaker sympathizers, and Haugeans, followers of the lay preacher Hans Nielsen Hauge. Religious factors, a desire to worship freely without the interference of the Norwegian Lutheran State Church, influenced their decision to emigrate. But in the manner of later emigrants, they were also moved by a hope for material improvement. Their guide and agent was the enigmatic Cleng Peerson. He had gone to America in 1821, crossing by way of Gothenburg, Sweden, and returned in 1824 to report on his findings. He was back again in time to greet the "Sloopers" when they docked in New York harbor. With assistance from American Quakers, most of the "Sloopers" moved to northern New York state and settled in Kendall township on land Peerson had bought. There on the shores of Lake Ontario they struggled through the hardships of pioneer life.

It is significant that the initial emigration occurred in a district with close historical ties to England. The idea of emigration as an alternative to staying at home came from the British Isles. It spread to western Norway and eastward from there. But a decade or so passed before emigration became an annual occurrence.

In the mid-1830s news of better opportunities in the West reached Kendall. It was again the restless wanderer Cleng Peerson who served as pathfinder. He explored new land and selected a site for a settlement in the Fox River valley, LaSalle County, Illinois, about seventy miles southwest of Chicago. In 1834 and 1835 the majority of the Kendall settlers sold their small plots and moved to the Fox River settlement. Not until the frontier for Norwegian settlement had moved west to the Fox River and Norwegian colonies were established to receive newcomers did overseas migration become a regular occurrence.

The Kendall settlement had served as a bridgehead in the New World and individuals had made their way to it before mass emigration commenced. One such person was Knud Andersen Slogvig, who came in 1831. He returned to Norway in 1835, reporting favorably on conditions in America, and in 1836 he served as guide on one of the two emigrant vessels that that year set sail from Stavanger. Their crossing heralded the era of yearly emigration. As people learned of the opportunities on the other side of the Atlantic, emigration took hold and like a dangerous and highly contagious disease—indeed it was referred to as "America fever" almost from the beginning—spread from the southwestern coastal regions to fjord settlements farther north and to the valleys of East Norway.

The diffusion of knowledge about America determined when emigration began in a specific district. Letters home from immigrants constituted the most important source. Famous are the letters from Gjert Gregoriussen Hovland, like Slogvig an emigrant of 1831, which told of opportunities for personal advancement and freedom across the sea as well as of fertile and plentiful land. About Illinois he wrote in a letter from 1838, published in the West Norwegian newspaper *Den Bergenske Merkur*, that he and others who from childhood in Norway were used to working "will think that America is the Land of Canaan, especially in regard to its fertile soil that brings forth fruits of every kind without fertilizer." Hovland concluded that "Norway can no more be compared to America than a desert to a garden of herbs in full bloom." His correspondence circulated widely among the footloose Norwegian peasantry hungry for land, stimulated their imagination, and encouraged many to risk the perilous journey across the sea to make a new life for themselves and their children in the middle of the North American continent.

Emigration Reaches the Southeast

News of America came to eastern Norway in 1836. How it traveled illustrates the importance of the spread of information in the early exodus. The two brothers Ole and Ansten Nattestad from Veggli in Numedal that year took the ancient path across the mountains to Rogaland in western Norway. They were wanderers in straitened circumstances and intended to buy sheep on the coast that they would drive back east to sell. They even came to Peer-

son's home community of Tysvær, where they were given America letters to read. Excited by the accounts these letters contained, they shared the good news on their way back, spreading America fever by word of mouth. Already the following spring, in 1837, the first group emigration occurred from East Norway, the so-called Rue party, consisting of fifty-nine people, including the Nattestad brothers. Most of the emigrants came from Tinn in Upper Telemark, a region exceptionally rich in folk tradition.

It was crowded on the small farms in the mountain communities of Norway; agricultural land was restricted and there were constantly new mouths to feed. A population explosion in the 19th century was bursting the bounds of an ancient and inefficient agrarian system. The Nattestad brothers were both younger sons and could not expect to inherit a farm. Socially they belonged to a marginal class in the peasant community; they had experienced both hard living conditions and social barriers. Exploring conditions overseas thus represented an exciting possibility. Already the following year Ansten made a visit back to his home community; his return from America created a great stir and generated much interest in the new land. "Even though I only told about my experiences in a matter-of-fact manner to those I met," Ansten later wrote, "the news of America spread like fire throughout the land" and "all winter people came great distances to hear about America." Many decided to seek their fortune there. Not only younger farmer sons joined the exodus, but many small farmers sold their property and emigrated. In fact, the class of independent farmers for a long time continued to provide the majority of the emigrants from a mountain community like Tinn. This undoubtedly accounts in part for the amount of rather prestigious Norwegian folk material that found its way to America from these communities. (177, 179, 184) Considerable means were required to finance the move; these could be assembled through the sale of the family farm. Beginning about 1850, however, the lower social classes were represented in increasing numbers—the cotter class and agricultural laborers—as monetary assistance came from kin and previous neighbors now settled in America.

Emigration Moves North

Until the mid-1840s the majority of emigrants came from the coastal district of Ryfylke north of Stavanger, the upland community of Voss east of the city of Bergen, and Upper and Lower Telemark in present-day Telemark county and Numedal in the county of Buskerud to the east. All of these areas had distinctive folk art traditions. As many as 63 percent of the 6,200 emigrants in this period came from the eastern mountain communities, where these traditions were especially strong.

During the next twenty years, 1846-1865, the urge to go to America moved beyond this early core region. The county of Oppland, within whose boundaries lies the mountain district of Valdres, became the region hardest hit by emigration. Six of every thousand of its average population succumbed to the America fever annually; Telemark showed an emigration intensity of 7.6 per thousand during the first half of the period, but after 1856 dropped below Oppland. These were in a national context very high figures; for the kingdom as a whole, emigration intensity equaled on an annual basis only about 2.3 to 2.5 per one thousand of population during these same twenty years. If we consider emigration intensity within specific districts in these counties, the consequences of emigration are even more pronounced. Between 1856 and 1865, Valdres, for instance, lost 15.6 inhabitants per thousand of its population each year, surpassed only by the district of Sogn in the adjacent county to the west where a loss of 17.2 per thousand nearly stagnated population growth.

An increased agricultural production could have relieved some of the hardships caused by the rapid growth of population that affected Norway, and indeed all of Europe. For the kingdom of Norway as a whole, the number of people rose from 883,487 in 1801 to 1,701,756 in 1865; nearly 80 percent of them in the latter year lived in some agricultural community. Population pressures were a constant fact of life and they became a compelling and decisive force in Norway's move toward modernization. The highland districts were here at a distinct disadvantage. The small and hilly acreage held by most farmers, with poor soil, early frost, and primitive tillage, could not meet the needs of a rapidly expanding rural population. Many were pressed to the wall by adverse conditions; prospects for the young—to marry and start a family or even to be gainfully employed—appeared dim at best. These communities lacked the economic means to mechanize and to modernize agricultural production. A transformation of the rural economy therefore came late to the districts most heavily involved in the overseas movement. Strong traditions in emigration were well established long before any change occurred.

In the mid–1840s, the promise of America reached Hallingdal, located like Numedal in the county of Buskerud, and in time emigration from there surpassed Numedal. Eager to improve their own and their children's lot in life, the farmers sold their ancient holdings, passed down from one generation to the next, and went to America. The county governor, showing little understanding of

the prevailing circumstances, mused sentimentally why "it was especially in the mountain areas that emigration occurred," which he thought gave no support "to the old wisdom that the mountain farmer holds on to his home." With these mountain farmers from Hallingdal, Norway's second strongest tradition in folk painting came to America (155–166). The strongest had already arrived there with the immigrants from Telemark. (171–184)

Valdres began to experience emigration about the same time as Hallingdal. One of the early emigrants was a rather well-to-do farmer from Aurdal in Valdres, Nils H. Fjeld, who left in 1847 with his wife and seven children. In an interview in the Koshkonong settlement in Wisconsin in 1870 he told how the increase of his family and a series of poor harvests in Norway dimmed his prospects there. Thoughts of his children's future caused him much anxiety. "Meanwhile," Fjeld related, "rumors about fertile soil and cheap land in America also reached Aurdal and there was much discussion of drawbacks and advantages in the New World as compared to Norway." The emigrants were obviously people who made individual decisions based on realistic evaluations of conditions on both sides of the ocean. And the entire movement before 1865 assumed a strong family composition with almost as many children as in the general population. This may well have contributed to the amount of household material, much of it richly decorated in accordance with local tradition, that crossed the Atlantic. The emigrants' move was permanent; they sought a new life in America for themselves and their descendants.

Gudbrandsdalen, the central valley stretching some 140 miles north from Lake Mjøsa to the border of Romsdalen, east of Valdres but in the same county, experienced overseas migration from mid-century, accelerating rapidly from the mid-1850s. The pioneer emigrant Johan Nordboe from Ringebu had, however, left the valley as early as 1832 at the advanced age of sixty-four. He was a farmer and decorative painter, and perhaps a social outsider. Nordboe emigrated with his much younger wife and four children, eventually settling on a large tract of land in Texas, outside the major regions of Norwegian settlement, and "as far from his countrymen as possible." Others settled in the Midwest, where Coon Valley, Wisconsin, became a center. To this area Gudbrandsdalen's rich tradition in acanthus carving was brought by Knut Li (Lee) of Øyer (47, 47b) and later carried by him to the prairies of North Dakota. (Fig. 11)

The earliest emigrants from Setesdal in the county of East Agder to the west of Telemark left in the late 1830s. The folk art of this secluded valley, which not until later oriented itself toward the sea, was exceedingly conservative, a circumstance which led to objects of essentially Medieval character reaching America from here. The impulse to go to America was strong from the mid-1840s and for about a decade. Then emigration declined suddenly because of a flourishing shipbuilding industry and seafaring that gave employment and absorbed much of the surplus population; a crisis in the sailing ship economy toward the end of the century again produced a second and much larger exodus from this region of Norway. The earlier emigration from Setesdal had been encouraged by personal contacts with immigrants in America from Telemark and by the agitation in Johan Reinert Reiersen's *Veiviser for Norske Emigranter* (Pathfinder for Norwegian Emigrants) published in 1844. It was one of the several immigrant guides, or so-called "America books," which provided systematic information, and in a certain sense may be regarded as expanded America letters. The manuscript of the first guidebook by Ole Rynning, *Sandfærdig Beretning om Amerika* (True Account of America) was brought to Norway by Ansten Nattestad and published in 1838. These books were eagerly read by people who were considering emigration.

Mass Emigration: 1866–1910

Between 1836 and 1865, a founding phase in Norwegian emigration, 77,820 emigrants are registered. During these thirty years the movement was dominated by people from the inner fjord communities in West Norway and the upland communities and mountain valleys in East Norway. Official statistics indicate that nearly half, or some 37,000, of these "America-travelers" hailed from Oppland (including Gudbrandsdalen and Valdres) and Telemark in about equal numbers, and somewhat fewer from Buskerud (including Hallingdal), the three counties with the strongest folk art traditions in Norway.

Norwegian emigration leaped from 4,000 in 1865 to 15,726 in 1866, and in the course of only eight years, 1866 through 1873, 110,896 Norwegians emigrated. The era of mass emigration had begun. What historian Marcus Lee Hansen termed "a folk migration" was obviously under way. The authorities from the start took a dim view of the loss of citizens through overseas migration; they revealed a poor grasp of its causes, even to dismissing it simply as the result of unreasonable expectations communicated by Norwegians already in America. In 1845 the county governor explained the motives for the emigration from Sogn as follows: "It is assumed that overpopulation in Sogn will continue to make emigration from this district necessary . . . the vice of drunkenness and the resulting immorality, crime, poverty and dissatisfaction with existing conditions . . . in addition the emigration to America here

as elsewhere is partly caused by exaggerated accounts of the joy and prosperity which supposedly can be found there." But even though official Norway deplored the mass exodus and mustered arguments against leaving the fatherland, there was never any question of physically hindering people from leaving. Well known is the early admonition by Bishop Jacob Neumann in Bergen to the peasants, "to stay in the land and support yourself honestly." Liberal views in regard to freedom of mobility were even so accepted early, and they prevailed throughout the 19th century. Emigration was consequently voluntary and the result of thousands of individual decisions.

From the middle of the 1860s steamships gradually replaced sailing vessels in the emigrant traffic. This transportation revolution made mass emigration possible. Small Norwegian shipping companies had conveyed the emigrants directly on Norwegian brigs and barks from some Norwegian port. The difficult transition from sail to steam allowed foreign, for the most part British and to some extent North German, steamship lines to enter the promising Scandinavian market. The majority of Norwegian emigrants went by boat to Hull and by train to Liverpool, thence by steamer to America. They might also depart from Glasgow; the Allan Line, which early captured a substantial part of the Norwegian market, was headquartered there. As late as 1871 a third of all Norwegians who emigrated to the United States still shipped out on a Norwegian sailing vessel, but only four years later not a single direct emigrant ship left a Norwegian port. Steamships not only shortened the crossing radically, but also removed much of the suffering and menace to life that had prevailed under earlier conditions by sail. Ticket prices fell making going to America more affordable. In addition the new reliable mode of transportation made the move less permanent—people could travel back and forth across the Atlantic. A decision to seek America no longer appeared as an irrevocable commitment.

Following the first emigration wave, there was a calmer period from 1873 as the movement responded to the reduced needs of the American market place. A recession convinced potential emigrants to postpone their plans of going to America. In the last quarter of the century an Atlantic economy emerged where the emigrants became a part of the equation; they provided the labor for the modernization and expansion of American economic life. Even before 1880, activity increased in all sectors of the American economy. An effective information network existed in the form of letters, newspaper accounts, returned Norwegian Americans, agents of the steamship lines, and information disseminated by American employers. The year 1880 heralded the largest mass departure of Norwegians. It lasted until 1893 when a beginning American industrial depression and unemployment again curtailed departures. In the preceding years ten of every thousand Norwegians had emigrated annually, giving Norway one of the highest rates of emigration in Europe, exceeded only by Ireland. In all, between 1866 and 1895, a period of thirty years, 407,494 emigrants are registered. Even so, Norway's population continued to grow, so that around 1890 it surpassed two million.

Immigration intensity remained high in the districts with long traditions of going to America. Between 1866 and 1890, when Norway as a whole had an annual emigration rate of about seven per thousand, the figures for Oppland were 17.5, Buskerud 10.5, and Telemark 9. From the 1890s East Agder experienced a second major emigration, affecting the district of Setesdal. During Norway's final great emigration wave from the turn of the century and until World War I when some 200,000 Norwegians left for America, East Agder had in the first decade of the new century an annual emigration intensity of 14.9 per one thousand. The rate of emigration remained fairly high as well in the central highland counties, but by the end of the final great exodus emigration had run its course there.

As the massive new waves of immigrants washed into mid-America after the Civil War, the movement gradually changed character. It was more urban and more skilled; the urban exodus included not only ordinary workers, but especially toward the end of the century also highly trained professionals. It reflected the changes occurring in the Norwegian economy. Norway's cities grew and an industrial culture gradually transformed Norwegian society; industry and commerce gave new opportunities for employment. Opportunities in America, as suggested earlier, also little by little changed from land ownership and agriculture to urban trades and employment. The earlier family migration shifted toward a departure of individuals. By the end of the era of mass migration the movement had to a marked degree become a youth migration, and the proportion of men to women had consistently increased. Now the mass migration of folk art had also essentially ceased, but a road across the Atlantic had been established along which some folk art continued to travel as inherited goods (177), as mementos, brought back on visits home, or as collector's items purchased both by immigrants and other Americans for their intrinsic aesthetic value (33, 43, 126).

By 1910 every third Norwegian was living in the United States if one counts only the Norwegian-born and their children. They numbered more than one million people. It is a remarkable comment on the transfer of Norwegian set-

tlement, experience, and influence to the soil of the New World—a Norwegian America in fact came into being.

Patterns of Settlement

In terms of the size of the American population, the Norwegian portion did not of course loom. But in their regions of concentrated settlement Norwegian Americans might be a dominant social group. Within four years of the founding of the Fox River settlement in Illinois in 1834, Norwegian settlement turned northwestward into Wisconsin, and in the 1850s the attention of Norwegian settlers shifted from Wisconsin to Minnesota. Norwegian settlements emerged in northeastern and central Iowa before the Civil War, even earlier than the arrival of Norwegians in Minnesota. With the beginning of mass emigration in the mid-1860s, immigrants and settlers from older farming communities pressed on to the western districts of Minnesota, and subsequently, as Norwegian farmers overcame the fear of the windswept grassland, to the Dakota frontier; and from the late 1870s they moved on to the northern part of the territory. The majority of Norwegian agrarian settlements developed in the northern region of the so-called Homestead Act Triangle established by the Homestead Act of 1862 between the Mississippi and the Missouri rivers.

The regional Norwegian composition of especially the early settlements preserved old loyalties and local cultural expressions. In the pioneer farming communities the immigrants lived in some basic ways much like they would have in the rural *bygd* back home in Norway. Local dialects and customs were retained. While holding on to many traditional sociocultural traits, they slowly succeeded as American farmers when measured by farm size, livestock, and machinery. In 1912 the linguist George Flom wrote that there were in the large and prosperous Koshkonong settlement south of the city of Madison, Wisconsin, clusters of different rural folk side by side. The Telemarkings were most numerous in Pleasant Spring township, the Sognings in Christiana township east of the Telemarkings, and still farther east the Numedøls. After a period of seventy years, Flom insisted that they spoke "their own dialect authentically."

A pattern of settlement that demonstrated local loyalties developed naturally with the westward movement. The Fox River settlement became a receiving point and a mother colony for the spread of settlement. It was from there that Ole Nattestad in the summer of 1838, while his brother Ansten was in Norway, founded the Jefferson Prairie settlement in southern Wisconsin. The following spring this settlement became the destination for Ansten and a large group of immigrants from Numedal and Upper Telemark; some of the members of the party took land in what became the Rock Prairie settlement west of Beloit. The group character of the early exodus encouraged the growth of compact settlements of people from the same *bygd* in Norway. They became neighbors again in America, acquiring land close together, and attracted others from the home community.

The centrality of a shared Lutheran faith in forming communities was made visible by the many houses of worship with their imposing steeples that marked the immigrant farming communities. The construction of the simple log Muskego church, held to be the first such Norwegian edifice in America, was begun in 1843. The Lutheran church and clergy exerted a powerful influence on the immigrants. The congregation served religious, social, and even economic needs, and created a tight social network; based on regional backgrounds it might even be culturally more cohesive than the settlement as a whole; it might represent a common set of values and traditions of a specific *bygd* group. Even the name of the church often suggested a narrow regional identity; to give only one example, the Vang Church in the Valdres settlement, Goodhue County, Minnesota, got its name from a prominent parish in the home valley.

Bonds of kinship to the pioneer colonies strengthened the regional tendency as the older immigrant farming communities gave up their youth to new settlements farther west. And familial relations guided Norwegian immigrants to specific destinations in the American West. The *bygd* was in reality recreated in the New World, but not to the exclusion of people who hailed from other districts in Norway. Specific *bygd* groups were predominant and gave a particular local cultural quality to the settlements they founded. As they participated in the westward movement, Norwegians retained the tendency to associate with fellow *bygd* folk whether they were immigrants or their sons and daughters who had never viewed the particular Norwegian landscape that typified their home area.

To be sure, a gradual mixing process did occur as the immigrants trekked west and formed new settlements. Some settlements represented several *bygd* groups. The productive amateur historian Hjalmar Rued Holand in his *De norske settlementers historie* (The History of the Norwegian Settlements) is an excellent guide to the nature of the regional composition of the immigrant farming communities. "Rock Prairie is principally a Numedal *bygd*," he relates, "but it is also the oldest and most important Halling

settlement in America." "Later the Hallings spread," Holand continues, "and formed settlements in Clayton, Allamakee, and Mitchell counties, Iowa, in Spring Grove, New Richland, Kenyon, and Blooming Prairie in Minnesota, and, biggest of all, in Richland County, North Dakota." On their way west to their final destination, Norwegian settlers stopped temporarily with fellow Norwegians they knew, often fellow *bygd* folk. This created a sense of solidarity and of belonging to a larger community than the immediate one in which they lived.

There were many *bygder* of Telemarkings throughout the Upper Midwest. A party of immigrants from Telemark in 1839 founded Muskego, the famed pioneer settlement by Lake Muskego south of the city of Milwaukee, known particularly as the cradle of Norwegian-American Lutheranism. As the Telemarkings moved west from Muskego, they founded Winchester a few miles from the city of Neenah; they also settled in the so-called *"Indielandet"* farther north in Waupaca and Portage counties, and they were, Holand claims, "the most numerous of all *bygd* folk in Koshkonong," the second most important settlement in the founding of an immigrant church.

The heaviest concentration of Norwegian settlers was, however, outside *Indielandet* in western Wisconsin. There Holand describes the Trempealeau Valley, the region between the cities of La Crosse and Eau Claire, as "the most densely settled Norwegian region of all." The *bygd* constituency here was mixed, but Holand claimed that northwest of Black River Falls, "in a labyrinth of narrow valleys and steep hills, where the smell of coffee never dies and tobacco smoke never is put out, there the Upper Telemark mountain folk live in heartfelt contentment."

Manitowoc on the shores of Lake Michigan in eastern Wisconsin was the first Valdres *bygd* in America; the largest concentration of *Valdreser* emerged among the highland peaks called Blue Mounds west of Madison. During the early emigration era, Blue Mounds became, in the words of Holand, "the place where the longings and the hopes of all *Valdreser* met." South of the city of Scandinavia in *Indielandet* a small colony of Setesdøls came into being. The Gudbrandsdøls formed a large settlement in the northwestern part of *Indielandet;* the narrow Coon Valley south of La Crosse with its heavy concentration of Gudbrandsdøls Holand simply dubs "America's Gudbrandsdal." "Coon Valley is a unique place," Holand tells, "where Norwegian customs, both good and bad, have been retained longer than in any other place in America."

A regional flavor and a specific *bygd* identity persisted as settlement spread north and west from Wisconsin. The first major Setesdal colony, for instance, flourished in York township in Fillmore County, Minnesota. From southwestern Kandiyohi County up toward the Red River Valley, bounded to the west by prairie and to the northeast by forest, there appeared a belt of Norwegian settlements in which the Setesdal element remained strong. In South Dakota, Norwegians chose land mainly in the valleys formed by the Big Sioux River and its tributaries. North Dakota, after the two Dakotas gained statehood in 1889, became the most Norwegian of all states. It was in the Red River Valley, a slightly sloping plain created by the river and its tributaries, that Norwegians settled in greatest numbers. In this area immigrants from Hallingdal joined those from Setesdal establishing a local cultural character.

Norwegians were the most rural major immigrant group in the 19th century. Norwegian-American ethnocentric qualities emphasized an untainted and simple rural existence. They celebrated a wholesome rural life and the heroic aspects of the Norwegian pioneer saga on the American frontier. Statistics support a Norwegian-American idiosyncratic attachment to the countryside and the small town. In 1910 about 80 percent of the one-million strong Norwegian stock, the immigrants and their children, lived in the agrarian states of the Upper Midwest. According to the federal census, only about 42 percent of the entire Norwegian-American population—which included the large urban colonies outside the Midwest—were classified as urban. Norwegian Americans were dedicated to farming as a way of life and exhibited from one generation to the next a persistent rural orientation associated with the family farm and traditional values. Their preference was obviously life outside the big city. As recently as 1940 over half of all Midwestern Norwegians lived on farms or in small villages and towns. This fact, together with the retention of Norwegian regional characteristics in the American settlements, kept the immigrants at least in their sentiments attuned to the folk cultures from which they came. When they found it necessary in the twentieth century to reinforce their ethnic identity, it was to these cultures they turned, cultures of which vestiges in the form of folk objects still existed among them.

LITERATURE CONSULTED

Julie E. Backer, *Ekteskap, fødsler, og vandringer i Norge 1856–1960* (Oslo: Statistisk Sentralbyrå, 1965), pp. 157-203.

Theodore C. Blegen, *Norwegian Migration to America: The American Transition* (Northfield, MN: The Norwegian-American Historical Association (NAHA), 1940).

Arnfinn Engen, ed., *Utvandringa—det store oppbrotet* (Oslo: Det Norske Samlaget, 1978).

George T. Flom, *A History of Norwegian Immigration to the*

United States: From the Earliest Beginning down to the Year 1848 (Iowa City, Iowa: Privately published, 1916).

Einar Haugen, *The Norwegian Language in America: A Study of Bilingual Behavior*, 2 vols. (Bloomington: Indiana University Press, sec. ed., 1969).

Hjalmar Rued Holand, *Norwegians in America: The Last Migration*, trans. by Helmer M. Blegen (Sioux Falls, SD: The Center for Western Studies, 1978).

Hjalmar Rued Holand, *De norske settlementers historie* (Chicago: John Anderson Publishing Co,, 4th rev. ed., 1912).

Odd S. Lovoll, *The Promise of America: A History of the Norwegian-American People* (Minneapolis: The University of Minnesota Press, 1984).

Odd S. Lovoll, *A Folk Epic: The Bygdelag in America* (Northfield, MN: NAHA, 1975)

Carlton C. Qualey, *Norwegian Settlement in the United States* (Northfield, MN: NAHA, 1938).

Ingrid Semmingsen, *Norway to America: A History of the Migration*, trans. by Einar Haugen (Minneapolis: University of Minnesota Press, 1980).

ODD LOVOLL is King Olav V Professor of Scandinavian Immigration Studies, St. Olaf College, and Editor, Norwegian-American Historical Association, both in Northfield, Minnesota.

Geometric Textiles of the 18th and 19th Centuries
Square Interlock Weaves

101.

101. Coverlet in square interlock technique (*rutevev*) with a stylized lily pattern (*liljekors*). Norw. Probably Sogn. Ca. 1850. Wool, linen. H. 61⅜" W. 50" Norsk Folkemuseum (NF 671–95).

Coverlets with the weft threads interlocking in various ways to create geometric patterns have been extensively used in Norway since the 1600s and possibly earlier, primarily on the west coast. The orientation of the design can be diagonal (as here), horizontal and vertical (102), or horizontal (107). The designs can be simple and strong (as here) or complex (105). These coverlets and chip carving are the major representatives of the geometric strain in Norwegian folk art.

102. Coverlet in square interlock technique (*rutevev*) with the nine crosses pattern (*nikross*). Norw. Karmøy, Rogaland. 19th century. Linen, wool. H. 62⅝" W. 54¾" Norsk Folkemuseum (NF 666–26).

The design here is an elaborate version of the four-armed cross in 101, but the orientation is horizontal and vertical with the major motif in an octagon rather than a square, all common characteristics.

102.

103. Small coverlet in square interlock technique with the nine cross pattern. Norw.-Am. Jan Mostrom, Chanhassen, MN. 1991. Wool, cotton. H. 47" W. 36½" Mike and Jan Mostrom.

Inspired by an early coverlet related to 102 in the private museum Little Norway, Blue Mounds, WI, this Norwegian-American weaver made her own version, not directly copying the colors or all elements of the design but working closely within the Norwegian tradition.

103.

104. (See front endpaper for illustration) Coverlet in square interlock technique (*rutevev*). Norw. in Am. Folkedal family, Hardanger. Found in Iowa. 19th century. Wool, cotton or linen. H. 62¼″ W. 54¾″ Adeline Haltmeyer Collection. John Haltmeyer.

The eight-petaled rose is the most prevalent motif in square interlock coverlets as it is in west coast embroidery. Found in many textile traditions, it probably entered Norway through Renaissance pattern books. The alternating colors of petals give dynamics to a symmetrical design.

105. Coverlet in square interlock technique (*rutevev*). Norw. in Am. Hardanger type. Ca. early 1800s. Wool, linen. H. 61½″ W. 51″ Vesterheim, gift of Clara Asbjornson (80.80.3).

This, as well as the preceding coverlet (104), came to America early with immigrants, a sign of both its prevalence and its significance in the household. It represents a complex pattern of designs within designs but with the standard vocabulary of motifs.

106. Quilt with geometric design of Norwegian character. Norw.-Am. Pieced by Eli Guttormsdatter and Anna Marthe Eriksdatter; quilted by Ellen Knudson, Kendall County, IL. Completed 1865. Cotton, wool. H. 81″ W. 65″ Vesterheim, Luther College Collection (5569). (Detail shown)

No evidence exists of early square interlock weaving among the immigrants although looms are prevalent. Much evidence of early quilting is found in spite of its limited significance in Norway. Examples with variants on the eight-petaled rose, also used earlier in America, tempt one to consider continuity in the design tradition.

105.

106.

107.

107. Coverlet in square interlock and other techniques. Norw. in Am. Nordhordland type. Found in Ottertail County, MN. 19th century. Wool. H. 59″ W. 57″ Otter Tail County Historical Museum.

Influence either from weaves done on the later horizontal loom with treadles or from an early local tradition in striped coverlets may have led to the horizontality in square interlock coverlets from Nordhordland. The interlock technique is combined with across-the-loom weaving and inlays.

Across the Loom and Inlay Weaves

108. Coverlet in bound weave (*krokbragd*). Norw. in Am. Haugesund area. Late 19th century. Wool, cotton. H. 71″ W. 46″ Barbara Solberg.

When colors were properly coordinated with changes of shed in weaving a specific type of three-harness twill, jagged stripes resulted on the surface and a heavy layer of floating threads on the back. This gained prominence over interlock weaving in the 19th century because of easier production on the treadle loom and greater warmth.

109. Coverlet in a bound weave variant (*danskbrogd*). Norw. Sjevesland, Øysebo, Vest-Agder. Before 1828. Linen, wool. H. 69¾″ W. 51″ Vest-Agder Fylkesmuseum. On loan from Kathrine Holmegaard Bringsdal.

A variant on bound weave (108), limited primarily to Vest-Agder in southwest Norway, allowed patterns of small squares to be added to the surface. Associated by name with Denmark, little is known of the technique's history.

110. Wall hanging in *danskbrogd*. Norw.-Am. Mary Temple, St. Paul, MN. 1994. Wool, cotton. H. 52″ W. 29½″ Mary Temple.

In spite of regional and limited use in Norway, "danskbrogd" has been revived in the Norwegian-American community. It lends itself especially well to the starry night or falling leaves effect in this piece.

111.

112.

111. Coverlet entitled *"Døvleteppet"* in Vestfold inlay technique (*Vestfoldsmett*). Norw. Vestfold. Late 18th century. H. 62¼″ W. 50½″ Vestfold Fylkesmuseum (VF 3647).

This localized coverlet technique appeared in Vestfold during the 1700s well east of *danskbrogd* (109). Its designs are made by threads laid into a ground weave of different color. Related weaves occur in Sweden, Finland, the Mediterranean, the Near East, and elsewhere.

112. Small wall hanging in Vestfold technique. Inspired by *Døvleteppet* (111). Norw.-Am. Lila Nelson, Minneapolis, MN. 1987. Wool, cotton. H. 79″ W. 38½″ Lila Nelson.

Vestfold weaving enjoyed a revival around World War II, especially in table runners and women's jackets. The earth tones used led to monotony and the demise of the trend. American weavers with Norwegian connections in the 1980s turned to originals like 111 and built on its festive color.

113.

114.

113. Coverlet in *skilbragd* overshot technique. Norw. in Am. Telemark. Late 19th century. Wool, linen or cotton. H. 76″ W. 58″ Little Norway.

Coverlets with a plain linen or cotton ground into which a pattern is woven with colored wool yarns have been common since the 18th century. Lighter than the preceding coverlets, they also served as table covers, backings for sheepskin coverlets, and ceremonial textiles at baptisms, weddings, and funerals.

114. Small coverlet in *skilbragd* technique. Norw.-Am. Liv Bugge, Neenah, WI. 1993. Cotton, wool, linen. H. 48″ W. 40″ Liv Bugge.

While the preceding *skilbragd* (113) was exceptional and possibly late in the folk tradition, this one, also from Wisconsin, but woven there by a young Norwegian immigrant, is more typical of early examples.

echnique with checker pattern. Norw.
a. 1900. Wool. H. 70½″ W. 67″

e Norwegian rya often had a pattern-
t of the earlier backings attached to
gely to the west coast, where this
ted, and is associated with use on
ter is in Finland and Sweden

pile technique. Norw.-Am. Betty
N. 1994. Wool. H. 40″ W. 40″ Betty

this rya by a contemporary Norwegian
he knots of the pile that show through
und in Voss where the weaver learned
onal ryas is added while weaving.

Folk Dress

117. Woman's and man's festive costume. NORW. Setesdal. 19th century. Wool, linen, silk. Adult size. Norsk Folkemuseum.

All evolving from the long pants or skirt and long shirt of Medieval times, distinct styles of dress developed in different areas after the Renaissance. The two parts, however, remained fundamental with the changes being largely in additions over them and shifts in their length and the location of the waistline. The woman's costume of Setesdal had essentially this form by the mid 18th century and the man's by the mid 19th. Geometric embroidery helps retain a Medieval and Renaissance character.

118. Married woman's festive costume. Norw. Hallingdal. 19th century. Wool, linen. Model: H. Ca. 63″ Adult size. Norsk Folkemuseum.

The high waist, pre-Empire in origin, is characteristic of the female costume in Hallingdal. The floral embroidery on the apron and skirt are reflections of the Baroque. The headdress gives matronly grandeur to the figure.

119. Married woman's festive costume. Norw. in Am. Hardanger. Early 20th century. Wool, cotton, linen. Adult size. Vesterheim, Luther College Collection (204)

Having acquired essentially this form in the 17th century, the Hardanger female costume in the late 19th century gained status as the national costume of Norway (Fig. 26). The heraldic clarity of its black, white, and red (accented by green trim) and its geometric embroidery made it well suited for this.

120. 121.

120. Free interpretation of bridal costume from Hardanger. NORW.-AM. Mrs. Ole J. Myrlie, Hills, MN. Ca. 1910. Wool, linen, cotton, metallic lace, glass. Adult size. Vesterheim, gift of *Hardangerlaget* through Bruce Hitman (86.131.1.1–10).

This nostalgic American simulation of the maker's wedding attire in Norway served from 1912 to 1986 as a symbol of origin for immigrants from Hardanger. It was worn in actual or mock weddings at the annual meetings of their society (*bygdelag*) (Fig. 32). It also represents the migration of what might be called a cult of the bride in late 19th century Norway.

121. Dress with Hardanger embroidery. NORW.-AM. Grace Rikansrud, Decorah, IA. Signed and dated 1979. Cotton, cotton blend. Size 12. Grace Nelson Rikansrud.

Without pretense of being a traditional costume, this Norwegian-American dress based on it and incorporating traditional embroidery still serves as a symbol of origin. Comparable examples go back to the turn of the century.

Rural Norwegian Dress and its Symbolic Functions

AAGOT NOSS

THE DRESS that will be dealt with here is "folk dress," the clothing formerly worn by men, women, and children belonging to the fishing and farming communities in almost all parts of Norway. There is no question but that folk dress as long as it was used in its traditional way carried specific symbolic meaning.

In the past Norwegian folk dress formed an integral part of a social structure very different from our own. As far as general character is concerned, it relates to what is found in the other folk arts. The garments, or the separate components of them, could be entirely without decoration when used for work. For festive occasions they were to varying degrees decorated. Embroidery is the most distinguishing type of adornment on folk dress. This could be white, black, or multi-colored. Other handcrafted folk objects could also be completely plain but are generally decorated with the type of floral painting called "rosemaling" or with carving, much of which reflects European stylistic directions. The painter, the carver, and the embroiderer have all found their own form of artistic expression within a common stylistic framework. A female embroiderer in an old family of rosemalers, who were originally men, felt she was carrying on the tradition in her way. "For the others it was rosemaling," she said, "for me it's embroidery." A fascinating project for the future would be to investigate these embroiderers and learn more about what the connection between their work and that of the carvers and painters might have been.

Generally folk dress communicated in various ways the sex, age, status, and occupation of the wearer. It also generally indicated the wearer's place of origin or domicile. Worn on special occasions, it emphasized the solemnity of the event.

Folk dress may be seen as evidence of a group sense of identity. Both directly and indirectly it has been a major bearer of traditions relating to local resources, the oral transmission of skills, and local culture in general. Folk dress is also the natural expression and confirmation of inherited criteria relating to quality of materials, to standards of workmanship, and to form and design as such. It adhered to certain unwritten rules regarding the use of color and pattern in weaving, embroidery, and knitting, and of design in metalwork, such as brooches, buttons, buckles, and the like.

These aspects of folk dress constitute an extensive field of intriguing study, in which the casual observer no less than the full-time expert can experience a sense of discovery. This might be in detecting unexpected correlations or noting for the first time some detail that brings the daily life of our forebears suddenly closer to us. The interesting thing is that the apparent idiosyncracies of folk dress are never wholly accidental. Topography and chronology account for most of the more marked differences, but slight diversions from the prevailing mode can often be a matter of personal choice on the part of the maker or wearer.

There is evidence that folk dress under the influence of transient fashions from the outside world adopted certain features intended to lend a cosmopolitan air. The symbolic function of such new elements would probably be to indicate that the wearer was "with it," as one might say today. At any rate, whatever was "in" in Europe sooner or later made its appearance in some form in those places closest to

Fig. 17. Johannes Flintoe. Watercolor. 1822. Hardanger Group. From left to right, including bridal couple: An old man dressed in clothes resembling those worn in the Middle Ages; a girl with the typical hair arrangement for an unmarried girl; the bride with crown, decorated bodice front, red skirt, white apron, and embroidered hand covering; the bridegroom in best clothes with decorated hat and the bridegroom's kerchief tucked into his shirt; a child, dressed like an adult; a woman, dressed as a newly-married wife on her first Sunday in church, with blue skirt, white apron, red jacket, and the married woman's headdress.

the main routes of communication by land or sea. The result could be both successful and even stylish.

Although it is clear that folk dress served a symbolic function in one way or another, it is also true that the role of the woman's headdress was of singular importance. In many regions the type of headdress indicated immediately whether the wearer was an unmarried girl, a bride, a married woman, a widow, an old maid, or even an unmarried mother. The headdress indicated first married or unmarried status, and secondly other aspects reflected social standing. The headdress for a married woman, for example, might be a white headscarf folded in a certain way or a white cap. Unmarried girls could have their hair braided or wrapped in ribbons, with or without an additional head covering (Figs. 17–19).

The distinction between the headdresses for married and unmarried women gradually disappeared in some districts. It is difficult to realize today how confusing this would be to men accustomed to dress signals. A comment from Hordaland made around the end of the 19th century expresses this bewilderment succinctly: "A man could go badly astray here."

In yet other districts both married and unmarried women used headscarves or caps of specific fabrics and colors. The color of the cap itself—or simply the color of its edging—could be enough to tell who was who. Everyone understood the local "codes." (Fig. 20)

Folk traditions in clothing held their ground in Norway over many centuries. This is evident both from the detailed depictions of folk dress found in late 18th and early 19th century Norwegian art, especially in the well-known drawings and paintings by Adolph Tidemand, Joachim Frich, and Johannes Flintoe (See Figs. 25, 20, 17), and second from the many extant examples of early dress. It was not until the 1800s that folk dress was gradually replaced by fashionable dress of the type familiar to us today. In fact in some areas folk dress survived and was in daily use right up to the 1950s, and in a few instances even on into the 1960s.

What follows is a simplified account of folk dress and

Fig. 18. Photograph. 1920s. Ål in Hallingdal. The headdress for the married woman consists of seven items: From left to right, (top row) hair-ribbon, support for the white cap, tassel, (middle row) the cap (the token of the married status), lace edging, (bottom row) pad for holding the cap, and a scarf-covered support.

Fig. 19. Photograph. Early 20th century. Ål in Hallingdal. Headdress for the unmarried woman: The *jentepannelin* is a type of *lad*. In this example the support is decorated with ribbons and has a tassel on top. The girl is wearing churchgoing clothes.

the traditions relating to it up to its disappearance as a continuous, authentic folk phenomenon. Much in the customs pertaining to use make its symbolic function very clear and document that folk dress is infinitely more than mere wearing apparel. The actual garments served the practical purpose of clothing the human body, but their varied wealth of detail provided information beyond the scope of modern dress. Nowadays people of both sexes and of all ages can give signals concerning interests, inclinations, availability, profession, and so on by means of a wide range of clothes, yet it would be difficult today to convey solidarity among the people of a particular geographic unit through the medium of regular dress. Nevertheless, this was one of the conscious functions of folk dress in rural societies with deep local roots.

The customs related to folk dress originated far back in pre-history and persisted through time. Folk dress itself is at all times conditioned by these handed-down customs, while also being subject to a natural development from within and to the effect of certain influences from outside. The interaction of these elements varies not only in time but also from place to place. This is part of the basis for dividing dress into regions, each with its own typical "trademarks." In many cases the borders of these regions of like dress coincide with earlier parish boundaries. Within the same area and in the same period, minute details make it possible to pinpoint a dress custom to an even more closely defined locality, such as a smaller dependent parish or even a specific neighborhood. This type of identification is usual from the 18th century onward, but there is evidence of its existing already in the 17th century, and it may well prove to go still further back in time.

The following elements are essential to any description of folk dress. For *women*: The headdress was always the most distinctive requirement both indoors and outdoors, whether a headsquare, a hat, a cap, or a scarf. The clothing itself consisted of a jacket over a shirt (cut differently from a blouse) or undershirt, a skirt with an attached or separate bodice, an underskirt, a belt, an apron for most outfits, and often a neckerchief. In addition there were silver brooches, rings, buttons and eyelet fasteners for the shirt, bodice and jacket, as well as buckles for the belt, jacket, and coat. Special outdoor clothes were uncommon, but we have examples of wool coats or capes for best use, and the full-length outer garment called a *"kjol."* For *men*: The ordinary headwear was a hat or cap. The clothing itself usually consisted of jacket, waistcoat, shirt, trousers or knee-breeches, and a neckerchief. There was a metal ring fastener for the shirt, as well as buttons for shirt, jacket, waistcoat and trousers. For *children*: Clothing was similar to adult dress, but of modified quality. All three categories naturally included gloves, mittens, stockings, and appropriate footwear.

The norms regarding the use of dress were time-honored and rigid. From newborn babes in their cradles to the dead in their coffins, everyone was dressed according to long-standing unwritten rules. The general principles were the same from region to region, but with local deviations—the changes taking the form of variations on a known theme. Everywhere the church was the pivotal point around which people's lives centered. A distinction was made between church clothes and those for use outside church. Church-going clothes were used only in church, and were put away at home until the next church attendance. "Full church attire" was worn for the church's main feast days such as Christmas, Easter, and Pentecost, as well as on special occasions. The ceremonies of christening, confirmation, and marriage were *red-letter* days in the

Fig. 20. Joachim Frich. Watercolor. Ca. 1840. Nordfjord. A country couple: The girl's cap, decorated with two red ribbons tied at the back, is worn over a white forehead cloth (for a married woman the ribbons would be black); the young man wears the typical small cap called a *"koll-luva,"* made of triangular pieces of fabric.

life of the individual—and, by extension, of the community—being marked by the wearing of the very best clothes and certain other characteristic features.

The first rituals in life were *baptism* and *christening*. A child had to be baptized as soon as possible after birth, since it was considered a heathen until after baptism, which therefore took place in the home. A christening which confirmed the baptism was subsequently held in church. The newborn baby was always given a silver fastener for the shirt, which was a very significant feature of the child's outfit and was used daily. A silver coin might also be sewn into one end of the swaddling band. The reason for these customs was that, up to our own times, silver was often considered to give protection against evil. As for the christening cap, it was usually very elaborate, decorated with bands, lace, beads or embroidery. In some areas, including Telemark and Setesdal, an embroidered covering cloth of linen or cotton was placed on the head as well as the little christening cap. In West Norway a covering cloth of red fabric, often decorated with Christian symbols, was traditionally laid over the child for the actual christening ceremony (Fig. 21).

Fig. 21. Photograph. 1914. Selbu in Sør-Trøndelag. When taken to its christening, the child was wrapped in the *brurplagget,* the embroidered linen cloth which the bride had worn over her crown on the way to church for her wedding.

Confirmation, the transition from childhood to adulthood, was marked by the young person being given the church clothes he or she would wear for many years after. In some places (Ål and Hol in Hallingdal and all of Setesdal) a specific confirmation headdress is known to have been used, although most often the headdress for later church attendance as a grownup served the same purpose at the confirmation service. Confirmants often had to work to earn their new outfits, and the girls would probably make at least some of their clothes themselves.

Marriage had its own particular dress traditions, and the bride always wore a headdress that was exclusively for the use of brides. This was either a special supported ornamental headdress, the so-called "*lad*," or a bridal crown. The *lad* (from the Old Norse *hlad*) is a support of differing shapes strengthened through the use of various materials—felt, bark, or roots, for example—and then so heavily decorated with ornaments, such as silver, ribbons, and beads, that the basic construction is totally concealed (Fig. 22). In some places the crown has replaced the *lad*. The *lad*, made of a rectangular piece of material, has then become an integral part of the crown headdress, either used to hold the crown in place (Fig. 17) or laid outside its lower edge to hide the essential binding. The bridal headdress could be used only once in a woman's life. A widow who remarried would either use a special headdress representing her particular status or the usual married woman's headdress. The earliest bridal attire consisted of some type of *lad* headdress, a black (or sometimes red) jacket, red skirt, and an apron that was either white or had a light ground color.

The special characteristics of the bride's outfit were a decorated bodice, most often a red bib (Fig. 23) or collar with silver and other adornments, a belt covered with metal decoration, a bridal pendant, belt hangings (Telemark and Setesdal) and a hand covering (Hardanger). It was the custom for the bride's jewelry to outshine everybody else's both in quantity and quality. All in all, a bride was intended to make a lasting impression on those who saw her. An elderly woman once remarked to me: "Oh, when I was young I thought a bride was an absolutely glorious sight!"

The bridegroom wore his best church-going clothes, often with a hat-cloth hanging jauntily from his hat (Telemark and Setesdal) and a bridegroom's kerchief tucked into his shirt-front (Telemark and Hardanger) (Fig. 17).

The married women who attended the bride were dressed in their finest church clothes and sometimes wore a bridal pendant and silver belt for the occasion. In Setesdal the matron of honor might even be dressed like the bride, apart form the bridal headdress (Fig. 24).

Rural Norwegian Dress and its Symbolic Functions

An event next only to the wedding itself in importance came when the newly married bride changed her clothes after the ceremony "to appear as a wife." For the first time in her life she would put on the married woman's headdress and the attire that would later be her best church clothes, sometimes still wearing the bridal pendant and silver belt. At this juncture, the symbolic function of dress was to make a visible declaration to all present of the woman's new status.

The special privilege of dressing the girl as a bride before the ceremony and the bride as a wife afterwards was traditionally carried out by the matron of honor in the loft (Fig. 13-14). As a result of this ritual dressing operation, the loft, a storehouse for textiles and clothing, acquired a certain mystique above and beyond its existence as a functional building that symbolized the wealth of the farm.

Funerals had their own traditions. People took leave of the dead in and from their homes, not with a minister in church. A neighbor would "sing the corpse out" and also spoke on behalf of the deceased. This custom lasted in some places up to 1950–1960. One of my sources quoted an old saying often recited at this point beside the coffin on behalf of the dead: "What you are I have been, what I am you will be."

The shroud could be the bride's white undergarment or the bridegroom's long shirt, or a specially sewn garment. Since they were not in church, those attending wore non-churchgoing clothes. There was no general tradition of mourning clothes, although a mourning scarf in the form of a white cloth of linen or cotton draped behind the neck and down the front of the jacket is known from Hordaland. Anyone seeing a woman dressed like this would recognize the signal and might ask: "Who is she wearing that scarf for?"—realizing immediately that she had lost a close relative.

To indicate mourning the side points of the married woman's headsquare, always folded in a triangle, were wrapped round the head to hide the point (which often had embroidery) at the back. When a woman from Voss was laid in her coffin, her head was swathed in this manner.

Fig. 22. Photograph. Early 20th century. Vinje in Telemark. Bride with *lad*, a support strengthened with roots and decorated with gilded silver ornaments so that the basic construction is concealed.

Fig. 23. Photograph. Skodje in Sunnmøre. Bib, part of bridal dress. The red fabric is decorated with beads, lace, and metal ornaments. Privately owned.

The coffin itself was covered with a shawl (Setesdal) or a piece of pattern-woven cloth. In Setesdal the shawl belonged to the woman's church clothes (Fig. 25). It was also used round the child at its christening. This christening cloth in Valdres was generally the one used on the coffin. The same pattern-woven cloth was also used there as a hanging in front of the main window of the house as part of the Christmas decorations.

The study of wearing apparel from former times is both limited and conditioned by the fact that not many working clothes seem to have survived. For obvious reasons each generation has taken extra care of the most expensive items and of the finest examples of handwork in the particular family's possession. We know, however, that clothes for everyday wear were of the same cut as best clothes, but made of stronger materials and with little or no decoration. Otherwise, clothes that were no longer good enough for best wear might be used for ordinary wear until they were worn out. Nothing was discarded as long as it could be useful in any way. In fact, some of the most touching and interesting extant pieces are those which were once industriously patched and mended with a skill that would be hard to match today. Such garments may also be said to have had a symbolic function in visually demonstrating the virtue of thrift, which of necessity was so highly valued in earlier times. A woman born in 1868 recalled many years later that, as a little girl, the difference for her between holidays and weekdays was wearing her skirt right side out on Sundays and inside out on other days—thus in the simplest possible way demonstrating the symbolic function of dress. Two categories of days were differentiated by the inner and the outer side of the same garment.

Every year great numbers of people from all over the world visit the Norwegian Folk Museum in Oslo, which is the largest museum of cultural history in Norway. From the USA alone come hundreds—indeed thousands—of visitors annually whose ancestors followed the customs summarized here, in both the making and the wearing of Norwegian folk dress. They can view the exhibits and study in detail the various techniques used in folk dress, which are explained with the help of photographs. An understanding of the symbolic function of dress in rural Norway, however, is dependent on the combination of such factual knowledge with a genuine feeling for the past. This can be acquired by reading or by taking note of what has been passed down through oral tradition over the years and has as such often been carried to distant and sundry places. The search will lead us down an obscure path of social history which has yet to be fully explored.

For references see Noss in bibliography.

AAGOT NOSS is Chief Curator Emeritus, Costumes and Textiles, Norwegian Folk Museum, Oslo. Norway. Article translated from Norwegian by Barbara Hiff, Oslo, Norway.

Fig. 24. Photograph. 1910. Setesdal. Wedding group: In the front row, the bridal couple in the center, the two matrons of honor flanking them, the bridegroom's best men at both ends. The bridal headdress is a *lad* decorated with jewelery.

Fig. 25. Adolph Tidemand. Watercolor. 1848. Valle in Setesdal. Two women, each carrying a baby wrapped in the shawl (*tjeld*) she wears. The same shawl will one day be laid over the woman's coffin. Each child wears a *reglehuve* (Old Norse *dregill*), the separate band placed round the head along the edge of the cap, and a little cap decorated with brightly colored embroidery.

Norwegian Folk Dress in America

CAROL HUSET COLBURN

BY THE LATE NINETEENTH CENTURY the traditional use of distinctive dress among rural Norwegians was in rapid decline and among rural Norwegian immigrants in America virtually extinct. As the traditional use was passing, however, new patterns of use and new stylistic elements in the dress itself emerged. The direction taken was on the one hand toward what has come to be called the national costume, a type of dress that represents all of Norway, and on the other the "bunad," a standardized type of regional dress. Both were based on dress that had deep and subtle meaning in rural Norwegian society as described by Aagot Noss in the previous essay, but both became more two-dimensional in symbolic content and less defined in their use.

The developments mentioned occurred primarily in Norway but were echoed among immigrants in America. To them, however, the national costume and the bunad became primarily something for public display, closely associated with meetings of national groups such as the Sons of Norway or the *bygdelag* (provincial Norwegian organizations) and, naturally, with dance and music groups or parades. While public uses also became important in Norway, a tradition in more intimate personal use also continued there, such as for baptism, confirmations, and weddings.

To understand the concept of a national costume, the type initially most common among the immigrants, and of the bunad, one must consider how they came into being. Radical changes in dress were taking place in Norway at the time of mass emigration. In most areas around 1860, there was still a clear distinction between urban dress and that of rural areas. Rural dress, both everyday and festive, was based on long local tradition while urban dress reflected the changing fashionable styles dominant in both Europe and America. The differences represented not only occupation and place of residence, but also the economic structure of the society concerned. Nearly all materials used in folk dress were produced locally within the group that wore it. Fashionable dress represented participation in the international marketplace for both goods and services. For the poorest people in both town and country, of course, neither full folk dress nor fashionable dress was financially within reach. What they wore day in and day out was plain, well-patched, utilitarian clothing of homemade fabric. This was slow in being replaced by inexpensive mass-produced material.

When national consciousness was rising in the nineteenth century after Norway had been under Danish and finally Swedish rule for over four hundred years, the Hardanger region with its deep blue fjords and snow-covered mountains became symbolic for all of Norway, to Norwegians and tourists alike. It was celebrated in poetry, song, painting, and theatrical tableaux. A part of its picturesqueness was its traditional folk costume in heraldic black, red, and white. In the decades leading up to independence in 1905, the wearing of this picturesque costume came to symbolize an allegiance to Norway as a nation rather than only to the region. Whereas it had evolved originally as a basic type of traditional dress that could be varied in detail subject to individual taste, once it came to be adopted as a national costume the type as such was frozen. It was, however, reproduced in materials of all qualities and worn by all who wished to show their national sentiment regardless of their origin. It continued to serve as a bunad for Hardanger, but since it is best known as a national costume it will here be dealt with apart from its regional association.

Fig. 26. Postcard from Norway illustrating national costume, Ca. 1890s. Color postcards of this kind could have been an inspiration to Norwegian Americans who made their own costumes. The decorative designs in the beadwork appear to be drawn on the photograph for clarity. Carol Huset Colburn, Cedar Falls, IA.

By the 1890s, the national costume was even available from stores in Oslo.[1] For many, it served a function similar to that which festive folk dress had served previously but with national rather than regional associations and without the same subtleties of meaning. Many young people received their first full national costume at their confirmation, and it was thereafter used as "best clothes" for significant family or public occasions. The national dress was also used by traditional dance and singing groups both when performing in Norway and in other countries when they appeared as cultural representatives of Norway. Perhaps its most debased use was as the uniform of waitresses and other servants in hotels and restaurants catering to tourists.

While national dress continued to be worn in these ways, another development in folk dress, the bunad, occurred. The bunad movement was founded by Hulda Garborg (1862–1934) in close conjunction with her work in preserving and reviving the folk dance at the turn of the century. She encouraged the use of folk dress based on that of regions other than Hardanger, resulting in a variety of costumes more or less faithfully based on earlier folk dress. Her ideas were disseminated through the travels and performances of her dance group and through the publication of books which gave instruction for making a variety of regional costumes. She published the first edition of *Norsk Klædebunad (Norwegian Folk Dress)* in 1903, including patterns. In 1917 a second edition appeared, this time including photographs of bunads and further embroidery patterns.[2] Her popularization of the bunad idea involved a simplification and modernization of folk dress for contemporary use.[3] One of the most identifiable and lasting changes she made was introducing a woolen cap with wool embroidery for the Halling costume.

While Hulda Garborg was the first to encourage the modern creation and use of bunads, others were also influential in the movement throughout the twentieth century. Klara Semb was a student of Hulda Garborg whose work continued until 1965. She encouraged more accurate reproduction of early regional types. A number of organizations, including *Landsnemnda for Bunadspørsmål* (The National Bunads Committee) and *Norges Husmorlag* (Norway's Homemakers' Society), have continued to encourage historical accuracy of materials and details, to the extent that a great many Norwegians now use bunads quite authentic to the province of their origin or of their present residence for family or other special occasions.[4] A most impressive display of bunad use occurs annually on May 17, the Norwegian Constitution Day. On this occasion the bunad is used for public parades, community festivals, and private parties, demonstrating pride both in the nation and in regions of origin.

Both of these major developments in Norwegian dress were echoed among Norwegian Americans, who, as demonstrated elsewhere in this volume, maintained an interest in their Norwegian heritage. The primary source for documenting Norwegian-American dress is photographs. Examples of Norwegian immigrant dress which have been preserved in families and museum collections also contribute to our knowledge. Of literary sources, letters and memoirs are the most important, but dress is generally taken too much for granted to be given extensive comment in writing.

A studio photograph from 1907 of a family from Ål, Hallingdal, exemplifies the simultaneous use of regional folk dress, national costume, and fashionable dress in Norway at the time (Fig. 27). The photograph was taken in Oslo, just before the family's departure for America. The mother is in the folk dress of the Hallingdal region, where traditional folk dress continued in daily use until the 1950s. The daughters are wearing Hardanger folk dress, undoubtedly as national costumes. The father and the youngest son are wearing suits that are influenced by international fashionable men's wear but with rural Norwegian details in tailoring. The oldest son is wearing a suit which could not be distinguished from that of an American, an Englishman, or any other fashionable gentleman.

Although this photograph is from relatively late in the emigration period, the image can be seen as representative of families who emigrated during the height of the movement slightly earlier. All the types of clothing worn by the family came with the immigrants on their journey to the new land. Many brought a combination of folk dress, national costume, and fashionable dress in their immigrant trunks.

What happened to this Norwegian dress when the immigrants arrived in America? Some continued initially to wear it, as exemplified by the story of another family who arrived from Hallingdal in 1857. The family had been separated by unfortunate circumstances before emigrating. When the wife saw a man walking across the field to her, she recognized the *Hallingdrakt*, the distinctive dress of Hallingdal, and knew it would have to be her husband Lars.[5] This was a case of retention of the folk dress, at least for the trip across the ocean and westward into the Middle West. Conclusions drawn from extensive research are that he would not have worn his Halling dress for long.[6] If he couldn't afford anything else, he might have used various parts until they were worn out, and then recycled the materials for other purposes. If he could afford clothes more

Fig. 27. Family on their way to America in folk dress, national dress, and fashionable dress. Photograph taken in Oslo (Kristiania) in 1907. Photographer Nyblin. Ål Bygdearkiv, Norway.

in line with those of his American neighbors, he may have put his old clothes in the trunk to save for an unforeseen future.

Clothing from the old country is known occasionally to have been used to celebrate important events such as baptisms, confirmations, weddings, funerals, and holidays, where continuity between the old way of life and the new was desired. Documented instances are rare because most early photography occurred in studios, not in homes and churches. An immigrant letter, however, indicates that family clothing was sent from Norway for a baptism. Describing the dress of her little daughter Ellen to her family, Caja Munch wrote in 1857, "She has three red dresses about the same cut as the baptism robe that my dear Nanna sent her." In another reference to Ellen's clothing, Caja Munch wrote, "Rest assured that both Munch and I have exerted ourselves to keep her from catching a cold during this hard winter in such an airy house. She has completely worn out the scarf I got for my confirmation, who would have imagined that it would be used for this purpose?"[7] Attractive scarves were an important part of the new clothing traditionally worn by confirmants in Norway and, under normal circumstances, these scarves would have been kept for use as best clothing throughout the woman's life.

In letters written back home, recent immigrants were more likely to describe breaks in traditional patterns of use rather than continuation of the familiar. "Malta, Illinois. January 7, 1890. Around here there were many who went out and plowed on Christmas Day. Here where I work at least we kept the holiday. I am ashamed to admit it, yet it is true, that I went around in an old, worn, and dirty dress, and this is surely the first time in the 26 Christmases that I have lived that I have not washed myself or changed clothes. You must not be angry with me when you read

this. I could not help it, and it is so difficult to be among strangers."[8] This was written by Berta Serina Kingestad, a single woman who worked in other people's houses. What she misses is the custom in Norway of bathing for Christmas and donning one's best traditional garb. Berta's letters home reflect a strong interest in clothing, often referring to exchanges of scraps of fabric to help family members visualize each other's dress.

A railroad worker in Montana wrote of similar dismay over not being able to recognize Christmas with a change of clothing. "Warm Springs, Montana. December 25, 1890. Yes, tomorrow it's herring and old clothes again. That is to say, I have had my old clothes on all day today, too. Holidays here never last more than one day—and even that one is sad enough."[9]

In spite of the frustrations experienced by immigrants over American customs of dress, there is evidence in immigrant letters of these customs also being transferred back to Norway, thus speeding the transition away from folk traditions in dress even there. Berta Serina Kingestad again wrote home, this time in response to the news of the death of one of her sisters in Norway: "Malta, Illinois, February 14, 1890. When you write, you mustn't forget to tell me if you and Mother have black dresses; if not, I shall try to send you a little money when I get my wages here, so you can each get a dress. I will go to town as soon as the weather permits and buy one for myself. I have no black dresses now. I will enclose a little scrap of my collar and mourning band. That is what they use in this country, and you will get a scrap of my dress in my next letter if we live so long."[10] Berta in America is instructing her mother and sister in Norway on how to observe mourning within the constructs of fashionable dress, as the folk dress tradition in Norway generally lacked such a mourning tradition.

We have seen that even for people who wanted to maintain the old customs of dress in America it was difficult. However, new uses for traditional clothing evolved as a social and cultural life among Norwegians in America began to form. Norwegian-language theater presented one new possibility. Old traditional dress was brought out of the trunk or new garments modeled on them were reconstructed for the stage. Norwegian-American playwrights often used themes of assimilation, utilizing devices of rural dialect and dress to differentiate between the characters who followed the old ways and those who were adopting the new. Marcus Thrane (1817–1890), the early Norwegian social reformer who came to America as an exile, used such devices in plays performed during the 1860s–1870s by the *Norske Dramatiske Forening* in Chicago.[11] Theater continued to be a public forum where traditional Norwegian dress was used until the mid-twentieth century. Extant photographs of plays staged include some characters in retained folk dress, some in the national costume or bunad, some in fashionable dress. The clothing indicates the characters' orientation to their changing society, but for us it also indicates how the immigrants looked on dress and what their resources for the various types were.

If folk costumes were not available from the trunks of immigrants, the small *carte-de-visite* format photograph was enormously popular and served as a ready reference for Norwegian dress. In Norway, photographers were making their living creating images of folk life, with distinct regional costumes a primary subject. Marcus Selmer from Bergen made hand-colored full-length portraits of his subjects in representative regional dress in the 1860s and 1870s. These were widely distributed and made their way to America where they were kept in the albums of Norwegian-American families. For first generation immigrants, of course, memory was the most ready source for reconstructing traditional dress but the use of it is difficult to document.

By the 1890s, the wave of nationalism which swept Norway in the struggle for freedom that culminated in 1905 was also felt among Norwegian Americans, some of whom wanted to reveal their sentiments through dress. However, by this time few of them had original Norwegian clothing available. Photographs, postcards, and information brought back by tourists were again props to aid memory for recreating Norwegian dress, which now functioned purely as a symbol of national sentiments (Fig. 26).

The components for an American interpretation of Norwegian dress in the 1890s were a red vest, a white blouse with sleeves which often reflected fashionable 1890s leg-of-mutton sleeves, a floor-length dark skirt with colorful horizontal ribbons applied near the hem, and a white apron with an insert of geometric embroidery or lace and often a lace edging. Hair was worn down or in a loose braid. The decorative trim was made to simulate that on the original Hardanger costume but was simplified for easier production and often consisted of commercially available materials adapted to the purpose. Since there were few actual examples to copy, interpretations could become quite free. If original pieces were available from the old immigrant trunks, these were incorporated with those that were newly created (Fig. 28).

The political situation in Norway was not the only reason for a rise of interest in national dress. During the 1890s, round-trip travel between Norway and America became more frequent. The transition to steam had considerably shortened the journey and many immigrants were

Norwegian Folk Dress in America

Fig. 28. An 1890s portrait of two Norwegian-American women in Zumbrota, Minnesota, in Norwegian dress displaying family heirlooms from Norway. Anna Dyreson Homme on the left was a second-generation immigrant who appears to have created a costume by adding ribbon to her bodice and wearing a blouse with the then fashionable leg-of-mutton sleeves. Her un-identified companion is in quite authentic Hardanger or national dress but without the beaded belt. Rolland Falk, Covered Bridge Restaurant & Lounge, Zumbrota, MN.

now adequately established to afford it. Previously immigration had generally meant a one-way trip. Norwegian Americans were now again brought in direct contact with Norway and became more aware of dress being used there. Some tourists had cameras, resulting in photographs taken in the open countryside where vestiges of traditional folk dress could still be seen. Not all of these can be relied on as historic documents, especially not those by traveling professional photographers, because models could be dressed to suit the takers' wishes.[12] As sources for reconstructed costumes, of course, they have their own validity. The fact that photographs taken in Norway were subsequently used by Norwegian Americans to construct their own, perhaps nostalgic, view of their former homeland is shown in the work of Herbjørn Gausta, a Norwegian-American painter who in the 1890s traveled and photographed in his native Telemark and later used his photographs as the sources for paintings that became well known in the Norwegian-American community.[13]

The final separation of Norway and Sweden in 1905 was cause for celebration and for display of nationalism both in Norway and in America. During this first decade of the 20th century, many variations of Norwegian dress were created. These appear to have been worn primarily for public events where dress served the additional symbolic function of indicating solidarity among Norwegian Americans. The usual model was the national costume, but if particular ties had been maintained with a region other than Hardanger, or if pieces of family clothing from such an area had been saved, the costume could have another model. Many introduced headpieces, which had seldom been seen on 1890s photographs in America, indicating an attempt to be more true to the authentic use of folk dress. The easily adopted square cap was the most common type. It had precedent in the original Hardanger costume as the headdress of a young unmarried woman, but with the national costume it was also used by married women instead of the elaborately pleated matron's headdress. A photograph from Norway Day, Seattle, Washington, 1909 (Fig. 29) shows both these types as well as the traditional Hardanger wedding crown (worn with the additional wedding regalia) and a variety of other unusual headpieces.

Norwegian-American *bygdelag* organizations, consisting of people from specific regions in Norway, used dress as an identifying symbol as early as the first decade of the new century. The *bygdelag* movement had begun in the 1890s but gained greater momentum after the turn of the century. Yearbooks intended for both American and Norwegian subscribers included photographs of immigrants from the district with which the organization was concerned. By the 1910s, these included immigrants in bunads as well as in national dress, echoing the beginning use of bunads in Norway and reflecting the regional emphasis within these organizations themselves. The bygdelags sponsored trips to visit the old country, and they often invited Norwegian guests to their gatherings. These generally made their public appearances in festive Norwegian dress. Thus the exchange of information concerning both the national costume and the bunads became very direct.

During the early decades of the 20th century the *bygdelag* blossomed, with massive annual gatherings of enthusiastic participants. The 1911 *Hallingstevne*, a meeting of the organization made up of immigrants from Hallingdal, held in Brooten, Minnesota, provides an excellent example of how costumes were used at these gatherings. The three-day event attracted 6,000 people from many parts of the United States.[14] The *Hallinglag* was known for its spirited meetings, as opposed to the more pious nature of some regional gatherings; thus there was ample opportunity for the wearing of Norwegian dress. The programs included plays, tableaux, dancing, and, of course, traditional food. A photograph of dancers in costume at the event includes very traditional Hallingdal festive dress and the national costume (Fig. 30). The kitchen workers, who also posed for the photographer, give a wonderful example of how the immigrants interpreted everyday Hallingdal dress (Fig. 31).

The *Hallinglag* was not the only one that featured traditions in dress from the home region at its meetings. Thor Ohme in writing about the first meeting of the *Hardangerlag* in 1911 says, "Next came the bridal party led by the toastmaster, fiddler, bride and groom; followed by about 50 people in Hardanger bunads . . . Everybody enjoys seeing the colorful costumes and I admire the ladies

Fig. 29. Group photo taken on Norway Day, Alaska Yukon Exposition. University of Washington, Seattle, 1909. The fact that approximately all 100 central figures are in Norwegian dress and that some have ribbons indicate that this might have been a costume competition. Most relate to the national costume, but tremendous variety is revealed. The prominence of a central bride and groom indicates that a wedding may have been the theme. Nordic Heritage Museum, Seattle, WA.

Fig. 30. Folk dancers at the annual meeting of an organization of immigrants from Hallingdal at Brooten, MN, June 22–24, 1911. The group includes both immigrants and visitors from Norway. The couple on the left are in the Hardanger costume, here probably representing the specific region of origin rather than Norway in general. Costumes from Hallingdal representing several types and periods in time are worn by the two other couples. John and Joyce Bohmer, Brooten, MN.

who keep up their bunads and proudly wear them."[15] The *Hardangerlag,* of course, was especially fortunate because the costume for its region had become the national costume that had long been widely used and was readily available.

As indicated by the quotation from Ohme, a distinctive feature of the *Hardangerlag* annual meetings was the celebration of a wedding, either a mock or an actual one, carried out in traditional Hardanger manner and with traditional dress. The bridal costume included an elaborate crown as well as other decorative elements and accessories reminiscent of the traditional wedding dress in the Hardanger region of Norway. The *Hardangerlag* organization owned this fanciful costume, which was altered throughout the years. It appeared in several photographs from the 1920s and 1930s, indicating the importance of the wedding to the Hardanger *bygdelag* (Fig. 32). It now is part of the collection at Vesterheim, the Norwegian-American Museum, in Decorah, Iowa, having been worn by many brides and having been the focus of many gatherings (120).

The Hardanger bride has long held an important place in the Norwegian imagination. In the Hardanger romanticism of the mid-19th century, the wedding is the major event, celebrated in poetry, song, painting, and tableaux. The crowned bride is the central figure. The ritual wedding of the *Hardangerlag* is only one immigrant manifestation of this Norwegian lore. A Norwegian-American photograph from 1915 documents that even the authentically dressed Hardanger bride doll, popular in Norway at least since the 1890s, was also cherished in America at a rather early date (Fig. 33).

In 1914, the first of several large Norwegian-American celebrations was planned. The occasion was the centennial of the signing of the Norwegian constitution. The recognition was not concentrated in one location as it would be for the next comparable occasion eleven years later, but divided among Norwegian-American communities all over the country. This provided a most appropriate opportunity for a public display of costume. The *Chicago Daily Tribune* reported that there were 5,000 participants in the parade there.[16] Photographs in Ingrid Semmingsen's book *Veien Mot Vest (The Way to the West)* show a children's parade, and a parade of dance groups in folk dress of varied design, most based on the national costume but also prominently featuring the man's costume of Telemark.[17] The women's and children's costumes reflect the influence of fashionable dress with skirts and aprons shorter in length than those seen in previous decades (Fig. 34).

Norwegian Americans in Minnesota celebrated the centennial with two processions crossing between Minneapolis and St. Paul; "Thousands of people lined the parade routes; the many colorful peasant costumes (bunader) made a great impression."[18] At this celebration so much enthusiasm for artifacts pertaining to Norway was generated that a proposal was discussed by *bygdelag* representatives to found a museum including "documents, domestic handicraft, clothing and costumes" in Minneapolis.[19] The proposal never was carried out as discussed, probably because a museum—ultimately to become Vesterheim—already existed at Luther College in Decorah, Iowa. World War I was also about to begin, which rapidly changed national feeling concerning the display of ethnic origins. The anti-foreign sentiment

Fig. 31. Kitchen workers wearing interpretations of festive and everyday Hallingdal folk dress at *Hallingstevne* at Brooten, MN, June 22–24, 1911. Plaid fabric and a bibbed apron on the woman in the center recall the everyday folk dress which was still being worn at this time in the district of Hallingdal. John and Joyce Bohmer, Brooten, MN.

Fig. 32. Photograph from Ca. 1920 of wedding party at which the *Hardangerlag* bridal costume was worn. It had been made in 1912 by an immigrant in Hills, Minnesota, and was used for actual or mock weddings at the organization's annual meetings. All the women in the photograph wore the square cap of unmarried women as was often done in America, regardless of marital state. The Norwegian American Historical Association, Northfield, MN.

Fig. 33. Portrait of mother and child from Stoughton, Wisconsin, 1915. Prominence of the Hardanger bride in Norwegian and Norwegian-American romantic thought is evident from the doll in this picture. The mother's dress has a completeness and authenticity, even to the matron's headdress, that indicates it may represent true Hardanger folk tradition rather than being a national costume. Vesterheim, Norwegian-American Museum Archive, A. V. Eklund Collection.

served to censor dress as well as language. *Bygdelag* meetings continued to be held, but they were more subdued than before the war and were more a celebration of patriotism than of ethnic cultural life.

After the war, during the 1920s, there was a resurgence of interest in the *bygdelag* meetings and in ethnic origins in general. At a 1926 Halling reunion in Spring Grove, Minnesota, the cartoonist P. J. Rosendahl captured the spirit of the Halling costume in motion on dancers better than still photographs at the time could have done (Fig. 35). The men of Hallingdal were known for their use of knives, which are everywhere present, and for a dance which involved kicking a hat off a pole. Clearly, participants again donned their folk dress, which added enjoyment to the dancing, a regular activity at the meetings. Odd Lovoll's study of the *bygdelag* movement reports that in the 1920s the *bygdelag* organized displays of the handicraft of the old world, and gave prizes for the finest costumes.[20] Banquet-style photographs from *bygdelag* meetings of the time indicate the prominence of dress at these gatherings. A photograph of the *Vosselag* is typical, showing that if only a few of those attending the meeting were in costume they were usually placed in the front row or in the center of the photograph, as if to verify the authenticity of the group (Fig. 36).

Again in the 1920s a large-scale celebration became the focus of attention: the 1925 centennial celebration of the arrival in New York of the first organized shipload of immigrants from Norway. An exhibit portraying the heritage and development of the Norwegians in America through the century was planned. Families were asked to send examples of weaving, costume, jewelry, wood carving, and china either made in Norway or having Norwegian designs made by the Americans of Norwegian descent. The resulting catalog of exhibits is extensive, listing many costumes, such as that contributed by Mrs. B. Amundsen of Rochester, Minnesota, in the category of Arts, Crafts, Relics and Curios: "Hardanger Costume in Seven Pieces—Cap, Apron, Waist, Skirt, Belt, Beaded Vestee, Vest."[21] Throughout the catalog of the exhibit, English was used for items of Norwegian dress which do not necessarily have direct American counterparts. The use of this terminology makes it clear that the organizers of this exhibition began to have the wider American public rather than only their fellow Norwegians in mind. It was also intended for a new generation of Norwegian Americans, for whom the Norwegian language was losing its familiarity.

Norwegian dress also figured in other aspects of the centennial festivities. Tableaux of significant events in the history of Norwegian Americans and dance performances

Fig. 34. May 17 parade in Chicago, 1914. Young immigrant folk dancers in parade celebrating 100 years of Norway's constitution. The bunads are based on folk dress from Hardanger and Telemark. Norwegian Emigrant Museum, Hamar, Norway.

Fig. 35. Cartoon by P. J. Rosendahl in *Aarbok for Telelaget*, 1926. "A Hallinglag in Spring Grove, Minnesota." Famous for his cartoons in the Norwegian language newspaper *Decorah Posten*, Rosendahl saw the humor of his fellow immigrants' behavior in an American context. The colorful band at the bottom of the women's skirts, the knives in the hands of the men, and the acrobatic nature of the dance were enough to identify these people as from Hallingdal to the artist's immigrant audience. Norwegian American Historical Association, Northfield, MN.

Fig. 36. Detail of group photograph of *Vosselaget* Ca. 1927. Folk dress in Voss was near that of neighboring Hardanger. The prevalence of the proper matrons' headdresses and their contrast to the fashionable hats is striking here. The elaborate flat bridal headdress of Voss worn by the central figure indicates that wedding romanticism also played a part in this organization as it did in the *Hardangerlag*. Norwegian American Historical Association. Northfield, MN.

all required some version of Norwegian dress. Tableaux listed in the program include "Landing of Leif Eriksson, the discoverer of America, in the year 1000," which photographs indicate was done in Viking-age dress, and "Arrival of first immigrants from Norway in New York, in the year 1825."[22] No photographs of this tableau have been uncovered, but the costuming was undoubtedly quite fanciful. Photographs of the dancers at the event indicated that the costumes were of recent origin, conforming in shape with the 1920s tubular silhouette instead of the hourglass silhouette of turn-of-the-century bunads. There were at least two distinct types of Norwegian dress used by the dance group: the 1920s version of the national costume, and the bunad of West Telemark.

The 1930s saw the gradual decline of *bygdelag* activity, although not the end. The interest in domestic arts and handicrafts in the 1930s prolonged the practice of the needle arts necessary for producing the national costume and bunads. Serious collectors such as Martha Brye brought fine examples of Norwegian handicraft to America.[23] Descending from a Hallingdal family, she purchased a bunad of Hulda Garborg type from that area when traveling in Norway. She wore it for a professional photograph about 1927 and for special events, including the Brye family centennial celebration. She also wore it when exhibiting her collection of Norwegian folk art or speaking to church and college groups about Norwegian culture.

World War II in the 1940s brought another reaction against the visible display of ethnic origin in America; however, because of Norway's occupation by Germany, Norwegian heritage was not as censored as that of some other nations. Photographs from the 1940s of guides at Little Norway, Blue Mounds, Wisconsin, indicate the continued use of dress there to reinforce the Norwegian identity of this private museum in the eyes of visitors. The man's costume is an interesting blend of romantic notions relating to European heritage (Fig. 37). The basic form is not Norwegian, but reflects German-Swiss dress, probably because of the strength of these nationalities in the surrounding area of Wisconsin. Just as Norwegian-American fiddling became mixed with the Irish and the Swiss, dress has in this case revealed the same flexibility.

In the decades since World War II, use of the national costume has declined but use of the bunad has increased in America. Norwegian dress is seen primarily in the public forums of *bygdelag* meetings, Sons of Norway meetings, and community festivals that celebrate America's immigrant heritage. The Sons of Norway organization, which was begun in 1895 as a mutual-support organization, has become international and is accessible to Norwegians on both sides of the Atlantic. The wearing of costumes to special Sons of Norway functions is now a common practice.

The 1960s and 1970s again introduced a period of increased travel with the availability of inexpensive charter flights sponsored by ethnic organizations. Second, third, and fourth generation Norwegian Americans made their first visits to Norway, went to family farms, and learned about the early folk dress and bunads worn in the districts of their origin. The result was a resurgence of interest in bunads that signified regional background and in compliance with sanctioned models. The time of fanciful reconstructions of traditional Norwegian folk dress is disappearing. For Norwegian Americans who do not know what region in Norway their ancestors came from, the na-

Fig. 37. Guide at Little Norway in a free interpretation of Norwegian dress that incorporates Swiss and German characteristics drawn from the strong presence of people with these backgrounds in the area. The mixing is more typical in other areas of immigrant culture, such as folk music, than in dress. Blue Mounds, Wisconsin, August, 1942. Photographer: Arthur Rothstein for U. S. Office of War Information. Library of Congress, Neg. number LC–USW 3–6418.

tional costume is still the obvious choice. But even here there is greater concern than in the past with having it relate as much as possible to the original folk dress of Hardanger from which it derived.

The number of Norwegian Americans who own full regional or national regalia is undoubtedly now greater than ever before, but it is still small compared to those who display their ethnic origin through wearing a quality Norwegian sweater or simply a *sølje,* the brooch that is a basic part of the bunad in most regions. For today's casual lifestyle in America, these are easier to adopt than the entire formal national costume or bunad. Even a sweat shirt with silk-screened rosemaling or a T-shirt with a humorous quip such as "You can always tell a Norwegian but you can't tell him much" will suffice to give the wearer a feeling of kinship with a group and distinctiveness from people outside it.

As has been the case since immigration, regardless of what form it takes, Norwegian Americans derive a sense of connection with their ultimate place of origin through symbolic dress. Dress also conveys a sense of pride in their ancestry and of solidarity with other Norwegian Americans. These are very public things whether exhibited within or outside the group, something that has typified the use of Norwegian dress among the immigrants from an early point. The association with rites of passage relating to the individual—such as baptism, confirmation and marriage—that it retains to a degree in Norway has all but disappeared on this side of the Atlantic.

1. Kjersti Skavhaug, *Norwegian Bunads* (Oslo, 1982), 17.
2. Hulda Garborg, *Norsk Klædebunad* (Kristiania, 1903 and 1917).
3. Aagot Noss, *Nærbilete av ein Draktskikk* (Oslo, 1993), 295.
4. Skavhaug, *Norwegian Bunads,* 9–12.
5. From a story in *Emigranten,* August 24, 1857, and related in Joan Buckley, "Norwegian-American Immigrant Women as Role Models for Today," in Harald S. Naess, ed., *Norwegian Influence on the Upper Midwest* (Duluth, Minnesota, 1975), 100.
6. Carol Colburn, "'Well, I wondered when I saw you what all those new clothes meant.': Interpreting the Dress of Norwegian-American Immigrants," in Marion John Nelson, ed., *Material Culture and People's Art Among the Norwegians in America* (Northfield, Minnesota, 1994), 118–155.
7. Peter Munch, ed., *The Strange American Way* (Carbondale, Illinois, 1970), 62.
8. Solveig Zempel, ed., *In Their Own Words: Letters from Norwegian Immigrants* (Minneapolis, 1991), 44.
9. Zempel, *In Their Own Words,* 94.
10. Zempel, *In Their Own Words,* 46.
11. Thrane Report, June 9, 1963, in Kenneth O. Bjork Papers; Naeseth, Henriette, Box 10, Norwegian American Historical Association, Northfield, MN.
12. Anna Helene Tobiassen, "Private Photographic Collections as an Ethnological Source," in *Ethnologia Europaea,* XX:1, 81–94.
13. Marion J. Nelson. *Herbjørn Gausta: Norwegian-American Painter.* Offprint *Americana Norvegica Vol III: Studies in Scandinavian-American Interrelations,* eds., Harald S. Naess, Sigmund Skard, 14–15.
14. John Owen Bohmer and Joyce Sandvig Bohmer, *1886–1986 Brooten My Hometown: Those Were the Days My Friend* (Brooten, Minnesota, 1986), 168–170.
15. Arthur Hitman and Gerdes S. Monson (trans.), *Hardangerlaget 75th Anniversary May 30–31, 1986* (Sioux Falls, South Dakota), 159.
16. Odd S. Lovoll, *A Century of Urban Life: The Norwegians in Chicago Before 1930* (Northfield, MN, 1988), 248.
17. Ingrid Semmingsen, *Veien Mot Vest: Utvandringen fra Norge 1865–1915,* 2nd ed. (Oslo, Norway, 1950).
18. Odd Lovoll, *The Promise of America: A History of the Norwegian-American People* (Minneapolis, 1984), 183.
19. Odd Lovoll, *A Folk Epic: The Bygdelag in America* (Boston, 1975), 107.
20. Lovoll, *A Folk Epic,* 224.
21. *Norse-American Centennial: Catalog of Exhibits Exclusive of Fine Arts: Minnesota State Fair Grounds June 6-7-8-9, 1925,* Norwegian-American Historical Association archives.
22. *Norwegian American Centennial 1825–1925 Commemorating the One Hundredth Anniversary of Norwegian Immigration to the United States.* O.M. Norlie Collection, Norwegian-American Historical Association.
23. Marion John Nelson, "Material Culture and Ethnicity," in *Material Culture and People's Art Among the Norwegians in America,* 41–43.

CAROL COLBURN is Associate Professor, Theater Costume Design, University of Northern Iowa, Cedar Falls, Iowa.

Forms Dictated by Function and Technique

122. Basket of fine birchroots (*teger*). Norw. Aust-Agder? Mid-19th century. Birchroot. H. 13¾″ Diam. 15⅞″ Norsk Folkemuseum (NF 1898–243).

The material in Norway's most characteristic baskets is fine birch roots gathered in marshy places where they run along the surface of the ground. Coiling is the standard technique.

123. Basket and cover. Norw. in Am. Norway. 19th century. Birchroot. H. 3″ Diam. 5″ Roger and Shirley Johnson.

Decoration in birchroot baskets comes through variations in the technique or applied elements (not seen here) rather than color. Being containers, many migrated with the immigrants but production ceased and has not been substantially revived.

124. Hardanger violin. Norw. Jon Ellefson Steinkjøndalen, Bø, Telemark. Signed and dated 1871. Wood. L. 23⅝" W. 7⅝" Fylkesmuseum for Telemark og Grenland (BM 1927).

The folk fiddle in much of Norway, probably of Scottish origin, had four additional drone strings and required local production. A carved lion's head, mother-of-pearl and bone inlay, and pen scroll work became integral parts of the instrument. The Steinkjøndalen family was important in its development.

125. Hardanger violin. Norw.-Am. Helland Brothers, Cameron, WI. Signed and dated 1906. Pine, maple, ebony, mother-of-pearl. H. 4" W. 24¼" D. 8" Bow: L. 28¼" Vesterheim, gift of Christian Hovde (81.90.1a,b).

Two violin makers ancestrally connected with the Steinkjøndalen family, Knut and Gunnar (1885–1976) Helland, continued to practice their art in Wisconsin and later in North Dakota. A part of their production was Hardanger violins for the immigrant community, in which the instrument continued to be played by direct tradition into the 1960s and in revived form since.

126. Iron-clad strong box. Norw. in Am. Said to be from Nordland. 17th century? Oak, iron. H. 10″ W. 10¼″ D. 8½″ Kay Hurst Haaland.

Strong boxes were a part of life, especially before banks. This unusual example with two compartments came to America from Oslo after World War II. Nordland origin is possible because of a relation in shape to ivory boxes found in Norway thought to be from its northern neighbor Russia.

127. Money chest with iron grid-work and later rosemaling. Norw. in Am. Vest-Agder painting. Dated 1614. Painted oak, iron. H. 12¾″ W. 21½″ D. 14½″ Vesterheim, gift of Ruth Herber (77.58.13).

This strong box of standard type is unusual because of its early date and 19th century painting. The latter suggests Setesdal origin. It was obtained around 1900 by the Minneapolis passenger agent Jens Johnson, who bought antiquities from newcomers needing cash.

126.

127.

Open, Incised, and Burnt Decoration
Open Work

129.

128. Rigid heddle loom with cut-out decoration and rosemaling in Telemark style. Norw. in Am. Probably Telemark. 1838. Painted wood. H. 9¼" W. 16¼" D. ¼" Inscription: "Ingebor Jokums Dattr Naeste 1838." Little Norway.

The heddles for the backstrap weaving of bands needed alternating slots and holes for making a shed. Additional open work was therefore natural. The rosemaling indicates Telemark origin for this American-found piece.

129. Rigid heddle loom with cut-out decoration. Norw. in Am. 1822. Painted wood. H. 13¼" W. 12¾" D. ½" Inscription: "KND 1822". Roger and Kathe Lashua.

The suggestion of a face and the beading in the open work of this immigrant piece are reminiscent of Trøndelag carving. The colors on the slats with holes, as seen also in 128, are guides to the weaver in properly distributing the colors in her warp threads.

128.

Incised Decoration

130. Butter mold with deep incised carving. Norw. in Am. 1835. Pine. H. 12" W. 8¼" D. 8¼" Inscription: "IASK 1835" plus "INDJ" (the latter in the mold). Adeline Haltmeyer Collection. John Haltmeyer.

Mold decoration must be incised to leave patterns in relief. Initials are frequent motifs. The large size is not uncommon because butter represented the wealth of the farm. Custom also required that what was put out on Christmas Eve should last the entire holiday season.

131. Butter mold with incised acanthus decoration. Norw.-Am. Member of Hunder family, Chaseburg, WI. 19th century. Butternut. H. 6¼" W. 5¼" D. 5¼" Adeline Haltmeyer Collection. John Haltmeyer.

That the previous butter mold (130) was brought to America suggests that the owner expected the tradition of its use to continue here. It may have, because this example of American production shows wear.

132. Carved ale dipper with chip carving and incised decoration. NORW. Telemark. Dated 1786. Wood. H. 7¼" W. 16¾" D. 15" Norsk Folkemuseum (NF 1906–329).

Incising continued beyond Medieval-inspired chip carving. Here, below a chip-carved border of the earliest known Medieval type, tendrils of Baroque complexity are depicted with fine incised lines. The piece documents the continued combining of the geometric and the organic (See 2).

133. Oval bentwood box and clamp-on cover (*tine*) with incised and chip-carved decoration. NORW. Bygland, Setesdal, Aust-Agder. 18th–19th century. Wood. H. 8½" W. 16⅛" D. 7⅞" Norsk Folkemuseum (NF 1897–436).

Executed with fine incisions, this piece brings Romanesque palmette chains, Gothic chip-carved borders and rosettes, and Rococo S- and C-scrolls into a unified design. It is a classic example of retaining the old while absorbing the new (See also 1), a characteristic typical of Setesdal and Telemark.

132.

133.

134. Round bentwood box and domed slip-on cover (*sponeske*) with incised decoration. NORW. IN AM. John H. Budalsplads, Budalen, Trøndelag. Signed and dated 1827, No. 287. Stained pine. H. 5½″ Diam. 10¾″ Inscription: "Ingre Ingebrightsdatter 1827". Jim and Mary Richards.

Budalsplads in less tradition-bound Trøndelag rejected older decoration and adopted the plant-based organic designs that had developed in painting and embroidery. He had an amazing ability to translate effects of color and modeling into his linear technique.

135. Three-tiered double box in bentwood technique with incised decoration. NORW. IN AM. Trøndelag type. Dated 1814. Pine, birch. H. 7″ W. 11¾″ D. 6¼″ Vesterheim, Luther College Collection (1862).

Budalsplads's technique of incising through a stained surface (134) had local tradition, but the more usual decoration was plant motifs stylized to the point of eccentricity, a Trøndelag characteristic also found in the form of this multi-unit box.

136.

137.

136. Spoon with line-incised decoration (*kolrosing*) and acanthus carving. NORW. IN AM. Norway. Late 19th century. Birch. L. 13½" W. 4" Vesterheim, gift of Bruce Hitman estate (91.42.18).

Fine line decoration (see also 61) consisting of one cut with the tip of a sharp tool is often found in the bowls of spoons. It can be pictorial but consists more often of acanthus scrolls. The line here is heavier than usual. Soot or ground bark is worked into the incisions before sealing.

137. Linked wedding spoons carved from one block. NORW. IN AM. Knut O. Sletto, Hol, Hallingdal. Spoons came to Fergus Falls, MN. Ca. 1900. Wood. Spoon: L. 6" W. 2" Total L. 36" Vesterheim, Luther College Collection (332).

The line decoration here is almost lost. The custom of spoons linked by a chain carved from one block for use by the bride and groom at a wedding meal of sour cream porridge (*rømmegrøt*) goes back into the 19th century. Most existing examples, possibly including this one, were made as souvenirs.

138. Linked wedding spoons carved from one block. Norw.-Am. Gullick Fjeld (1859–1940), Elbow Lake, MN. From Hjartdal, Telemark. Signed and dated 1923. Maple? Each spoon L. Ca. 8″ W. 2¼″ Total L. 44″ Grant County Historical Society. Gift from Joyce Thompson Kaehler, Selma Thompson Bruse, and Esther Thompson Wevley.

These wedding spoons, made forty-one years after the carver emigrated, reveal remarkable retention of style and techniques. Spoon carving, even for everyday use, continued for about a generation in early immigrant communities.

139. Rectangular box with line-incised decoration (*kolrosing*). NORW.-AM. Judy Ritger, River Falls, WI. Signed and dated 1994. Basswood. H. 2¾″ W. 10″ D. 4″ Judy Ritger.

The immigrant carvers who knew line-incised decoration from direct tradition died in the 1940s. It was revived in the 1980s through the teaching of Ragnvald Frøysadal of Gudbrandsdalen at Vesterheim. American practitioners, such as Ritger, design their own work.

140. Powder horn with incised decoration. NORW. IN AM. Found in Caledonia, ND. 19th century. Horn. H. 1⅛″ W. 6″ D. 3″ Jim and Mary Richards.

Line incisions emphasized by the addition of a dark substance are here used on both wood and horn. Steaming and pressing the horn flat gave a better surface for decoration.

141. Butter container in stave construction (*smøreske*) with burnt decoration. NORW. Hordaland. 19th century. Wood. H. 11¾″ W. 11″ D. 8¼″ Norsk Folkemuseum (NF 1992–4713).

Pressing the tip of heated irons, often decoratively cut, into wood is the most common method of ornamenting small Norwegian wood objects. Examples date from the 17th century on. It is associated with the west coast but found everywhere.

139.

140.

*Burnt Decoration
(Svidekor)*

142. Porridge container in stave construction (*ambar*) with burnt decoration. Norw. Setesdal. 18–19th century. Wood. H. 10¼" Diam. 10¼" Norsk Folkemuseum (NF 1992–3532ab).

Zigzag lines, circles, semi-circles, and crosses dominate early burnt decoration. The neglect of this technique, used primarily for geometric designs, has left undue emphasis on the organic in Norwegian folk art. Masterful designing places pieces like this aesthetically with the best produced in the folk culture.

143. Open porridge or milk container in stave construction with burnt decoration. Norw. Aust-Agder. 19th century. Wood. H. 7⅞" Diam. 10⅝" Norsk Folkemuseum (NF 1992–3579).

The unique way in which traditional elements have been put together in this piece to create a feeling of stability and strength is another illustration of the individual's capacity for free expression within tradition and of masterful folk design.

142.

143.

144. Spouted ale tankard (*tutekanne*) in stave construction with various types of burnt decoration. Norw. Buskerud. Mid 19th century. Wood. H. 15½″ W. 12¼″ D. 11″ Norsk Folkemuseum (NF 1992–772).

Sometime in the mid 19th century burnt decorators in Hallingdal introduced the spiraling scrolls of the carvers, painters, and embroiderers to their previously geometric art. This involved more scratching than stamping and represented a decline in the old tradition. The effect, however, is rich and dynamic.

145. Round bentwood box and slip-on cover (*sponeske*) with burnt decoration. Norw. Telemark. Ca. 1900. Wood. H. 8¼″ Diam. 16½″ Norsk Folkemuseum (NF 1948–768).

Telemark too finally brought the organic style to burnt decoration. The technique strongly suggests the use of an electric needle. Building on local "rose" embroidery and adding garlands of Louis Seize origin, the designs are elegant and pleasing although without the strength of earlier work (141–143).

The Immigrant's Luggage: Observations Based on Written Sources

Jon Gjerde

The "America fever" that coursed through mid-19th century Europe struck those living in the valleys and fjords of Norway particularly hard. When Norwegian peasants learned with increasing clarity of the opportunities that the United States offered, their home communities would never again be the same. As they sifted through the information about available land and a republican government that offered "freedom" to its citizenry, these peasants were forced to separate fiction from fact in order to make a sensible decision about emigration, certainly one of the most momentous decisions they would ever be required to make. Once they decided to emigrate, moreover, they needed to separate their possessions into those that they would take with them and those they were forced to abandon. As they surveyed their belongings and decided what they should pack, they were unconsciously creating the corpus of objects that we observe today as folk art carried from Norway to the United States.

By exploring the series of events between the moment when Norwegian peasants heard about America and when those who decided to emigrate lost sight of their homeland, we may try to understand the fear and the wonder of emigration and the more prosaic, but very important, decisions of what to include in the immigrants' luggage. The knowledge of America, after all, was imperfect and the decision of whether or not to emigrate and what to take with them were often made with ambiguous expectations. Rumors and stories about the riches of America swirled about the Norwegian peasant community and many in these isolated settlements were dubious about the promise of America. "The strangest stories were told about America," remembered an immigrant about the months leading up to his decision to leave Norway, "and the dangers of the trip across the ocean." Some prospective emigrants heard:

Fig. 38. *The America-Travelers Bid Farewell.* Lithograph after Adolph Tidemand (1814–1876). Original about 1860. Norsk Folkemuseum. (Image cropped at ends)

that skippers often sold emigrants as slaves to the Turks; others maintained that the ocean swarmed with horrible monsters capable of devouring the whole ship—cargo and all. But according to some accounts, an even worse fate awaited those who were not swallowed by sea beasts or crushed between towering icebergs. In America, so the stories went, the natives commonly captured white men and ate them on festive occasions to the glory of their gods.

Early emigrants were viewed by some "with suspicion and pity"; they were considered "foolish daredevils"; indeed, "it was even hinted that they acted upon the inspiration of the Devil himself who thus sought to lead them to destruction."[1] As more reliable information diffused into these communities in the form of "America letters," newspaper articles, and emigrant guidebooks, however, larger clusters of people crossed the seas to a foreign land.

The emigrants' decision to leave home was followed by their selection of what they ought to carry with them. Their luggage would be their psychological as well as physical security. Some of their property obviously had to stay behind. Those who owned land had to sell it along with their animal stock, their homes, and farm buildings. Yet what movable property should they take? They surely could not carry it all. Auctions thus echoed throughout the fjords and valleys each spring while "Americans," as they already were known, sold off belongings in anticipation of their move. The auctioneer's shouts often solidified in the "Americans" minds the reality of emigration. In one emigrant song, Kari was forced to sell her spinning wheel, which for her was a familiar friend. "Good-by, my old comrade," she sang to the spinning wheel,

> "as now I must leave thee,
> my heart, it is breaking,
> my going will grieve me.
> No longer at night
> by the glow of the fire
> Shall we sit and gossip
> and know heart's desire."[2]

If the farm auction symbolically ended the old life in Norway, the preparations for the voyage represented a bridge to a new life in America. As cumbersome or less useful items were prepared for sale, valuable articles were gathered and made. Since the journey typically took place in the spring, women spent much of the winter making new clothes. They spun, wove, and sewed throughout the dark winter months. Decoratively painted trunks, which were being replaced by chests of drawers as storage furniture, were taken down from the second floor of the storehouse, where they had traditionally been kept (Fig. 13–14), and made ready as crates to be used for the voyage. And since securing provisions for the journey was daunting, the family prepared food, baked flat bread, slaughtered and salted beef. These provisions were first packed in bentwood or stave-constructed containers which often had burnt, carved, or painted decoration but had served as purely functional objects around the household. Much of the food was put in large copper kettles that were used for making cheese and brewing beer because it was assumed that such a practical dual-purpose object would also be much needed in America.

Amidst this preparation, the "Americans" confronted many practical questions. Their plans, after all, were made for living in a place they had never seen and thus were based on knowledge gleaned from the reports, in the form of "America letters" and guidebooks, of those who had gone before. They learned that they had to equip themselves with food and utensils for a voyage that in the early period could last up to twelve weeks. They also knew that they must take what would be most useful in their new homes. What was rare in the United States? What was abundant? How difficult would it be to transport their possessions and would they be forced, as others had been, to pay a premium to their ship's captain for excess baggage? Perhaps these questions were not as harrowing as the prospect of sea-monsters, but they could be just as important. The thousands who fled Norway, after all, typically were not wealthy people. The costs of relocation were considerable. They needed to be practical and well informed to avoid unnecessary expenses. Moreover, the earliest emigrants expected as well that they were leaving their homeland forever. Keepsakes, family heirlooms, and remembrances of the old home were treasures that could be chosen only once. It was these decisions—based on personal, practical, and sentimental considerations—that governed what would be contained in the immigrants' luggage.

Miscalculations did occur. Consider the immigrant family that lugged a wagon and two heavy millstones across the sea.[3] But conventional wisdom grew with increased emigration and blunders became less frequent. By analyzing the surviving evidence, we are able to piece together the way in which decisions were made about what to pack for the journey westward.

Emigrants at first tended to rely on guidebooks which were for them—and are for us—a treasure trove of information. Ole Rynning's *Sandfærdig Beretning om Amerika (True Account of America)*, published in 1838, for example, offered specific advice on what to take to America.[5] He listed things that would be consumed on the trip: types of food, medicine, and toiletries that were important. He also provided advice on durable goods that would be used in the new home, such as bedclothing, including furs, and *vadmel*, a heavy woolen cloth that was sometimes felted and that was basic to both male and female traditional dress. Artisans were advised to take their tools. Men were told that rifles—which cost fifteen to twenty dollars in the United States—should be transported either for personal use or for sale. Finally, he suggested items that were typically Norwegian and thus as yet unavailable in the United States. Women should take a *bakstehelle,* a round flat iron plate for flatbread baking, and their spinning wheels. And, when possible, emigrants were advised to bring a hand mill, silver goods, and tobacco pipes, the latter two again for sale.

The accounts that followed Rynning's, such as Johan Reinert Reiersen's 1844 guidebook, *Veiviser for Norske Emigranter til De forenede nordamerikanske Stater og Texas* (Guide for Norwegian Emigrants to the United North American States and Texas), were less concerned with preparations for the journey.[4] If they offered practical advice, they were aimed more at pragmatic matters upon arrival in the United States than on what to bring in preparation for it. As more people emigrated, it seems, letters written from America to friends and relatives in Norway, rather than guidebooks, became the principal source of information on what to bring.

In many ways, immigrant letters reiterated wisdom offered in the guidebooks, but on a much more intimate level. As such, they considered three basic ideas about the emigrants' luggage. First, they continued to give practical advice about surviving the voyage. Food and water obviously were central concerns, since the emigrants needed to be certain that they would remain nourished during the long journey. Many whispered the oft-told stories of abuse committed by sea captains on their human cargo.

A second theme—one that interests us more—was the

advice on serviceable items that immigrants should carry with them for use in the United States. The counsel was often based on relative costs: immigrants should bring items that were either costly or rare in the United States. Anders Andersen Qvale, writing from Wisconsin in 1850, told his brother Torger that it was wise to have all kinds of rough cloth, especially *vadmel*, that Norwegian tailors in the United States could sew. It was not advisable, however, to stock up on footwear since boots and shoes were cheaper in the United States. Burlap was useful to bring to make into sacks, as were carpentry tools such as chisels and sawblades, both small and large. Blacksmithing tools were also advantageous to carry to America. He advised his sister Gjertrud to bring dresses and noted that women in America dressed "like the upper classes in Norway." He suggested that she carry implements for cloth production, including sheep scissors, cards—"a pair cost a half dollar," he wrote—a spinning wheel, and a tailor's scissors.[5]

A letter written to Sweden about the same time as Qvale's to Norway urged moderation in packing, since "it doesn't pay to bring things over for the future because it is expensive to haul them out here from New York, and also a lot of trouble to keep everything together when you have a lot of stuff." Besides, the writer continued, "the prices are the same here as in Sweden."[6] As late as 1870, a Norwegian American living in Texas requested varieties of fruit trees and current bushes from Norway! "It goes without saying," she added "that I will pay for the trees and for their transportation here, and I will give you a good cow for your trouble." But she cautioned against bringing other belongings. Clothes were not expensive in the United States, she contended, and although nice furniture was costly, the costs of transportation would offset any savings. Perhaps out of sentimentality, or for prestige, she advised to bring "at least a chest of drawers or a chiffonier."[7] These were recent introductions to the rural home in Scandinavia and considered special. An immigrant from Telemark, Norway, is known to have brought the chest of drawers that she had received as a confirmation gift. Well over a century later this was still in the family and was then donated to Vesterheim, the Norwegian-American Museum.

The third and most private bits of advice concerned personal heirlooms and treasures that emigrants had to carry with them or lose forever. Clearly, heirlooms—especially small ones—were part of the immigrants' luggage. As M. A. Madson has illustrated, immigrants took diminutive treasures such as vinaigrettes, small smelling bottles from Norway.[7] Yet these were among the least discussed areas of practical advice in letters, probably *because* they were private considerations. One bit of advice relating to precious materials seems callously practical. A letter from a Swedish American advised his kin that "you should not sell old silver in Sweden" because it can yield higher prices here. Besides, he continued, "we have a goldsmith . . . who works every day on things like that and does the best work that can be done." If silver and gold work done in the United States was highly regarded, however, the "new silver that is prepared in Sweden doesn't sell here for any more than the old because it is not in fashion now."[8] Aesthetics, in this case related to fashion and the market, apparently also entered into what was brought.

The content of the immigrants' luggage was thus often based on prosaic considerations. Yet in addition to private treasures that immigrants might take with them, practical objects that survived the voyage in some cases were transformed into cultural treasures in the new land. A Swedish letter writer, for example, advised that food be carried in pewter and copper utensils since, in his case at least, they had become treasured items in the United States.[8] A Norwegian immigrant woman noted that she used a butter tub (141) daily even if it held no butter.[9] Lavishly carved wooden items and hand-wrought copper kettles, practical items at the outset, soon became cherished remembrances of the Old Country.

No better example of this fact is the transformation of the emigrant trunk, in which the emigrants' belongings were stowed, into a treasured family heirloom. A Swedish immigrant vividly recalled in 1880 the preparations made by his family over thirty years before. And the construction of the trunk was a central remembrance. Their chests, he wrote, "were made by carpenters versed in the art, and ironbound by father who was a blacksmith." It was then that "a painter was called in to put the finishing touches on the work, and when done the chests looked large and strong enough to cross the Atlantic in."[10] A Norwegian journalist observed the array of chests and boxes, many of them newly painted in the rosemaling fashion of the region, that waited on the quay in Christiania in 1868. On them were painted the names of their owners and strange American addresses—Milwaukee, Chicago, Madison, or Minnesota—that were to be their destinations. Years later, these chests would have become family heirlooms, pieces of folk art that silently attested to the family's origins and the journey across the sea. The most dramatic revelation in literature of the trunk's symbolic significance appears in *Giants in the Earth*, the Norwegian immigrant novel by Ole Rølvaag (1876–1931). To Berit, the immigrant wife, the

trunk comes to represent both the Norwegian womb to which she wants to return and the coffin in which her loneliness will end.

After they accumulated advice, took down their old trunks, made food and clothing, the "Americans" began to pack their belongings and ready themselves for the journey. Women typically had selected those goods that embraced the female world, such as kitchen utensils and the devices used in cloth manufacture (128–129). Men were charged with loading those firearms and farm implements that were to be taken (Fig. 38). Once the luggage was packed, it was carried by its owners on the journey from their peasant homes to the port where their ship was docked (Fig. 16). The spring became an "emigrant season" when people streamed out of their mountain and fjord homes down to the sea and eventually to teeming cities whence they would sail.

When they reached the seaport, the "Americans" often created their own small subculture. Peasants, dressed in colorful homespun costumes that signified their region of origin, clustered near the port and distinguished themselves from their urban countrymen. They continued to make their last preparations for the journey; women from Hallingdal, for example, were seen baking the last flatbread that would be consumed at sea. Amidst the human throng was the assortment of belongings closely watched by their owners. A journalist in 1868 commented on the immigrants' luggage at the quay in Christiania (now Oslo). He observed immigrant trunks and "sacks of potatoes, kettles and pans, mattresses and sheepskin coverlets, jugs of brandy and kegs of herring." To him, the whole expanse seemed to be a state of "chaos."[11]

Finally, the moment of embarkation neared. The loading of the chests preceded the passengers and they were rowed out to a wooden vessel and were hoisted on deck. The harbor, oftentimes still covered with winter ice, next became the place of farewells. The "Americans" said goodbye to family, friends, and fatherland. They often took part in a solemn religious ceremony that offered testimony to the danger that might ensue and reminded them that they should remain true to their ancestors' God. Finally, they joined their personal belongings on the ship. Reunited with their possessions—now their single tangible link with the old world—they were prepared to embark on a new life. As they sailed through the fjords or out of the harbor, the emigrants watched their old country slowly disappear behind them. A new land awaited in which all they would have of Norway was what they had selected for their luggage.

1. Svein Nilsson, *A Chronicler of Immigrant Life: Svein Nilsson's Articles in Billed-Magazin, 1868–1870*, trans., C. A. Clausen (Northfield, 1982), 10–11.
2. Theodore C. Blegen and Martin B. Ruud, eds., *Norwegian Emigrant Songs and Ballads* (Minneapolis, 1936), 85–87.
3. Ingrid Semmingsen, *Norway to America: A History of the Migration* (Minneapolis, 1978), 58.
4. See Johan Reinert Reiersen, *Pathfinder for Norwegian Emigrants*, trans., Frank G. Nelson (Northfield, 1981).
5. Orm Øverland and Steinar Kjærheim, *Fra Amerika til Norge: Norske utvandrerbrev, 1838–1857* (Oslo, 1992), 156–57. On the changes in dress, see Carol Colburn, "'Well, I Wondered When I Saw You, What All These New Clothes Meant': Interpreting the Dress of Norwegian-American Immigrants," in Marion John Nelson, ed., *Material Culture and People's Art Among the Norwegians in America* (Northfield, 1994), 118–155.
6. H. Arnold Barton, *Letters from the Promised Land* (Minneapolis, 1975), 82.
7. "Vinaigrettes, Little Immigrant Treasures," in Nelson, ed., *Material Culture*, 156–175.
8. Barton, *Letters from the Promised Land*, 82.
9. Letter from Henrietta Jessen, 1850, in Blegen, ed., *Land of Their Choice* (Minneapolis, 1955), 266.
10. Barton, *Letters from the Promised Land*, 53.
11. *Skilling-Magazin,* March 21, 1868, quoted in Semmingsen, *Veien mot Vest* (Oslo, 1942), 1:110–111.

JON GJERDE is Professor, History, University of California, Berkeley, California.

Rosemaling: a Folk Art in Migration

Nils Ellingsgard

THE DISTINCTIVE STYLE of decorative folk painting generally known as rosemaling that sprang up in the Norwegian countryside two centuries ago was not completely indigenous to it. Rosemaling resulted from the meeting of a deeply rooted rural culture with such upper class styles as Baroque, Regency, and Rococo from the continent that had migrated north and had by way of urban culture and the church in Norway reached the rural people. It was primarily in the east-central valleys of Norway that the foreign element merged with an existing aesthetic to create this distinctive style of painting with its many local variants. But migration continued. From these valleys rosemaling was carried over the mountains to the west coast, where strong distinctive styles of painting had not yet developed.

Rosemaling's last geographic migration was to America. There it came during the mid-19th century primarily in the form of decorated household objects, especially trunks, as part of the immigrants' luggage. Here it would flourish again a century later in circumstances quite different from those out of which it originally grew.

Rosemaling has experienced social and economic as well as geographic migration. Its major sources were clearly in the art of an international upper and middle class urban society. Its creation, however, occurred among the most economically disadvantaged inhabitants of rural Norway, although its early patrons were Norwegian farmers of some means. In the late 19th and the 20th centuries, it has in revived form migrated back up the socioeconomic scale; its major patrons now represent the upper and middle class society from which its inspiration originally came. Rather than necessarily reflecting the basic current tastes of that society, as rosemaling did in its original environment, it now relates more to nostalgia and the need for identity.

It was about 1750 when decorative painting began striking root in the rural districts of Norway, but the real breakthrough came with the economic upswing that occurred toward the end of that century. It is also then that we see the first signs of regional styles. Rosemaling ultimately spread over most of the country but experienced its greatest initial development in the inner districts of eastern and southern Norway. Telemark (171–184) and Hallingdal (155–163, 166) are considered the core areas of the art. Here the most distinctive local styles came into being and here we find the greatest number of painters.

Those who chose rosemaling as a form of livelihood were generally poor cotters and people without land. For many a small farm was a subsidiary source of income, but painting was their main occupation, and they got paid both in cash and in kind. Occasionally they had to content themselves with nothing more than room and board, especially when conditions in the area were extraordinarily bad. There are also examples of well-to-do farmers getting involved with rosemaling simply because they had inclinations and talents in that direction. A special case is the wealthy farmer, innkeeper, and master of the Rococo style, Peder Aadnes (1739-1792) from Søndre Land in central Norway, Norway's greatest 18th century painter. During his entire life he traveled over large parts of eastern Norway on horseback or in a carriage and painted for farmers, for officials, and in churches. This wealthy painter, in other words, shared the lifestyle of his poorer colleagues. Migration seems to have been as inherent in the disposition of the painters as it was in the nature of their profession.

The rural painter did not have the same basic training as painters belonging to guilds in towns. In some cases he was practically self-taught. But this does not mean in any way that he was an amateur. He had acquired the funda-

Fig. 39. (preceding page) *The Rosemaler*. Kai Fjell (1907–1989). 1942. (Cf. 183). Private possession. Photo: O. Væring. The work is a semi-surrealistic presentation of the rosemaler and his domestic life.

mental knowledge needed to practice the profession, often in direct contact with urban painters. But he had the advantage of an informal relation to the models on which he built, not having to copy them slavishly as the urban painter was taught to do. Characteristics from various stylistic periods could be used side-by-side in rosemaling according to the painter's own tastes and inclinations. This could lead to the original sources becoming totally unrecognizable. The freedom of the rosemaler made room for a spontaneous, personal, and unconventional form of expression to develop in his work. This is what gives rosemaling its charm and artistic distinction.

In the course of the 19th century the number of rosemalers greatly increased in rural eastern Norway. There no longer was a market for all of them in their home area, and many painters had to go far afield to make a living. The usual direction was over the mountains to western Norway where folk art was less developed. The decorative painting that did exist there was for the most part amateur work on drinking vessels, small boxes, and other minor objects. The few examples of totally decorated interiors that did exist were largely the work of urban painters.

The economy in western Norway had a somewhat different structure than in the east. The development of agriculture had fallen behind. Well into the 19th century in many places people continued to live in the old houses with an open hearth in one corner from which the smoke had to find its way out through a hole in the ceiling. The orientation was more toward the sea, toward shipping and fishing. Year after year the bounteous catches of herring had a ripple effect, reaching the inner fjord districts and even the farmers there. Although one cannot speak of prosperity, western Norway had moved further in the direction of a money economy than the east. There was more cash, and that led to painters and other craftsmen from the east going there, for longer or shorter periods, to get work. Some settled there for good.

It was migrant painters from the east who gave rosemaling a professional basis in the west. First came those from Hallingdal. Already in the 1790s we find Lars Aslakson Trageton (1770–1829) in Ryfylke, where he established a local tradition closely related to early Hallingdal painting. Around the same time Vebjørn Hamarsboen (1766–1809) was traveling around Hordaland, Nordfjord, and Sunnmøre. These painters got decorative commissions in churches as well as on farms. Both Lars and Vebjørn settled in the west, married there, and had sons who continued the rosemaling profession.

Other Halling painters made shorter trips to the west with their satchel of paints on their backs. During the winter they turned to their skis for getting over the mountains, a trying and treacherous journey in any kind of weather. All in all we find signs of about twenty painters from Hallingdal in the west before 1850, which means about one-third of all Hallingdal painters of which there is a record in the classic period. Among the best known was Elling T. Ellingplassen (1797–1882) from Hol. His unmistakable, self-styled Rococo decoration appears on trunks and cupboards both in Hordaland and in Sogn. When his sons Thomas and Lars grew up, they joined forces with their father on painting trips to the west. Thomas settled later at Steine in Hardanger, got a small farm through marriage, and worked as a rosemaler for the rest of his life. His brother, Lars (Moen) got pneumonia after a strenuous trip home in a ferocious snowstorm during the winter of 1870. At long last he arrived home but died shortly after, just forty-two years old.

A younger brother of Elling, Torkjell T. Sausgardhaugen (1801–?), must have been just as active on the west coast as at home in Hallingdal. He painted among other things a fine trunk at Kjørnes in Sogndal, which today is at Vesterheim in Decorah, Iowa. The trunk received a new owner's name in 1859. This owner was a daughter of the schoolteacher and woodworker Christian Olson Kjørnes (14). Both father and daughter emigrated to Benson, Minnesota, in the 1870s to join their son and brother, the prominent immigrant woodcarver Lars Christenson (Kjørnes) (70 and Fig. 10). That is how the trunk got to America. Its painter, Torkjell Sausgardhaugen, had emigrated to America twenty years earlier with a wife and five children.

A second migrant painter from Hol, Peder A. Tufto (1795–1863), picked up work in Hardanger five winters in a row, and each time he headed home with 100 shiny *dalere* (early Norwegian coins generally worth more than the American dollar) in his pocket. The money came in handy because the painter had as a young man played some part in Halvor Hoel's rebellious march on the capitol city of Christiania (now Oslo) in 1818. Halvor Hoel, a well-to-do farmer from Hedemark, was a political agitator and spokesman for the farmers who were dissatisfied with the government's money politics and extreme taxes. "Peder, the painter" got out of serving time but was sentenced 571 *dalere* in court costs, a high amount that he struggled for years to pay off.

The well known painters Torkjell Gåsterud (1787–1873) and Embrik Bæra (1788–1876) from Ål have also left traces in the west. It is said that Embrik brought his wife with him to prepare and paint the grounds before he came along with his rosemaling brushes.

By around 1830 the Telemark painters also began in earnest to go west. They were more numerous than those from Hallingdal, and they came with their elegant interlacing designs which gradually gained dominance in the southern regions of western Norway, especially in Hardanger. In Midhordland, the region around Bergen, as well, the Telemark rose (the term used for the basic motif in Telemark painting) became important. This was especially true in Os, where the painting also includes reflections of older geometric art.

The legendary Thomas Luraas (1799–1886) from Tinn was without question the most popular of all Telemark painters (12, 179–180). It is said that people in Hardanger had unfinished trunks standing from six to seven years in hope that the itinerant master would show up. To own a Luraas trunk became a status symbol.

In his younger years, Thomas Luraas was an adventurer like no other, and he did not always stay above the law. At twenty he was arrested near Bergen, accused of counterfeiting. But he managed to escape his guards and set out for the woods with his handcuffs on. He got rid of those by striking them against sharp stones, and so he continued, night and day, until he came to his home farm in Tinn. Here he supplied himself with food, clothing, and painting equipment; and so he set out on an escape that lasted nearly three years. His path went north from valley to valley all the way to the Røros region southeast of Trondheim. Already a proficient painter, he found work in both town and country, but he had to watch out. Thomas was being sought by the authorities over the entire country. He always went under a pseudonym, sometimes speaking Swedish.

At home in Telemark, his mother got some prominent men to seek pardon for him from the king, and this was finally granted on the condition that he report for his military service. He had also been escaping from that. Two of his brothers set out to find Thomas and tell him that he had been pardoned. They followed his tracks over hill and dale from district to district, recognizing his rosemaling, all the way to Trondheim. There they caught sight of him, but they had to take him by force before they could convince him that he was now a free man.

After that day Thomas Luraas became, for the most part, a law-abiding citizen, but the desire to travel was in his blood, and all his life he continued to be on the move with his art on the west coast and in Telemark, Numedal, and Hemsedal. This lengthy account of Norway's best known, and to many also the best, rosemaler gives an indication of the close link between rosemaling and migration.

Other rosemalers as well revealed some of Luraas' foot- looseness and had confrontations with the law. Examples are the temperamental Sevat Bjørnson (1808–1889) and Ola Tveitejorde (1817–1879). The latter had the misfortune of killing a man during a fistfight in Voss in 1860 and had to spend seven years in jail. But these stories must not be taken to mean that the itinerant rosemalers were necessarily inclined toward criminal acts. These were just an occasional consequence of their creative and volatile natures. There are many who assumed social responsibility in their communities and some who were even religious advocates.

Competition could be stiff, especially for younger painters who were little known. Ole S. Strand (1821–1913) from Valdres found that out the first time he went on a painting trip to Sogn. He was small, weak, and quiet, and no one would give him work. Finally a servant girl allowed him to paint her trunk for one mark (about ¼ kilogram) of wool. Ole put all he had into the work, and with that his reputation was made. Now everyone wanted him, and from then on he was always welcome in Sogn.

Farther north on the west coast as well, painters from Hallingdal, Valdres, and Gudbrandsdalen have left their mark. They were clearly the models for local painters, who up to 1850 were just feeling their way ahead in the rosemaling profession. West-coast painters have often mixed stylistic elements from several eastern districts, but their work generally has an unmistakable, robust character that is typically west Norwegian.

Norwegian rosemaling continued its expansion westward throughout the 19th century, and it did not stop at the coast. Emigration to America was a consequence of the same economic and social circumstances that brought rosemaling into being and contributed to its migrant character. A significant factor behind these circumstances was the sudden growth of population before the breakthrough of industry that could absorb the overflow. People from all levels of society were tempted by a fuller life on the other side of the ocean. It was not only poor cotters and artisans who scraped together money for a ticket. Well-to-do farmers too sold their land and livestock and left the country, often with their entire family. Common to most of them, poor and rich alike, was having been part of a deep-rooted rural culture with strong traditions going far back in time. It was a heritage they took with them into a new and unknown world.

Emigration was heavy from some of the areas where rosemaling had its strongest foothold in Norway. It is therefore natural that many painters were swept along with the tide of emigration. Every fourth painter, on the average, from Telemark, Hallingdal, and Valdres emigrated to America. This included some of the most gifted,

such as Nikuls Buine (175) and Tor Øykjelid(1825–?) from Telemark, Syver H. Grøt (1811–1865)(160) from Hallingdal, and Helge O. Kvale from Valdres. To what extent they had planned to continue their profession in the New World we do not know. They must have found enough to do, at least in the beginning, building a home and clearing and breaking the land for farming. The market could not have been the best either. In Norway rosemaling was going out of fashion about 1860–1870. This may have contributed to a lack of interest and low demand among Norwegian Americans of the time as well. Ola O. Strand, who emigrated together with 156 others from Valdres in 1864, got a farm in Goodhue County, Minnesota. He was called "the rosemaler" by other Norwegians in the area, but there is no evidence of his continuing to do rosemaling for extra income alongside farming as he had done at home in Norway. His colleague, Erik Hagene, also from Valdres, wrote home that he worked as a regular house painter and that the pay was good. Of the well-known rosemalers, only Erik G. Veggesrudlia from Eggedal is known with some certainty to have decorated at least several objects in America, and these appear to have been for neighbors and relatives (Fig. 12). He emigrated to the Decorah area of Iowa in 1869.

There is, however, early rosemaling in America by other painters who had not gained a reputation in Norway. A highly unusual product of Norwegian immigrant culture is a large cupboard at the Minneapolis Institute of Arts, made and painted for "John Eriksen. Brithe Sjurs-Datter Engesethe, Aar 1870" (154). John immigrated to DeForest, Wisconsin, from Leikanger in Sogn together with his parents in 1846. The cupboard is now attributed to Aslak Lie (1798–1885) from Valdres (see page 93), who would have to have learned rosemaling before he emigrated. The blue and white marble border around the door panels is typical for Sogn, but the rosemaling itself is characteristic of that in Valdres. A similar cupboard is in the private museum Little Norway near Blue Mounds, Wisconsin. It was made for a younger brother of John's and has the inscription "Erik Eriksen and Solvi J. D. Engesethe 1868." Holzhueter found Lie's signature on it.

As we have seen, the contribution of early immigrant painters to rosemaling in America was negligible. Rosemaling came rather in the form of decorated objects by the thousands that the immigrants brought with them. Much of this has been preserved and can be found over the entire continent. The trunks make up a special category of immigrant objects with rosemaling. The immigrants needed something to haul their possessions in, and the trunk was the most common piece of storage furniture on the old farms. Everyone had at least *one*, both poor and rich, men and women. The owner's name and the year were usually placed on it, and, to be really proper, it should also be decorated with fine rosemaling. The fanciest were the dowry trunks which young women received in anticipation of marriage. Today, countless well-decorated trunks in fairly good condition can be found in American homes and museums, but we must assume that a great many have also been lost. They were exposed to rough treatment on the long voyage, first the trip to the coast, then week after week on the ocean, and finally across the country on paddle-wheel boats and ox carts to the Midwest where most Norwegians settled.

When Isak Dahle of Mount Horeb, Wisconsin, advertised in 1927 for the second time in the local newspaper for Norwegian objects to place in his private museum, he gave notice that he was not accepting trunks and spinning wheels. He must already have received enough of these or was afraid of being too flooded with calls. A similar policy must have been in effect although unstated at Vesterheim, Norwegian-American Museum, Decorah, Iowa. After six years of collecting Norwegian material in 1902, it had accessioned only one trunk. Later, when it appeared that even trunks could become scarce, the attitude must have changed. Today the museum has nearly 150 trunks.

To the total number of existing trunks with painted decoration can be added about 200 more still in private possession that were registered as part of the research for my book *Norwegian Rose Painting in America*. Many trunks are also in local museums throughout the vast areas where Norwegian immigrants settled.

Even if trunks dominate in the migration of Norwegian rosemaling across the ocean, we must not forget the items that came in the trunks: tankards, ale bowls, other drinking vessels, baskets, and small boxes. Vesterheim, other museums, and private collectors have a goodly number of them, and many are being handed down as heirlooms from generation to generation in Norwegian-American families.

Several stories are known about the meaning that such familiar mementoes from the old country could have for immigrants and their descendants. Øystein Vesaas in *Rosemaaling i Telemark* (II, 95), tells a story indirectly relating to the great rosemaler Nikuls Buine from Fyresdal (175). Nikuls emigrated in 1852 with his wife Gro and eight children. They put out from Porsgrunn at the end of May on the brig *Washington* and reached New York after sailing well over seven weeks. The trip continued by canal boat to Buffalo and by steamboat to Racine, Wisconsin. But Nikuls had contracted cholera on board and died the day

after arrival. Two other women in the group also lost their husbands, and two years later the three widows with their families made the trek across the prairies of Wisconsin to Trempeleau Valley near the Mississippi River. This was completely unsettled territory at the time. Twenty years later two immigrants who were also from Fyresdal came to Trempeleau Valley late one evening and left their luggage outside where they were to stay. When they came out in the morning they found one of the three widows, now an old woman, standing in tears by the things they had left out. She had recognized her decorated dowry trunk which she had not been able to take with her. She had to have it and was able to make the purchase.

Almost the entire realm of rosemaling in Norway is represented in America. This includes all the local variants and, as it seems, most of the painters, both those known by name and those identified only by style. The most prolific areas—Telemark, Hallingdal, Valdres, Gudbrandsdalen, and Agder—dominate. Much is also from the west coast, and in this we often meet again the migrant painters from Hallingdal, Telemark, and other eastern valleys. But local painters as well, especially from Hardanger and Ryfylke, are among them.

Classic rosemaling in Norway was a product of economic and cultural circumstances in a specific period, a form of art that grew naturally out of its time in the meeting of Norwegian rural and European urban culture. It withered with the passing of the old rural society. Already by about 1850 rosemaling was on the decline in both quality and quantity. What characterizes the painting of this later period is insecurity in the use of color, with too many hues and nuances employed in one design (184). A number of new synthetic colors came on the market, and this did not improve the situation. In general the decline is related to the final breakthrough of industrialism.

But the migration had not come to an end. Rosemaling was to experience a renaissance in the 20th century. It woke to new life in Norway with the Neo-Romantic and national currents around 1900 when it entered a broader and more urban popular culture. The interest has grown especially since 1950. This must be looked on as a reaction against the mass production and standardization of the time. Most of today's rosemalers in Norway come from the rural society, but the market is no longer only there as it was in the early days. The people who buy and commission work are generally established urban citizens who like to surround themselves with folk art from the milieu out of which most of them originally came. They like it in their city homes but want it especially in their mountain cabins where they can retreat to a world symbolic of their past, which in hindsight seems more fulfilling and secure than that in which they spend much of their everyday lives. The social and economic migration of rosemaling has brought it right back to the established people of the city from whom it originally received the spark that led to its explosion in the Norwegian countryside two centuries earlier.

In America the renaissance in rosemaling since 1950 has been exceptionally strong. There the masses of objects that had come in through the migration of peoples had lain as seeds, so to speak, since the 19th century waiting for the conditions that would make them grow. These came with the wave of ethnic awareness that arose among Americans of all backgrounds after World War II. To Norwegian Americans this involved not only giving more attention to the physical vestiges of their place of origin but using these as points of departure for further growth. A blossoming has occurred in rosemaling among Norwegian Americans and those under their immediate influence that echoes in vitality and breadth that which occurred in the rural districts of Norway in the early 19th century. The wealth of seeds, if that metaphor can be maintained, alone cannot account for this. The close contact which the immigrant craft community has maintained with Norway, both with its original source material, now primarily in museums, and with its contemporary traditional artist/craftsmen has contributed much. They are the teachers, but the best of the Americans take the same free position in relation to them that the old rural painters in Norway took in relation to their continental models. This means that the American material often has its own character and that not only the tradition but also some of the creative force behind it endured the Atlantic crossing.

NILS ELLINGSGARD is a painter and scholar of rosemaling in Oslo, Norway. Article translated from Norwegian by Heather Muir, Minneapolis, Minnesota.

Paint and the Flowering of Norwegian Folk Art
Rosemaling in the Gudbrandsdalen, Low Country, and Valdres Styles

146.

146. Traveling trunk with painting in the Lesja style. Norw. Gudbrandsdalen. Mid 18th century. Painted wood, iron. H. 8¾″ W. 18¼″ D. 19⅛″ Sandvigske Samlinger, Maihaugen (19747).

Rosemaling, a general term for Norwegian folk painting, developed in the wake of acanthus carving as the last category of folk art to flourish in Norway. The style on this small trunk even attempts to simulate the three-dimensionality of carving and is closely associated with the Klukstad family of carvers (50, Fig. 6).

147. Plate with rosemaling in the Lesja style of Gudbrandsdalen. Norw.-Am. Judy Ritger, River Falls, WI (See also 139). Signed and dated 1994. Painted basswood. H. 1″ Diam. 25″ Nordland Rosemalers Association.

The regional styles of rosemaling in America, except for that of Os, are revived rather than direct continuations of tradition. Ritger is the major representative of the Lesja style, which she learned from the Norwegians Nils Ellingsgard and Ragnvald Frøysadal and from study of original examples.

147.

148. Two-piece secretary with floral painting. NORW. Attributed to Peder Aadnes (1739–1792), Nordre Land, East Norway. 1763. Painted wood. H. 97⅝" W. 53⅛" D. 26¾" Inscription: "Anne Jacobs Daatter Bye Fød [born] 1738 den 25 Martius Anno 1763". Norsk Folkemuseum (NF 1939–714).

Well south of Lesja but still in the central valleys, the flowers of late Baroque and Rococo entered rural painting in the 1760s through Aadnes, who had close urban connections. This essentially city piece has the massiveness and flamboyance in decoration characteristic of country furniture.

148.
detail

150.

149.

149. Turned ale bowl with acanthus carving and rosemaling in the Aadnes style. Norw.-Am. Painter: Enid Grindland, Alexandria, MN. Turner: Paul Loftness. Carver: Hans Sandom. Signed and dated 1988. Painted basswood. H. 5″ W. 22 Inscription: "Malachi 3:10. I will open the windows of heaven for you and pour down for you an overflowing blessing." Enid Jerde Grindland.

Through Ellingsgard, the Aadnes style developed adherents in Norwegian America around 1980. This style of bowl has prototypes in Valdres where Aadnes painted. The inscription reflects the close association between folk art and religious expression among Norwegian Americans.

150. Turned ale bowl with rosemaling in the Aadnes style. Norw.-Am. Painter: Eldrid Skjold Arntzen, Windsor, CT. Turner: Jack McGowan. Signed and dated 1989. H. 5¼″ Diam. 16″ Translated inscription: "Let us not forget our forefathers in all our rushing about: They gave us a heritage to cherish. It is greater than many would believe." Eldrid Skjold Arntzen.

The sentiment in this inscription is national, an association that next to religion is strong in Norwegian-American ethnic art. The work, however, indicates also a strong attraction to the purely aesthetic.

151.

151. Chest of drawers with rosemaling in the Valdres/Aadnes style. Norw. Ola Hermundson Berge (1762–1825), Valdres. 1793. Painted pine. H. 46⅝″ W. 41¾″ D. 20⅛″ Inscription: "K.D.1793". Sandvigske Samlinger, Maihaugen (15196).

Valdres painters under Aadnes influence, among whom Berge is central, further stylized the flowers, eliminated detail, and made the brush work looser.

152.

152. Turned ale bowl with acanthus carving and rosemaling. Norw. in Am. Painting attributed to Ola Hermundson Berge, Valdres. Found near Fergus Falls, MN. 1823. Painted wood. H. 4⅞″ Diam. 9½″ Translated inscription: "Sidsel Knudsdatter Wiigh: Anno: 1823 When I am full, Then I have friends. When everything is gone, They forget me." Vesterheim (85.6.1).

Simplification continued, as seen in this late work by Berge. Tongue-like leaves or petals shading from one side to the other become a hallmark of Valdres rosemaling. Acanthus carving on turned bowls is also a Valdres characteristic.

153. Spouted ale tankard (*tutekanne*) in stave construction with rosemaling. Norw.-Am. Painter: Ethel Kvalheim, Stoughton, WI. Maker: Severt Rasmuson, Detroit Lakes, MN. Signed and dated (by painter) 1992. Painted pine. Vesterheim, gift of Ethel Kvalheim (92.83.1).

Building on Aadnes-inspired Valdres painting, the veteran rosemaler Kvalheim, whose work goes back in direct line to Norway through her neighbor and early mentor Per Lysne (201), decorated this tankard by a craftsman who also acquired his techniques directly through observing traditional craftsmen in his native Nordfjord before emigrating around 1900.

153.

154. Cupboard with painting in Valdres/Sogn style. Norw.-Am. Aslak Lie (see page 93), Springdale, WI. 1870. Pine. H. 88¼″ W. 52½″ D. 21¾″ Inscription: "John Eriksen. Brithe SjursDatter Engesethe Aar 1870." Minneapolis Institute of Arts.

The Valdres style of painting as found in Sogn, where Valdres painters were influential, was among the few to be continued by direct tradition among Norwegian Americans. This cupboard is one of two American examples done for brothers in the Engeseth family from Leikanger, Sogn, between 1868 and 1870. The tradition stopped with them.

Hallingdal Rosemaling and Related Styles

155.

155. Spouted ale tankard (*tutekanne*) with rosemaling. NORW. IN AM. Herbrand Sata (1753–1830), Ål, Hallingdal. 1804. Painted pine. H. 14½″ W. 14¼″ D. 9¾″ Inscription: "Johannes Grimsgard" "N.O.D. Anno 1804 N.H." Vesterheim, Luther College Collection (807).

Hallingdal, southwest of the areas just covered, shortly before 1800 developed one of the two most distinctive styles of rosemaling. The starting point for Sata, the father of Hallingdal painting, was the Rococo, but he soon reverted, as seen here, to the greater symmetry and solidity of the Baroque.

156. Turned ale bowl with lip (*trøys*) and rosemaling. Norw. Nils Bæra (1785–1873), Ål, Hallingdal. 1835. Painted wood. H. 3⅞″ W. 13¾″ D. 10¾″ Inscription: "K.E.L. 1835." Norsk Folkemuseum (NF 1992–69)

Nils, a son of Sata (155), brought an almost whimsical delicacy to his father's style without departing from its fundamental centrality or tight composition. He was prolific and highly influential.

157. Trunk with rosemaling. Norw. in Am. Embrik Bæra (1788–1876), Ål, Hallingdal. Trunk came to Minnesota. 1841. Painted pine. H. 27¾″ W. 47″ D. 25½″ Inscription: "Haagen Hermandsen Sire fød (born) 1820 malet (painted) 1841." Martha Langslet Hoghaug.

Sata's son Embrik acquired the fundamentals of Hallingdal painting from his family but brought a more bizarre imagination to them. While retaining the basic central flower from which others spring, Embrik has given the various elements exotic form without specific prototypes. Individual expression is pronounced.

156.

157.

158.

159.

158. Hanging brush cupboard with acanthus carving and Hallingdal rosemaling. Accompanying towel with Hardanger embroidery (not shown). NORW.-AM. All work by Sallie Haugen DeReus, Leighton, IA. Signed and dated 1994. Painted wood, cotton. H. 24½" W. 17½" D. 6¾" Towel: H. 34" W. 26" Sallie Haugen DeReus.

Nils Ellingsgard, the second rosemaler brought as a teacher to Vesterheim in the 1960s, is the father of Hallingdal painting in America today. One pupil, as seen here, has mastered many traditional Norwegian arts.

159. Turned ale bowl with rosemaling. NORW. Ola Feten (1808–1884), Ål, Hallingdal (See also 72). Mid 19th century. Painted wood. H. 3½" Diam. 9" Norsk Folkemuseum (NF 1948–620).

The flower with spiraling petals has Rococo prototypes, but in Hallingdal the spiral became more important than the flower, an indication of local fascination for abstract design. Feten was a pupil of Nils Bæra (156).

160.

160. Turned ale bowl with rosemaling. NORW. Syver H. Grøt (1816–1885), Hol, Hallingdal. 1847. Painted wood. H. 4 Diam. 11⅜" Inscription: "Lars Larsen Houg Den 19de Juli 1847." Norsk Folkemuseum (NF 1948–597).

The major painters in Hol got their inspiration and training from the Sata-Bæra clan in neighboring Ål. The most lyrical Hol painter was Syver Grøt who emigrated to Iowa at thirty-two and quit painting. Presenting the central flower from the side, as here, rather than the top as seen previously, was common.

161. Turned ale bowl with rosemaling in Hallingdal style. NORW.-AM. Judith Nelson Miner, Minneapolis, MN. Signed and dated 1990. Painted basswood. H. 6⅞" Diam. 16½" Translated inscription: "Do not judge a man by his good qualities, but by how he makes use of them." Wisconsin Folk Museum.

The central Hallingdal flower when presented from the side in a bowl has an appealing dynamic effect. Miner represents a group of exceptional Hallingdal painters in Minneapolis.

161.

162. Turned and carved ale bowl with lip (*trøys*) and rosemaling. Norw. Torstein Sand, Hol, Hallingdal (See also 166). 1835. Painted wood. H. 4¼″ W. 16¾″ D. 14½″ Inscription: "1835 Mekkel Olsen Moen." Norsk Folkemuseum (NF 1909–406).

The Hallingdal flower presented from the top in a bowl took many forms. The sunburst vitality of this one is picked up in the tendrils surrounding it. The primary colors, red, yellow, and blue, with accents of white, create a brilliant effect found in much Hallingdal painting.

163. Turned ale bowl with rosemaling in Hallingdal style. Norw.-Am. Painter: Dorothy Peterson, Cashton, WI. Turner: Jack McGowan. Dated 1987. Painted wood. H. 4⅞″ W. 16″ D. 12½″ Jack McGowan.

The Norwegian Americans often temper old native work, replacing primitive vibrance with balance and control. What is already aesthetic is further aestheticized, an indication that sheer beauty has a place with religious and national associations in perpetuating the tradition.

164.

164. Turned wedding bowl with acanthus carving and rosemaling. Norw.-Am. Painter: Jo Sonja Jansen, Eureka, CA. Turner: Paul Loftness. Carver: Hans Sandom. Signed and dated 1992. Painted wood. H. 5½″ W. 22½″ D. 15¾″ Translated inscription: "Legacy. Heritage. And the two shall become one, and the one shall become many." Jo Sonja Jansen.

The product of a painter whose concepts are personal and who draws on anything in her artistic background to give them form, this work fits no stylistic slot but the flowers have some relation to Hallingdal. It is a truly folk creation executed by an individual of extreme technical and aesthetic sophistication.

165. Turned ale bowl with rosemaling. Norw. in Am. Attributed to Knut E. Horne (1763–1848), Oppdal, Trøndelag. 1828. Painted pine. H. 6½″ Diam. 16″ Translated inscription: "Wine makes a mocker, strong drink makes one rowdy; and anyone misled by them does not become wise. 1828." Vesterheim, Luther College Collection (823).

Although far north of Hallingdal and ordinarily different in its rosemaling style, Trøndelag painting is here presented as an extension of Hallingdal because this specific piece echoes work from that area (Cf. 155). The greater simplicity and realism is characteristic of rosemaling outside its major centers.

165.

Altar and Architectural Figure Painting

166. Door with painted text and scene of Samson and the lion. NORW. Torstein Sand (1808–1887), Hol, Hallingdal (See also 162). 1828. Painted wood. H. 57″ W. 35″ Translated inscription: "Here I have eaten my bread for many years with honor. I have not suffered need because, thank the Lord, I will praise His name with my heart, mind, and mouth, as long as I live; He will always be praised." Norsk Folkemuseum (NF 1909–390).

Based on an illustration in the Bible of Frederik II, 1587, this "guardian of the door" is transformed into decoration. The plot of ground is that from which the Hallingdal flower often grows, roots and all. The puffs on the pants become C-scrolls. The hatching on the coat of mail resembles the line work on the flowers with spiraling petals (159).

167. Painting: *Samson and Delilah*. Norw.-Am. Peter O. Foss (1865–1932), Boston, MA. Immigrated in his 20s. Ca. 1900. Oil on canvas. H. 66″ W. 52″ Vesterheim, gift of William Currier. (81.61.4).

This Norwegian-American presentation of Samson exemplifies the ongoing appeal of sensational Old Testament subjects but a loss of the old decorative style. Its strength lies in its expressive naiveté rather than its design qualities. The context is American folk art

168. Altar painting from Kjose church: *The Last Supper*. (Related to an engraving after Lambert Lombard). NORW. Vestfold. 1606. Wood. H. 71¼″ W. 54⅞″ Translated inscription: "Anno Domine 1606. God look favorably on you, Peder Iffuerson and Mergret Brede, who had me made and presented me here" plus Biblical quotation relating to the Last Supper. Norsk Folkemuseum (NF 1901–312).

Probably by an urban painter, this work represents a typical treatment of the most common subject for altars during the Baroque period in Norway. John Rein (169) would undoubtedly have seen similar examples before emigrating.

169. Altar painting from Rose church: *The Last Supper*. Norw.-Am. John A. Rein (1858–1916), Roseau, MN. From Ørlandet and Hitra near Trondheim. 1895. Paint, canvas, wood. H. 78¼″ W. 33¼″ (inside frame). Roseau County Historical Museum and Interpretive Center.

Rein did retain a sense for both the decorative and the expressive. The use of this subject for an altar and the arrangement of figures around the table, neither of which is common in America, also comes from Norway (168). Some faces, however, are drawn from Leonardo Da Vinci as found in one version of the 1890 Holman Bible, Waverly Publishing Co., Chicago.

170.

170. One of four doors (only upper half shown) with painted Biblical subjects. Norw.-Am. Martin Olsen (1829–1881), Elkhorn, WI. From Gjerpen, Telemark. Ca. 1860. Oak, oil, possibly earth pigments. H. 69″ W. 26″ Inscribed with the names of the Biblical figures. Vesterheim, purchased with assistance from Julie Cahill (91.127.1.1).

The doors, all similar, are the only known examples of early immigrant folk interior decoration, although this is common in Norway. As is often true there, the models are illustrations, here said to be from *The Complete English Bible* (London 1788). Putting guardian figures on doors is also Norwegian (166), but little of Norwegian folk style is evident.

171. Turned ale bowl with rosemaling, painted ship, and figures. Norw. Telemark. 1765. Painted wood. H. 9⅞″ Diam. 19⅝″ Translated inscription: Interior: "My class [military] fights for kingdoms and countries, and mine [clergy] prays for the country and all other classes. Ours [farmers] nourishes and enriches the country and its people, and ours [citizens] unites everyone in all countries. ST 1765." Exterior: "Some people drank from me last night. They left behind both their bags and hat. They went down on this earth. I am still standing full on Sigur Knudson's table. 1765." Norsk Folkemuseum (NF 1906–428).

This bowl indicates that early figure painting could be exceedingly quaint and primitive.

172. Turned ale bowl with rosemaling and painted figures. Norw. Attributed to Sondre Busterud (1763–1842), Kviteseid, Telemark. 1828. Painted wood. H. 6⅜″ Diam. 16⅛″ Translated inscription: Exterior: "Dan was the first King of Denmark. After Dan came Homle and Lotter, his sons." (remainder unclear). Interior: "A farmer drank from me tonight. He lost his gloves and his hat. He couldn't stand on this earth. I am still standing with ale on the table 1828." Norsk Folkemuseum (NF 1948–611).

The eerie surrealism is exceptional. Class may again be involved (171) because officers appear to alternate with farmers. The unusual three-part division in the border also appears on the box by Landsverk (62), who went to school in Kviteseid fifty years after this bowl was painted.

Telemark Rosemaling and Related Styles

171.

172.

173

174

175.

173. Turned ale bowl with rosemaling and painted figure on horseback. Norw. Ola Hansson (1761–1843), Hovin, Telemark. 1805. Painted wood. H. 8⅝″ Diam. 20⅞″ Translated inscription: "Big guy is my name. There is no one like me in all of Norway. I can take on 15 men. It's better that you drink me down. Then shame upon your throat (unclear) HSJEDH 1805." Norsk Folkemuseum (NF 1906–427).

Hansson is the father of rosemaling in Telemark and an exceptional figure painter. Rather than fully integrating figures with the decoration he, like Øvstrud (73), lets them stand out with slightly awkward individuality.

174. Round bentwood box and slip-on cover (*sponeske*) with rosemaling. Norw. Ola Hansson (See also 173). Dated 1806. Painted wood. H. 7½″ Diam. 15¾″ Norsk Folkemuseum (NF 1896–717).

Some of Hansson's early work, like this example, had the realistic and pastel flowers of Rococo but, like Sata in Hallingdal, he abandoned them for the more stylized and less fragmented Baroque.

175. Oval bentwood box and clamp-on cover (*tine*) with rosemaling. Norw. in Am. Nikuls Buine (1789–1852), Fyresdal, Telemark. Before 1851. Painted pine, birch. H. 6⅜″ W. 14⅞″ D. 8⅝″ Illegible inscription. Vesterheim (86.38.1a,b).

Hansson's younger contemporaries in Telemark continued to build on Rococo, leaving Hansson somewhat isolated. From it they developed the C-scroll with roots, branches, and flowers called the "Telemark rose," a hallmark of Telemark folk painting. Buine emigrated with this piece to America and died upon arrival.

176.

176. Pedestal plate (*stettefat*) with rosemaling. Norw. Hans Glittenberg (1780–1873), Heddal, Telemark. Painted wood. H. 5⅛″ Diam. 18⅛″ Norsk Folkemuseum (NF 1895–1132).

Together with the C-scroll, Glittenberg also continued some of the pastel color and realistic flowers of Rococo. Softly shaded, full-bodied leaves and blossoms and precise, virtuoso line work characterize the painting of this prolific and influential artist.

177. Trunk and base with rosemaling. Norw. in Am. Hans Glittenberg (See also 176). 1847. Painted pine. H. 42″ W. 47″ D. 27″ Inscription: "Gunder Svenssen Groven in Juni. Aar 1847." Karine Clark, Gladys Fjelland, and Orman Overland.

Brought to America in 1934 long after the family had emigrated, this trunk is much better preserved than many that came as luggage, even the base being intact. It is a classic example of what might be called "the beautiful style" in rosemaling.

178. Turned ale bowl with rosemaling in Telemark style. Norw.-Am. Ethel Kvalheim, Stoughton, WI. Signed and dated 1989. Painted basswood. H. 7″ Diam. 15″ Translated inscription: "The greatest joy one can have is to make others happy." Vesterheim (89.43.5).

The legacy of Glittenberg in 20th century Norwegian America is superbly revealed in this bowl by a rosemaler who has been involved with the art for close to half a century.

177.

178.

179. Small footed trunk with rosemaling. Norw. in Am. Thomas Luraas (1799–1886), Tinn, Telemark. Found in Iowa. 1830. Pine. H. 11½″ W. 12½″ D. 10″ Inscription: "AOD" "AODJ 1830." Nancy Morgan.

A younger contemporary of Glittenberg and equally long-lived and prolific, Luraas became even more influential because of his wide travels. He is as flamboyant as Glittenberg is beautiful.

180. Turned ale bowl with rosemaling. Norw. Thomas Lurass (See also 12,179). Mid-19th century. H. 11⅜″ Diam. 23¼″ Translated inscription: "Pour ale in me and set me on the table for the guests to give them a lift and quench their thirst so they dance the Halling [an acrobatic dance for men] freely." Norsk Folkemuseum (NF 1992–302).

Strong primary colors add to the verve of Luraas's painting in his early and high period.

181.

181. Screen with rosemaling in Telemark style. Norw.-Am. Addie Pittelkow, St. Paul, MN. Signed and dated 1989. Painted wood. H. 29¾″ W. 25¼″ D. 6⅛″ Inscription: "Peace be within your walls and quietness within your towers. Psalm 122:7." Vesterheim (89.43.3).

The Luraas style as translated by the contemporary Norwegian Sigmund Aarseth established a core strain in American rosemaling. He has taught at Vesterheim and elsewhere since 1967. Pittelkow is the major propagator of the style in Minnesota's Twin Cities. The object is non-traditional but the biblical inscription is typical of rosemaling in America.

182. Plate with rosemaling in Telemark style. Norw.-Am. Norma Getting, Northfield, MN. 1992. Painted wood. H. ¾″ Diam. 35½″ Translated inscription: "Matthew 17:20 He said to them, 'Because of your little faith. For truly, I say to you, if you have faith as a grain of mustard seed, you will say to this mountain, move hence to yonder place, and it will move; and nothing will be impossible to you.'" Norma Getting.

Transparency was advocated by Aarseth and relates here to the spiritual dimension of faith.

182.

183. Bed with rosemaling in the Telemark style. Norw.-Am. Painter: Karen Jenson, Milan, MN. Builder: Larry Schiller. Dated 1982. Painted wood. H. 89" W. 88" D. 67" Inscriptions identify Biblical sources of the scenes and include the evening and morning children's prayers in English (See Appendix II): Karen Jenson.

Of Swedish background but closely affiliated with the Norwegian immigrant community, Jenson is a major representative of the Luraas/Aarseth direction in rosemaling. With its masterful scroll work, marbleizing, and naive figure painting, this bed, now used for over twelve years by the artist, epitomizes the recent flowering of rosemaling in America.

183. detail

184.

184. Trunk with rosemaling. Norw. in Am. Olav Luraas (1840–1920). Tinn, Telemark. Trunk came to Minnesota. Painted pine. 1868. Inscription: " Ole Olson Fetland Mallet [painted] Aar 1868." H. 32" W. 48" D. 24" State Historical Society of North Dakota (SHSND 12323).

The Luraas family brought its own tradition to an end. The line work and scrolls in this piece by a son of Thomas are so dense that they seem tied in. The color too has lost its clarity through heavy shading. The work is striking as an ultimate of its type but also marks its finale.

185. Round bentwood box and slip-on cover (*sponeske*) with rosemaling. Norw. in Am. Attributed to Kjetil Haukjem (1774–1859), Numedal. 1842. Painted pine. H. 7¼" W. 16⅛" Inscription: "JSD 1842." Mary and Arnold Pleuss.

Painting in areas neighboring Telemark also made extensive use of the C-scroll. Looser brush work with less emphasis on precise outlining give the painting of Haukjem in Numedal northeast of Telemark a fresh and casual character.

186. Traveling trunk with rosemaling. Norw. in Am. Gunnar or Erik Veggesrudlia, Eggedal. 1869. Painted pine, iron. H. 10¾" W. 19¼" D. 13⅝" Inscription: "J.G.S.B. 1869." Vesterheim, Luther College Collection (1299).

The freer quality of Numedal painting but with more outlining is found farther north in Eggedal. In 1869 Gunnar Veggesrudlia died and his son Erik left for Iowa. Which one painted this trunk that year is uncertain. Of early identified artists who emigrated, Erik alone is known to have continued some painting (Fig. 12).

187. Bentwood food basket (*sendingskorg*) with rosemaling. Norw. in Am. Telemark motif probably painted in Hallingdal. Found in Flom, MN. 1872. Painted wood. H. 12" Diam. 15" Inscription: "Aagot Bjørnsdatter 1872." Jim and Mary Richards.

A characteristic Telemark border (176) is here painted in a technique and on an object that belong to Hallingdal, an indication of Telemark's impact even in areas with strong local traditions. The cross-breeding has resulted in an object of exceptional taste and beauty.

185.

186.

187.

188. Trunk with rosemaling. Norw. in Am. Jorund Tallaksen Tjørehom, Sirdal, Aust-Agder. Trunk came to Minnesota. 1839. Painted pine. H. 27″ W. 45″ D. 22¼″ Inscription: "Aslag Torgusen Potten 1839." Vesterheim (87.69.1).

The C-curve of Telemark also entered Aust-Agder, but was used with distinctive yellows shading into red. The jagged outlines are a part of Tjørehom's personal style. The trunk migrated with the family that commissioned it.

189. Bentwood box and clamp-on cover (*tine*) with rosemaling in Aust-Agder style. Norw.-Am. Patti Goke, St. Cloud, MN. Dated 1994. Painted basswood. H. 7½″ W. 13⅓″ D. 7″ Vesterheim (94.49.1).

The styles of Agder have been little taught in America, but recent painters in North Dakota and Minnesota, primarily in Agder settlements, have been inclined toward them, drawing inspiration from old pieces (188).

189.

188.

Rosemaling in Vest-Agder and West Norwegian Styles

190.

190. Turned ale bowl with painted bridal procession. Norw. Attributed to Tore Risøyne (1762–1820), Fjotland, Vest-Agder. Painted wood. H. 7″ Diam. 19¾″ Translated inscription: Interior: "A farmer drank from me last night so he forgot both his cap and his hat. Now he lies in a mess on the street. I am still standing full of ale on the table." Exterior: "I am set out because my friends are those who are gathered here and love beer, says Ole Eiersen Smiland 1803." Norsk Folkemuseum (NF 1990–1406).

Southwest of Telemark in Vest-Agder, a primitive tradition of German and Dutch Renaissance and Baroque inspiration arose. Interiors and furniture were decorated, but the ale bowls with quaint and earthy wedding processions are the best known products.

191.

192.

193.

191. Oval bentwood box and slip-on cover (*sponeske*) with rosemaling. NORW. IN AM. Vest-Agder type. Found in Illinois. Early 19th century. Painted pine. H. 5¾" W. 15½" D. 9⅞" Mary and Arnold Pleuss.

The transition in style as one progresses west and north up the Norwegian coast is gradual. The decoration on this Vest-Agder box of Dutch and German inspiration has a lightness and delicacy that relates to painting in neighboring Rogaland (192). The symmetry reflects ongoing Renaissance presence.

192. Traveling trunk with rosemaling. NORW. Ryfylke, Rogaland. 1846. H. Ca. 11" W. Ca. 24" D. Ca. 14" Inscription: "Rasmus GudmanSen Haarans[?] Aar 1846." Ryfylkemuseet through the efforts of Gunnar and Bergljot Lunde.

Symmetry in Rogaland painting comes both from the resident Hallingdal painter Lars Aslakson Trageton (1717–1839) and a local Renaissance tradition. The decoration here is characteristically delicate but primitive.

193. Hanging corner cupboard with rosemaling in the so-called American Rogaland style (Cf. 191–192). NORW.-AM. Vi Thode, Stoughton, WI. Signed and dated 1975. Painted wood. H. 21¾" W. 16½" D. 11½" Vesterheim (78.99.2).

Color prints of Rogaland painting published in Stavanger have inspired American painters since the late 1930s. The teaching of Bergljot Lunde from there at Vesterheim since about 1970 led to a new explosion of interest. Thode represents this phase.

194.

195.

194. Plate with rosemaling in American Rogaland style. Norw.-Am. Nancy Morgan, West Des Moines, IA. Signed. 1987. Painted wood. H. 1″ Diam. 20″ Vesterheim (87.98.1).

American Rogaland came to have only vague reference to early painting from the area. The major difference is the greater precision and density in the American work. Geometry is pronounced, but the details can have individual character.

195. Turned ale bowl with rosemaling in free Rogaland style. Norw.-Am. Painter: Trudy Peach, Monticello, MN. Turner: Jack McGowan. 1994. Turner signed and dated 1985. Painted wood. H. 6⅛″ Diam. 15¼″ Jack McGowan.

Though criticized for their geometry, American Rogaland painters reveal that immigrant rosemaling can develop in its own direction. This is evident here where reflections of Hallingdal have come back and a strong border reminiscent of Agder/Telemark carving (132) has been added. The result is still unified and fresh.

196. Round bentwood box and slip-on cover (*sponeske*) with rosemaling. Norw. in Am. Viksdal, Sunnfjord. Found in Minneapolis. Late 19th century. Pine. H. 5⅛″ Diam. 15⅛″ Estelle Hagen Knudsen.

Momentarily jumping north to Sunnfjord, we discover a *Norwegian* schematization of rosemaling. The production of items for sale began here around 1800 and reached mass proportions by the 1860s. While the designs are schematic, the execution is free and lively. Many examples migrated.

196.

197.

197. Trunk with rosemaling and depiction of buildings. Norw. Attributed to Nils Midthus (1795–1875), Os, Hordaland. 1831. Painted wood. H. 31⅛″ W. 47″ D. 30″ Inscription: "BJDH 1831." Norsk Folkemuseum (NF 1952–240).

Rosemaling was also done for sale back down the coast in Hordaland. Midthus's style grew partly out of small Hardanger sales items with figures and buildings. He added the Telemark scroll and created a new style for commercial production.

198. Oval bentwood box and clamp-on cover (*tine*) with rosemaling. Norw. in Am. Attributed to Nils Midthus (See also 197, 200). 1850. Pine. H. 8½″ W. 15¼″ D. 7½″ Inscription: "Olina Oles Datter 1850." Irene M. Lamont.

This family piece of a Norwegian-American painter is from the middle period of Midthus's production. The shaded oval leaves with veins are a hallmark for Os. They and the color green gain prominence, while the Telemark rose with shell-like roots also remains.

199. Ale bowl with rosemaling in Os/Telemark style. Norw.-Am. Irene Lamont, Eau Claire, WI. Signed and dated 1985. Painted basswood. H. 7⅞″ Diam. 22½″ Vesterheim (85.65.4).

Echoes of the family piece (198) continue in the painting of Lamont. The veined leaves, the Telemark rose, blue shell forms, the red ground with blue border, and even the simulated fluting on the latter are all here. Without copying, she works within a tradition.

198.

199.

200. Small trunk with rosemaling. NORW. IN AM. Attributed to Nils Midthus or Ola Lien Midtbo, Os, Hordaland. 1864. Painted pine. H. 8½″ W. 17″ D. 11¼″ Inscription: "Martha Karina Jons Datter Koldal 1864" and "MKJDK Aar 1864." Vesterheim, gift of Selma Anderson (77. 39.1).

By the 1860s flowers viewed from the top or near so became increasingly prevalent in Os painting. White, red, or black became the almost exclusive ground colors, creating festive effects. Many examples came to America because they were contemporaneous with late mass emigration.

201. Plate with rosemaling in free Os and Hallingdal styles. NORW.-AM. Per Lysne (1880–1947), Stoughton, WI. From Lærdal, Sogn. Signed. Ca. 1935. Painted wood. H. 1″ Diam. 19⅝″ Translated inscription: "The smørgaasbord is on the table—help yourself!" Vesterheim, Luther College Collection (299).

Os painting came live to America in 1907 with Lysne, the son and assistant of a decorator. His repertoire of styles was great, including his version of the Hallingdal seen in the center here, but Os, seen in the border, was the most natural to him and the one others learned from him. He too painted commercially.

201.

200.

202. Chair with painting in the Os style. NORW. IN AM. Annanius Tveit (1847–1924) or his school. Early 20th century. Painted wood. H. 35″ W. 24½″ D. 18″ Little Norway.

In Norway the Os style was further commercialized by Tveit, son of Midthus (197, 198, 200). Around 1890 he painted sales items for a firm in Bergen and later established his own workshop in Os from which he after 1896 supplied the West Norwegian Arts and Crafts Society. The style remained fresh and imaginative.

203. Three-legged chair (*rokkestol*) with rosemaling in the Os style. NORW.-AM. Painter: Norma J. Wangsness, Decorah, IA. Craftsman: Willis R. Wangsness. Signed and dated 1983. Painted wood. H. 21½″ W. 19¾″ D. 13″ Willis and Norma Wangsness.

The work of Per Lysne (201) led to much American painting in the Os style between the 1930s and 1950s. Kvalheim (153, 178) created the finest early examples. Wangsness has recently returned to it, drawing inspiration more from Norwegian work than from Lysne.

204. Porridge server in stave construction (*ambar*) with rosemaling. NORW. IN AM. Follower of Nils Midthus (197–198, 200). 1885. Pine. H. 11¼″ W. 15½″ D. 12¼″ Inscription: "Martta A. Rykken" "Aar 1885." Alex and Suzanne Medlicott.

The Os style reached Seattle directly, not through Lysne. The husband of the painter Agnes Rykken there stemmed from Hordaland where he received this exceptional example of Os design and painting from his family. The impact of it and other objects from the area are immediately evident in Agnes' work.

204.

205.

205. Child's desk and stool with rosemaling in free Os style. NORW.-AM. Agnes Rykken (1901-1991), Seattle, WA. Signed and dated 1964. Painted wood. Desk: H. 32″ W. 24½″ D. 15″ Stool: H. 18″ W. 12″ D. 12″ Inscription: "Look in thy heart and read. SREM 55" (year of daughter's birth). Alex and Suzanne Medlicott.

Rykken was aware of Peter Hunt's efforts to revive American folk art before she discovered that of her own background, an indication of a link. The rider here reflects Hunt, but the shaded leaves with veins and the fantasy flowers are elements from Os, freely used in a design of great imagination and taste.

Fig. 40. Hans Aall pictured shortly after he founded the Norwegian Folk Museum in 1894. After his fifty-two years of leadership the museum consisted of 140 rebuilt structures, about 80,000 objects, and four modern exhibit halls. Courtesy Norsk Folkemuseum.

Fig. 41. Dentist Anders Sandvig captured for posterity on a postcard in 1907. At his passing in 1950, the Sandvig Collections (Maihaugen Museum) consisted of about 100 relocated houses and about 20,000 objects. Courtesy Norsk Folkemuseum.

Collecting, Researching, and Presenting Folk Art in Norway

Tonte Hegard

> ANY PROGRESS made in the civilizing process will always cause the new to emerge partly at the expense of the old. This inevitable development neither can nor should be prevented. But on the other hand it becomes the duty of the generation which brings about this process to do their best, according to their ability, to ensure that the line of tradition as relates to culture is not completely severed—that an attempt is made to rescue from obliteration the evidence of our people's past or, at least, to conserve it through depiction and description . . . In these districts there are, fortunately, still preserved precious remainders of the art and crafts of our forefathers—buildings as well as furnishings, that with their woodcarving and decorative painting testify to such an amazing degree the artistic abilities of our people.

With these words, sixteen men—five museum directors, five architects, and Norway's two university professors of art history and archaeology—in 1907 began a proclamation titled "For Norwegian Folk Art." The purpose was to motivate culturally interested citizens to provide financial support for an ambitiously planned documentation and publication project. The work was to be carried out by an architect traveling from district to district drawing to-scale plans, taking photographs and describing objects of interest. The results were to be presented in a series of regional books. The publications would have three objectives: they would serve partly as fundamental research material, partly as material for popular education and, from the standpoint of the industrial arts, as a source of inspiration and of models for architects and craftspeople.

A desire to protect the last remnants of a vanishing culture prompted the major pioneers in the museum field to action already in the 1880s and 90s. But because the shift in the agricultural economy from an almost barter system to one based on money was reaching increasingly remote areas, the pioneers realized that it was already impossible to collect a body of folk art from pre-industrial society that would be close to comprehensive. Because of the tempo of social change as well as a substantial lack of economic resources for the project, changes had to be made in the procedures only a few years after a systematic effort was instigated. Documentation in the form of exact measuring and photography then became a necessary and valuable supplement to the ensuing work. This article will focus on the main features in the collecting of folk art during the formative years before 1910.

The interest in folk culture is awakened

Folk art is an international term found in most languages. In Norway, this was a rural art form while in other countries it may be linked to other segments of the population. The concept itself implies that folk art can be studied either as a part of folk culture or as art history. Both methods have been employed since the collecting of folk art began. There is no sharp distinction between the two approaches, and modern folk art research concerns both.

In order to understand the strong interest in folk culture found in Norway in the decades around 1900, one must keep in mind the major phases of development in the history of the country. Norway was in union with Sweden in the years 1814 to 1905. This meant that the two nations shared a king but had their own constitutions, separate parliaments, and their own cabinet ministers. Before the country joined this union, it was ruled for 500 years together with one or both of its neighboring countries Denmark and Sweden in varying constellations of power and with changing systems of government.

In the 1800s the peasant culture was looked on as the bearer of Norway's national cultural heritage, in contrast to the urban and civil-servant cultures which had absorbed impulses from abroad. The farmer was thus the

link back to former days of glory when Norway, too, was an independent nation. During the 1840s, progressive leaders and ideologists focused their attention first on folk literature and language, then on music, and thereafter, from the 1870s and 80s, on the material culture. Here it was, not unexpectedly, the folk art which commanded their greatest attention.

SCATTERED EARLY ATTEMPTS AT COLLECTING OBJECTS REPRESENTATIVE OF THE FOLK CULTURE

The systematic collecting of folk material belongs to the 1890s and later, but a few earlier attempts need to be mentioned. Bergens Museum was established in 1825 for the collecting of national artifacts, and already in the 1840s the founder, Wilhelm Christie (1778–1849), expanded the definition to include the everyday furniture, utensils, implements, and tools of farmers and fishermen. Before his death in 1849 this former President of Parliament had acquired about 400 objects for the museum. Fifty years passed, however, before his institution again took up this work.

The Collection of Antiquities (*Oldsaksamling*) at the University of Christiania (later Kristiania, and Oslo after 1924) had from its founding in 1828 acquired a few exceptional examples of later cultural material in spite of its emphasis on archaeology. Between 1860 and 1895 Nicolay Nicolaysen (1817–1911), Antiquarian of the Society for Ancient Monuments (*Fortidsminnesforeningen*), established in 1844, channeled carved fragments from stave churches and secular architecture to the university collection. The basis of selection was largely artistic. In the 1870s and 1880s the ethnographic division of the university collection acquired about 1600 objects illustrative of folk life, primarily costumes and folk art.

Even two embryonic attempts at outdoor museums where the people of the capital could be enlightened about their ancestral background occurred in Kristiania before the 1890s. Between 1881 and 1888 King Oscar II of Sweden and Norway at his own expense moved a stave church, two types of storehouses, and both an open-hearth house and a house with a chimney to royal property on Bygdøy near Kristiania. Nicolaysen took the initiative in this and added his scientific approach to the enthusiasm of the king's chamberlain.

The lumber baron Thomas J. Heftye, driven by national romantic impulses, in 1884 moved two peasant houses to his rural residence Frognerseter overlooking the city and the fjord. The new buildings too were in imitation of early rural architecture. Motivated by his interest in outdoor life, he allowed several of his small buildings to serve as rest stops for hikers. At Frognerseter they could also view what in 1881 was referred to as Norway's most important collection of folk antiquities, one of the first assembled by a private individual. Heftye's environment-based preservation efforts were public contributions which he considered appropriate to a man of his social standing. Neither his nor King Oscar II's preservation activities, however, continued beyond the 1880s.

In Scandinavia one rightly associates the collecting of rural material for public enlightenment with the Swede Artur Hazelius (1833–1901). When he began his systematic collecting for the Nordic Museum in Stockholm in 1872, he was the first to draw serious attention to the need for preserving material documents of a rapidly changing culture. This soon went beyond the rural culture. The museum's outdoor division, Skansen, opened in the fall of 1891.

In the spirit of Scandinavianism, Hazelius included Denmark and Norway in his area of concern, but here limited his efforts to folk material. His first collecting in Norway was done in the fall of 1874 when he established connections with local buyers who covered large areas of the country. Substantial numbers of Norwegian folk objects during the last decades of the 19th century thereby landed in Sweden, with which Norway was of course in political union.

FOLK ART BECOMES THE FOCUS

Within folk arts, woodcarving was the phenomenon first made the subject of analysis. Already in the 1860s, as mentioned, some carved architectural fragments had received attention and were given a place in the university museum collections. In 1878 the country's first professor of art history, Lorentz Dietrichson (1834–1917), published a book on the origin and development of the art of woodcarving. King Oscar II assumed the costs of the publication. In the 1880s weavings, especially those with pictorial subject matter, were of interest, and around 1890 attention was paid for the first time to the painted decor of the peasant society.

In this early period, woodcarving, weaving, and decorative painting constituted what in a narrow sense was deemed to be folk art. But throughout the 1900s the term had come to encompass many more categories. After World War II there has also been a shift in the interpretation of the term. The generations influenced by the teachings of functionalism today tend to find aesthetic qualities in objects made without any decorative purpose—in the shapes of simple tools and articles for everyday use.

Fig. 42. Tron Eklestuen from Vågå in Gudbrandsdalen was one of the most esteemed buyers of his time and delivered artifacts to the Sandvig Collections, the Kristiania Museum of Applied Arts, and the Norwegian Folk Museum. Photograph from 1898. Courtesy Riksantikvaren, Directorate for Cultural Heritage, Oslo.

The Museum of Applied Art
As a Collector of Folk Art

In 1876 Christiania, the capitol, obtained its museum of applied art. It was a relatively early manifestation of the European Arts and Crafts movement modeled after the Victoria and Albert Museum in London, which was established in the wake of the first great Universal Exposition in 1851. The purpose of the Museum of Applied Art was to promote taste and a sense of style in both artisans and consumers; the leveling tendencies of mass production in the new industrial age were feared. In addition to museum exhibits, the distribution of prints and the organization of instruction for artisans were means by which the museum exerted influence.

One of the museum's four main tasks was to secure worthy examples of the country's "folk industry", which was the term for folk art and home crafts until the turn of the century. The examples were intended to serve as models for contemporary design. The selection of artifacts was of course based solely on their aesthetic value, without any intention of securing either a categorically or a geographically representative collection for the future.

The Norwegian Folk Museum
As a Collector of All Categories of Artifacts

The establishing of the Norwegian Folk Museum in 1894 instigated systematic and scientifically founded collecting of artifacts from the peasant culture. Whereas quality had been the determining factor in the selection of objects for the Museum of Applied Art, the criterion for the Norwegian Folk Museum was breadth of scope. As expressed in the museum's mission statement: "The Museum collects and exhibits everything which sheds light on the cultural life of the Norwegian people." Even from the beginning, the scientific criterion—dependable background information on the origin and use of the objects—was a determining factor in the collecting effort.

With the entire country as its domain for collecting, the intention of the Norwegian Folk Museum was to illustrate the development of Norwegian culture from the Reformation to the end of the 1800s in both rural and urban areas. Consequently one soon had a motley collection containing early and late, rare and common, good and bad examples of articles for everyday use as well as the most exquisite examples of folk art. Old buildings were seen as one category. The museum moved authentic buildings from the countryside and rebuilt them on museum land. Thus some of the objects could be seen in their appropriate environment.

Based on a scientific program, the Norwegian Folk Museum set out to illustrate in geographic terms as well as in scope and over time the cultural development of the country. The Museum was a private enterprise, owned by an association but founded on the initiative of one man, the twenty-five-year-old library assistant Hans Aall (1869–1946). With strategic and long-term planning and a firm hand he managed the Museum through fifty-two years (Fig. 40. See also Figs. 43 and 44b).

Although the Museum was a private institution, it soon became a national museum in name as well as in deed. Therefore, in 1907 a valuable collection of folk art objects—mainly woodcarving—was deposited at the Norwegian Folk Museum by the government's comprehensive university museum. The same year it also assumed responsibility for the historic rural Norwegian buildings and their contents that King Oscar II had moved to the very grounds that the Norwegian Folk Museum would ultimately occupy. Some years later, the Folk Museum took over parts of the valuable folk art collection from the Oslo Museum of Applied Art as well. In the folk arts too the Norwegian Folk Museum thus became the central museum that quickly got control of the earliest collected material. The latest major acquisition of such material was a large portion of the objects collected in Norway by Artur Hazelius for the Nordic Museum in Stockholm but transferred back to the country of its origin in the 1980s.

THE SANDVIG COLLECTIONS— THE MODEL FOR LATER LOCAL MUSEUMS

In the 1900s, a number of local museums of cultural history grew up throughout the long country of Norway. Their collecting efforts always were—and still are—more or less limited to defined districts. When the first very modest funding was awarded to a local museum in 1902, the Parliament providentially passed a resolution to set geographical boundaries for every local museum's sphere of collecting. The purpose was to prevent senseless competition for the same buildings and objects between neighboring institutions.

The Sandvig Collections (also referred to as Maihaugen) in Lillehammer was the first and is still the largest local museum. It began as a purely private labor of love; already in 1887, dentist Anders Sandvig (1862–1950) started collecting smaller folk art objects during his annual den-

Fig. 43. As time went by, less and less unoccupied space was available in the temporary exhibit halls at the Norwegian Folk Museum. Photographed about 1906. Courtesy Norsk Folkemuseum.

tistry travels in the district (Fig. 41. See also Figs. 44b and 45a and b). Seven years later he bought a ramshackle but interesting old house, transported it about 200 kilometers and rebuilt it in his garden. The house provided exhibit space for his then approximately 1000 objects, largely folk art material. The accessibility gave him publicity—which in turn provided access to new objects.

In the course of six years, six buildings were moved to his by now overcrowded yard. They represented local building customs at different stages of development. After the municipality rejected an offer to buy the collection, some Lillehammer citizens formed a foundation in 1901 in order to realize a relocation and further expansion. In 1904, the original six buildings, along with four recently acquired, were reopened at the spacious Maihaugen site. A time of renewed expansion started. Sandvig continued as the museum's sole instigator of ideas and its administrator for forty-two more years. Until 1918 he did this in addition to carrying out his professional duties as a dentist, as there was no salary budgeted for him.

In those founding years, Sandvig never pretended to be scientific in his choice of objects. In the platform for Maihaugen he provided that all levels of local society—from the civil servant to the large-scale farmer to the cotter—be set in relief. Thus his collecting efforts first and foremost carried out that plan. Sandvig did not have as a criterion that an object should be accompanied by substantiating background information and supplemental material of importance to research (Fig. 42).

Local museums— zealots and folk art

In the wake of the separation of Norway from Sweden in 1905 followed a wave of strong emotional interest in the country's national cultural heritage. Many local communities took the initiative to found their own museums of cultural history. The collections established after 1905 were usually modeled on Maihaugen. This was most natural; Maihaugen was a museum for one geographically limited area as opposed to the Norwegian Folk Museum which covered the entire country.

Local museums possess important parts of Norway's total folk art heritage. The efforts of the museums were mainly prompted by idealism until long after World War II; this is often still the case. Thus the collections reflect to a large degree the personal interests of local dedicated souls.

Folk art is one of the best represented categories in the local museums. Esthetic qualities were naturally the central criterion for selecting the treasures that local communities felt *ought to* be secured in their own museum. Only as a rare exception was there a systematic and scientific plan behind the collecting efforts of these smaller museums.

It was common for the local museums, as long as they owned only a building or two, to use these relocated buildings purely for exhibit space (Fig. 44a). But as soon as the demand for such space had been met, they usually attempted appropriate furnishing. Still most museum interiors are more crowded with everyday and decorative objects than what would have been usual in such cramped quarters at the time they were in use.

Folk art research— the two principal lines

Only a few years after the material vestiges of the peasant culture began receiving some attention, the demand arose for a systematic accumulation of knowledge through the investigation of the collected material. *Tradition and outside influence* were the key concerns and the main focus of folk art researchers up to World War II.

Already from the start, the Norwegian Folk Museum had a wealth of material (Fig. 43), and in the years 1903–1907 the enthusiastic research assistant Harry Fett (1875–1962)—who later served for thirty-three years as Norway's first Director for Cultural Heritage (*Riksantikvar*)—flung himself into investigating the hitherto unexplored field of folk art. After several years' study in Europe, Fett was thoroughly trained in the method of stylistic analysis prevalent in European art research. He was particularly absorbed by the response of peasant art to impulses from abroad. His short-lived but groundbreaking research in the area of folk art was of great importance through its classification of wood carving into clearly defined periods and distinct geographic areas.

Later folk art researchers, both at the Norwegian Folk Museum and other institutions, have been more interested in traditions than in outside influences. The first results of this approach too were presented before 1910.

Through producing a *catalogue raisonné* for the annual temporary exhibits covering various categories of material, the results of Norwegian Folk Museum investigations were continually presented to the general public. In the Fett period from 1903 to 1907, the subjects were folk costumes, musical instruments, old Norwegian cast iron stoves, and furniture used for seating.

From 1910 the emphasis of the Norwegian Folk Museum shifted more toward folk life studies. Now a far greater range of objects and their uses, forms, and functions were seen in a wider context and made subjects of

De Sandvigske Samlinger, Lillehammer
Interiør fra Hjeltarstuen

analysis relating to the study of entire rural communities. For this research, contextual information was as important as the collecting effort.

COLLECTING AND DOCUMENTATION — TWO ASPECTS OF THE SAME MATTER

Hans Aall, Anders Sandvig, and the directors of Norway's three museums of decorative arts were the initiators of the proclamation of 1907 quoted in the introduction. All the major leaders thus agreed that the road ahead would have to include a combination of collecting and documentation. Hans Aall expressed it in 1908 when the Norwegian Folk Museum applied for a departmental grant to hire someone specifically as a field researcher: it was necessary to revamp the methodology and be more rigid in priorities. Only objects "imperative" to be preserved as originals should be collected; otherwise one should make do with photographs or measurements and written records of objects in various categories.

In response to the request for grants, two extensive field and registration programs were started in 1908 and 1910, respectively. The first was directed by the Kristiania Museum of Applied Art, the other by the Norwegian Folk Museum. In both cases, one person traveled from farm to farm and from district to district, registering, measuring, and photographing. The two field researchers applied separate methods — in line with the differences between the two museums in terms of overall purpose and approach to collecting.

Architect Johan Meyer (1860–1940) of the Museum of Applied Art carried out, in agreement with the Museum's objectives, an unsystematic registration in the sense that he documented only buildings, furnishings, and single objects selected on a basis of narrowly defined qualitative criteria. In another sense, his registration was systematic, since he thoroughly trawled district after district looking for objects that qualified. His results were successively published in the series *Fortidskunst i Norges Bygder* (Ancient Art in Norwegian Rural Districts). This work continued until Meyer's death in 1940, and he left behind an exceptionally comprehensive body of documentary material.

In accordance with stipulations in the grant request, Curator Gisle Midttun (1881–1940) was in 1910 hired as traveling registrant, surveyor, photographer, and collector, a work he continued to his death thirty years later. Partial results of this field program were published from 1921 on in the cultural history series *Norske Bygder* (Norwegian Rural Districts). This was an extensive, multidisciplinary publication project which also included information about the natural environment of the districts, their administrative and economic history, language, folk literature, archaeology, and so on, putting the material culture in perspective. The articles were written by a number of specialists. Nine volumes were finished before 1940. Time had by then run out also for this method of documentation and the work was not continued after the war.

In the first three volumes, Midttun himself wrote about art in the rural districts. The articles are to some extent summaries concentrating on traditional woodcarving, weaving, and painting, but also covering other decorative crafts. Yet they clearly emphasize regional artistic characteristics, and the author combines insight derived from his extensive field work with that gained through his archival studies. Although established art historical methodology is employed in dealing with the material, a first attempt at a broader approach to art history research is also found here. This appears as early as the 1920s.

It was precisely as a component of the entire peasant culture that folk art was approached after World War II. New questions were now asked about the old material, and new answers emerged. The most important folk art from pre-industrial times had already been collected by the museums in the early 1900s.

There has always been a battle over just who would get the gems in Norwegian folk art. Museum acquisitions

Fig. 44a. Interior from the Hjeltar House (*Hjeltarstuen*) at Maihaugen. Courtesy Norsk Folkemuseum. Photographed in 1904.

Fig. 44b. Interior from the Grøsli House (*Grøslistua*) at the Folk Museum. Courtesy Norsk Folkemuseum. Photographed in 1902.

The open-air divisions of the Norwegian Folk Museum and the Sandvig Collections at Lillehammer were based on two separate concepts of communicating historic information. Anders Sandvig wished Maihaugen to be a collection "where one can walk right into the homes of the people who lived there and learn about their way of life, their tastes, their work." Courtesy Norsk Folkemuseum.

Hans Aall explained his exhibit technique this way: "Into the old buildings go only furniture and artifacts which belonged there at an earlier date or that can adequately represent the original furnishings. No more, no less. We do not, however, intend to create an illusion. The more one strives for this, the stronger the public senses the lack of reality of any museum. It is much better to keep the interiors a little removed from reality, like closed off rooms in an old house. They always trigger our imagination, so that we try to imagine the real life which once throbbed right there."

Also, the circumstances were vastly different. The Norwegian Folk Museum had from the start its own exhibit halls for the display of smaller objects. The Sandvig Collections had the open-air museum only.

have had to be made in competition with the considerable purchasing power of private individuals both domestic and foreign. They were looking for single objects to satisfy personal aesthetic tastes while the museums sought objects that could give insight into the lives of earlier generations.

Today, when we experience the keen interest the Norwegian heritage evokes in the United States, a look at the situation eighty-two years ago gives us a thought-provoking perspective on the efforts of the Norwegian museum pioneers. In 1913, Hans Aall and Anders Sandvig together allocated $1,200 for a speaker to travel in the United States. From June to October the promoter Eirik Hammer gave twenty-three talks to miscellaneous organizations and lodges in the Norwegian settlements (See Appendix V). He also published some articles and was interviewed by the press. The purpose of the tour was to raise interest and financial support for the two museums back in the old country. Attendance at the lectures and meetings varied greatly, but on the whole Hammer felt very welcome. Even so, he had to sum up his report with the following statement:

> Unfortunately there still remains much to be done before our emigrated countrymen possess a full understanding of the importance of the two museums to our national development. Nevertheless I deem it possible, on occasion, to obtain small contributions from the organizations of people from specific districts in Norway, and maybe to get a few individuals interested to the point that they will support the institutions; but any extensive fund raising effort is out of the question. For that there is too little understanding of museum operations among the emigrants.

Fig. 45a. Lower Bjørnstad as photographed in Vågå, 1898, and b, after it had been reassembled at Maihaugen in 1912. Courtesy *Riksantikvaren*, Directorate for Cultural Heritage, Oslo. Photographer of 45b, Jiri Havran.

Anders Sandvig already in 1904 consciously set out to move and reassemble a complete farmstead precisely as it had originally been. This introduced at a very early point a new concept in the preservation and presentation of the past. Buildings should not be pulled out of their natural context but looked on and saved as part of a larger whole.

In spite of this idea, most outdoor museums are composites of buildings from many places, and the addition of outbuildings comes late in their development. The concentration is first on types of dwellings, the centers of early life. A solution in some areas since the 1920s has been to establish a local museum on a more or less intact farmstead with buildings of historic interest.

SOURCES

My knowledge in the field of museum folk art collecting is first and foremost based on extensive archival studies at the Norwegian Folk Museum, the Sandvig Collections, and the Museum of Applied Art in Oslo in connection with my two books on the museum system (unfortunately available only in Norwegian): *Romantikk og fortidsvern. Historien om de første friluftsmuseene i Norge* (Romanticism and the Preservation of Historic Buildings. The History of the First Open-Air Museums in Norway) (Oslo 1984) and *Hans Aall—mannen, visjonen og verket* (Hans Aall—the Man, the Vision, and the Achievement) (Oslo 1994). Both books contain extensive notes and references (in Norwegian).

General references relating to this article beyond those found in the general bibliography, of which those by Anker and Kloster were of special importance, include:

Anker, Peter. "Rosemaling, skurd og vevnad." In *Norges kulturhistorie* 3. Oslo, 1980.

Dietrichson, Lorentz. *Det norske Kunstindustrimuseum*. Lecture on the 10th anniversary of the museum's founding. Christiania, 1886.

Glambek, Ingeborg. *Kunsten, nytten og moralen. Kunstindustri og husflid i Norge 1800–1900*. Oslo, 1988.

TONTE HEGARD is Senior Advisor, *Riksantikvaren*, Directorate for Cultural Heritage, Oslo, Norway. Article translated by Liv Nordem Lyons, Fort Collins, Colorado.

Tradition and Revival:
The Past in Norway's National Consciousness

ALBERT STEEN

EARLY NORWEGIAN RURAL CULTURE as it appears in building traditions and decorative arts has a leading place today in Norwegian national consciousness. This is due to special conditions in Norway's history. In contrast to most other European countries, Norway has never had a court or rich landed gentry, and the cities have been small, with few wealthy citizens. The cultural foundation of the country is therefore different and less rich than that of most other nations farther south on the continent. Norway did not have painters, composers, and poets of European caliber until the mid-19th century. They appeared just when the currents of nationalism began getting stronger.

Elsewhere in Europe during the 19th century interest had been growing in national history and folk culture as it is revealed in poetry, folk songs, fairy tales, music, and folk art. In Norway this interest coincided with the need to assert national identity and to affirm that the country after all had an artistic tradition and consisted of people with a reserve of creative ability.

For centuries the people had lived spread out and quite isolated in valleys, among fjords and mountains. A clear class distinction arose between the farmers and fishermen on the one hand and the few city dwellers and bureaucrats on the other. Poverty could weigh heavily, and hundreds of thousands packed up and left in hope of a better future on the other side of the ocean. Nonetheless, economic conditions improved during the course of the 19th century. New channels of communication were being developed between the city and the country. The farmers were represented in the national assembly at Eidsvoll in 1814 that wrote the country's constitution, and they have been represented in parliament, the Storting, ever since.

Fig. 46. Tapestry: *The Yellow Birds* (detail) Gerhard Munthe (1849–1929), designer. Ca. 1898. Vesterheim. Photo: Darrell Henning.

Large areas of Norway outside the main thoroughfares at the beginning of the previous century had scarcely been surveyed. The first to set out as explorers, of a sort, were a few foreign tourists and painters in search of picturesque subjects. Some wrote travel accounts when they came home about their remarkable experiences and their impressions of the wild, mountainous country of Norway.

Few to this point had shown much interest in or understanding of the rural culture. City residents knew little about its various forms of expression and generally looked condescendingly on the whole phenomenon. Interestingly enough, it was Norway's first great National Romantic painter, Johan Christian Clausen Dahl (1788–1857), who first made the general public realize that the country had irreplaceable national treasures which were worth preserving (see frontispiece). As early as 1836–1837 he published at his own expense a book containing plates of stave churches, *Denkmale einer sehr ausgebildeten Holzbaukunst* (Monuments of a Highly Developed Art in Wood Architecture). In 1844, Dahl was among the founders of the association with the long name *Foreningen til Norske Fortidsminnesmerkers Bevaring* (The Association for the Preservation of Norwegian Historical Monuments). This association came to be of great significance in a time when stave churches from the 13th century were being torn down without much hesitation. Interest in the old stave churches and early building traditions grew, and the association soon secured several of the churches and took over responsibility for their maintenance.

THE NATIONAL AWAKENING

The period around the middle of the century was an exciting time of growth in Norway, both economically and culturally. A small nation on the edge of Europe awoke to an awareness of its distinctiveness and possibilities. It was

natural to search back through history for the basis of a distinctive national character. In this time of national romantic enthusiasm, interest centered around Norway's period of greatness in the time of the Vikings and the early Middle Ages, a time when the land was free before it came under Danish and Swedish rule. The folk, whose culture had been least affected by foreign domination, came to be looked on as the major link between the present and that heroic period.

Historians proclaimed the unique antiquity of the Norwegian people and their native culture. Linguists confirmed this through the study of rural dialects, which they found had direct affinities to Old Norse. From these dialects they constructed a new Norwegian written language. Folklorists collected folktales and ballads, publishing them in a vernacular that reflected these early characteristics. Writers turned to subject matter from Norwegian history and folk life, and composers incorporated the exotic ancient sounds of folk music in their compositions. The collecting of folk art has been dealt with by Tonte Hegard in the preceding essay. Painters studied and often lived for extensive periods abroad, but during the summer they traveled in the Norwegian countryside and made sketches and preliminary studies for paintings of Norwegian nature and folk life. The Norwegian farmer was idealized, the proud descendant of saga times.

THE DRAGON STYLE

Lorentz Dietrichson (1834–1917), who in 1875 became Norway's first professor of art history, promoted a national style that would replace in Norway the carnival of historical styles then the fashion in Europe. He believed that the source of the unique and native for Norway was to be found in its proud heritage from the Viking era and the Middle Ages. Dietrichson recommended the stave churches as the specific model for a national architecture. While in Stockholm, where he had been for ten years before returning to assume his duties in Norway, Dietrichson had had his residence built in the so-called Nordic style. Then he came in contact with Norwegian architects who were interested in his ideas, and in the 1880s and 1890s *dragestilen* (the dragon style), as the new style came to be called, broke through in full force (Fig. 47).

The dragon style was chosen and launched as being typically Norwegian, created from different elements of the oldest accessible architectural and decorative sources. At the same time, the ever-energetic Dietrichson published large books with plates which could serve as patterns for designers, *Den Norske Treskjærerkunst, Dens Oprindelse og Udvikling* (The Norwegian Art of Woodcarving, its Origins and Development), 1878, and *Norges Stavkirker* (Norwegian Stave Churches), 1892.

Buildings in the dragon style were composed of elements from stave churches, gables and various projections and often carved dragons rising proudly from the outermost point of the ridge board. Also characteristic of the style was the positioning of the building units at right angles to each other, a form suggested in the roof lines of stave churches. Dragon style buildings, however, were of notched, brown-stained logs, a type of construction drawn from folk rather than church architecture. In form and detailing there were also contributions from Norwegian folk architecture, primarily from the most stately building on the farm, the storehouse, with its stave-constructed porches, carvings (1), and cantilevered upper stories (1a). Motifs from Nordic medieval woodcarving are a pervasive feature (Fig. 1). Romanesque and Gothic details are brought together with masks, dragons, and serpentine interlacings on portals and gable boards.

As the desire for independence grew and the dissolution of the union approached, the dragon style became an important symbol of Norwegian distinctiveness (5). It could also be put to use in welcoming the tourists from abroad who were now coming in increasing numbers.

Toward the end of the 19th century, a series of tourist hotels were constructed around the country, especially along the fjords of the west coast. It was natural to build them in the dragon style, as many tourists were already familiar with it from the exhibition pavilions for Norwegian products abroad. The goal was to draw well-to-do guests and be able to offer them a pleasant stay in beautiful natural surroundings, preferably with sweet little blond girls in national costume to wait on them (Fig. 26).

Some of the most splendid buildings in the dragon style were located, like the castles of the fairy tales, on high places. A favorite was the ridge just north of Oslo, with its broad view of the woods and fjord (Fig. 47). The style offered many possibilities for variation, and one often finds impulses both from the Swiss style, with its greatly extended roofs, and from Turkish architecture, with enclosed porches having colored panes of glass and a "moonlight" lamp in the ceiling, weakly reflecting Islamic mosques. These are curious elements in a supposedly national style, but to create unity out of diversity was a requirement of the time. Unfortunately, only few examples remain after the devastation of fire on these highly flammable structures.

The dragon-style houses were usually furnished with rich ornamentation, the carved woodwork on both the exterior and interior having a unifying effect. Carpentry

Fig. 47. Holmenkollen Hotel. Holm Hansen Munthe (1848–1898). Oslo. 1890 with 1907 addition. Photograph 1909. Photo: Mittet & Co.

shops and wood carvers, especially on the west coast, received numerous commissions to furnish the parlors, dining rooms, and public cafes with enormous buffets and corner cupboards and to carve ceilings, wall panels, and pillars in rich dragon style (Fig. 48). Proficient woodcarvers, generally the products of folk tradition, such as Lars Kinsarvik from Hardanger (4), Magnus Dagestad from Voss, and John Borgersen from Saude became especially well known. Ole Moene of Oppdal specialized in small pieces, such as storage boxes, knives, and cases for jewelry or other objects, all having detailed acanthus designs and a technical refinement that often exceeded that of their folk models. His work was highly sought by royalty as well as tourists.

Exhibitions

Exhibitions at home and abroad were important for improving quality and stimulating creativity in both the industrial and the home arts. In 1896, architect Henrik Bull (1864–1963) was commissioned by the Association for Handicraft in Oslo to design the interior and furniture for a dining room. It was a large suite, in which Norwegian dragons, Viennese Baroque, and European Art Nouveau met in fluid harmony (Fig. 48). The dining room became a good ambassador for Norway in its struggle for political autonomy, gaining renown at the exhibition in Stockholm (1897) and receiving the gold medal at the World Exposition in Paris (1900). At the exhibitions in Paris (1867) and Vienna (1873), Norway shared a pavilion with Sweden, but in Paris in 1889, in Chicago in 1893 (4), and at the famous exhibition of 1900 in Paris, Norway had its own pavilions in the dragon style, and it celebrated triumphs with many medals and honorary mentions for its silver and gold work, furniture, wood carving, and textiles.

Filigree and drinking horns, dragon-silver and enamel

Then as now, tourists bought souvenirs and usually wanted to take home "something typically Norwegian". It could be something in silver, a piece of weaving, or a rosepainted wooden storage box. Silver jewelry of traditional type for national folk dress—brooches, pins, and clasps—

was especially popular (117–121). Jacob Tostrup (1806–1890) of Oslo had the country's largest jewelry firm. From the middle of the last century he frequently accepted nimble-fingered lads from the countryside, who often were familiar with the old techniques, to apprentice in his workshop. Telemark and Setesdal had long traditions in filigree and granulation. Thus, a folk style through filigree began to enter the broader market, not only as jewelry for national dress but as decorative details on pieces designed in imitation of early Norse objects: beakers, tankards, and drinking horns. In the 1870s the dragon style and Romanesque vines began to be used as ornamental motifs on everything from jewelry and silver flatware to coffee services, resplendent punch bowls, and table centerpieces (Fig. 49). The major jewelers besides J. Tostrup were David Andersen (1843–1901), P. A. Lie, and L. Thune in Oslo, Theodor Olsen in Bergen, and Henrik Møller in Trondheim.

In the 1890s, Norwegian enamel work gained attention abroad. An especially refined type is the so-called window enamel (*plique à jour*), in which a skeleton of filigree thread is filled in with transparent enamel of different colors. It is a demanding technique which Norwegian goldsmiths learned abroad from Russians and Hungarians. The window enamel became a Norwegian specialty in a short time, representing the ultimate in Norwegian goldsmithing of the 19th century while having no long native tradition on which to build. Although often purely Art Nouveau in design, *plique à jour* was made national in Norway partly through the styles and shapes it took.

The Museums of Applied Art

With the many exhibitions came criticism of what some considered a decline in the quality of artistic handicrafts and the industrial arts. It was levied against mass production, the poor design and the weak aesthetic concepts in manufactured goods. Norway, as mentioned by Hegard,

Fig. 48. Dining room suite. Henrik Bull (1864–1953). 1897. Oslo Museum of Applied Art. Photo: Oslo Museum of Applied Art.

Fig. 49. Covered box in *plique á jour* technique. Torolf Prytz (1858–1938), designed for J. Tostrup, Oslo. 1889. Oslo Museum of Applied Art. Photo: Oslo Museum of Applied Art.

followed the lead of John Ruskin and William Morris in England, where the first arts and crafts schools and museums with collections that might serve as models were established.

Already in 1873 Lorentz Dietrichson had been instrumental in founding a museum of applied arts in Stockholm, and in 1876 the Oslo (then Kristiania) Museum of Applied Art (*Kunstindustrimuseum i Oslo*) was established as one of the first in Europe. Comparable museums were founded later in Bergen and Trondheim. The purpose was to revitalize the native handicrafts, and for this models were to be found in the old crafts, the older the better. It was therefore important to build up a library with prints of ornamentation from Nordic antiquity and the early Middle Ages. Some of this could still be studied *in situ* or had already come into museums. And then there were the folk arts and crafts in the countryside which were thought to have roots going back in direct line to antiquity. One purpose of the applied arts museums was to collect such material as examples for use in craft education.

"Husfliden" — help for self-help

Beginning in 1886, the Oslo Museum of Applied Art received government appropriations to support the artistic advancement of the home crafts. The intention was to develop a permanent work force of producers in the countryside by giving them training and obtaining good patterns and models. In the same year, a mobile class in woodcarving was started in Hardanger, in Lesjaskog, and later at Bø in Telemark and other places. The Norwegian-American carvers E. Kr. Johnsen and L. Melgard had participated in such classes before emigration (5, 57, 59). In like fashion, courses were conducted in weaving, in birchroot basket making, and, for a short period, in rosemaling.

The training activities had a socioeconomic aspect in addition to the national: to create opportunities for production and sale of traditional craft items from the rural areas. In 1886 the Oslo Museum of Applied Art formed various sales organizations to find customers for the producers. Eventually these combined to form The Norwegian Association for Home Crafts (*Den Norske Husflidsforening*), which is still today a vital nationwide organization managing both instruction and sales.

The home craft movement has from the beginning been oriented toward production, selling simple, unpretentious but honest, functional items in wood and fabric for everyday use in the home. The home crafts sales outlets, often called simply "*Husfliden*," also sell a fine line of furniture such as cupboards, shelves, tables and chairs, perfectly made of first class materials and without varnish or paint finishes. But Norwegians also recall from their childhood white play furniture with red roses, toys, and hobby horses. Reproductions of or designs inspired by Norwe-

gian folk furniture of unpainted pine are continuously being made around the country in small workshops, and they are today a popular element in the interior of Norwegian homes and cabins.

NATIONAL REORIENTATION

Norwegian artists who had studied abroad began to settle back in their native land in the 1890s. This contributed to a more richly nuanced view of "the native" in the arts. They were well aware of developments in the other Nordic countries, and through newspapers and magazines they followed the debates over new ideas and directions in art and culture. One group of artists gathered around the art historian Andreas Aubert (1851–1913). He considered Dietrichson and the older generation's interpretation of "the native" with its emphasis on antiquity as far too narrow. Aubert asserted that Norwegians had to accept fresh impulses in color and design from the vigorous folk art of the 1700s, which had hitherto been little appreciated. The wood carving of the Baroque and the rose painting of the Rococo periods were a fountain from which the handicrafts could draw inspiration and be renewed. He maintained that Norwegians had a special gift for color, "a national color instinct" which had to be cultivated and nourished through artist-generated designs for the handicrafts and industrial production.

Andreas Aubert was a proponent of current ideas regarding the psychological effect of color and the decorative in art. Painting, sculpture, and the crafts were one and the same, and he urged artists to strive for a richer aesthetic environment and to follow William Morris's motto "Art for all—art in all".

GERHARD MUNTHE AND THE DECORATIVE ARTS

One of Aubert's closest friends was the painter Gerhard Munthe (1849–1929), who became the great revitalizer of Norwegian decorative arts around the turn of the century (Fig. 46). Munthe found the dragon style and much of contemporary handicrafts tasteless, anemic, and colorless. He had, as had his fellow painter Erik Werenskiold (1855–1938), grown up in the countryside, and he believed that the rural culture was richer, more luxuriant and inspiring than the dragon style creations and the copying of archaeological patterns.

When Munthe built his home "Leveld" outside Oslo in 1899, he used the traditional Norwegian farmhouse as his model, such as he had known from his childhood in Elverum in eastern Norway and such as Werenskiold had drawn when he illustrated the folk tales. Munthe's house unfortunately no longer exists, but the watercolors he made of it show bright and colorful interiors with a comfortable mix of older furniture from town and country and some new pieces made from his own designs. To us his house seems strikingly modern—bright, comfortable, and unpretentious—much as we like to furnish our homes today, one hundred years later.

Munthe's and Werenskiold's artists' homes came to exert influence on the design of homes and interiors throughout the succeeding century, just as that of the artist Carl Larsson did in Sweden. One finds that influence, for example, in the work of architects Arnstein Arneberg (1882–1961) and Magnus Poulsson (1881–1958), who sought to find a national and personal architectural style with origins in well-proportioned farmhouses from eastern Norway and Telemark. With the addition of some decorative details from the residences of public officials, they also hoped to bridge the rural and the urban strains that had so long gone their own way in Norwegian culture.

Like his house, Munthe's larger works of interior decoration are also gone, the victims of fire and war. The major example of his national decorative style that remains is the 1896 edition of the 14th century Snorre Sturlason's *Kongesagaer* (The Sagas of the Norwegian Kings) for which Munthe did the overall design while other artists, including Werenskiold, also contributed illustrations.

As a pictorial artist Munthe turned away from realism toward a decorative form of expression in which the imagination was allowed greater scope. He focused on the rhythmic elements as an important part of the design and content of art and on the psychological and symbolic effects of color. Traditional rural culture was to be the fount of inspiration for creativity, not a source of copying or imitation. The content of legends, folk songs, and fairy tales was often dramatic, violent, and full of blood and conflict. Munthe wanted to accentuate the raw, the wild, and the vigorous which lay in the Norwegian sagas and folk art; and in the 1890s he developed his own two-dimensional style with a few strong basic colors in pure tones without shading (Fig. 46).

Throughout the 1890s interest in decorative art grew both in Europe and in America. Munthe naturally absorbed impulses from abroad, both from Art Nouveau and Japanese decorative arts, which were fashionable at the time. Nevertheless, he rejected all suggestions that he might be influenced by international movements and stressed that he only interpreted what for him was "typi-

cally Norwegian" in the design and color of the fine and decorative arts.

Weaving courses and the Art of weaving

At the end of the 1880s interest arose in Norway's weaving traditions, and the museums of applied arts, in cooperation with the home craft movement, began offering weaving courses in many locations nationwide. The collecting of coverlets and pillow covers with geometric designs, especially from Sogn (101) and Hardanger (104–105), and of pictorial coverlets with Biblical subjects from Gudbrandsdalen (32–34, 36) got underway. Reconstructions of the ancient upright loom appeared and books were published about dyeing yarn with natural materials.

Gerhard Munthe took his point of departure from the decorative elements in traditional rural art. The native weaving technique with its structured pattern blocks and lively color (101–105, 107) inspired him to paint a series of water colors with themes from legends, folk tales, and folk songs that gained attention as a new national style when they were exhibited in Oslo in 1893. Munthe was not personally very interested in textiles, but his decorative style received wide attention and became popular not least because it was picked up as a model for a great many tapestries (Fig. 46), something which did not always please the artist. Munthe was skeptical of the constant reproducing of his work, and he spoke about all these "weaving ladies" who drowned his watercolors in wool.

The Museum of Applied Art in Trondheim founded a weaving studio in 1898 which chiefly worked from patterns made by Munthe. The studio's tapestries were constantly included in domestic exhibitions, awarded medals, and purchased by museums and institutions abroad.

Some people felt that one could easily go too far in rallying around the "national and distinctive" and emphasizing the independent development of all genuine Norwegian culture apart from the cultural mainstreams elsewhere in Europe. Frida Hansen (1855–1931) had established her weaving studio in Stavanger at the beginning of the 1890s and attracted many students. Her free compositions, devoid of specific national reference, were extremely successful abroad, where she also received prizes and good reviews. But at home in Norway, recognition eluded her. Here Munthe had set the norm, and common opinion held that Frida Hansen's refined textile art was un-Norwegian and too heavily influenced by foreign Art Nouveau and impulses from Japan. That says something about how strictly the lines were drawn. Only in recent decades has Frida Hansen's art been retrieved from obscurity and given the level of recognition in her home country that she highly deserved as an independent creative artist.

Older Norwegian pictorial tapestries from the 16th, 17th, and 18th centuries (32–34, 36) and Gerhard Munthe's decorative art influenced most of the large tapestries that were carried out for the decoration of public buildings in Norway in the 1930s and the years following World War II. The very original Hannah Ryggen (1894–1970) wove freely and expressively without specific cartoons. She was born in Sweden but realized the debt she owed to traditional Norwegian weaving; as she once declared, "I am Norwegian 200 percent!"

Norwegian textile art in recent decades has drawn its major inspiration from abroad and now enjoys the status of an independent form of artistic expression on a par with painting and prints. But the textiles of home production with early prototypes, including everything from wall hangings and table and bed covers to knitted sweaters, mittens, and national costumes, are perennially popular.

Artists for industry

The museums of applied art had from their inception made a mission of closer cooperation between art, craft, and industry, goals related to those of the Arts and Crafts Movement in England. At first, interest on the part of artists was not overwhelming, but in the decades immediately following 1900 it began eventually to grow.

The versatile and gifted Gerhard Munthe was a pioneer of this movement in Norway. As early as around 1890 he had designed patterns for wallpaper and rugs, later for works in silver as well. In 1892 he designed patterns for *Porsgrunds Porselænsfabrik* and *Egersunds Fayancefabrik*, Norway's leading producers of fine ceramics.

The ceramic lines with national associations designed by Munthe and other contemporary artists of his caliber represent what might be called the artistic mainstream in Norwegian decorative arts. On the popular level, the national element in ceramics is more blatant. The Egersund company already in the late 1860s began decorating pieces with decals of scenes from folk life drawn from prints which in turn went back to works by major Romantic painters. Such ware remained in production at least until 1925.

The Porsgrund factory in 1908 put out its *Nordisk* (Nordic) line, which included many pieces based directly on folk objects (Fig. 50). One of the most popular was a free version of the ale bowls with bridal processions that originated in Vest-Agder in the late 18th century (190).

Variants on this line, often with stenciled rosemaling, have remained in production to the present day. Since World War II the Porsgrund company has retained a decorator with a background in traditional rosemaling to supply designs and create unique pieces.

The period up to the great centennial exhibition of 1914 was characterized by optimism and economic progress. This is reflected in elaborate sets of massive furniture, inspired by the early furnishings in wealthy Norwegian rural homes, with wood carving, gilding, and overtones of Neo-Baroque. There was also at the time a noticeable tendency to go back to the simplicity of Norway's empire style as known from the homes of public officials in the decades following 1814. This tendency led to the purely geometric forms of 1920s Neo-Classicism.

From international rationalism to national nostalgia

International trends in style and interest in industrial design as a means of raising living standards at the lower levels of society was characteristic of the rational functionalism that dominated the 1930s and 1940s. The era had little appreciation of the past or of national romanticism, worshiping instead the rectilinear and the practical.

Resistance during the German occupation of Norway in 1940–1945 created greater solidarity and caution in matters relating to national cultural values, and the Nazis' attempt to revive the dragon style and other national symbols was met with scorn and contempt.

Reconstruction after the war demanded enormous effort and thrift. People preferred to live in small wooden houses rather than in the large concrete apartment buildings which arose in cities and other areas of high population. There was great demand for inexpensive and practical furniture, and Norwegian woods returned to popularity. A number of young interior designers further developed traditional Norwegian furniture designs for execution in native woods such as elm, ash, oak, and birch that harmonized well with pale wool drapes and rag rugs on unpainted pine floors.

A strong affinity for wood is strikingly apparent in Norwegian homes. The ideal framework is the traditional folk interior which becomes the setting for basic country furniture such as unpainted trestle tables, shelves, and china cabinets. Norwegians want something of the past around them, either antiques or newly created objects with symbolic associations.

Recent decades have been characterized by increasing wealth and by influences from all corners of the earth. There is also, however, a distinct tendency, especially among young people, to assert national uniqueness in response to encroaching internationalism. The current blossoming of handicrafts is interesting because it generally ties in with the past while having its own approach to form.

Interest in Norwegian traditions and the Norwegian life style is characteristic of the time. Norwegian folk dancing, folk music, and the Hardanger fiddle (124–125) have become increasingly popular and valued in large segments of the population, even in the cities. This national enthusiasm reached its height to date during the winter Olympics in Lillehammer and the refusal of Norway to join the European Union, both in 1994. Traditions in the folk culture and folk arts are an important part of the legacy that Norwegians carry with them into the future.

Albert Steen is Curator Emeritus, Oslo Museum of Applied Art, Oslo, Norway. Article translated from Norwegian by Lisa Torvik, St. Paul, Minnesota.

Fig. 50. Examples of the Nordic line. Porsgrund Porcelain Factory, Porsgrund. 1908. Vesterheim. Photo: Courtesy Vesterheim. Photographer: Darrell Henning.

206. Pair of cupboard doors with rosemaling. Norw.-Am. August Werner (1893–1980), Seattle, WA. Signed and dated 1955. Painted wood. H. 43¼″ W. (of pair) 33″ Vesterheim, gift of Agnes Werner (84.76.3).

Rykken turned back for models. Werner, also in Seattle, turned to fantasy where memory failed. What remains of tradition is only the ability to create complex organic designs in colors chosen for expressive and decorative effect. This brings up the question of what tradition is, the ability to create within a given framework or the carrying on of forms?

207. Chair with grotesque painting. Norw.-Am. August Werner (See also 206). Ca. 1940. Painted wood. H. 37½″ W. 18″ D. 22″ Nordic Heritage Museum.

Images from folk lore—trolls, gnomes, etc.—do not appear in folk art. The folk may have recognized a fundamental distinction between oral and pictorial depiction. It was urban artists who crossed the line in the late 19th century and gave images from lore pictorial form. It is in their tradition that Werner here is working.

206

207.

208. Log rocking chair with pictorial carving. Norw.-Am. Theodore Rovelstad (1866–1950), Elgin, IL. 1914. Elm? pine. H. 27″ W. 19″ D. 19¼″ Inscription: "Peace 1914." Vesterheim, gift of John Peters (90.20.1).

The concept of a log chair is Norwegian but of rockers American. Flat relief with a stained surface is Norwegian but the style here is naive and the tool a power router. The lion with axe on the front represents Norway; but does 1914 denote the centennial of its constitution or the outbreak of World War I? The latter would make "Peace" and the olive branches a plea. Enigmatic free expression.

209. Lamp with American and Norwegian symbols. Norw.-Am. Chris Moe (1862–1940), Portland, OR. 1930–1931. Various woods. H. 72″ W. 19½″ D. 19½″ Inscription: "All because God is love. We Love God. Our Country our Flag. Our Churches. And Schools. Our Fellow Men. God's Creations. The Whole Universe." Allan Katz.

Moe relates to Norwegian tradition in his love for wood, his ability to work with it, his respect for God and country, and his inclusion of the Nidaros Cathedral. His style and specific technique, however, are his own or from other sources.

209.

208

OUR COUNTRY OUR FLAG OUR CHURCHES AND SCHOOLS

210. Pictorial textile with Christian text and symbols. Norw.-Am. Nettie Bergland Halvorson, Houston, MN. Ca. 1912. Mixed fabrics. H. 78″ W. 138″ Translated inscription: "The law of Moses fell to the earth and became nothing but what remained was faith in Jesus." Vesterheim (78.19.1).

Halvorson had not inherited a technique adequate for her artistic needs. She therefore created one, threading small squares of cloth on a net as she produced it. Her style too was unique. What remained from Norway was the language of her faith. As an artist, she was left to find her own way in the New World.

MOSES LOV
FALT TIL JORDEN
OG BLEV TIL INTET
MEN DET SOM
BLEV IGJEN VAR
TRO PAA JESUS

RDEN OG BLEV TIL INTET

Appendices

Appendix I

Photo Credits For Catalogue Items

NORWAY. FOR ITEMS FROM:

Drammens Museum. Courtesy of the owner.

Fylkesmuseum for Telemark og Grenland. Courtesy of the owner. Tom Riis, photographer.

Kunstindustrimuseet i Oslo. Courtesy of the owner.

Norsk Folkemuseum, Ryfylkemuseet, and Samuel Thengs. Courtesy of the owners. Bjørg Disington, photographer.

Sandvigske Samlinger. Courtesy of the owner. Leif Stavdahl, photographer.

Vest-Agder Fylkesmuseum. Courtesy of the owner.

Vestfold Fylkesmuseum. Courtesy of the owner. Bjørg Disington, photographer.

AMERICA. FOR ITEMS FROM:

Martha Langslet Hoghaug. Courtesy of the owner. Richard Tonder, photographer.

Allen Katz. Courtesy of the owner. Luigi Pellettiere, photographer.

Minneapolis Institute of Arts. Courtesy of the owner. Gary Mortensen, photographer.

Minnesota State Historical Society. Courtesy of the owner. Peter Latner, photographer.

St. Louis County Historical Museum. Courtesy of the owner. Bruce Ojard, photographer.

State Historical Society of North Dakota. Courtesy of the owner. Todd A. Strand, photographer.

Vesterheim, Norwegian-American Museum and all lenders not mentioned above. Courtesy of the owners. Darrell Henning, photographer.

Appendix II

The Norwegian originals of translated inscriptions and lengthy English inscriptions not included in the captions

The spelling and punctuation of the original has been followed as closely as possible in spite of irregularities. Corrections are included in parentheses only where there is an obvious but possibly misleading error.

10. Ale bowl.
"Drikk av bollen med (men) drikk med måte for mye øll gjør de (deg) alt for kåte."

11. Ale bowl.
"Jon EndreSen Dalen, 1816" "Drik om ver from lad Kjengen blive tom."

12. Ale bowl.
"Gud give os Fred og gode Aar Saa Driker vi af mig Saa magen god Taar D:G.D.M. aaret 1845."

39. Powderhorn.
"Olaf Strangeson Adammann Eva Kuende Samson. K. Tidrick og Lavrin Rolland Fera Kunde Tallag Peder: Son Egen Hand Ano 1716."

40. Ale bowl.
"Ved Mose Slag gav Klippen Vand Tap øl i Mig ieg Ledske Kand, Anno 1799 TTSB."

72. Hanging wall cupboard.
"Hjort Ravn Løven Griffen Ulven Bjørn Crokedille Dragen I Johannes Aabenbarning Dyret med 7 Hoveder og 10 Horn."

76. Hobby horse.
"Ride ride ranke Hesten heter Blanke."

100. Ale bird.
"Med skaal i hand og venn ved side hensvinder livets dage blide Aar 1994."

150. Ale bowl.
"Lat oss ikkje forfedrane gløyma under alt som me venda og snu: For dei gav oss ein arv til a gøyma, Han er større enn mange vil tru."

152. Ale bowl.
"Naar Jeg Er Met. Da Har Jeg Venner. Naar Alt er Wæk. De Mig for Glemmer."

161. Ale bowl.
"Man bør ikke bedømme en mann efter hans gode egenskaper, men efter hvordan han gjør bruk av dem."

164. Wedding bowl.
"Legat" "Arvegods" "Og de to skall blive ett og de ene skall blive mange."

165. Ale bowl.
"Viin gjør en Spotter, staerk Drik gjør at en larmer; og hver som forvildes derved, bliver ikke viis. Aar 1828."

166. Door with painted text.
"Her haver Jeg Ædet mit Brød i mange Aar med Ære. Jeg har ei lidet Nød, thi Takker jeg vor Herre: hans Navn Jeg Love vil, af Hiærte, sind, og Mund, Saalenge jeg er til; Ham Prise Skal hver Stund. Samson"

168. Altar painting.
"Anno Domini, 1606 Gud verre dig, Peder Iffuerson oc Mergret Brede blid som lod mig giøre oc gaff mig hid."

171. Ale bowl.
(Interior): Min Stand strider for Riger og Land, og min beder for Land og hver Stand Vor nærer og beriger Land og Mand og kons forener ælle udi alle land ST 1765."
(Exterior): "Her drack nogle af mig i Nat De glemte adt baade skrepe og Hat De gick ned paa denne Jord Enu stander jeg fuld paa bord hos Sigur Knudson 1765."

172. Ale bowl.
(Exterior): Dan var den første konge i Danmark etter Dan kom Homle og Lotter hans sønner: og saa herskiold den drott de kom ikke En S T S." (Interior): "Der drack en bonde af mig i natt han tapede bort hansker og hat han konde ei staa paa dene jor ennu staar jeg med øl paa bord 1828."

173. Ale bowl.
"Store guban er mitt navn Dislige fins ikke i Naarges lan Tii jeg vel fekder Femtten Man Heller kan du mig utsupe saa skam sku faa Din strupe HSJEDH 1805."

178. Ale bowl.
"Den største gleda ein kan ha, det er a gjera andre glad."

180. Ale bowl.
"Tap øl i mig og set mig paa bord For Gjesterne og giv dem En Qvaeg og Leske de dans Haligen nok saa Fritt."

182. Plate.
"Matteus 17:20 Fordi dere har så lite tro, svarte han. 'Sannelig, jeg sier dere: Om dere har tro som et sennepsfrø, kan dere si til dette fjellet: Flytt deg herfra og dit! Og det skal flytte seg, og ingenting skal være umulig for dere.'"

183. Bed.
"Genesis 3:6, Genesis 7:7–8, Jonah 3:17, Second Kings 2:12, Elijah 1:12. Now I lay me down to sleep. I pray the Lord my soul to keep. If I should die before I wake, I pray the Lord my soul to take. Now I wake and see the light, Tis God has kept me through the night. To Him I lift my voice and pray That He would keep me through the day."

190. Ale bowl.
(Interior): En Bonde Mand han drak af mig i nat Saa han for led Baade lue og hat Nu liger Bonden paa gaden pøl ennu staar jeg med Fuld af øl paa Bord." (Exterior): Jeg settes frem for venner er saa mange som her er forsamlet her og ølet haver kier siger han Ole Eiersen Smiland."

201. Plate.
"Smørgaasbordet er nu dækket—Vær saa god!"

210. Pictorial textile.
"Moses lov falt til jorden og blev til intet men det som blev igjen var tro paa Jesu."

Appendix III

American craftsmen in the Norwegian folk tradition who have acquired gold medal status through repeated awards in the annual national competitions sponsored by Vesterhiem, Norwegian–American Museum, 1969–1994

Rosemaling

Gary Albrecht, Madison, WI. 1979
Eldrid Arntzen, Windsor, CT. 1987
Violet Christopherson, Marinette, WI. 1969
Sallie DeReus, Leighton, IA. 1974
Carol Dziak, Lovingston, VA. 1980
Shirley Evenstad, Richfield, MN. 1983
Rhoda Fritsch, Aurora, IL. 1991
Norma Getting, Northfield, MN. 1993
Jean C. Giese, DeSoto, WI. 1988
Enid Grindland, Alexandria, MN. 1987
John Gundersen, Indianapolis, IN. 1976
Marlys Hammer, River Falls, WI. 1990
Barbara Hawes, Grand Rapids, MI. 1971
Karen Jenson, Milan, MN. 1979
Ethel Kvalheim, Stoughton, WI. 1969
Irene Lamont, Eau Claire, WI. 1985
Susan Louthain, Platteville, WI. 1973
Gyda Mahlum, Beloit, WI. 1972
Judith Miner, Minneapolis, MN. 1981
Nancy Morgan, West Des Moines, IA. 1990
Sunhild Muldbakken, Sioux Falls, SD. 1984
Marilyn Olin, St. Paul, MN. 1991
Thelma and Elma Olsen, Elkhorn, WI. 1980
Trudy Peach, Monticello, MN. 1986
Dorothy Peterson, Cashton, WI. 1975
Addie Pittelkow, St. Paul, MN. 1970
Eileen Riemer, Waukesha, WI. 1977
Judy Ritger, River Falls, WI. 1989
Agnes Rykken, Seattle, WA. 1969
Elaine Schmidt, Hales Corners, WI. 1990
Nancy Schmidt, Waukesha, WI. 1990
Nancy Schneck, Milan, MN. 1984
Sheila Stilin, Rhinelander, WI. 1989
Vi Thode, Stoughton, WI. 1970
Suzanne Toftey, St. Cloud, MN. 1988
Pat Virch, Marquette, MI. 1974
Trudy Wasson, Eden Prairie, MN. 1976
Ruth Wolfgram, Whitefish Bay, WI. 1974
Barbara Wolter, Milwaukee, WI. 1991

Woodcarving

Else Bigton, Barronett, WI. 1988
Marvin Kaisersatt, Faribault, MN. 1991
Becky Lusk, Coon Valley, WI. 1992
Timothy Montzka, Forest City, MN. 1988
Phillip Odden, Barronett, WI. 1983
David Rasmussen, Waverly, MN. 1990
Harley Refsal, Decorah, IA. 1984
Hans Sandom, Minnetonka, MN. 1984
Glen Simonson, Wilton, WI. 1987

Weaving

Åse Blake, Atlanta, GA. 1988
Julie Brende, Waterloo, IA. 1985
Liv Bugge, Neenah, WI. 1993
Ruth Duker, Carmichael, CA. 1991
Nancy Jackson, Vallejo, CA. 1991
Rosemary Roehl, St. Cloud, MN. 1992
John Skare, Bricelyn, MN. 1987

Appendix IV

Craftsmen in the folk tradition brought as teachers from Norway to Vesterheim, Norwegian–American Museum, 1967–1994

Rosemaling

Sigmund Årseth
Knut Andersen
Kari Signe Bråthen
Knut Buen
Ida Bjørgli
Gunnar Bø
Egil Dahle
Nils Ellingsgard
Olav Fossli
Ragnvald Frøysadal
Oskar Kjetså
Bjørg Kleivi
Bergljot Lunde
Anund Lunden
Sigrid Midjås
Ruth Nordbø
Kari Pettersen
Eli Sælid
Alfhild Tangen
Olav Tveiten
Tanja Westhagen
Hans Wold

Wood Arts

Johan Amrud
Knut Arnesen
Ole Bismo
Ragnvald Frøysadal
Kåre Herfindal
Johann Hopstad
Margrete Jacobsen
Harald Kolstad
Arve Mosand
Wiggo Pettersen
Gunneid Schumann
Rolf Sogge
Rolf Taraldset

Fiber Arts

Oline Bredeli
Else Bjørk
Jorunn Finne
Åse Frøysadal
Anne Holden
Anne-Lise Hopstad
Anne Landsverk
Turid Nygaard
Ulla Suul
Birgit Tveiten
Marit Anne Tvenge

Knife Making

Håvard Bergland
Oddvin Kollbotn
Halvor Sissjord

Appendix V

1) Itinerary of Eirik Hammer's lecture tour of the United States, 30 May-27 October (no talks in the period 25 June–16 August), 1913:

Brooklyn, New York; Eau Claire, Wisconsin; Minneapolis and Glenwood, Minnesota; Fargo, North Dakota; South Bend, Everett, Tacoma, and Seattle, Washington; Portland, Oregon; Butte and Anaconda, Montana; Bismarck, North Dakota; Fergus Falls, Cloquet, Duluth, and Virginia, Minnesota; Ashland, Wisconsin; Minneapolis, Minnesota; Grand Forks and Fargo, North Dakota.

Bibliography

In addition to covering the major references on Norwegian folk art and its aftermath in America, this listing includes some specialized material relating to specific items on the checklist and some general references in English for the non-Norwegian reader. Most items listed have been used in the preparation of the commentaries on individual objects as well as the essays on Norwegian folk art and Norwegian folk art in America. The sources for subjects peripheral to folk art itself but covered in the essays are not included here but given after several of these essays.

Anderson, Kristin M. "Altars in the Norwegian–American Church: An Opportunity for Folk Expression." In *Material Culture and People's Art Among the Norwegians in America*, edited by Marion John Nelson, 199–226. Northfield, Minnesota, 1994.

———. *Per Lysne. Immigrant Rosemaler*. Unpublished M.A. paper, Art History, University of Minnesota. Minneapolis, 1985.

Anker, Peter. *Chests and Caskets*. Oslo, 1975. Translated from Norwegian.

———. "Folkekunsten." In *Norges kunsthistorie*, 3:317–368. Oslo, 1982.

———. *Folkekunst i Norge*. Oslo, 1975.

Anker, Peter, and Istvan Racz. *Norsk folkekunst*. Oslo, 1975.

Arneberg, Halfdan. *Norwegian Peasant Art* 1–2. Oslo, 1949–1951.

Asker, Randi. "Noen karveskurdskister med muruspjeld." *Drammens Museums Årbok* 1965–66, 9–36, 39–42. Drammen, 1967.

Blomqvist, Karin. "Reflektioner kring tolv täcken i vestfoldsmett," *Vestfold minne* 1990, 13–24. Tønsberg, 1990.

Brekke, Nils Georg. "Rosemåling i Kvinnherad. Motivgrupper og stilformer." In *Bygdebok for Kvinnherad*, 585–600. Bergen, 1972.

———. "Rosemåling i Midthordland." In *Bygdesoga for Os*. Bergen, 1980.

Brekke, Nils Georg and Nils Ellingsgard. *Rosemåling i Vest–Agder*. Kristiansand, 1987.

Burke, Peter. *Popular Culture in Early Modern Europe*. New York, 1978.

Christie, Inger Lise, ed. *Med egin hand*. Norsk Folkemuseum, Oslo, 1993.

Christie, Sigrid. *Den lutherske ikonografi i Norge inntil 1800*, 1–2. Series: *Norske minnesmerker*. Oslo, 1973.

Colburn, Carol. "'Well, I Wondered When I Saw You, What All These New Clothes Meant': Interpreting the Dress of Norwegian-American Immigrants." In *Material Culture and Peoples Art Among the Norwegians in America*, edited by Marion Nelson, 118–155. Northfield, MN, 1994.

Dahl, J.C. *Denkmale einer sehr ausbildeten Holzbaukunst aus den fruhesten Jahrhunderten in den innern Landschaften Norwegens*. Dresden, 1837.

Dietrichson, L. *Den norske Træskjærerkunst, dens Oprindelse og Udvikling*. Christiania (Oslo), 1878.

Ellingsgard, Nils. *Norwegian Rose Painting*. Oslo, 1988. Translated from Norwegian.

———. *Norwegian Rose Painting in America*. Vesterheim, Decorah, IA, 1993.

———. *Rosemåling i Hallingdal*. Oslo, 1978.

———. *Rosemåling i Valdres*. Fagernes, 1989.

Engelstad, Helen. *Dobbeltvev i Norge*. Series: *Fortids kunst i Norges bygder*. Oslo, 1958.

———. *Norske ryer. Teknikk, form og bruk*. Series: *Fortids kunst i Norges bygder*. Oslo, 1942.

———. *Refil, bunad, tjeld*. Series: *Fortids kunst i Norges bygder*. Oslo, 1952.

Fett, Harry. "Folkekunst." *By og bygd* 3 (1945): 1–42. Oslo, 1944.

Figg, Laurann. "The Great Norwegian Cover-Up." *Scandinavian Review* 82, 3 (Winter 1994): 68–75. New York, 1994.

Fischer, Ernst. "Från granatapple till skybragd." *By og bygd* 21 (1968–69): 101–118. Oslo, 1969.

———. "Nordiske flamskvävnader i Nordiska Museet." *By og bygd* 18 (1964–65): 53–84. Oslo, 1966.

Fossnes, Heidi. *Norges bunader og samiske folkedrakter*. Oslo, 1993.

Fuglesang, Signe Horn. "Woodcarvers—Professionals and Amateurs—in Eleventh Century Trondheim." In *Economic Aspects of the Viking Age*, edited by David M. Wilson and Marjorie L. Caugill, 21–31. British Museum, London, 1981.

Gilbertson, Donald E. and James F. Richards, Jr. *A Treasury of Norwegian Folk Art in America*. Osseo, WI, 1975.

Gjerdi, Trond. *Møbler i Norge*. Oslo, 1976.

Gjessing, Guttorm. "Hesten i fornhistorisk kunst og kultus." *Viking* 7 (1943): 5–143 plus plates. Oslo, 1943.

Gjaerder, Per. *Esker og tiner*. Oslo, 1981.

———. *Norske drikkekar av tre*. Oslo, 1975.

Grevenor, Henrik. "Gårastolen." *Kunstindustrimuseet i Oslo Årbok* 1935–37, 5–19. Oslo, 1937.

Graabraek, Elin. *Tepper i Vestfold*. Vestfold Fylkesmuseum, Tønsberg, 1987.

Hauglid, Roar. *Akantus* 1–3. Oslo, 1950.

———. "Gildebord og høisete. Middelalderens ringbord." *Foreningen til norske fortidsminnesmerkers bevaring årsberetning* 1941, 45–66. Oslo, 1943.

———. *Hus, peis og billedvev*. Series: *Fortidsminner* 40. Oslo, 1956.

Hauglid, Roar, et al. *Native Art of Norway*. 2 ed. New York, 1967.

Henning, Darrell, Marion John Nelson, and Roger L. Welsch. *Norwegian–American Wood Carving of the Upper Midwest*. Vesterheim, Decorah, IA, 1978.

Historieskrift om Øyer kirke. Øyer Menighetsråd, Øyer, 1983.

Høeg, Ove Arbo. "Dendrokronologi." *Viking* 8 (1944): 231–282, plates 44–45. Oslo, 1944.

Hoffmann, Marta. "En gruppe vevstoler på Vestlandet. Noen synspunkter i diskusjonen om billedvev i Norge." *Norveg, Folkelivsgransking* 6 (1958): 7–196. Oslo, 1959.

———. "Folkekunst - hva menes med det?" *Kunst og kultur* 66, No. 2 (1983): 66–79. Oslo, 1983.

———. *The Warp-Weighted Loom. Studies in the History and Technology of an Ancient Implement*. Oslo, 1964.

Kangas, Gene and Linda. "Harald Thengs: Repatriating the Viking Decoys." *Decoy Magazine* 14, 2 (March/April 1990): 6–13. Berlin, MD, 1990.

Kielland, Thor B. *Norges billedvev 1550–1800* 1–3. Series: *Fortids kunst i Norges bygder*. Oslo, 1953–55.

Kloster, Robert. "Expansjon i bygdekunsten." *Bergens Museums Årbok* 1941 (History and Antiquities Series, No. 3): 1–22. Bergen, 1941.

———. "Folkekunst." In *Norsk kunstforskning i det tyvende-århundre* (Festskrift til Harry Fett), 47–69. Oslo, 1945.

———. "Kunstarbeide og håndverk." In *Sogn*. Series: *Norske bygder*, 180–194. Bergen, 1937.

———. "Tradisjon og impuls. En orientering på grunnlag av renessanse innslaget i bygdekunsten." *Viking* 7 (1943): 145–163. Oslo, 1943.

———. "Vestnorsk bygdekunst." *Bergens Museums Årbok* 1937 (History and Antiquities Series, No. 3): 1–21. Bergen, 1938.

Landsverk, Halvor. "Fra biletverda i folkekunsten." *By og bygd* 8 (1952–53): 1–70. Oslo, 1953.

Lincoln, Louise, ed. *The Art of Norway 1750–1914*. Minneapolis Institute of Arts, Minneapolis, 1979.

Magerøy, Ellen Marie. "Karveskurd." In *Kultur historisk leksikon for nordisk middelalder* 8. Copenhagen, 1963.

———. *Norsk treskurd*, 2nd ed. Oslo, 1983.

Martin, Philip. *Rosemaling in the Upper Midwest*. Wisconsin Folk Museum, Mount Horeb, WI, 1989.

Meyer, Johan. *Fortids kunst i Norges bygder*: l. *Gudbrandsdalen*. Kristiania (Oslo), 1909–11. 2. *Telemarken*. Kristiania, 1913–26. 3. *Numedal*. Oslo, 1930–32. 4. *Østerdalen*. Oslo, 1934. 5. *Sunndalen på Møre*. Oslo, 1938.

Midttun, Gisle, ed. *Norsk bygdekunst fra middelalder til nutid* (Festskrift til Hans Aall). Oslo, 1929.

Molaug, Ragnhild Bjerregaard. "Ullkurven fra Seljord." *By og bygd*)1943): 55–66. Oslo, 1942.

Molaug, Svein. "Hest og mangletre." *By og bygd* 9 (1954): 19–48. Oslo, 1954.

———. "Krutthornskurdens opprinnelse og stilpreg." *Hærmuseets Årbok* 1947–48, 55–70. Oslo, 1950.

Monsen, Marit. *Høvrer av tre*. Oslo, Bergen, Tromsø, 1977.

———. "Statisk og dynamisk skurdornamantikk i norsk folkekunst." *By og bygd* 24 (1973): 39–50. Oslo, 1974.

Nelson, Marion John. "American Woodcarvers from Telemark." *Telemark Historie* 8 (1987): 24–51. Bø, 1987.

———. "Folk Art in Minnesota and the Case of the Norwegian–American." In *Circles of Tradition. Folk Arts in Minnesota*, 24–44. St. Paul, 1989.

———. "Folk Arts and Crafts of the Norwegians in America." *Migranten* 1 (1988): 38–63. Norsk Utvandrer Museum, Hamar, 1988.

———. "The John Eriksen Cupboard." *The Minneapolis Institute of Arts Bulletin* 63 (1976–1977): 61–73. Minneapolis, 1979.

———. "The Material Culture and Folk Arts of the Norwegians in America." In *Perspectives on American Folk Art*, 79–133. New York, 1980.

———. "Material Culture and Ethnicity. Collecting and Preserving Norwegian–Americana Before World War II." In *Material Culture and Peoples Art Among the Norwegians in America*, 3–72. Northfield, MN, 1994.

———. *Norway in America*. Vesterheim, Decorah, IA, 1989.

———. *Three Landsverks: The Art of an Immigrant Family*. Vesterheim, Decorah, IA, 1975.

Nicolaysen, Nicolay. *Kunst og haandverk fra Norges fortid*, Series 1 and 2. Kristiania (Oslo), 1881–1894.

Noss, Aagot. *Adolph Tidemand og folk han møtte*. Oslo, 1970.

———. *Joachim Frichs draktakvareller*. Oslo, 1973.

———. *Johannes Flintoes draktakvareller*. Oslo, 1970.

———. *Lad og krone, frå jente til brur*. Oslo, 1991.

———. *Nærbilete av ein draktskikk, frå dåsaklede til bunad*. Oslo, 1992.

———. *Statuane i Nordmandsdalen*. Oslo, 1977.

Pamela Publications. *A Collection of Norwegian Rosemaling in America*. Minneapolis, 1986.

Refsal, Harley. *Woodcarving in the Scandinavian Style*. New York, 1992.

Schetelig (also Shetelig), Haakon. "Karveskur paa Vestlandet." *Bergens Museums Årbok* 9 (1913): 1–22, plates 1–28. Bergen, 1913.

Sjøvold, Aase Bay. *Norwegian Tapestries*. Oslo, 1976. Translated from Norwegian.

Skavhaug, Kjersti (English edition with Bent Vanberg and Karen Hybbestad-Schwantes). *Norwegian Bunads*, 6th ed. Oslo, 1991.

Skou, Ingri. *To norske treskjærere: Ole Moene og Lars Kinsarvik*. Oslo, 1991.

Steen, Albert and Sissel Ree Schjønsby. *Røtter. En bok om tre*. Lillehammer, 1994.

Stewart, Janice. *The Folk Art of Norway*, 2nd ed. New York, 1972.

Sundt, Eilert. *Om husfliden i Norge, til arbeidets ære og arbeidsomhedens pris; første beretning*. Christiania, 1867.

Svensson, Sigfrid, ed. *Nordisk folkkonst*. Lund, Sweden, 1972.

Tschudi-Madsen, Stephan, ed. *På nordmanns vis. Norsk Folkemuseum gjennom 100 år*. Oslo, 1993. English, German, and Norwegian text.

Vesaas, Oystein. *Rosemaaling i Telemark* 1–3. Oslo, 1954–1957.

Visted, Kristoffer. "Nyere folkekunst." In *Norsk kunsthistorie* 2: 631–660. Oslo, 1927.

Visted, Kristoffer and Hilmar Stigum. *Vår gamle bondekultur* 1–2, 3rd ed. Oslo, 1971.

Wang, Marit. *Ruteåklær. Bidrag til en karakteristikk, ordning og plassering*. Bergen, 1983.

Weiser-Aall, Lily. "Magiske tegn på norske trekar?" *By og bygd* 5 (1947) 117–144. Oslo, 1947.

Index

Numbers in *italic* refer to illustrations.

Aadnes, Peder, 65, 71, 97, 190, *196–197,* 198–199
Aal church, 91
Aal, Hans Jacob, *238,* 242, 245, 247
Aarseth, Sigmund, 97, 220, 222, 268
Acoma, 28
Adam and Eve, 55
Adoration of the Magi, 43, 51–53
Aesthetic Movement, 59
Africa, 45
Agder, 120, 123, 129, 194, 226, 231
Ål (Hallingdal), 62, 64–66, 68, 86, 91, 101, 150, 152, 158, 191, 203–204
Ål Bygdearkiv, 159
Alaska Yukon Exposition, 162
Allan Line (ship), 129
Albrecht, Gary, 97, 267
Ambrosiani, Sune, 61
American Scandinavian Foundation, 6
Åmli house (Setesdal), *46*
Amrud, Johan, 268
Amsterdam, 123
Amundson, Mrs. B., 166
Andersen, David, 252
Andersen, Harry and Josefa, 78
Andersen, Knut, 268
Anderson, Alfred, 92, *113*
Anderson, Kristin, 99, 269
Anderson, Selma, 234
Anker, Peter, 6, 38, 40, 47, 61, 247, 269
Århus, Per A., 69
Arlington (WA), 75
Arneberg, Arnstein R., 254
Arnesen, Knut, 268
Arntzen, Eldrid S., *198,* 267

Art Deco, 92
Art Nouveau, 251, 254–255
Arts and Crafts Movement, 241, 255
Asbjornson, Clara, 135
Association for Handicrafts (Oslo), 251
Association for the Preservation of Norwegian Historical Monuments, 240, 249
Atlantic, 12, 14, 90, 94, 129, 194
Atnadal (Gudbrandsdalen), 77
Aubert, Fredrik L.V. (Andreas), 254
Aurdal (Valdres), 128
Aust-Agder, 69, 128–129, 171, 182, 226
Austria, 43

Backer, Julie E., 131
Bæra, Embrik, 65–66, 191, *203*
Bæra, Nils, 65–66, *203,* 204
Bagn church (Valdres), 65
Båhuslän (Sweden), 119
Bakken, Olav, 93, *108*
Bakken, Reidar, 93
Barikmo, John, 42, *59*
Baroque, 14, 17, 39, 52, 61–67, 69, 72–73, 91, 94, 98–99, 145, 176, 190, 196, 202, 215, 227, 254, 256
Barronett (WI), 104, 112
Barton, Arnold H., 188
Benson (MN), 23, 86, 89, 91, 191
Berge, Ola Hermundson, 65, *199–200*
Bergen, 6, 43, 62, 69–70, 89, 119, 126, 191, 235, 253
Bergens Billedgalleri, 4

Bergens Museum, 22, 240
Bergland, Håvard, 268
Bergstrom, James and Marilyn, 26
Bigton, Else, 267
Bishop, Robert, 6
Bismarck (ND), 6–7
Bismo, Ole, 268
Bjaalid, Bjørn, 67, 69
Bjella, Ola O., *62,* 65
Bjørgli, Ida, 268
Bjørk, Else, 268
Bjork, Kenneth O., 169
Bjørkvik, Halvard, 15, 37, 98, 119
Bjørnsdatter, Aagot, 224
Bjørnson (Uppheim), Sevat, 24, 65, 192
Bjørnstad farm (Gudbrandsdalen), *47,* 246, 247
Blake, Ase, 267
Blegen, Helmer M., 132
Blegen, Theodore C., 131, 188
Blix, Thomas, 62, 64
Blue Mounds (WI), 131, 168
Bø (Telemark), 19, 172, 253
Bø, Gunnar, 268
Boe, Liv Hilde, 6
Bohmer, John and Joyce, 162, 164, 169
Boise (ID), 28, 32
Borg, Lars J., 62, *73,* 78, 92
Borgersen, John, 251
Boston, 89, 94
Bøverdalen (Gudbrandsdalen), 53
Bragenes church (Drammen), 73
Brandes, Georg, 37
Bråthen, Kari, S., 268
Brede, Mergret, 210
Bredeli, Oline, 268

Breen, Clarence, 62
Brende, Julie, 267
Bringsdal, Kathrine Holmegaard, 138
Brinkeberg (Telemark), 67
Brooklyn, 93
Brooten (MN), 162, 164, 169
Bruse, Selma Thompson, 179
Brussels, 44
Brye, Martha, 168
Buckley, Joan, 169
Budalen (Trøndelag), 43, 177
Budalsplads, John H., 43, *177*
Buen, Knut, 268
Buffalo (NY), 193
Bugge, Eva, 6
Bugge, Liv, *141,* 267
Buine, Nikuls, 68, 193, *215*
Bull, Henrik, 251, *252*
Bull, Ole, 51, 89
Burke, Peter, 40
Burmann (legend), 56
Buskerud, 128–129, 183
Busterud, Sondre, 67, *212*
Bye, Ann Jacobs Datter, 196
Bygdøy, 240
Bygland (Setesdal), 176

Cahill, Julie, 212
California, 54, 207
Calmar (IA), 104
Catholicism, 37
Cedar Falls (IA), 15, 157
Charlemagne, 54
Chicago (IL), 19, 126, 160, 166, 187, 211, 215
Christ, 42, 44, 63
Christenson (Kjørnes), Lars, 23, 24, *86, 88–89,* 91–92, 191
Christian (faith), 18, 57, 61, 152
Christian III (Bible), 45

Christiania, (see Oslo)
Christmas, 41, 43, 151, 155, 159, 175
Christopherson, Violet, 267
Christie, I.L., 63, 70, 97
Christie, Wilhelm, 240
Christiana township (WI), 130
Civil War (American), 105, 129–130
Clark, Karine, 216
Classic, 38, 63, 71
Clausen, C. A., 188
Colburn, Carol, 15, 157, 169, 188, 269
Columbian Exposition, 19
Comenius, 101
Coon Valley (WI), 73, 90–91, 107, 117, 128, 131
Copenhagen, 122
Cottage Grove (WI), 82, 90, 93
Count of Larvik, 120
Counter-Reformation, 62
Crucifixion, 63
Cubism, 64
Currier, William, 209
Curtis, Sylvea Bull, 51

Dagestad, Magnus, 251
Dahl, Johan C., 4, 19, 249, 269
Dahle, Egil, 268
Dahle, Isak, 89, 193
Dalager, Rudolph L., 24
Dano-Norwegian Union, 122
Dawson (MN), 116
Decorah (IA), 6, 34, 72, 89, 93, 96–97, 99, 109
DeForest (WI), 90, 93, 193, 201
Denmark (and related), 14, 29–30, 37, 47, 62, 99, 101, 120, 122–123, 138–139, 157, 240, 250
DeReus, Sallie H., *204*, 257
DeSoto (WI), 117
Deventer (Netherlands), 123
Dietrichson, Lorentz, 240, 247, 250, 253–254, 269
Directorate for Cultural Heritage (*Riksantikvaren*), 6, 15, 241, 243, 247
Disington, Bjørg, 265
Dovre (Gudbrandsdalen), 75, 96, 104
Dragestil (see "dragon style")
Dragon style, 250–251, 256
Drammen, 73
Drammens Museum, 73, 265
Duker, Ruth, 267
Dziak, Carol, 267

East Agder (see Aust-Agder)
Easter, 151
Eau Claire (WI), 89, 131, 232
Egersund, 115
Egersunds Fayancefabrik, 255
Eggedal (Buskerud), 68, 93, 193
Eidsvoll (Akershus), 249
Eklestuen, Tron, 241
Eklund, A.V. (collection), 165
Elgin (IL), 260
Elkhorn (WI), 94
Ellingplassen, Elling, 191
Ellingsgard, Nils, 6, 14–15, 68, 71, 97, 189, 194–195, 198, 204, 268–269
Elverum (Hedemark), 254
Empire (style), 145
Engan, Hans, *106*
Engen, Arnfinn, 131
Engeseth (family), 93, 98
Engeseth, Erik J., 193, *201*
Engeseth, John Eriksen, 193
Engesethe, Brithe Sjurs Datter, 193, 201
Engesethe, Erik Eriksen, 193
Engesethe, Solvi J.D., 193
England (and related), 42, 52, 94, 123, 126, 129, 158, 255
Eriksdatter, Anna Marthe, *135*
Eriksson, Leif, 168
Europe (and related), 12, 63, 89, 129, 149, 185, 194, 243, 249, 251, 253–254
European Union, 256
Evenstad, Shirley, 267
Exposition Universelle (1900, Paris), 251

Falk, Rolland, 161
Fargo (ND), 96
Faribault (MN), 30
Faroe Islands, 40
Federåd house (see also Bjørnstad farm), *47*
Fergus Falls (MN), 178, 200
Fertile (MN), 111
Feten, Ola, 65, *101*, *204*
Fett, Harry, 243, 269
Fifteenth Wisconsin Regiment, 105
Finland, 33, 45, 139, 142
Finne, Jorunn, 268
Fjagesund (Telemark), 18
Fjeld, Gullick, 179
Fjeld, Nils H., 128
Fjell, Kai, *189*
Fjelland, Gladys, 216

Fjotland (Vest-Agder), 116, 227
Flamm, Susan, 6
Flanders, 43
Flatla, Jan, 6
Flemish, 43–44
Flintoe, Johannes, *148*, 149, 150
Flisaker (Hedemark), 74
Flom (MN), 22, 109, 224
Flom, George, 130–131
Folkedal family, *135*
Folkedal, Jon Endresen, 23
Forening til Norske Fortidsmin- nesmerkers Bevaring (see Association for the Preservation of Norwegian Historical Monuments)
Forest Lake (MN), 32
Foss, Peter O., 94, *209*
Fossli, Olav, 268
Fosston (MN), 113
Fox River Valley settlement (IL), 126, 130
France (and related), 44, 62, 65
Frederik II (Bible), 45, 208
Frich, Joachim, C. G., 150, *151*
Fritsch, Rhoda, 267
Frogneseter (Oslo), 240
Frøysadal, Åse, 268
Frøysadal, Ragnvald, 180, 195, 268
Fylkesmuseum for Telemark og Grenland, 18, 108, 172, 265
Fyresdal (Telemark), 194, 215

Gangstad, Eugene E., 82
Gåra (Bø, Telemark), 19
Garborg, Hulda, 158, 168–169
Gåsterud, Torkjell, K. S., 191
Gausta, Herbjorn, 162, 169
Germanic, 6
Germany (and related), 29, 32, 40, 44, 52, 69, 91, 99, 129, 168, 227
Getting, Norma, 97, *221*, 267
Giese, Jean, *117*, 267
Gilbertson, Don and Nancy, 111
Gjærder, Per, 42
Gjerde, Jon, 15, 185, 188
Gjerpen (Telemark), 212
Glambek, Ingeborg, 247
Glasgow, 129
Glittenberg, Hans, 68, 71, *216–217*
Glomsdal (Østerdalen), 53
Goke, Patti, *226*
Goodhue County (MN), 193
Gothenburg (Sweden), 126

Gothic, 25, 30–32, 38, 40, 176, 250
Gransherad (Telemark), 108
Grant County Historical Society, 179
Greece, 38
Grindland, Enid J., *198*, 267
Grøsli house (Numedal), 245
Grøt, Syver H., 65, 193, *205*
Groven, Gunder Svenssen, 216
Guda (Trøndelag), 34
Gudbrandsdalen, 33, 39–40, 43–44, 46–47, 49, 51–54, 61–65, 68, 70, 73–75, 77–79, 82, 89–92, 96, 103, 112, 124–125, 128, 180, 192, 194–195, 255
Gudbrandsdøls, 131
Gundersen, John, 267
Guttormsdatter, Eli, *135*
Gunhildgard, Truge, 65

Haaland, Kay H., 173
Hagene, Erik, 193
Hallingdal, 24, 40, 62, 64–69, 72, 86, 89, 91, 93–94, 97, 101, 125, 127–128, 144–145, 158, 162, 164, 183, 188, 190–192, 194, 204, 207, 224, 231
Hallinglag, 162–167
Hallings, 130–131, 158, 162, 164, 166, 191
Hallstatt (Austria), 43
Haltmeyer, Adeline Johnson (collection), 23, 30, 104–105, 134–135, 175
Haltmeyer, John, 23, 30, 82, 104–105, 134–135, 175
Halvorson, Nettie, 94–95, *262–263*
Hamarsbøen, Vebjørn O., 191
Hammer, Eirik, 247, 268
Hammer, Marlys, 267
Haugen, Einar, 132
Hansen, Frida, 254
Hansen, Marcus Lee, 128
Hanson, James L., 25
Hansson, Ola, 67–68, *214*, 215
Hardanger (and related), 19, 23, 44, 68–70, 92, 94, 96, 134–135, 146–147, 149, 152, 157–158, 160–162, 166, 169, 194, 251, 255
Hardangerlag, 147, 162, 164, 167
Härjedalen (Sweden), 119
Harmon, Carol and Tim, 83
Hasvold, Carol, 6

Index

Hauge, Hans Nielsen, 37, 126
Haugesund (Rogaland), 137
Haukjen, Kjetil, *224*
Havran, Jiri, 247
Hawes, Barbara, 267
Hazelius, Artur, 61, 240, 242
Heddal (Telemark), 67, 216
Hedemark, 25, 40, 62, 74, 81, 120–121, 191
Heftye, Thomas J., 240
Heg, Colonel, 105
Hegard, Tonte, 15, 239, 247, 250, 252
Hegg farm (Voss, Hordaland), 26
Helland, Gunnar and Knut, 92, *172*
Hellelykkjun, Erik O., *124*
Hellelykkjun, Hans O., *124*
Hemsedal, 192
Henning, Darrell, 6, 62, 89, 91, 249, 257, 265
Herfindal, Kare, 268
Herod (feast), 43
Hervey, Robert, 6
Hiff, Barbara, 155
Hills (MN), 165
Hillsboro (ND), 91
Hitman, Arthur, 169
Hitman, Bruce, 147, 178
Hjartdal (Telemark), 179
Hjelle (Valdres), 4
Hjeltar house (Gudbrandsdalen), *244*, 245
Høeg, Ove A., 39
Hoel, Halvor, 191
Hoghaug, Martha L., 203, 265
Høiness, Ellen, 6
Hol (Hallingdal), 65–66, 152, 178, 191, 205–206, 208
Holand, Hjalmar R., 130–132
Holbein (embroidery), 44
Holden, Anne, 268
Holger, the Dane, 54, 56
Holland (and related), 40, 44, 69, 123, 227
Hollander, Stacy, 6
Hollander, The, 62
Holman (Bible), 91, 94, 211
Holmenkollen (hotel), 251
Holstein (Denmark), 122
Holt, Erik Rist, *75*, 96, 104
Holzhueter, John, 93, 193
Hopstad, Anne-Lise, 268
Hopstad, Johann, 268
Hordaland, 20, 79, 93, 150, 153, 180, 191, 236
Hovde, Christian, 172
Horne, Knut E., *107*

Houg, Lars Larsen, 205
Houston (MN), 263
Hovden, Knut, 93
Hove, Mary, 6
Hovin (Telemark), 67, 215
Hovland, Gjert G., 126
Hull (England), 129
Hunder family, 175
Hunt, Peter, 237
Hus, Lars L., 69–70
Husfliden. also *Den Norske Husflidsforening,* 253
Huslegaarden, Ole H., 25
Hyllestad (Setesdal), 110

Idaho, 28, 32
Iffuerson, Peder, 210
Impressionism, 64
Indielandet (WI), 131
Industrial Revolution, 12, 123
Ingebrightsdatter, Ingre, 177
Iola (WI), 59
Iowa, 6, 34, 62, 72, 89–90, 93, 96–97, 99, 104, 109, 130–131, 193, 224
Ireland, 129
Isaachsen, Olaf W., *118*
Islamic, 250

Jackson, Jon, 91
Jackson, Nancy, *54*, 96, 267
Jacobsen, Margrete, 268
Jämtland (Sweden), 119
Jansen, Jo Sonja, 97, *207*
Japan, 254–255
Jefferson, Thomas, 9
Jefferson Prairie settlement (WI), 130
Jenson, Karen, 22, 97–98, *222–223*, 267
Jessen, Henrietta, 188
Johannesen, Betty B., *143*
Johnsen, Reverend Erik Kr., 19, 91, 253
Johnson, Jens, 173
Johnson, Roger and Shirley, 67, 106, 171
Johnson, Ruth, 77
Jonsdatter, Johanne, 43
Jutland (Denmark), 40, 122

Kaehler, Joyce T., 179
Kanavin, J. Bjørn, 6
Kandiyohi County (MN), 131
Kaisersatt, Marvin, 267
Kangas, Gene and Linda, 115
Karmøy (Rogaland), 134
Kastrup, Peder, 64
Katz, Allan, 260–261, 265

Kelley, Helen, *52*
Kendall settlement (NY), 126
Kilbere City (WI), 25
Kingestad, Berta Serina, 160
Kinsarvik, Lars T., *19,* 69, 251
Kirkeby, Ane Bitnes, *34*
Kjaerheim, Steinar, 188
Kjellstad, G., 70
Kjetså, Oskar, 268
Kjørnes, Christen O., *24*, 191
Kjørnes, Lars Christenson (see Christenson, L.)
Kjose church (Vestfold), 210
Kleivi, Bjørg, 268
Kloster, Robert, 40, 70, 247, 270
Klukstad family, 195
Klukstad, Jakob B., *60,* 63–64, 71, 74–75
Knudsen, Estelle Hagen, 231
Knudson, Ellen, *135*
Knudson, Sigur, 212
Kogan, Lee, 6
Koldal, Martha Karina Jons Datter, 234
Kollbotn, Oddvin, 268
Kolstad, Harald, 268
Kongsberg church (Buskerud), 67–68
Koshkonong settlement (WI), 128, 130
Kravik family, 68
Kristiania (see Oslo)
Kunstindustrimuseum i Oslo (see Oslo Museum of Applied Art)
Kvale, Helge O., 193
Kvalheim, Ethel, 93, 97, *200*, 216, *217*, 267
Kvamme farm (Gudbransdalen), 53
Kviteseid (Telemark), 18, 64, 67, 91, 212

LaCrosse (WI), 31
Lærdal (Sogn), 93, 234
Lake Park (MN), 83, 91
Lamont, Irene, 232, *233,* 267
Landsnemnda for bunad-spørsmål (The National Bunads Committee), 158
Landsverk, Anne, 268
Landsverk, David, 81
Landsverk, Halvor (see bibliography), 46, 101
Landsverk, Halvor (carver), 45, *77,* 91–92, 96
Landsverk, Pernella, 77

Landsverk, Tarkjel, *76–77, 81,* 82, 91, 212
Lanser, Howard, 6
Larsson, Carl, 254
Lashua, Roger and Kathe, 28, 174
Last Supper, 63, 94
Latner, Peter, 265
Lee, Knut O. (also Li, Lie, and Knud), *73,* 90, *91,* 128
Leeper, Don, 6
Leikanger (Sogn), 193, 201
Leonardo da Vinci, 94, 211
Lesja (and related), 60, 63–64, 74–75, 112, 195
Leveld (Oslo), 254
Leyden (Netherlands), 123
Lie, Aslak, 93, 193, 199
Lillehammer, 47, 243, 256
Lista (Aust-Agder), 46, 55
Listad, Kristen E., 63, *78,* 92, 103, 104
Little Norway (WI), 23, 57, 89, 134, 141, 168, 174, 193, 235
Liverpool (England), 129
Loftness, Paul, *198, 207*
Lom (Gudbrandsdalen), 39, 53
Lombard, Lambert, 210
London, 241
Long Island (NY), 115
Louis XIV, 62
Louis *Seize,* 183
Louthain, Susan, 267
Lovoll, Odd, 15, 125, 132, 166, 169
Lund, Miles V., *28, 32,* 96
Lunde, Bergljot, 97, 268
Lunde, Bergljot and Gunnar, 229
Lunden, Anund, 268
Luraas, Knut, 68
Luraas, Olav, 68, *224*
Luraas, Thomas, *23,* 68–69, 71, 191, *218–219,* 220, 222, 224
Luraas Øystein, 68
Luraas-Rui, Knut, 68
Lusk, Becky, *106, 117,* 267
Luther College (IA), 166
Luther College (IA) (collection), 19–20, 29, 89–90, 135, 177–178, 202, 207, 224–225, 234
Lutheran (and related), 37, 130–131
Lyons, Liv N., 247
Lysne, Per, 93, 97, 99, 200, *234,* 235, 269
Lysøen, 89

McGowan, Jack, *198, 206, 231*
Madison (WI), 89, 92–93, 187
Madsen, Stephan Tschudi, 6
Madson, Michelle A., 187
Magerøy, Ellen M., 38
Mahlum, Gyda, 267
Maihaugen, 47, 73, 103, 107, 112, 124, 195, 199, 238, 242–243, *244, 245, 246*
Malachi (biblical), 198
Malta (IL), 60
Manitowoc (WI), 131
Marifjøra (Sogn), 84
Massachusetts, 94
Matthew (biblical), 220
Medhus house (Hallingdal), 66
Medieval, 12, 17–20, 33, 37–41, 43, 46, 49, 59, 61, 68, 91, 97, 128, 144, 176
Mediterranean, 139
Medlicott, Alex and Suzanne, 136–137
Melgaard, Leif, 77, *78–79,* 92, 96, 253
Melheim, Hermund, 14, *84–85,* 86, 92, 96
Menomonie (WI), 51
Mevasstaul, Knut, *66,* 67
Meyer, Johan J., 245
Middle Ages, 12, 18, 33, 37–43, 45, 61, 119–120, 123–124, 149, 250, 253
Midthordland, 191
Midjås, Sigrid, 268
Midtbø, Ola L., 69, *234*
Midthus, Annanias (see Tveit)
Midthus, Nils, 69, *232, 234,* 235–236
Midttun, Gisle, 245, 270
Migration Period, 38, 40, 61
Milan (MN), 22, 222
Milwaukee (WI), 187
Miner, Judith N., *205,* 267
Minneapolis (MN), 52, 78, 92, 99, 139, 164, 173, 205, 231
Minneapolis Institute of Arts, 51, 193, 201, 265
Minnesota, 19, 30, 32, 52, 67, 76–78, 83–84, 86, 89, 90–92, 94, 97, 99, 101, 105–106, 109, 111, 113, 116, 130–131, 164, 187, 203, 226, 231
Minnesota Historical Society, 79, 113, 265
Minnesota Museum of American Art, 6
Minnetonka (MN), 77
Moe, Chris, 92, 95, *260–61*
Moen, Lars Ellingson, 191

Moen, Mekkel, Olsen, 106
Moene, Ole, 251
Molaug, Svein, 38, 40
Møller, Henrik, 252
Monsen, Marit, 37
Monson, Gerde S., 169
Monticello (MN), 97, 231
Montzka, Tim, 32, 96, 267
Møre and Romsdal (also *Møre og Romsdal*), 64, 105
Morgan, Nancy, 218, *230,* 267
Morken (Gudbrandsdalen), 74
Morris, William, 253–254
Mosand, Arve, 268
Moses (biblical), 54–55
Mostrom, Jan, 96, *134*
Mostrom, Mike and Jan, 134
Mount Horeb (WI), 89, 193
Muir, Heather, 194
Muldbakken, Sunhild, 267
Munch, Caja, 159
Munch, Eggert, 65
Munch, Peter, 169
Munthe, Gerhard, *248,* 254–255
Munthe, Holm Hansen, 251
Museum of American Folk Art, 6, 8
Muskego church, 130
Muskego settlement (WI), 131
Myrlie, Mrs. Ole J., 147

Naeseth, Henriette, 169
Naess, Harald S., 169
Naeste, Ingebor Jokums Dattr, 174
Napoleonic Wars, 122
National Gallery (Oslo), 119
National Romanticism, 19, 67, 256
Nattestad, Ole and Ansten, 126–128, 130
Navaho, 34, 45, 68
Near East (and related), 45, 49
Nelson, Betty Rikansrud, *34*
Nelson, Frank G., 188
Nelson, Lila, 96, *139*
Nelson, Marion J., 6, 15, 37, 67, 89, 99, 169, 188, 270
Neo-Baroque, 256
Neo-Classicism, 91, 256
Neo-Romantic, 194
Nestestog, Aslak, 67
Nestestu, Aasmund A., *82,* 90–91, 93
Netz, Warren and Kirsten Landsverk, 81
Neumann, Bishop Jacob, 129
New York (NY), 6, 8, 115, 126, 166, 168, 187

New World, 263
Nicolaysen, Nicolay, 240, 270
Nidaros Cathedral, 260
Nilsson, Svein, 188
Nordbø, Ruth, 268
Nordboe, Johan, 128
Nordby, Dr. and Mrs. E. J., 19
Nordfjord, 151, 191, 200
Nordhordland, 136
Nordic, 19–20, 40, 61, 63, 250, 255
Nordic Heritage Museum (WA), 6, 26, 143, 162, 259
Nordic Museum (Stockholm), 39, 61, 240, 292
Nordre Land, 196
Norske Dramatiske Forening (Norwegian Drama Society, Chicago), 160
Norges Husmorlag (Norway's Homemaker's Society), 158
Norsk Folkemuseum (see Norwegian Folk Museum)
Norlie, O.M. (collection), 169
Nordland Rosemalers Association, 195
Norskedalen (WI), 76
North Dakota, 92, 96, 108, 128, 131, 172, 226
North Dakota Heritage Center, 6, 91
Northfield (MN), 15, 220
Norway Day (Seattle, WA), 162, *163*
Norwegian American Historical Association, 6, 132, 165–167
Norwegian-American Museum (IA) (see Vesterheim)
Norwegian Art and Craft Club of Brooklyn, 93
Norwegian Emigrant Museum (Hamar, Norway), 166
Norwegian Folk Museum, 6, 8–9, 15, 17, 20–21, 33, 46, 49, 53–56, 58, 64, 75–76, 79, 81, 101–102, 105, 110–111, 113–114, 116–117, 120–121, 124, 133–134, 144–145, 155, 171, 176, 180, 182–183, 196, 203–206, 208, 212, 219, 227, 232, 238, 241–243, 245, 265
Norwegian Grove church (WI), 90
Norwegian Information Service, 6
Norwegian Lutheran State Church, 126

Noss, Aagot, 6, 15, 95, 149, 155, 157, 169, 270
Numedal, 63, 68, 93, 102, 125–127, 130, 192, 224
Numedøls, 130
Nyblin (photographer, Hallingdal), 159
Nygaard, Turid, 268

Odden, Phillip, 96, *104, 112,* 267
Ohme, Thor, 162, 164
Øiefjeld (Telemark), 107
Ojard, Bruce, 265
Olason, Ola, 46
Oldsaksamling (see University of Oslo Collection of Antiquities)
Oles Datter, Olina, 232
Olin, Marilyn, 267
Olsen, Anders, 93
Olsen, Martin, 94, *212*
Olsen, Thelma and Elma, 267
Olson, "King," *83,* 86, 91
Olson, Ole "The Hermit," 96, *108,* 109
Olsrud, Bjørn, 73
Opdahl, John Petter, 6
Oppdal (Trøndelag), 207, 251
Oppland, 127–129
Oregon, 92
Oriental, 44–45, 68
Ørlandet (Trøndelag), 211
Os (Hordaland), 69–70, 93, 97, 232, 235, 237, 239
King Oscar II, 240, 242
Ose (Setesdal), 119–121
Oseberg ship, 38–39, 41–42
Oslo (Christiania, Kristiania), 6, 19, 36, 38–39, 46, 52, 57, 62–65, 67, 71, 73, 91, 97, 158, 173, 187–188, 191, 240–241, 251, 253–255
Oslo Museum of Applied Art, 15, 52, 56, 241, 245, 247, 252–253, 265
Otter Tail County Historical Museum (MN), 136
Our Saviour's Church (Oslo), 62
Overland, Orman, 188, 216
Øvstrud, Iver Gundersøn, 64, *102,* 215
Øyer (Gudbrandsdalen), 73, 91, 128
Øykjelid, Tor S., 193

Pacific Northwest, 94
Pacific Lutheran University, 31

Index

Paris, 44
Parliament (*Storting*), 122, 249
Passion (Christian), 63
Peach, Trudy, 97, *231*, 267
Pederson, Tallag, *55*
Peerson, Cleng, 126–127
Pellettiere, Luigi, 265
Pentecost, 151
Peterson, Dorothy, *206*, 267
Peterson, P. D., 89
Peters, John, 260
Petersson, Axel "*Döderultarn*," 65
Pettersen, Kari, 268
Pettersen, Wiggo, 268
Picasso, Pablo, 96
Pinnerud, Lars, 62, *74*
Pittelkow, Addie, *220*, 267
Pleasant Spring township (WI), 130
Pleuss, Mary and Arnold, 224, 229
Porsgrunds Porselænsfabrik, 255, 257
Porsgrunn (Telemark), 193
Portland (OR), 92
Potten, Aslag Torgusen, 226
Poulsson, Magnus, 254
Prytz, Torolf, *253*

Quakers, 126
Qvale, Anders Andersen, 187
Qualey, Carlton, C., 132
Qvatem, Anders Christensen, 24

Racine (WI), 193
Rasmuson, Severt, *200*
Rasmussen, David, 267
Ray (MN), 84, 92
Red River Valley (MN), 131
Reformation, 242
Refsal, Harley, 96, *109*, 267
Regency (style), 14, 62, 67, 190
Reiersen, Johan Reinert, 128, 186, 188
Reilly, Ann Marie, 6
Rein, John A., 94, *210*, *211*
Reindahl, Knute, 92
Renaissance, 14, 17, 39–46, 49, 51–52, 55–56, 58–59, 61, 63, 65–66, 69, 144, 227, 229
Restauration (ship), 8, 126
Richards, Jim and Mary, 177, *180*, 224–225
Richter, Franz, 109
Reimer, Eileen, 267
Riis, Tom, 265
Rikansrud, Grace N., 96, *147*

Riksantikvaren (see Directorate for Cultural Heritage)
Ringebu (Gudbrandsdalen), 128
Ringsaker (Hedemark), 74
Risøyne, Tore, *227*
Ritger, Judy, *180*, *195*, 267
Rochester Friends of Vesterheim (MN), 24
Rock Prairie settlement (WI), 130
Rococo, 14, 62, 64–65, 67–68, 86, 93, 99, 190–191, 196, 202, 204, 215–216, 254
Roehl, Rosemary, 267
Rogaland, 66, 97, 126, 134, 229, 231
Rollag (Numedal), 102
Rolland, Lavrin, 55
Rofshus (Telemark), 17
Rolvaag, Ole E., 8, 187
Romanesque, 17, 26, 38–40, 43, 46, 56, 67, 176, 250
Romantic, 255
Rome (and related), 38, 62–63
Røros (Trøndelag), 191
Roseau (MN), 94
Roseau County Historical Museum and Interpretive Center (MN), 211
Rosendahl, P.J., 166, *167*
Rovelstad, Theodore, 92, *260*
Royal Norwegian Ministry of Foreign Affairs, 6
Rudeng, Erik, 6, 9
Rue (emigrant party), 127
Ruskin, John, 253
Russia, 173, 252
Ruud, Martin B., 188
Ryfylke (Rogaland), 66, 93, 97, 127, 191, 193
Ryfylkemuséet, 229, 265
Rygg, Ketil, 65
Rygjestova (Telemark), 67
Ryggen, Hannah, 255
Rykken, Agnes, 93–94, 236, *237*, 259, 267
Rykken, Martta A., 236
Rynning, Ole, 128, 186

St. Cloud (MN), 226
St. Louis County Historical Society (MN), 84, 265
St. Olaf College (MN), 15
St. Paul (MN), 6, 19, 138, 164, 220
Sælid, Eli, 268
Samnander (Hordaland), 69
Samson (biblical), 55, 66

Samson and Delilah (biblical), 209
Sand (Rogaland), 93, 97
Sand, Torstein, 66, 94, *206*, *208*
Sandom, Hans, 77, 96, *198*, *207*, 267
Sandvig, Anders, *238*, 242–247
Sandvigske Samlinger (see Maihaugen)
Sata, Herbrand, 65, 67–68, *202*, 203, 215
Sata-Bæra family, 205
Saude (Rogaland), 251
Sauland (Telemark), 39
Sausgardhaugen, Torkjell, T., 191
Scandinavia (and related), 39–40, 43–45, 63, 89, 92, 96, 108, 129, 143, 187,
Scandinavian Airlines (SAS), 6
Scandinavian Cultural Center (WA), 31
Schetelig (also Shetelig), Haakon, 38, 40, 72
Schiller, Larry, *222*
Schmidt, Elaine, 267
Schmidt, Nancy, 267
Schneck, Nancy, 267
Schumann, Gunneid, 268
Seamonson, Norman, *29*, 96
Seattle (WA), 6, 93–94, 162, 236–237, 259
Selbu (Trøndelag), 122, 152
Seljord (Telemark), 76
Selmer, Marcus, 160
Semb, Klara, 158
Semmingsen, Ingrid, 132, 164, 169, 188
Setesdal, 26, 28, 37, 40, 45–46, 54–57, 61, 64, 110, 112, 116, 120–121, 125, 128–129, 131, 144, 152, 155, 173, 176, 182
Setesdøls, 131
Sheffield, Clarence, 6
Sigdal (Buskerud), 68, 83, 91
Simonson, Glen, 267
Sirdal (Aust-Agder), 226
Sire, Haagen Hermundsen, 203
Sissjord, Halvor, 268
Sjevesland (Øysebo, Vest-Agder), 138
Skansen (see Nordic Museum, Stockholm)
Skare, John, 267
Skavhaug, Kjersti, 169
Skien (Telemark), 43
Skjaak (Also Skjåk, Gudbrandsdalen), 74
Skodje (Sunnmøre), 153

Skolaas, Olav, *110*
Skrinde, Sylfest N., 62, *74*
Sletten, Engebret, 86, *87*, 91, 101
Sletten, Ole O., 64, 91, *101*
Sletto, Knut O., *178*
Slogvig, Knud A., 126
Smiland, Ole Eiersen, 227
Smith-Zimmermann State Museum (SD), 34
Sogge, Rolf, 268
Sogn, 23–24, 36, 38, 46, 66, 84, 86, 91–93, 121, 127–128, 133, 191–193, 201, 155
Sogndal (Sogn), 24, 91
Sognings, 130
Solberg, Barbara, 137
Solomon (biblical), 43
Søndre Land, 190
Sons of Norway, 157, 168
Sør-Fron (Gudbrandsdalen), 78, 92, 103
Sør-Trøndelag, 75
South Bend (IN), 143
South Dakota, 34, 131
Spanish, 45, 49,
Spring Grove (MN), 106
Stanton Publication Services, Inc., 6
State Historical Society of North Dakota, 224, 265
Stavanger, 8, 19, 123, 126, 229
Stavdahl, Leif, 265
Steen, Albert, 15, 41, 249, 270
Steine (Hardanger), 191
Steinkjøndalen, Jon Ellefson, *172*
Stilin, Sheila, 267
Stockholm (Sweden), 39, 61, 242, 250–251
Stone Age, 42
Stoughton (WI), 29, 97, 216, 229, 234
Strammerud, Jens, 62, *74*
Strand, Ola O., 192
Strand, Ole S., 192
Strand, Todd A., 265
Strangeson, Olaf, 55
Sturlason, Snorre, 254
Sunburg (MN), 28
Sundt, Eilert L., 70, 270
Sunnfjord, 70, 231
Sunnmøre, 191
Suul, Ulla, 268
Sveen, Dag, 63, 70, 97
Svensson, Sigfrid, 61
Sweden (and related), 19, 45, 57, 61–64, 92, 96, 98–99, 108, 119–120, 122, 139, 142,

275

Sweden (continued)
157, 162, 187, 191, 222, 239, 243, 250–251, 255
Swenson, Aaron, 22, 96, *109*
Swensrud, Ida and Hannah, 59
Swiss style, 168, 250
Syttende mai (17th of May), 158, 166

Tangen, Alfhild, 268
Taraldset, Rolf, 268
Teigen (photographer), 61, 66
Teigen, Erik, 91
Teigeroen, Ola Rasmussen "Skjåk-Ola," 62
Telemark, 17–20, 23, 26, 37–43, 46, 56, 58–59, 61–69, 72, 76, 82, 89–94, 97, 107–108, 111–114, 117, 120, 125, 127–130, 141, 152, 162, 166, 174, 176, 183, 187, 190, 192–194, 215, 224, 227, 231, 254
Telemarkings, 130–131, 154, 167–168
Temple, Mary, *138*
Texas, 128, 187
Thengs, Harold, 92, *115*
Thengs, Samuel, 115, 265
Thode, Vi, 97, *229*, 267
Thorp, Sara, 89
Tidrick, K., 55
Tinn (Telemark), 23, 127, 191, 224
Tjørehom, Jørund T., 69, *226*
Thrane, Marcus, 160
Tidemand, Adolph, *12*, 150, *155, 184*, 185
Tobiassen, Anna Helene, 169
Toftey, Suzanne, 267
Tokheim, Gene and Lucy, *116*
Tomlinson, Bruce and Linda, 30, 83
Tonder, Richard, 265
Tønsberg (Vestfold), 96
Torjusson, Olav, 67
Torvik, Judith, 124
Torvik, Lisa, 256

Tostrup, Jacob, 252, *253*
Trageton, Lars Aslakson, 66, 191, 229
Trempeleau Valley (WI), 194
Trøndelag, 33–34, 43, 57, 62, 120, 123, 174, 177
Trondheim, 70, 94, 119, 191–192, 253, 255
Tufto, Peder A., 191
Turkish, 250
Tveit, Annanias, 69, *235*
Tveitejorde, Ola Eirikson, 192
Tveiten, Birgit, 268
Tveiten, Olav, 268
Tveiterås, Johannes, Sr., 69
Tveiterås, Nils (see Midthus)
Tvenge, Marit Anne, 268
Tynset (Hedemark), 81
Tysvær (Rogaland), 127

Ugelstad, Janike Sverdrup, 6
University of Minnesota, 6, 99
University of Northern Iowa, 15
University of Oslo Collection of Antiquities, 36, 38–39, 240
Uppheim (see Sevat Bjørnson)
Urnes church (Sogn), 36, 46

Væring, O., 4, 13, 119, 125, 189
Vågå (Gudbrandsdalen), 33, 40, 47, 49, 124, 247
Valdres (and related), 4, 26, 40, 63, 65–66, 68, 72, 89, 93, 97, 125, 127–128, 131, 155, 192–194, 198–201
Valdreser, 131
Valle (Setesdal), 46, 119, 155
Vallejo (CA), 54
Valley City (ND), 108
Vang church (MN), 130
Vangsnes (Sogn), 142
Veggesrudlia, Erik G., *93*, 193, 224, *225*
Veggesrudlia, Gunnar, 93, *225*
Veggli (Numedal), 126
Veldre (Hedemark), 73

Vesaas, Øystein, 68, 193, 270
Vest-Agder, 69, 96, 116, 173, 229, 255
Vest-Agder Fylkesmuseum, 138, 265
Vesterheim, 6, 8, 19–20, 24, 28–29, 32, 51, 57, 59, 72, 77–78, 83, 86, 89–90, 93–97, 99, 106, 108–109, 135, 146–147, 164, 172–173, 177–178, 180, 187, 191, 193, 200, 202, 204, 207, 209, 212, 215–216, 220, 224–226, 229, 231, 234, 257, 259–260, 262–263, 265, 267–268
Vestfold, 45, 96, 120, 139
Vestfold Fylkesmuseum, 139, 265
Vestlandske Kunstindustri Forening (see West Norwegian Arts and Crafts Society)
Victoria and Albert Museum, 241
Vienna, 251
Viking(s), 19–20, 39–40, 42–43, 45, 61, 63, 72, 91–92, 250
Viking Ship Museum (Oslo), 38–39
Viksdalen (Sunnfjord), 70
Vinje (Telemark), 82, 153
Virch, Pat, 267
Viroqua (WI), 82
Voss (Hordaland), 20, 26, 127, 143, 153, 167, 192, 251
Vosselag, 166, 167

Wanamingo (MN), 86, 91
Wangsness, Norma, 97, *235*
Wangsness, Willis and Norma, 235
Warg, Lorin and Lorraine, 57
Warm Springs (MT), 160
Washington (ship), 193
Washington (state), 75
Wasson, Trudy, 267
Wemark (family member), *104*
Wentzel, Gustav, *125*

Werenskiold, Eric, 254
Werner, August, 14, 93–94, *259*
Wertkin, Gerard C., 6, 8
West Agder (see Vest-Agder)
West Norwegian Arts and Crafts Society (Bergen), 69, 235
West Norwegian Museum of Applied Art (Bergen), 6
Westhagen, Tanja, 268
Wevley, Esther T., 179
Whalan (MN), 76–77
Whore of Babylon (biblical), 64, *101*
Winchester settlement (WI), 131
Wisconsin, 25, 28–29, 51, 59, 73, 82, 89–94, 97, 104, 106, 112, 117, 130–131, 141, 168, 172, 194
Wisconsin Folk Museum, 205
Wise and Foolish Virgins (biblical), 43–44, *50*, 51, *53*
Woelfflin, Heinrich, 38
Wold, Hans, 68
Wolfgram, Ruth, 267
Wolter, Barbara, 267
World Exposition (1893, Chicago), 251
World Exposition (1900, Paris), 251
World Exposition (1987, Stockholm), 251
World Exposition (1873, Vienna), 251
World War I, 129, 166, 260
World War II, 64, 89, 93, 98, 139, 168, 173, 194, 240, 243, 245, 255–256

Zempel, Solveig, 169
Zumbrota (MN), 161

Index prepared with the assistance of Lila Nelson and Clarence Sheffield

Marion Nelson, the editor of this publication,
is Professor Emeritus of Art History at the University of
Minnesota in Minneapolis and Director Emeritus at
Versterheim, the Norwegian-American Museum,
in Decorah, Iowa. He has published extensively on
Norwegian-American art.

This volume is dedicated to Janice Stewart, who in 1953 published the first comprehensive work on Norwegian folk art in English, and to Lila Nelson, who has been of major support and assistance through a lifetime of involvement with the folk art of Norway and the art in America that stems from it.

MARION NELSON, EDITOR